# Maps and Air Photographs

# Maps and Air Photographs

## Images of the Earth

**G. C. Dickinson**
*Senior Lecturer in Geography, University of Leeds*

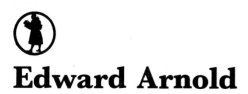

**Edward Arnold**

© G. C. Dickinson, 1979

First published 1969 by
Edward Arnold (Publishers) Ltd
41 Bedford Square, London WC2 4DQ
Reprinted 1970

First published in paperback 1976
Second edition 1979

**British Library Cataloguing in Publication Data**

Dickinson, Gordon Cawood
    Maps and air photographs. – 2nd ed.
    1. Maps. 2. Photography, Aerial
    I. Title
912          GA105

ISBN 0–7131–6145–0
ISBN 0–7131–6146–9 Pbk

Filmset in 'Monophoto' Baskerville 11 on 12 pt. by
Richard Clay (The Chaucer Press), Ltd., Bungay, Suffolk
and printed in Great Britain by
Fletcher & Son Ltd., Norwich

# Contents

vi   *Contents*

# Introduction to the Second Edition

For as long as men have inhabited the earth they have asked, of travellers and strangers, what the rest of the world was like. It was a question more easily put than answered, for in any statement of the complexities of content and position verbal description must soon have proved to be a tedious and limited form of communication. Even so there were powerful reasons – economic, political, even theological – for wanting to have such questions answered, and it is not surprising that maps, which developed to meet this need for precise, specific statements of 'what there was' and 'where it was', should have a history stretching back to antiquity.

This need for maps has never disappeared. Indeed as man's utilization of the world's resources has increased, and as he has sought to *control* them as well as to use them, maps have become so indispensable that it is not too fanciful to suggest that the 'map consumption' of a country is a reasonable indication of its level of economic and technological development. The same can be said, too, of other devices such as air photographs and remotely-sensed images of the earth, which have more recently joined the map in its traditional role of portraying the earth's surface.

It is hardly surprising that so powerful a range of tools as maps, air photographs and other associated images should have attracted a very wide spectrum of users, ranging from those who use them with professional expertise in their daily working lives to others who may have as yet only a limited acquaintance with them but who may be stimulated (or required) to know more about them and what can be done with them. It is to this last category of users of maps and air photographs that this book is particularly addressed. It seeks to expand the reader's knowledge and experience of maps and air photographs, to describe and explain what they show and how they show it, and to indicate some of the simpler ways in which they can be put to profitable use.

An introductory role is fundamental to this book. Full treatment of the many, often complex processes of production or utilization referred to in these pages would be impossible in so limited a compass. What can be attempted however is a brief description of the basic principles or characteristics of many of these processes and devices, in the belief that this will bring about an awareness of their importance, variety and potential contribution. Should this introduction happily stimulate the reader's interest in any of these topics further he is referred to fuller and more technical works in the 'Suggestions for further reading' section at the end.

Even at the introductory level just described, however, to provide a full description of maps and air photographs would be an enormous task. Maps are, after all, very varied things and only the broadest of principles unites the map of Africa in a school atlas and the sketch we draw on the back of an envelope to guide a new friend to our home for the

first time. Within this range some selection will have to be exercised, and in this book the overwhelming concern is with maps which can broadly be described as *topographical*, that is with maps which attempt to record the general features of the landscape in some degree of detail, say at scales of 1 : 1,000,000 (about 16 miles to an inch) and larger. Specialized maps recording only particular aspects of landscape such as roads, canals, mineral concessions and so on, are not specifically referred to in this book (though this does not mean that many of the features or processes described here do not have equal relevance for such maps), nor, generally speaking, are small-scale atlas maps; maps devoted to showing statistical information have already been dealt with by the author in 'Statistical Mapping and the Presentation of Statistics', a companion volume to this work.

With these exceptions, however, an attempt is made to consider here a very wide range of topographical maps and in particular to describe and discuss world maps not just British maps. Used to living in a well mapped part of the world the average Briton or West European is quite unaware of the much more limited cartographic resources available elsewhere, or of the very different styles and contents which he may encounter on a foreign map. In another respect, too, he may be different. Where maps are good, complete, up to date and easily purchased there will be an inevitable tendency to use them as 'portrayers of terrain' in preference to the more expensive air photograph. Elsewhere the choice may be less straightforward. In the many parts of the world where mapping is incomplete, or at relatively small scales, an air photograph may be a more obvious choice. Far more of the earth's surface is covered by air photographs than by good topographical maps and the photography may well be of more recent date and at relatively larger scale. In most situations, however, it is sensible to see map and air photograph as complementary rather than competitive, and it is because each has an important and distinctive contribution to make to portraying and understanding the earth's surface that they find a place together in this book.

In terms of form and content the air photograph is a less variable phenomenon than the map and poses fewer problems of selection. Nevertheless within this book attention is focused principally on the kinds of air photograph most likely to be encountered by beginners working in this field, i.e. black-and-white overlapping verticals at scales of approximately 1 : 60,000 and larger, although the final chapter attempts to show something of the potential of less conventional types of air photograph, and of other forms of imagery produced by non-photographic methods.

The role of 'picturing' the earth's surface is, however, only one aspect of the air photograph's utility. Equally important is the contribution which it has made, through the science of photogrammetry, to the actual mapping of that surface. Until recently this process had a clear two-part structure – one essentially *took* a photograph and from it one *drew* a map. Today this distinction is not quite so clear cut, thanks to the increasing use in the last twenty years of the orthophotomap, whereby the photo can *become* the map with little or no redrawing. If orthophotomaps become even more commonplace, as they may well do in parts of the earth which are poorly or badly mapped, the distinction between photograph and map will become somewhat artificial, and it is in recognition of this potential of the orthophotograph for turning what used to be a dichotomy into a virtual continuum, that the structure of this book has been changed drastically from that of the first edition. In that book maps and air photographs were treated separately. In this new

edition they have been taken as making a joint contribution to the provision of *images of the earth* and from this idea the new three-part structure of this edition has evolved.

In Part I *Extending the Image* the gradual extension and development of world mapping is traced against the background of increasing interest and demand and steady surmounting of technical obstacles. Here the air photograph appears mainly in the latter capacity as an important contributory factor to the accuracy and spread of mapping.

Part II *Creating the Image* is concerned almost entirely with maps and examines the content and design of the finished products, seeking to show how and why they present the form and variety that they do.

As its title *Using the Image* suggests, Part III is essentially the practical part of this book and describes some of the basic problems which maps and air photographs can resolve and some of the simpler techniques which can be used on them. It begins obviously enough with such matters of practical concern as scale, position and measurement of area, where the contribution of the map is dominant, before adopting, in the final chapters, a more speculative vein concerned with the examination of the earth's surface to determine what its patterns reveal or suggest. Here, despite the strongly entrenched traditional role of the map, the air photograph can be seen to come into its own and the last chapter, which offers a brief and general introduction to the interpretation of air photographs, also attempts to indicate its very wide potential in this field.

So far as this last chapter is concerned it is assumed that the reader will have no previous experience of working with air photographs. With maps, however, it seems reasonable to expect that he or she will already possess an elementary knowledge of map reading and be familiar with such devices as contours and conventional signs. This is no more than rudimentary knowledge, taught as such in secondary or, more often today, in primary schools. Yet once it has been acquired the intriguing world of maps and air photographs lies wide open and a journey into it can provide utility and pleasure. It is the author's hope that this book will serve as a satisfactory guide for that journey.

# Figures

# Part I
# Extending the Image

# Chapter 1

## The Developing World Scene – and the Need for Map Projections

During the last century, and even more during the last thirty years, our knowledge of the surface features of the earth has increased at a truly amazing rate. Today, for most of this surface, a photographic record already exists, though this may range from satellite photos showing vast areas at a very small scale to more conventional air photographs showing a wealth of landscape detail at larger scales for a smaller area, and from these photos we are able to produce maps which are more extensive, more complete and more accurate than ever before.

Because modern maps are derived from this detailed, pictorial record we confidently expect that in any one part of the earth they will present much the same picture, no matter what agency has produced them. This has not always been so. Sixteenth-century maps of the world, for example, differ very significantly one from another, and still further back in time, when philosophy rather than fact had to fill enormous gaps in world knowledge, an even greater diversity is found, Christian and Arab, Chinese, Greek and Roman each envisaging the world in his own particular way. The most obvious concern of these first four chapters is to relate how this ancient diversity was transformed into modern uniformity and to emphasize some of the more important obstacles which had to be overcome before this transformation could occur. Inevitably in doing this there will also be a need to describe many of the basic principles and techniques which underlie modern cartography.

*Cartography in the Classical World*

Although evidence of very early maps has been found in several parts of the world the western or European School of map making undoubtedly had its origins in the classical world of the ancient Greeks. As early as the fourth century BC Greek philosophers and scholars, working through logical analysis of known facts, were beginning to suspect the spherical nature of the earth; by the time another century had elapsed Eratosthenes of Cyrene, head of the great Library of Alexandria, was able to make the first practical attempt to measure its circumference. Like many another earth-measurer of later years Eratosthenes's theoretical knowledge was much sounder than the crude instruments with which he had to apply it, but even so his result – a circumference of 250,000 stadia (about

28,000 miles) – was surprisingly good, and as later centuries were to show, an established spherical earth measured to within 14% of its true size was no mean achievement two hundred years before Christ.

But this was not Eratosthenes's only contribution to cartography. A spherical earth needs spherical coordinates to define position upon it and it is known that he also constructed a map of the classical world based upon what today we should describe as seven meridians and seven parallels, including the equator and the northern tropic. The map itself has not survived but sufficiently detailed descriptions of it permit the reconstruction shown in Fig. 1A. When one considers its antiquity the known world around the Mediterranean appears surprisingly well shown and, as will become clear shortly, even as a world map the result can favourably be compared with many drawn a thousand years and more later.

Important though Eratosthenes's contributions to cartography may have been, they were completely overshadowed three hundred years later by the *magnum opus* of yet another Alexandrian Greek, Claudius Ptolemy (AD 90–168). Published under the composite title of *Geographia* this remarkable eight-volume work was essentially a description of the known world, but it included among its contents a discussion of the theoretical and practical considerations involved in making a map of the world, estimates of the latitude and longitude of some eight thousand places, and instructions for drawing twenty-six regional maps and two map projections. Unfortunately, no original of any of Ptolemy's maps has survived, nor in fact is it certain whether Ptolemy himself ever drew them, but we know from medieval copies of them that somebody did, and in all probability Ptolemy's one world and twenty-six regional maps formed the first atlas. It was Ptolemy too who gave us the names latitude and longitude, supplementing the former by *climata* (latitudinal divisions based on the length of the longest day) and measuring the latter from the legendary Fortunate Islands, the westernmost known land, usually thought today to be the Canary group.

For reasons which will be explained shortly Ptolemy's maps were enormously important in cartographic development. In the late fifteenth century, one thousand three hundred years after their original publication, they re-emerged, much copied, as one of the twin foundations of modern cartography, and it is from one of these medieval copies that the essential features of Ptolemy's world map shown in Fig. 1B have been taken. Coastlines, rivers and mountains, at least around the Mediterranean and its nearer neighbours, are well represented and with north at the top, the tropic almost correctly placed at 23° 51′ N, and converging meridians and curved parallels imitating their global counterparts, Ptolemy's world map has a distinctly modern look. The errors of the outer area, such as the enclosed Indian Ocean and an enlarged Ceylon, are understandable enough but in one less obvious respect there is a serious mistake – Ptolemy's earth is about a quarter too small. By using Posidonius's estimate of the earth's circumference – 18,000 miles, or 1° equals about 500 stadia instead of Eratosthenes's (better) 1° equals about 700 stadia – Ptolemy translated his estimate of the combined length of Europe and Asia as 180° instead of the actual 130°; it has been suggested many times that one of the factors encouraging Columbus and the westward-sailing explorers may have been Ptolemy's accidental 'narrowing' of the sea-gap between the Orient and western Europe.

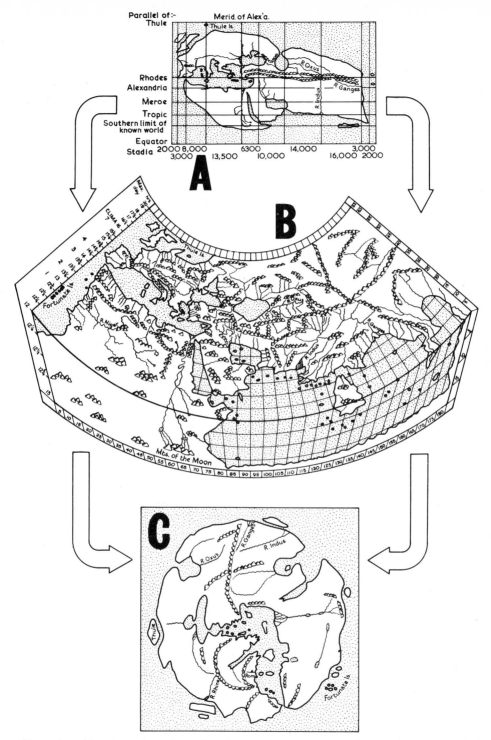

**Fig. 1:** Classical world cartography – rise and decline. **A:** A reconstruction of the world map of Eratosthenes (270–195 BC). **B:** Ptolemy's world map (*c.* AD 150) from a medieval copy published in Rome in 1490. (*Note:* much detail – rivers, mountains, names, meridians and parallels except in the Indian Ocean – has been omitted to preserve clarity.) **C:** A reconstruction of the Roman *Orbis Terrarum* (after E. Raisz, *Principles of Cartography*, by permission of the McGraw-Hill Book Company). Although the maps in both **A** and **B** are related to a spherical earth, that in **C** portrays the earth as a 'flat disc'.

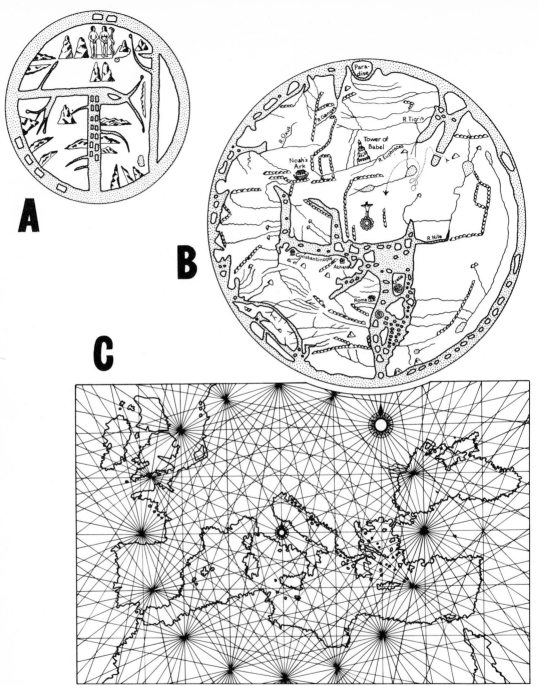

**Fig. 2:** Early medieval cartography – nadir and re-emergence. **A:** A twelfth-century (?) world map from a manuscript in the library of Turin. **B:** The thirteenth-century world map in Hereford Cathedral. **C:** An anonymous Portolan chart of the fifteenth century in the university library, Uppsala. In all three maps much detail and many names are omitted, though in **C** the only landward detail on the original was the delta of the Danube.

*Cartography in the Dark Ages and Early Medieval Period*

Unfortunately maps and ideas as sophisticated as Ptolemy's were not in vogue for long. Even in Roman times the spherical earth concept appears to have declined in favour of the idea of a flat disc (Fig. 1C) and with the dissolution of the Roman Empire the great bulk of classical learning, cartographic knowledge along with the rest, became lost to the western world.

The fact that cartography was now deprived of its former logical foundations did not, of course, prevent people wanting to know and show what the earth was like. Instead of classical logic, however, it was the teaching and philosophy of the Christian Church which were increasingly employed as the foundations of world mapping and maps now became as concerned to illustrate the divine scheme of creation described in the Bible as they were to portray geographical reality. Very often the whole range of biblical allusion is there. Pride of place is frequently given to Paradise and the Garden of Eden, putting east (since they were thought to lie in that direction), not north, at the top of the map; Noah's Ark, stuck on Mount Ararat, is usually there as well, and, for the lesser known 'outer areas', mythology and travellers' tales supplied plenty of horrifying footnotes or drawings of monsters.

The common form of these maps is almost always that of a flat disc in a surrounding ocean, a general concept inherited very probably from the Roman *Orbis Terrarum* style of map, but there is considerable diversity in style and detail. Some are so simplified as to be quite impracticable and seem merely to illustrate philosophical concepts – a Christian world centred on Jerusalem [1] or the world divided among the three sons of Noah, as in the common 'T-in-O' type map (Fig. 2A). Others, such as Fig. 2B, were more elaborate and had at least some practical pretensions as guides to travellers, incorporating within them detail from contemporary and classical itineraries which gave lists of towns and perhaps distances along principal routes. In the absence of any global framework details from these itineraries may well have given to the maps such crude local patterns and configurations as they possess; and the land-oriented approach may in part explain the noticeable weakness in the delineation of coastal features. Whatever their origins, maps of this kind, simplified or detailed, represent an amazing decline from Ptolemaic cartography, but it is just possible that we may be judging early medieval map-makers rather too harshly. Among the maps which have survived from this period there are a few which represent the earth as a sphere or hemisphere, for example one by Joannes de Sacrobusco, significantly a teacher of astronomy and mathematics at the University of Paris. Perhaps there were many more examples of this type of map which we do not know about; yet all the evidence points the other way, and it is not until the fourteenth and early fifteenth centuries that there are widespread signs of any cartographic revival.

*The Renaissance and the Revival of Cartography*

Along with many other branches of learning, cartography made tremendous progress during the period of the Renaissance, but it received its inspiration from two distinct and

[1] e.g. *Ezekiel* V, 5 'This is Jerusalem: I have set her in the midst of the nations, and countries are round about her.'

rather different sources. One was the rediscovery of the works of Ptolemy himself (his *Geographia* was translated into Latin about 1405), but the other and rather earlier one arose simply from the needs of practical men. Maps based on Christian philosophy might do very well in monastic libraries but for mariners on the high seas something much more realistic was needed; fortunately for fourteenth-century sailors they found it in the remarkable group of maps known as *Portolan Charts*, or simply *Portolanos*, an example of which is shown in Fig. 2C.

Here indeed is work belonging to a very different school of cartography from that which produced the maps in Figs. 2A and 2B, though many of the circumstances surrounding the origins of this school, and its methods, remain obscure. The oldest surviving Portolanos date from the early fourteenth century and are largely of Italian origin, but certain evidence suggests that these may have been copies from much earlier ones, and all obviously owed a great deal to the magnetic compass which had come into increasing use after about 1100.[2] So far as the early examples are concerned, many were probably based on little more than the surprisingly detailed and accurate knowledge of sailing distances and directions accumulated by Genoese and other sea-captains, but in the later ones compass bearings or even compass surveys may perhaps have been used to define the coastal detail, which is remarkably complete though often slightly exaggerated, emphasizing the enormous importance of such detail to sailors and navigators. In contrast land detail is usually insignificant, for these were marine charts rather than maps.

Oddly enough, despite their remarkable accuracy, the charts do not appear concerned with either latitude, longitude or a map projection, though since at first most of them were confined to the area of the Mediterranean and its surroundings, their extent was not sufficient for this to cause real difficulties in plotting or accuracy. Instead, replacing the map projection as it were, they are almost invariably criss-crossed by intersecting networks of *rhumb* lines (lines marking the direction of the compass points) springing from several elaborately decorated compass roses (Fig. 2C). No entirely satisfactory explanation of these lines has yet been offered. They could have served no strictly accurate navigational purpose, for rhumb lines were not fully integrated into map design until Mercator produced his famous projection in 1569 (see page 11), but they may have served as rough guides for course setting, bearing in mind the relatively short distances usually involved.

The main contribution of the Portolanos to cartographic revival was the reintroduction of the simple idea of an accurate map to suit practical needs, and little more. On the other hand the rediscovery of Ptolemy by the fifteenth-century western world (the Arabs had 'discovered' him much earlier) affected cartography in both its theoretical and its practical aspects. The immediate result, assisted by the contemporary development of printing, was the rapid production all over western Europe of world and regional maps based on Ptolemy's descriptions, sometimes but not always corrected and amplified by later knowledge. In some instances Ptolemy's errors were directly reproduced even where contemporary sources might have corrected them, for example his Mediterranean, 62° in length and almost 20° too long, was widely accepted in favour of the more reasonable

---

[2] It is impossible to fix a date for the 'invention' of the magnetized needle; the properties of magnetite or loadstone were known in the classical world but at what date these became incorporated into a navigational instrument is not known.

'rule-of-thumb' shape on the Portolan Charts; by 1554 Mercator had reduced this to 53° but the correct length did not emerge for another 150 years after that.

Erroneous or not, Ptolemy's maps added enormously to men's knowledge of what the earth was like, conferring great benefits on all who had to use and consult maps. For men who had to *make* maps, however, they did even more; they stimulated interest in two features which are the very basis of modern mapping – the idea of the spherical earth and the need for map projections to represent it on paper. Once started, map projections developed surprisingly quickly. In a very short time indeed Renaissance mathematicians had progressed well beyond Ptolemy's limited examples and one of the most striking features of world maps during the next two centuries is the great variety of projections on which they were based. This tendency to experiment with map projections was probably influenced a good deal by contemporary events. The increased use of globes (the earliest known example was made in 1492) would emphasize the need for realistic representation of shape on maps, and as the Great Age of Discovery continually enlarged the area which had to be shown on world maps, it increased the difficulty of doing so satisfactorily, and yet permitted a wider range of solutions.

Examples of world maps of this period are shown in Fig. 3, where two common characteristics may be observed. One is the vagueness and inaccuracies in the position of the lesser known parts of the world such as the Americas and the great southern 'Terra Australis', the other the representation of global position by reference to a projection representing the meridians and parallels of the globe. All too often the sophisticated nature of the projection itself contrasts starkly with the crude errors contained in the positions which are plotted on it; but once a projection giving a reasonable representation of latitude and longitude was achieved these were defects which needed only further exploration and more accurate positional determination to correct them. In effect two or three centuries were to elapse before many major errors were removed from world maps, and blanks filled. Exploration was slow and determination of longitude in particular proved a major problem, only tenuously solved before the experiments of the French Academy in the late seventeenth century,[3] but in theory and in spirit these fifteenth-century maps are the true ancestors of modern world maps. Their makers were working with a sphere, a projection, and latitude and longitude just as modern cartographers do, even if their global knowledge, their technique and hence their results were a good deal less accurate than our own.

If in Fig. 3 we disregard the variation resulting from imperfect knowledge of shape and position the maps differ only in one significant feature – the projection used. Superficially this introduces differences of shape almost as marked as those among the preceding 'ecclesiastical' maps but there is a major difference in spirit; one is the dissimilarity caused by reasoned and conscious mathematical choice, the other the result of philosophical and conceptual inadequacy. This conscious choice remains to the modern cartographer as much as to his predecessors, and though the casual map-user may overlook it in favour of more eye-catching choices such as style and content it is a choice which has to be made; modern map-making cannot even begin until this has been done. Anyone who

---

[3] The method used involved the observation of the moons of Jupiter and indicates how rapidly both astronomy and instrument-making had advanced; a more practical means resulted from Harrison's invention of a really accurate clock (chronometer) in 1735.

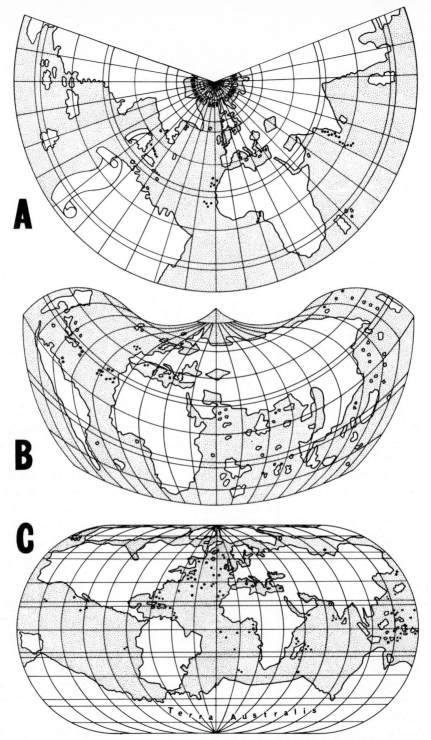

**Fig. 3:** Outlines of three sixteenth-century world maps. **A:** By Ruysch in 1508. **B:** By Apianus in 1520. **C:** By Ortelius in 1570. The scrolls in **A** contained notes such as 'Here came King Ferdinand of Spain's sailors', and served usefully to mask the unknown extent of North and South America.

wishes, therefore, to understand the basis of modern mapping must at least have an acquaintance with map projections and their properties, and this is what the next section attempts to provide. The approach used is not mathematical; most people do not need to know how to draw map projections, nor require to analyse their errors in precise detail. What they do want to know, when they find the name 'Transverse Mercator', 'Bonne's Projection' and so on in the margin of their map, is 'what is the basis of this projection?', 'why was it used?', 'what does it attempt to do?', and 'how well does it do it?'. If the examination is kept at this level map projections need not prove very daunting.

# Map projections

*The Basic Properties of Distance, Direction, Area and Shape*

Like many other things map projections are badly named. It is true that some map projections (the so-called *perspective projections*) *can* be obtained by allowing a source of light to project or cast shadows from the meridians and parallels of a hollow globe onto a sheet of paper. However the majority of projections in common use today have little relation to such an idea but are instead strictly mathematical devices, compromises by which the global network of meridians and parallels can be rendered two-dimensionally so that global position may be defined on a sheet of paper.

The element of compromise is fundamental. A spherical surface cannot be reproduced on flat paper, nor correspondingly can all the properties of position and relative position which exist on that surface. Some of these properties, and obvious choices are true representation of distance (i.e. true scale), direction (i.e. true bearing) area and shape, can be shown correctly over the whole of a map of the globe but all of them cannot be shown correctly together and even maintaining one of them correctly over the whole map may cause intolerable distortions in the others.

Distances, for example, can be shown correctly from one, or two, but no more, chosen points on certain special projections (the zenithal equidistant and the two-point equidistant projections respectively) but even then distances measured between any other points will be incorrect, and grossly so when away from the centre of the projection. An identical situation exists with respect to bearings.

Correct representation of shape on a map is impossible from the start; shapes on the earth's surface are 'spherical', i.e. they are three-dimensional in form, and they cannot be imitated two-dimensionally. Nevertheless it is obvious that some projections distort shapes and outlines very much whereas others give a fairly close representation of the global form, and cartographers therefore distinguish a class of projections known sometimes as *orthomorphic*, sometimes as *conformal* projections,[4] which present minimal distortion of shape over small areas. In effect this is obtained by ensuring that meridians and parallels always intersect at right-angles, as they do on the globe, and that at any one point scale in all

[4] An unfortunate feature of map projections is that many of them, and some of their properties, have alternative names. Where these occur they will be indicated by '(alternatively known as . . .)' in the text.

directions is equal; but it must be emphasised that over large areas scale may vary considerably and distortion will occur: a circle drawn on the globe will not normally appear as a circle on most orthomorphic projections.

Of the four basic properties, correct representation of area over the whole map is the most easily achieved, since equivalent areas can be produced by an infinite variation of dimensions within the same shape, or by employing different shapes, for example triangles, parallelograms and so on. Many *equal-area* projections (alternatively known as *equivalent* projections) maintain correct areas by balancing enlarged scale in one direction with reduced scale in another, often in a very exaggerated way in the outer areas of the projection.

Enough has been said here about the relationship between these important properties and projections to make it clear that the vast majority of topographical maps need a projection which offers above all a useful balance of properties, giving reasonable representation of all four factors (scale, shape, direction and area) and with errors kept to an acceptable minimum. Occasionally it may be necessary to have certain properties accurately shown, for example correct area on maps which are to show world distributions quantitatively, or certain aspects of bearing on navigational charts (see p. 14) but these are exceptional demands and most projections used today, even when they possess specific properties, such as equivalence of area or orthomorphism (conformality) are usually employed as much for their reasonable balance of properties as for the particular property itself.

One further point must be made here. As we shall see, a satisfactory balance of properties is not difficult to achieve over relatively small areas; it is when the area covered by the projection increases that difficulties arise, and most projections make a poor showing at their extremities when used to represent the whole globe. Fortunately, with topographical maps most projections do not have to cover large areas, and strictly speaking it is only necessary to consider in this book the limited number of projections used for topographical maps because of their excellence over limited areas. Conversely the much poorer showing which these and other projections make when applied over larger areas, as in atlas maps, is not our concern, but in the section which follows projections are nevertheless introduced first in a 'large-area coverage' context. There is a good reason for so doing. It is much easier for the novice to get the 'feel' of map projections, of the basic approaches and ideas which are possible, and of the errors which will develop as a result of these, when projections are seen in operation over wide areas. On the maps that follow the familiar graticule of meridians and parallels, and the shape of North America (added to all for comparative purposes), allow much easier appreciation of 'what is going on' than would any attempt to portray this over smaller areas. So too do the scale errors marked directly on the drawings. Once these are appreciated we can look more closely to see which of the projections we have met have been used for topographical maps, and why.

### Projections which Grew from Straight Lines

*The plate carrée* (alternatively known as the simple cylindrical, or cylindrical equidistant projection).     Two thousand years ago Eratosthenes needed a map projection; we could do worse than start where he did with one of the simplest solutions to the problem – it

goes like this: draw a straight equator, true to scale and crossed at the correct spacing by perpendiculars representing the meridians. Make the meridians their correct length, add the parallels as straight lines the same length as the equator and truly spaced along each meridian and we have a simple map projection, the *plate carrée* (Fig. 4B). It is not bad for a beginning. The most obvious defect is that the parallels, which should decrease in length towards the pole, all appear as long as the equator, giving the scale errors which are listed in the table below. However, scale is correct along the meridians and though exaggeration along the parallels is intolerable in high latitudes, within 10° of the equator it is only 1.54% or less, within 5° 0.38% or less, and within 2½° 0.095 % or less – virtually negligible. Although on this projection, therefore, neither shape nor area can be correct, provided that it can be restricted to a narrow band astride the equator the distortions are quite acceptable for topographical mapping. Fortunately for non-equatorial regions the projection can also be presented in a *transverse* form – which really means that it is 'turned round through 90°' so that its good 'narrow band', is now found astride any chosen *meridian* instead of astride the equator (see p. 25) – and in this form the projection has been used for topographical map series covering areas of relatively restricted east–west extent, for example the early editions of the Ordnance Survey maps of England and Wales. Rather confusingly this transverse form is known as the Cassini projection.

*Percentage Scale Errors\* Measured along the Parallels in Certain Map Projections*

| PARALLEL | PLATE CARRÉE AND MERCATOR'S | *Polar* VERSIONS OF ZENITHAL PROJECTIONS | | |
|---|---|---|---|---|
| | | STEREOGRAPHIC | EQUIDISTANT | EQUAL AREA |
| 0° | 0.00 | 100.0 | 57.1 | 41.4 |
| 10° | 1.5 | 70.4 | 41.7 | 30.4 |
| 20° | 6.4 | 49.0 | 30.0 | 22.2 |
| 30° | 15.5 | 33.3 | 20.9 | 15.3 |
| 40° | 30.5 | 21.7 | 13.9 | 10.2 |
| 50° | 55.6 | 13.2 | 8.6 | 6.3 |
| 60° | 100.00 | 7.2 | 4.7 | 3.5 |
| 70° | 192.4 | 3.1 | 2.1 | 1.5 |
| 80° | 475.9 | 0.8 | 0.5 | 0.4 |
| 90° | ∞ | 0.0 | 0.0 | |
| | | All errors are positive | | |

\* *The values for scale errors along the parallels in zenithal projections are taken from those given in the Oxford Atlas. Oxford University Press.*

*Mercator's projection* (alternatively known as the *cylindrical orthomorphic* projection).    Further projections are easily developed from the *plate carrée* by altering the spacing of either the meridians or the parallels. In 1569, when Mercator sat down to devise a projection which would be of real use for navigation he found that he had to choose the latter; it is not too difficult to see why.

The basic principle of navigation is simple: one sets and follows a given compass course,

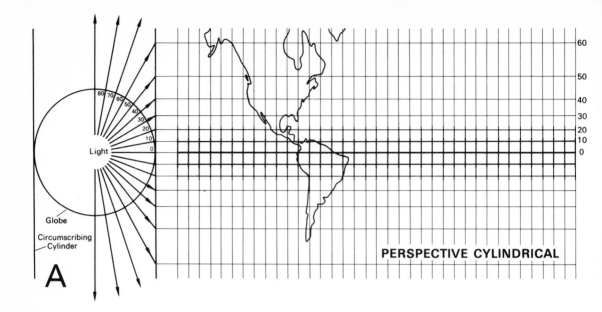

**PERSPECTIVE CYLINDRICAL**

**A**

**KEY**

Scale errors along
meridians and parallels

———— None, i.e. correct
length (to scale)

———— 2½% or less

———— 2½% to 10%

———— More than 10%
(and all
"construction" lines)

———⟶ Rays of light in
"true projections"

**B**

**PLATE CARRÉE**

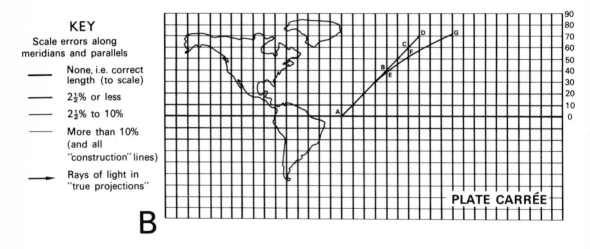

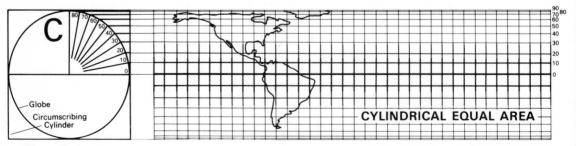

**CYLINDRICAL EQUAL AREA**

**Fig. 4:** Projections which grew from straight lines. **C, D, E** and **F** can all be regarded as modifications of the basic network of either the *plate carrée* (**B**) or the perspective projection (**A**). The scale errors indicated have been generalized to some extent.

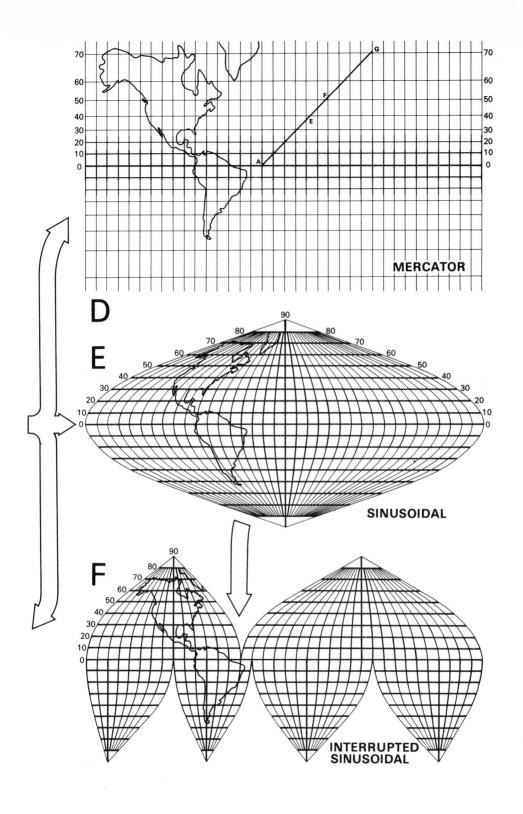

MERCATOR

SINUSOIDAL

INTERRUPTED
SINUSOIDAL

i.e. one follows a line of constant bearing, or *rhumb* line as it is called. On the globe this is a *curved* line crossing all the meridians at the same angle (angle *r* in Fig. 5) but for convenience of plotting navigators needed a projection on which it would appear as a *straight* line doing the same thing. Such a projection, therefore must have straight, parallel lines for the meridians, just as the *plate carrée* does, but for this specialized purpose the *plate carrée* is no use. Straight lines drawn on it look like representations of rhumb lines (i.e. they cross the meridians at a constant angle) but in practice they are not. A navigator who set out from A in Fig. 4B on a constant bearing of 45° would pass through E, F and G on the globe not B, C and D as the map seems to indicate. Mercator's problem, therefore, was to modify the *plate carrée* until E, F and G all lay on the straight line leaving A at 45°. The reason why, on the *plate carrée*, the line AD does not pass through the right places is fairly obvious. Shapes, and hence relative positions are all wrong; they have been exaggerated (or stretched) in one direction – along the parallels – but not in the other along the meridians, so that naturally the line AD misses its target. Mercator saw that if E, F and G were ever to be brought into the line AD without disturbing the straight meridians this could only be done by stretching the map north–south to balance the east–west stretch along the parallels, i.e. making exaggeration of scale along the meridian equal to that along the parallel at any point (see Fig. 4D). This was easier said than done. Since all the parallels are to be the same length the scale along each one becomes exaggerated, and increasingly so as one moves north or south from the equator. Along Mercator's meridians, therefore, scale must be *continually changing* to match this, so that when Mercator wanted to know how far from the equator his parallels would have to be placed he found himself faced with the problem of finding the sum of a series of constantly changing quantities. It is not generally known that Mercator was unable to do this exactly; not until the calculus was invented in the seventeenth century was this finally possible, but Mercator could and did find a very close approximation to the answer.

One apparent paradox must now be explained. Mercator's projection does not show bearings correctly. Mercator never said 'my map will show you the correct bearing of B from A' but rather 'my map will show you a simple way of getting from A to B. On it join A and B by a straight line; measure the bearing of this line against any meridian; set out from A on this bearing, keep to it and you will get to B.' This is not the shortest way from A to B however. Because we have drawn a straight line on Mercator's projection it must be a rhumb line as well, and this is a curved line on the globe. Now the shortest way from A to B is a straight line or *great circle*[5] course on the globe, something very different from the rhumb line, as Fig. 5 shows. The bearing, or more correctly *azimuth*, of B from A is its initial direction by the shortest route,[6] the angle Z in Fig. 5 not the bearing of the rhumb line, so that Mercator's projection does not show correctly the bearing of one place from another, only the correct bearing of the rhumb line course between them.

Navigators who want the best of both worlds – short great-circle courses and simple

[5] A *great circle* is any circle on the globe whose *centre is the centre of the globe*. The meridians and the equator (but not the other parallels) are examples of great circles.

[6] The terms bearing (see also p. 171) and azimuth are rather confusing and not always used correctly. The azimuth is the *initial bearing of the shortest route* to B from A. As Fig. 5 shows quite clearly anyone who set out to follow this route would find his actual *bearing*, i.e. direction relative to north, continually changing. Observe angle *g* on Fig. 5.

easily-sailed rhumb lines – can get this by finding the great-circle route on another projection, the *gnomonic* (see p. 17), plotting this on a Mercator chart, where it becomes a curved line, converting this arc to a series of chords – straight lines and therefore rhumb lines – and sailing along these; not exactly the shortest way but a very close approximation to it.

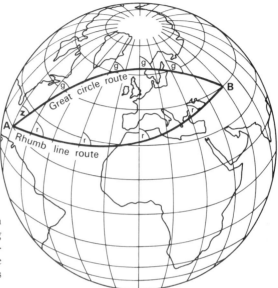

**Fig. 5:** Rhumb-line and great-circle routes between two points on the globe. Note the constant bearing r of the rhumb-line route and the constantly changing bearing of the great-circle route. On the globe the great-circle route is a straight line, and Z is therefore the azimuth of B from A.

One not unexpected by-product of Mercator's projection is that it fulfils the conditions for orthomorphism (see above p. 9) and shapes over very small areas are therefore shown correctly. On the other hand, as the table on p. 11 shows, scale, and hence area too, is grossly exaggerated in high latitudes, and the poles cannot be shown[7]: it is common knowledge that Mercator's projection makes Greenland look as large as South America though it is, in fact, only about one tenth of the area of the latter. Even so, within the same narrow equatorial band the scale errors on the parallels are as small as those of the *plate carrée*, and though these small errors are now present on the meridians too this brings about the orthomorphic property, which in turn ensures that azimuths, though not correct, are less distorted than on the *plate carrée*. In effect errors in azimuths are virtually negligible over observable distances.

Here then, for areas of restricted extent, is an even more suitable projection for topographic maps, though once again to provide world-wide availability it is the *transverse* form centred not on the equator but on a meridian (and alternatively known as the Gauss Conformal or Gauss-Krüger projection) which is usually used. Moreover by using an *interrupted* version of the transverse form (see p. 25) the projection can be used for topographical maps of very extensive areas, up to and including the whole world. The

---

[7] Since the pole (a *point*) has been infinitely exaggerated into a *line* this must be balanced by infinite exaggeration along the meridians and the poles are therefore situated at infinity.

Transverse Mercator Projection is in fact the projection used for the vast majority of the world's modern topographical map series.

Not surprisingly, for reasons described earlier, Mercator's projection has been widely used for navigation charts; however its very common use as a projection on which to draw large one-sheet maps of the world is much less easy to explain. There are several other projections which could serve as well or better for this purpose.

*The cylindrical equal-area projection.*     The parallels of the *plate carrée* can also be respaced to give an equal-area projection as Fig. 4C shows.[8] In effect equality of area is obtained only through gross distortion of scale in high latitudes and the projection is little used because better solutions are available.

*The sinusoidal (or Sanson-Flamsteed) and Mollweide's (or homolographic) projections.*     In the previous examples exaggeration of scale along the parallels has been a common fault. Why not then redraw the *plate carrée* with all parallels shrunk to their correct length and the meridians spaced properly along them? The result, shown in Fig. 4E, is the sinusoidal projection. It is not at all a bad projection and gives a central area of minimum errors, rather than a band as in the *plate carrée*, but one notices that it is now the meridians (except the central one) which show exaggeration of scale and they become awkwardly skewed to the parallels towards the periphery. Oddly enough it is also an equal-area projection,[9] showing the world much better than the cylindrical equal-area but less satisfactorily than the commoner *Mollweide's* projection (Fig. 6) which is simply a mathematician's solution to the request 'Draw me an equal-area projection of the world with an elliptical frame and straight lines for the parallels.' It is more pleasingly shaped in high latitudes than the sinusoidal, a fact which led J. P. Goode to produce the hybrid *homolosine* projection – simply a sinusoidal projection between the 40° parallels and a Mollweide's beyond, retaining the best areas of both components.

The worst defect of the sinusoidal and Mollweide's projections is the skewing of the meridians which results from gathering them together at the poles. If the map can be broken in some areas that do not matter – the oceans if the map is needed mainly for continental areas, or vice-versa – and the meridians gathered together at several 'central' meridians the good qualities of the 'central' areas are more widely spread. Fig. 4F shows such an *interrupted* (or *recentred*) sinusoidal projection. 'Interruption' of a projection is a most useful idea. Instead of having one extensive projection to cover a large area, the area is broken up into sections, each with its own projection. For example with the Transverse Mercator projection, which is perfectly acceptable within a narrow band astride a central meridian, as soon as the east–west extent causes the errors to become intolerable we simply start a 'new' projection based on a new central meridian. By dividing the earth into north–south strips, each 6° of longitude wide and with its own central meridian, the

[8] The construction is easy since the curved surface area of a zone of a sphere (i.e. the portion between two parallels) is equal to the curved surface area of a slice of similar height cut out of the circumscribing cylinder (see Fig. 4C).

[9] The proof is based on a theorem showing that parallelograms (the shapes on the map are very nearly parallelograms) with similar bases drawn between the same parallel lines are equal in area, no matter what shape they are.

**Fig. 6:** Mollweide's projection.

Transverse Mercator Projection can be used for topographical maps anywhere in the world. In this special form it is known as the *Universal transverse mercator projection*. 'Interruption' is not, of course, without its drawbacks too, for sections of an interrupted projection can never be pieced together again. Fig. 4F can be 'remade' into Fig. 4E only by redrawing, not by sticking together along the breaks, and it is impossible accurately to make assemblages of sheets from an interrupted projection, though at topographical scales the very small discrepancies can sometimes be overcome simply by stretching the paper.

The projections in Fig. 4 may also be thought of in another way as derivatives of a *perspective cylindrical projection*, formed by projecting a globe, from its centre, onto a circumscribing cylinder. The idea, and its results are shown in Fig. 4A. Although the projection is of little practical value, for its obvious errors have no compensating advantages, its equator and meridians have a useful arrangement and the parallels invite modification of the kind which we have already explored in Figs. 4B–F.[10]

### Projections Originating on a Flat Surface

Projecting the globe onto a cylinder did not get us very far. Let us try instead projecting it onto a flat sheet of paper touching the globe, at the north pole to begin with, and furthermore see what happens when we move the source of light, which we could not do effectively when it was contained in a cylinder. The results form a group of projections known collectively as *zenithal* or *azimuthal* projections.

*The orthographic, stereographic and gnomonic projections.*     Figs. 7A, B and C, show the projections produced when the light is placed at infinity, the south pole, and the earth's

[10] Other projections with differently spaced parallels exist in the cylindrical group, for example, Gall's stereographic, but they are not of sufficient importance to describe here.

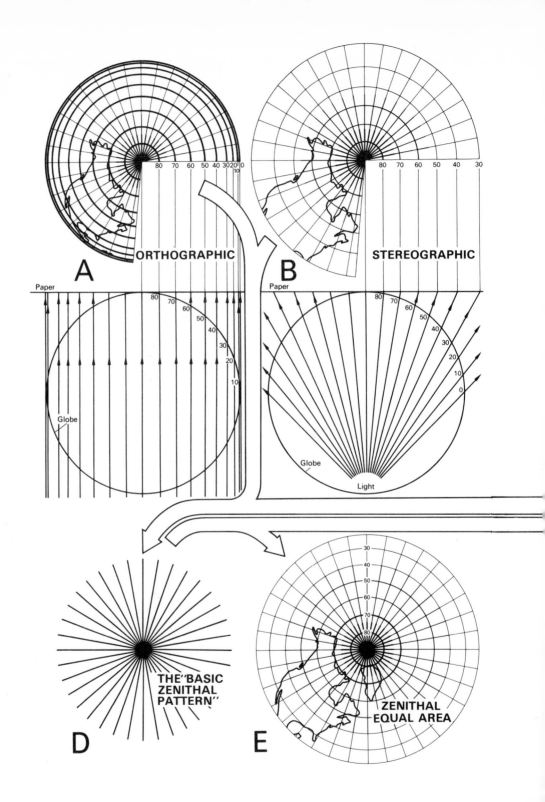

ORTHOGRAPHIC

STEREOGRAPHIC

Paper

80 70 60 50 40 30 20 10 0

Paper

80 70 60 50 40 30 20 10 0

Globe

Globe

Light

THE "BASIC ZENITHAL PATTERN"

ZENITHAL EQUAL AREA

A

B

D

E

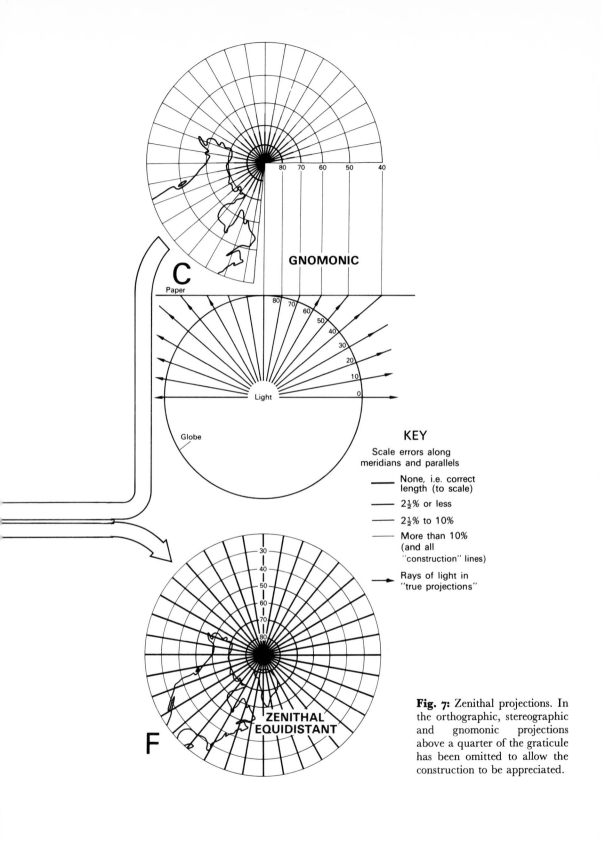

C

Paper

GNOMONIC

80 70 60 50 40

80 70 60 50 40 30 20 10 0

Light

Globe

**KEY**

Scale errors along
meridians and parallels

⸻ None, i.e. correct
length (to scale)

⸻ 2½% or less

⸻ 2½% to 10%

⸻ More than 10%
(and all
"construction" lines)

⟶ Rays of light in
"true projections"

30
40
50
60
70
80

**ZENITHAL
EQUIDISTANT**

F

**Fig. 7:** Zenithal projections. In the orthographic, stereographic and gnomonic projections above a quarter of the graticule has been omitted to allow the construction to be appreciated.

centre; they are known respectively as the orthographic, stereographic and gnomonic projections. The first and last are not only limited in extent to a hemisphere or less but contain such obvious distortions in their outer areas as to appear of little use. In fact both have a saving grace. The orthographic projection is simply the globe seen from afar, and is thus the easiest projection to envisage (see p. 25), while the gnomonic has the rare property (possessed by only one other projection, the *two point azimuthal*) of making all great circles straight lines, and vice versa. A straight line from A to B on a gnomonic projection is therefore the great circle route between them; hence the complementary roles of the gnomonic and Mercator's projection in navigation as described above.

The better balanced stereographic projection is much more reasonable in its errors especially in its central portion (see table, p. 11). Strangely enough it is also an orthomorphic projection,[11] but unlike Mercator's it has been little used for topographical maps except for polar regions; the Dutch official map series are also drawn on it. It is, however, a great 'cartographer's projection' and is used in the process of 'transforming' projections into transverse and oblique cases (see below).

*Zenithal equidistant and zenithal equal-area projections.*    All the preceding projections have concentric parallels and straight radiating meridians properly spaced about the pole (a property which indicates, incidentally, that bearings are correct from the centres of these, and all other zenithal projections). Let us however now abandon true projections, keep the arrangement of the meridians (Fig. 7D) but 'play about' with the parallels. Why not draw them their true distance from the pole, giving the zenithal equidistant projection (Fig. 7F), or calculate their radii so that they enclose on the map the same area as they do on the globe, giving the zenithal equal-area projection (Fig. 7E)? In the latter case the radii turn out to be the chord distances from the pole to the parallels, and the circles get (almost imperceptibly at first) closer together as one moves outwards from the pole. On both projections scale along the parallels is always exaggerated but, as the table on p. 11 shows, errors are very well controlled over a remakably wide area, and there is little to choose between the two projections in this respect. Even 45° (i.e. more than 3,000 miles) away from the centre scale errors along meridians and parallels are little more than 10% and 8% respectively, though the equal-area case balances positive errors with negative ones and so gives more noticeable distortion of shape; both become intolerably distorted if extended beyond a hemisphere. Neither has been much used for topographical maps since other projections cope more advantageously with small areas. For large areas and continents however they are much more successful and have recently been so used in atlases, though again usually in oblique or transverse form (see p. 25).

*Projections Derived from a Conical Surface*

The cone is the third surface onto which the globe can be projected to give a true map projection, but whereas only one cylinder will fit the globe, and a flat surface is invariable, any number of different cones can rest on the globe, from shallow ones touching near the pole to very tall ones touching near the equator; indeed the plane and cylinder can be

[11] It is not at all obvious that this is so but it can easily be proved mathematically.

thought of as the flattest and tallest of these cones respectively. Right from the start, therefore, there is an element of choice about conical projections, and the very important point of contact between cone and globe can be arranged where it best suits the area being mapped. For example in Figs. 8A–C contact has been made to occur at 50°N because this is suitable for North America.

As with cylindrical projections the true or perspective conic projection (Fig. 8A) is of no use except to provide certain 'basic features' around which further modification can take place. These features are (1) a standard parallel which is its correct length (it must be since at this point globe and cone coincide) and is represented by an arc whose radius is the slant height of the cone to that point (YZ in Fig. 8A); (2) other parallels as arcs of concentric circles, and (3) straight meridians radiating from the centre of these circles through points spaced correctly along the standard parallel. Note that the intersection at right-angles of radiating meridians and concentric circles holds out hope of reasonable representation of shape.

*Simple conic projection with one standard parallel* (alternatively the *conical equidistant with one standard parallel*).     This is the perspective conic but with the parallels spaced along the meridians at their *true distance* from the standard parallel (see Fig. 8B). The pole is not now at the centre of the circles but becomes exaggerated into an arc of small radius; in fact scale is too big along all parallels except the standard one, but close to the standard parallel errors are small and shapes and areas are quite reasonably shown. We can, however, improve on this.

*Bonne's projection.*     This is a simple conic projection which has been modified to remove exaggeration of scale along the parallels by spacing all meridians their true distance apart along every parallel. The resulting meridians are curved and lie skew to the concentric parallels (Fig. 8C), destroying the useful rectangular intersections of the simple conic. The meridians have also become slightly exaggerated in length, but even so Bonne's is an equal-area projection [12] with very reasonable shapes and errors around the central meridian. These properties, together with the relative ease with which it can be constructed and drawn, have caused it to be widely used for topographical maps, for example early Ordnance Survey maps of Scotland and the early French and Dutch official series. It is also frequently used for atlas maps of large areas.

*Conical Equidistant projection with two standard parallels* (alternatively *De l'Isles projection*).     As in other groups of projections, considerable benefit derives from letting loose the mathematicians on the simple basic ideas of the group. Suppose we say to them 'Forget all about cones and globes but devise something that will look like a conic projection. I want two standard parallels, both their correct length, their correct distance apart and both concentric arcs of equal angular extent. For the meridians, proceed as in the simple conic, i.e. space them correctly along these arcs and draw them in as straight lines radiating from the centre of the arcs: add the other parallels as concentric arcs their correct distance apart along these meridians.' This is child's play to the average

[12] For the same reason as the sinusoidal, see footnote 9, p. 16.

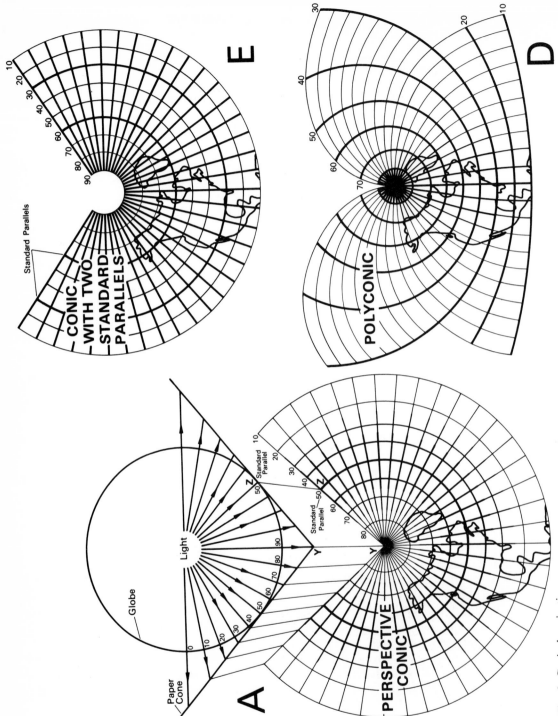

**Fig. 8:** Conical projections.

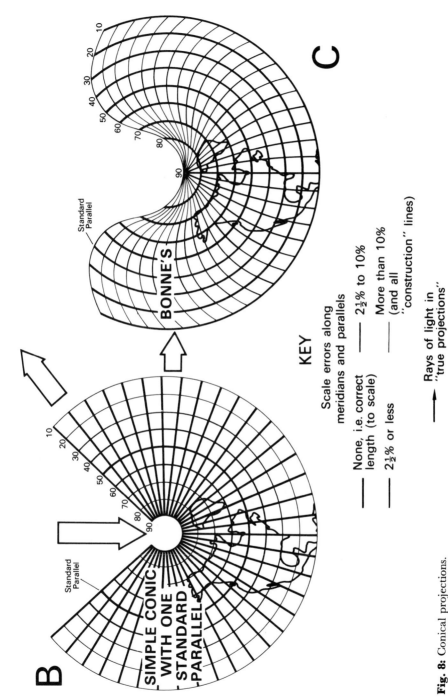

**Fig. 8:** Conical projections.

mathematician (even 'A'-level ones can manage it) who has only to calculate the radii for the two standard parallels to produce a very useful result, the conical equidistant projection with two standard parallels (Fig. 8E). Slightly better representation over large areas is obtained than with the simple conic with one standard parallel, especially if the standard parallels are carefully chosen;[13] scale is correct along all meridians as well as the two standard parallels, slightly too small along parallels between them and too large along parallels outside them; but errors are quite small over surprisingly large areas, and the whole of the USA for example could be mapped with less than 2% error.

*Alber's projection* (alternatively *the conical equal area projection with two standard parallels*).     If in relation to the parallels, the words 'their true distance apart' in the preceding specification is replaced by 'spaced so that the area between them is the same as that on the globe' we get Alber's projection. The meridians are drawn as before but all the parallels have their radii calculated so that the same equal-area condition is fulfilled. The mathematics is more complicated but the result even better; this time the maximum scale error for the whole of the USA would be no more than $1\frac{10}{4}$%.

*Lambert's conformal conic projection with two standard parallels.*     This is the most sophisticated of the mathematical derivatives of the conic group. It is, in effect, a 'mercatorized conic': i.e. two true-to-scale standard parallels again set the curvature for all the other concentric parallels, but their radii and the spacing of the parallels along the meridians are calculated so that scale error along any parallel is exactly balanced by a similar error along the meridian at that point. Errors are slightly larger than on Alber's, but because the projection is orthomorphic bearings are only slightly distorted and it has been used for air navigation charts as well as topographical maps: for example modern French maps and many military maps, especially those required for artillery purposes, are based on it.

*The polyconic projection.*     In one respect the standard parallel(s) of the conic group is a nuisance – it sets a shape to the other parallels and so to the map itself. This means, for example, that most conic projections for the northern hemisphere become very 'up-curved' if extended much beyond the equator, and world coverage is impossibly bad. The polyconic projection avoids this by having every parallel a standard parallel (i.e. treated exactly as if it were derived from a cone of its own). These parallels are spaced correctly along a central meridian and the meridians are truly spaced along the parallels. Away from the central meridian north–south scale errors increase rapidly, and in the form shown in Fig. 8D the projection is of little use; but it does solve the problem, for conical projections, of 'crossing the equator' and since the troublesome errors away from the central meridian can be damped down by interrupting the projection, presenting it as several narrow north–south strips, it has been used for such important maps as the International 1 : 1,000,000 map of the world (see pp. 114–16) and the maps of the United States Geological Survey.

[13] Fig. 8E does not really do justice to the accuracy of this projection. In fact the error along both 40°N and 50°N is little more than 3%.

*Transverse and Oblique Projections*

It will have become obvious by now that, at least in the cases of the 'true' or perspective projections (for example Figs. 4A, 7A–C and 8A), far more variety could be obtained than has been considered. Why in the zenithals consider only the case where the paper touches at the pole, why not touching at the equator instead, or why not have a horizontal instead of a vertical cylinder in the perspective cylindrical? Why not indeed? If we do this we shall get projections which, *because they are derived in the same way, must have the same properties as the 'normal' cases which we considered*, though they will look entirely different at first glance.

Fig. 9A shows part of the equatorial case of the gnomonic projection superimposed on a faint outline of the polar version (Fig. 7C). The resemblance is there, and plain to see if in the latter case we stop talking about pole, parallels and meridians and talk instead about 'centre', 'circles joining all points so many degrees away from the centre' and 'straight lines radiating from the centre'. Thus, in Fig. 9A, points 10, 20, 30 or 40 degrees away from the centre of the projection (along, for example, the central meridian or the equator) are spaced at exactly the same distances as in the polar case, becoming rapidly further apart as we go outwards, just as the parallels do in Fig. 7C. The properties of this projection are exactly the same as those of the polar case: great circles are all straight lines, and there are the straight meridians (all of which are great circles of course) to prove it.

Zenithal projections with the paper touching at the equator are called simply 'equatorial cases', whereas projections derived from a horizontal cylinder or cone are called *transverse*; but there is no need to stop there. We could use paper touching anywhere or a cylinder or cone placed 'cock-eyed' on the globe to give the *oblique* cases of the same projections. Fig. 5 is in fact an oblique orthographic projection of the globe. Like the polar case it looks like the globe from afar and is almost the only oblique projection the layman can visualise.

What of the other, much better, projections that were derived from the perspective ones? They too can be drawn in transverse and oblique forms. We have seen earlier, for example, how important to world mapping the Transverse Mercator projection is, and we know that it is called *transverse* because it is based upon a meridian (any meridian) and not the equator as is normally the case. Let us see how we might construct such a Transverse Mercator projection based on (say) 90°W and not the equator. We need a globe and a 'normal' Mercator projection on which the finished result will be plotted.[14] On the globe we draw in a new set of 'meridians' and 'parallels' using the meridian 90°W as 'equator' and having 'poles' at 180° and 0°. On the transverse projection 90°W is the new base line or 'equator' so that we can rule in the equator on the normal projection but mark it 90°W.[15] Suppose now that we wish to plot the position on the transverse projection of the 100°W meridian; we simply notice on the globe what are the 'latitudes' and 'longitudes'

[14] In practice the whole process is simply calculated but this description of what is involved will make the basis of the new projection clearer.

[15] Note that in Fig. 9B, to give some idea of the pattern of meridians and parallels when the projection is used for large areas, only the portion centred on 90°W and *lying north of the equator* is shown. Once 90°W is carried beyond the pole it becomes of course 90°E and the top portion therefore represents the northern half of the projection as centred on 90°E. If the projection was extended to cover the *whole* globe the patterns shown here would have to be repeated.

on the new network of the points through which it passes, plot these points on the normal projection, and join them by a line. This is the representation of the 100°W meridian and we can do this for any other line we require.

The result is shown in Fig. 9B, again with faint meridians and parallels from the normal case for comparison. Notice that, just as before, the 'pole', or better 'a point 90° away from the base line of the projection', cannot be shown. Since all meridians are alike the projection would show the same overall shape whatever meridian was chosen as the base line. In the transverse form, therefore, the useful properties of orthomorphism, and small scale and bearing errors found only in the equatorial regions of the normal case, can be obtained instead about any meridian anywhere on the globe.

### *Choice of Projection*

The choice of a suitable projection for a map is usually determined by its extent and its intended use. *Modern* topographic map series, for example, overwhelmingly favour conformal (orthomorphic) projections – the stereographic, Lambert's Conformal Conic or, especially, the Transverse Mercator – but this has not always been so and at one time a wider range including Bonne's, Cassini's and the (interrupted) Polyconic was in use. Unfortunately in the last three, though all offered ease of construction and relatively small errors, bearings were noticeably distorted since scale errors were not the same in all directions; with increasing emphasis on bearings, arising partly from artillery requirements in the 1914–18 war, conformal projections came into favour whenever map series were newly created or redrawn. Even with conformal projections bearings are not strictly correct of course, but since at any one point scale errors are the same *in all directions* bearings are less noticeably distorted than on the 'older' projections.

For navigational charts, for reasons explained earlier (p. 13), the normal Mercator's projection traditionally took pride of place for both sea and air purposes. In recent years however, as air navigation has become increasingly 'mechanized', dead reckoning from plotted courses has become subordinate to distance and bearing electronically measured along great-circle paths to fixed beacons, so that modern navigation demands a chart on which great circles are straight lines, or very nearly so, and distances are easily measured. In this respect Lambert's Conformal Conic has advantages over the traditional Mercator; at scales such as 1 : 1,000,000 and larger great circles differ only negligibly from straight lines and scale variations, always a troublesome factor in measuring distances on Mercator's projection, are sufficiently small to allow distances to be measured with a ruler.

Subtle differences such as these, which govern the choice of projection for a topographical map series, are often replaced by much 'coarser' reasoning when choice of a projection for a single sheet or atlas map is concerned. Here total extent coupled with general size and shape of the area to be mapped are more likely to dominate the picture. For nearly circular areas the zenithal projections, for example, tend to produce the most balanced results, switching to conicals as the area becomes more elongated and to cylindricals if the elongation is very pronounced. However, as sometimes happens with topographical maps as well, it may be one thing to know of a highly suitable projection and another to be prepared to go to the expense of computing it and completely redrawing a

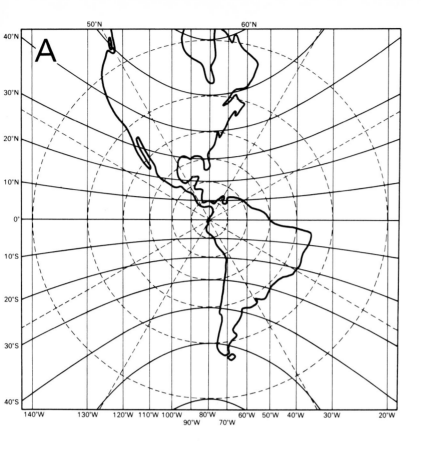

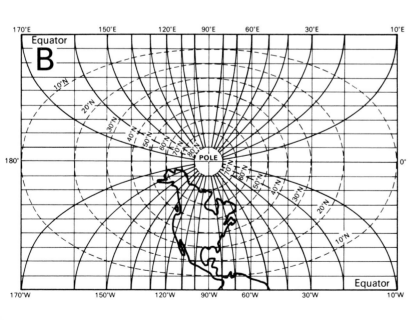

**Fig. 9:** Transverse versions of projections. **A:** Transverse gnomonic projection, centre 80°W. **B:** Transverse Mercator projection, central meridian 90°W. The pecked lines (9**A**) and feint lines (9**B**) mark the patterns of meridians and parallels in the normal versions (see Figs 7**C** and 4**D**). In **B** only a hemisphere is shown.

map onto it. Fortunately modern calculating aids can help this process a great deal, especially in the more complex projections like the oblique cases; the appearance in modern atlases of projections like the oblique Zenithals, which were formerly rarely used, is at least in part due to this factor. Even so, 'cartographic inertia' – reluctance to make expensive changes for relatively minor gains in accuracy – seems likely to ensure that at least some 'old faithfuls' of projections will continue to appear as well.

# Chapter 2

## Recording the Local Scene – the Marriage of Commerce and Surveying

The problems involved in mapping the whole world, or even a continent, reveal cartography at its most impersonal and scientific. Matters such as projection and the size and shape of the earth are remote from normal experience and, compared with other features, have only minor visual impact on the map itself. Quite different, and rather more obvious, aspects of the cartographer's work are revealed in a study of the evolution of local maps.

Local maps mean larger scales, more potential detail, and often the need to choose which features to include or omit, a not unimportant choice when we remember that local maps appeal to a much smaller audience than do continental ones. This possible choice of content serves as a useful reminder that map-making is a commercial enterprise, successfully accomplished only by combining the surveyor's ability to measure the land and the cartographer's judgement of the kind of map his customers need and are prepared to buy.

The problems of surveying, too, are more real and more apparent when studied through their effect on the form of local maps. Many of the surveying techniques which form the basis of modern mapping were developed first around the simpler problems of smaller areas, though paradoxically they had to grow and be considered on a world scale before our really accurate modern local maps could be made.

A brief review of the development of local maps in Britain offers a very satisfactory way of indicating just how closely connected all these factors are in determining map design.

The earliest known detailed maps of Britain are four related ones, probably derived from a common, unknown source, and drawn about the year 1250 by or for Matthew Paris, monk of St Albans Abbey. As Fig. 10 shows their style was essentially pictorial, with broad sinuous rivers, and exaggerated drawings of battlements or buildings to represent towns. More than three-quarters of the places marked had important monastic houses or land, so that the map shows quite small places as well as important towns and strongly reflects the monastic interests of its compiler. Accuracy of shape and position are poor, but these were only two among many considerations. One of the copies carries a revealing note that if there had been more room on the parchment the island would have been longer, and all appear to have been constructed around a sort of 'Pilgrim's Great North Road' – the route from Durham or Berwick to Dover (Dou'a). The road is unmarked but places on it are arranged in a straight line, making Dover appear in the middle of the

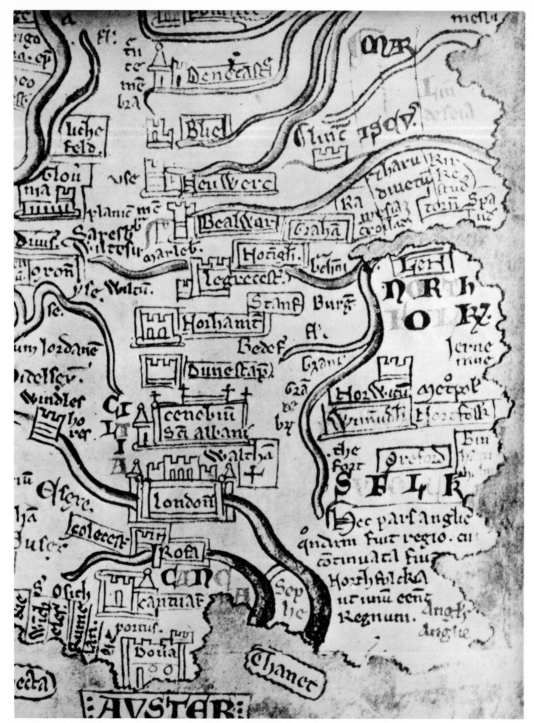

**Fig. 10:** Part of a manuscript map of England by Matthew Paris, *c.* AD 1250: reduced to two-thirds original size. (Reproduced from Edward Lynam, *The Mapmaker's Art*, Batchworth Press, 1953: by permission of Mr J. P. O'F. Lynam.)

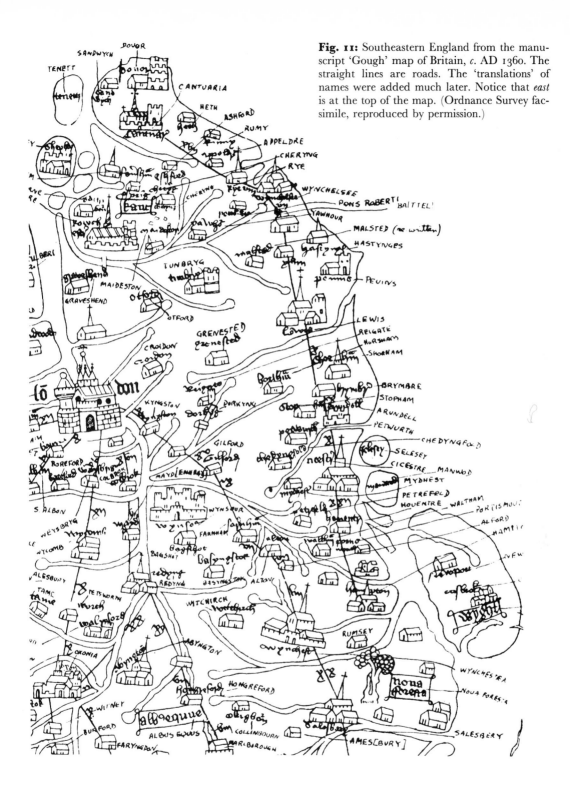

**Fig. 11:** Southeastern England from the manuscript 'Gough' map of Britain, *c.* AD 1360. The straight lines are roads. The 'translations' of names were added much later. Notice that *east* is at the top of the map. (Ordnance Survey facsimile, reproduced by permission.)

south coast (see Fig. 10). Scale is indicated merely by a crude marginal reference to the overall size of the island.

The anonymous Gough (or Bodleian) Map (Fig. 11) is much better. Drawn about 1360 it seems to have been compiled for travellers, very probably as an official map for couriers or Crown representatives. Though east-orientated it is much more complete and accurate topographically than Matthew's crude attempts, and conforms remarkably well to an overall scale of about 1:1,000,000. Once again the style is pictorial and detail largely confined to towns, rivers and some roads. The last-named feature, marked by thin red lines and showing some distances, probably in 'customary miles', present something of a problem. Several main roads, for example London to Dover, are omitted while other relatively unimportant ones, for example Caernarvon to Cardigan (the route of one of Edward I's itineraries) are marked, and it may be that these features were included not so much as roads but as a framework of distances, helping to fix the essential shape of the map.

Knowledge of the distances separating places is one of the easiest ways (in theory) by which their relative position can be established, and must in fact have been one of the earliest ways of getting anything like reasonable representation of shape and position onto maps. Measurement of long distances is difficult however, and since for a long time the values used were almost always estimates, this could never have offered a really satisfactory basis for mapping.

From about 1450 onwards there developed new and better techniques which reduced the amount of distance-measuring by relying on measuring angles instead, a principle which still underlies much modern surveying (see Fig. 19, p. 42). By the late sixteenth century angle-measuring instruments such as the *plane table* and *circumferentor* were in use in Britain, and two Englishmen, Digges father and son, had published Pantometria, a complete treatise on surveying. The Diggeses had also described a crude theodolite, the basic angle-measuring instrument of modern surveying, though really accurate instruments had to await the incorporation of the telescope, not itself invented until 1608. At about the same time contemporary developments in printing, first from wood blocks and later from engraved copper plates (see Chapter 6), were making possible the cheap mass production of maps.

Fortunately the course of English history provided increasing amounts of work for the newly trained 'surveighors'. Landowners of all kinds, and not least those who had newly acquired considerable estates following the dissolution of the monasteries, found it increasingly convenient to have maps of their lands, especially in settling legal actions and boundary disputes. A very early example of such a manuscript local map is shown in Fig. 12. Despite the increased scale the pictorial style persists, even down to true-to-life representations of churches and manor-houses, and detail though not plentiful is significant: the bridges, windmills, sea-bank (*fossatum maris*) and salt-marshes (*salsus mariscus*) beyond were important elements in the Fenland landscape. The two Fenmen of course are purely decorative, typical of the ornament with which the medieval cartographer loved to fill the large blank spaces on his maps.

Many early estate maps covered much smaller areas than this and showed considerable detail at quite large scales. Often each portion of land was numbered, its area marked in acres, roods and perches and perhaps its use as well, either on the map or in a written

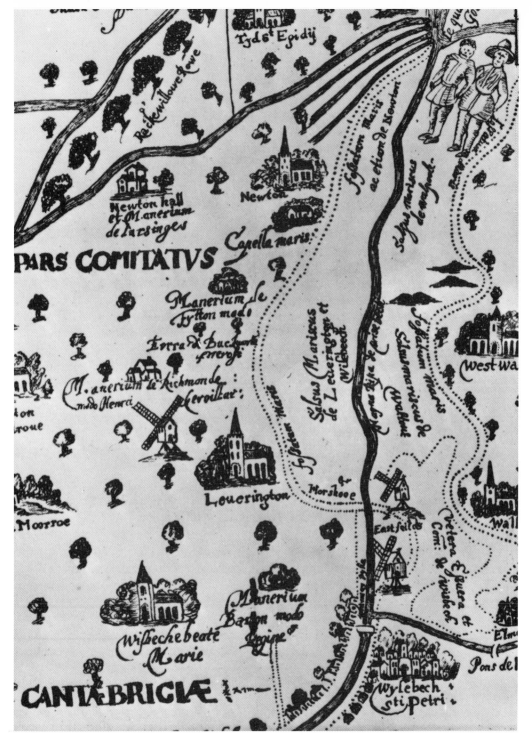

**Fig. 12:** Part of a manuscript map of the Hundred of Wisbech, fifteenth century, revised 1597 and 1657: reduced to two-thirds original size. (Reproduced from Lynam, *op. cit.*)

description or *terrier* which accompanied it. In Fig. 13A, which is an example of such a map, the style is still half-pictorial, but the potential of the larger scales must have suggested the need to replace this by some more accurate representation and pictorial detail becomes gradually eliminated until we get the clear 'all-in plan' style typical of estate maps of the late eighteenth century and after (see Fig. 13B).

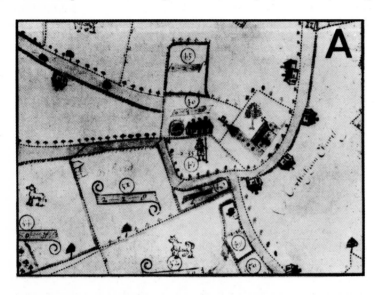

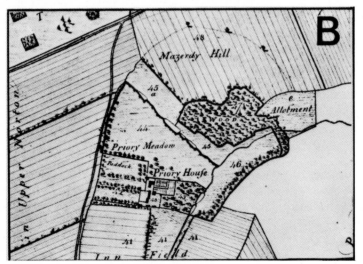

**Fig. 13:** The evolution of the estate map. **A:** Part of a manuscript map of Beckley, Navenden and Nathiam by Giles Burton, 1635. Note the numbered fields marked with their areas. **B:** Part of a manuscript plan of Heythrop Estate, Oxfordshire, 1791. Both maps are reduced to two-thirds original size. (Reproduced from Lynam, *op. cit.*)

The new sixteenth-century surveyors who had learned their trade mapping country estates were soon ready to tackle larger areas, and in Britain the county was an obvious choice. Most counties were of moderate size, and sales were likely to be helped by their social and administrative significance as well as by the enormous national interest in

England and things English which accompanied the country's contemporary rise to world-power status.

Although maps of English counties must have existed before 1570 (for there are references to them in contemporary accounts) the earliest known extant are those produced by Christopher Saxton, the 'Father of English Cartography', between 1570 and 1579. In nine years this remarkable man surveyed and published a map of every county in England and Wales, separately at first but in atlas form in 1579. Remarkably little is known of how he accomplished this tremendous feat, which was without parallel at that time. To have completed the work so quickly there could not have been any elaborate basic survey, such as triangulation, and Saxton probably began from church towers and vantage points, establishing angles to neighbouring towers and villages and guessing or asking the distance to places which he could see, much as in Fig. 19 (p. 42). Earlier maps and writings may also have been consulted and though Saxton worked single-handed he would often have had local assistance; his project had Queen Elizabeth I's blessing and he carried from her an open letter asking that he be 'conducted into any towre Castle highe place or hill to view that countrey and that he may be accompanied by ii or iii honest men such as do best know the countrey.'

In another sense too, Saxton was not entirely alone. Such an ambitious and expensive project as this was far beyond a surveyor's means. Because of the need to support the expense of making the survey, drawing the maps and making the printing plates, all of which would have to be financed before any return from map sales were available, the surveyors (who were not wealthy men) needed the financial backing of some person of substance. In Saxton's case this was Thomas Seckford, one of the Queen's Masters of Requests. Seckford's patronage no less than Saxton's skill was essential to the success of the work, though this does not belittle Saxton's achievement. His merit was not that he knew how to survey but that he conceived and accomplished his Herculean task, and it is as a pioneer, no less than as a surveyor and cartographer, that he is honoured.

The maps themselves, of which a typical portion is shown in Fig. 14, are perhaps a little disappointing on casual inspection. Detail is far from complete and the style is entirely pictorial with symbolic villages and towns, 'sugar-loaf' hills, groups of trees for wooded areas, and ring-fences enclosing trees for the parks of the gentry; of other detail, apart from rivers and bridges, there is little, and roads, for example, are not shown. The scale varies from about two to four miles to an inch to give an almost uniform sheet size for binding in atlas form.[1] As an artistic production the maps are very fine; the Flemish engravers, whom Saxton employed to make many of the printing plates, brought with them elaborate and decorative borders, cartouches (decorative motifs enclosing titles, scales, etc), incidental ornament and flowing lettering, all of which, though printed entirely in black outline, were later richly embellished by hand-colouring.[2] Judged by the standards of his day Saxton's maps were quite remarkable. They have been described as 'excellent in every

---

[1] There is also a variation in length, from 8¾ to 12½ furlongs, in the actual miles marked on the line scales of the different maps, due no doubt to the use of a mixture of Old English miles (2,140 yards) and 'customary' miles in their compilation. This type of difficulty was not completely eliminated until the introduction of the statute mile in 1593, though this measure was by no means universally accepted for a long time after that.

[2] Hand-applied colouring was the rule with all maps until colour printing came into use in the nineteenth century (see Chapter 6).

**Fig. 14:** Part of Saxton's map of Cheshire, 1577. The detail and style are typical of Saxton's maps. The scale of the original was $4\frac{1}{2}$ miles to an inch: this reproduction is slightly less than two-thirds original size. (Royal Geographical Society facsimile, reproduced by permission.)

way – valuable as being the first printed map of any county; important as an original work; accurate considering the means at his disposal, and well produced'. (Tooley, 1949 p. 65).* Indeed so high a standard did they set that they were still being issued, corrected and improved, well over a hundred years later.

A man who aspired to improve on Saxton's work was John Norden, estate surveyor and attorney. Norden set his heart on producing *Speculum Britanniae*, a series of pocket volumes each describing an English county and accompanied by maps with such cartographic improvements as roads, an index, standardized (pictorial) symbols for market towns, villages, Bishop's Sees, etc., 'bird's eye' plans of the larger towns, a marginal scale and smaller size for more convenience in carrying. So ambitious a project stood in great need of wealthy patronage but the first part, Northamptonshire – chosen probably to entice Lord Burghley (who lived there) into the role of patron – was a poor thing; Burghley was sympathetic but little else. The second part, Middlesex, was much better, containing excellent plans of London and Westminster; but Norden had to publish it at his own expense and, although most of his improvements were sound enough subsequently to become standard on later county maps, lack of proper financial backing brought the inevitable failure of the project with only a handful of counties ever completed.

A much more successful cartographer than Norden was John Speed who, though he did little original work, compiled in 1611 his *Theatre of the Empire of Great Britain*, a series of county maps based on Saxton, Norden and other sources. The style is very like Saxton's but the maps show the boundaries of the hundreds or similar county divisions, and each contains a 'bird's eye' plan of the county town (see Fig. 15), while the borders are richly ornamented with the arms of the local gentry, presumably to encourage patronage and arouse local interest. These highly decorative maps, which were extremely popular and ran to many editions, are often seen today in use as wall decorations in houses, hotels and inns.

The county map continued to dominate the English cartographic scene until the appearance of the Ordnance Survey maps in the early nineteenth century, though considerable changes were introduced into its style and form during this period, largely because of changes in the social and economic life of the country and the increasing part which maps could play in assisting them. Travellers, both private and official, began to increase rapidly in numbers; turnpike Acts diverted or newly created many lengths of road; the construction of canals demanded a closer knowledge of topography than anything which had gone before; in some areas factories and mines developed and formed important elements in the landscape, as also did the increasingly numerous parks of the gentry and the newly arranged holdings and farmhouses of the enclosure movement. These were important changes which brought not only a greater range of detail for the county maps to show, but also the need for greater accuracy in its representation, leading to the gradual replacement of the relatively inaccurate pictorial style by the much more 'plan-type' rendering which we have today.

Figs. 16 and 101 show some examples of the introduction of these modifications. On Symonson's map of Kent, made in 1596 (see Fig. 101 p. 243), main roads and hundred boundaries are marked, and villages are shown by a likeness of the church to aid recognition, with a circle and dot at the church door to mark its true position in the interests of accuracy. Bugden's map of Sussex in 1724 (Fig. 16A) has main roads and side-turnings

* Works referred to in the text are listed under Suggestions for Further Reading at the end of the book.

**Fig. 15:** The town plan of Caernarvon, inset into Speed's map of Caernarvonshire, 1610. The 'bird's eye' or 'aerial' type of representation is typical of early town plans. (Reproduced from J. A. Steers, ed., *Field Studies in the British Isles*, Nelson, 1964.)

(but not the actual side-roads), pictorial symbols for the churches and more important houses but a *plan* representation of the rest of the village; the important Sussex iron industry is represented by symbols for its water-wheels[3] and the furnaces and forges were shown by hammers. On Yates's map of Staffordshire in 1775 (Fig. 16B) almost the only pictorial element left is the church, the rest of the detail, much of which is 'industrial', being shown in plan or by conventional symbols. With the 'sugar-loaf' hills, replacement of a pictorial by a plan-type rendering was a little more difficult, but from about 1680 hachures (see p. 85) became increasingly used, and these are another feature of Yates's map.

These changes mirror those we have already seen on estate maps, and are found similarly in the large-scale town plans of this period, for example Fig. 17, where there was now little room for the inaccurate pictorial style Norden and Speed had introduced a century and a half earlier (see Fig. 15). Another interesting development of this period was the production of strip-maps for travellers. This was begun in 1675 by John Ogilby's publication of *Britannia*, a hundred-page atlas of strip-maps based on a survey (made with Royal approval) of all the main roads of the kingdom. Drawn at a scale of one inch to a

---

[3] Although not adopted in Britain the toothed-wheel symbol is still widely used on continental maps for a factory or watermill.

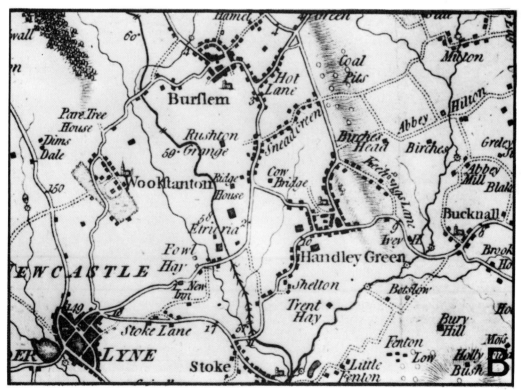

**Fig. 16:** Stages in the evolution of the County Map. **A:** Part of Bugden's map of Sussex, 1724. **B:** Part of Yates's map of Staffordshire, 1775. In many ways – style, amount and nature of detail – Bugden's map is roughly half-way between Saxton's county maps (*see* Fig. 15) and Yates's. (Reproduced from Lynam, *op. cit.*)

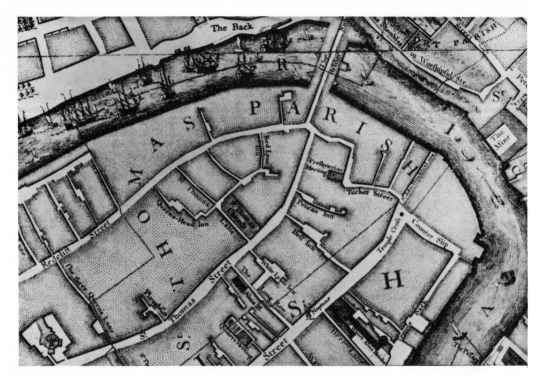

**Fig. 17:** Part of John Roque's plan of Bristol, 1742. Detailed plans of this kind mark a complete transition from the 'bird's eye' style of Speed (*see* Fig. 15). This reproduction is reduced to about three-quarters the scale of the original. (Reproduced from Lynham, *op. cit.*)

*statute* mile the maps show much information to guide travellers along the roads and are in half-plan, half-pictorial style with the hills in particular remaining as awkward 'sugar-loaves' (see Fig. 18A). Like Saxton, Ogilby was a pioneer in his field. His idea was much emulated and strip-maps suffered rather a similar transition in style to county maps, so that by 1790 John Cary was producing the neat, stylish versions shown in Fig. 18B, almost as much a social register as a map – and no doubt selling the better for it.

It was sound commercial sense for English cartographers to respond to the demand for even more accurate, detailed maps to service the increasing complexity of English social and economic life. Yet here was a very real dilemma. Surveying instruments and tech-niques were certainly capable of adding increased detail or accuracy to the maps of the eighteenth or early nineteenth centuries – but could this work be adequately financed and would it be justified by increased returns? Faced with this predicament it is not difficult to see that many maps of this period represent not what a surveyor/cartographer *could* do so much as what he could *afford* to do; in the same way the accuracy and completeness with which certain detail was shown on maps might be closely related to the difficulties involved in surveying it. Fig. 19 tries to illustrate some of the realities of the problem. Since angles were more easily measured than lengths quite a number of definite *points* – a village church, a prominent hill-top, a cross roads, a mansion, a bridge, could easily be

**Fig. 18:** The evolution of the 'strip' road map. **A:** Part of the road from York to Westchester (Chester) in Ogilby's 'Britannia', 1675. **B:** Part of the London to Richmond road by John Cary, 1790. The half-plan, half-pictorial style of **A** is similar to that of many contemporary county maps, just as the neat clear style of **B** is mirrored in most of Cary's other works. Both maps are reduced to about three-quarters the scales of the originals. (Reproduced from Lynam, *op. cit.*)

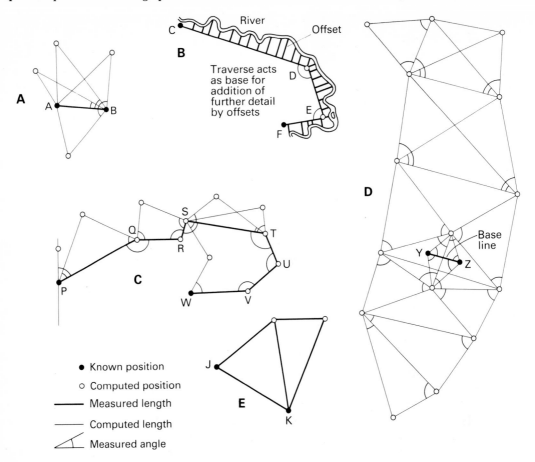

**Fig. 19:** Some basic surveying techniques. **A:** Fixing points by angular measurement and intersection. A large number of unknown points can be fixed from only two known ones in this way. **B:** Fixing irregular detail (a river) by means of multiple offset measurements. Offsets must be kept relatively short and a great deal of measurement may be involved. **C:** Traversing – fixing positions by combined measurement of length and bearing or angles. Additional detail may be added on either side of the traverse line by intersection (as in **C**) or by offset measurement (as in **B**). **D:** Triangulation. Many points may be fixed by angular measurement, starting from only one measured length, the base line YZ. **E:** Fixing position by measuring lengths, a difficult procedure to perform accurately until recently, following the development of instruments such as the geodimeter and tellurometer.

fixed by *intersection* from two other points whose relative positions were known (Fig. 19A). In contrast irregular, linear features – roads, rivers, coastlines, the boundaries of woodland or moor – were much more tedious to define accurately, demanding either continual measurement of position relative to a series of straight lines (Fig. 19B) or, in the case of roads the use of *traverses* along them, successions of measured lengths whose angular relations were known and which could also act as the basis for further angular observations to distant points (Fig. 19C). A much cheaper alternative, of course, was to fix the position of a very few points along such features and sketch in the rest.

Fixing local detail by methods such as those just described, and which involved making hundreds of small measurements, would work well enough in small areas. Over larger areas however, errors soon accumulated. The way to overcome this was to resort to a fundamental principle of surveying – to work from the whole to the part – *starting* with a framework of very accurately observed points covering the whole area of the map. Once this was done local measurement could all be reconciled to it and errors could never become greater than those produced in the framework itself. Such a framework was best produced by *triangulation* whereby, starting from only one carefully measured length or *base line*, angular bearings could then be used to establish successively the positions of a whole network of points many miles apart (Fig. 19D).

All this, however, in no way removed the basic question: was it all commercially worthwhile? There were some who thought it was. Sometimes before, but noticeably after, 1750 there appeared a new generation of county maps, far more ambitious than their forerunners. A basic scale of one inch to a mile (more in some smaller counties) was usually aimed at, as was a high degree of local detail properly related to a triangulated framework. Yates's map of Staffordshire (Fig. 16B) was such a map but between 1750 and 1800 virtually every county in England and some in Wales and Scotland were mapped at one-inch scale, encouraged in part by the Royal Society's offer of £100 premium for county maps provided that they were new surveys, accurately carried out and properly based on triangulation.

Even so the financial problems were enormous. A map of this kind could cost over £1,000 to produce (Donne's of Devon cost almost £2,000) and this was only possible by obtaining advance subscriptions from gentry, clergy or other intending purchasers. Not surprisingly this was more difficult to achieve in the less populous counties where in consequence standards might be skimped and map detail poor. The so-called 'pacification' of the Highlands in 1746 was so hampered by lack of satisfactory maps that the army had to make one for itself, at a scale of 1,000 yards to an inch.

The moral was really plain to see. At its best private-enterprise cartography could produce really good maps, but it was by its very nature inconsistent. If maps were now playing an increasing part in national life what was needed was something that would be uniform in scale, style, content and accuracy, and properly based on a full *national* triangulated framework. This was something far too big for private ventures; this was a job for the state.

# Chapter 3

## The State Intervenes – Wars, Colonialism and National Planning

The Duke of Cumberland, 'pacifying' the Highlands in 1746, was not the first statesman to feel the lack of good maps. In 1668 Colbert, working to restore an exhausted France for Louis XIV, had met a similar deficiency by asking the newly-formed Académie Royale des Sciences to prepare a map of the country more accurate than any then existing. There was no doubt in that body's mind how this should be done; the map must be based on an accurate national framework of triangulation (see Fig. 19D, p. 42) tied to and checked by astronomically observed latitudes and longitudes.

Experimental work on both triangulation and detail was begun around Paris under Picard and Vivier, producing in 1678 a useful local map at 1 : 86,400 scale, but war and financial difficulties prevented further work even though widespread astronomical determinations of latitude and longitude revealed serious errors on existing maps, for example up to $1\frac{1}{2}°$ error in longitude in Brittany (see Fig. 20). Similar periods of alternate activity and stagnation, for much the same reason, characterized all further attempts to pursue the work and it was not until the 1730s that France was eventually covered by the the chains of triangles which could form a foundation for all later official surveys, and not until 1746 that Louis XV ordered Cassini de Thury to complete the detailed survey.

The resultant map, which even then was not completed until 1789, may indeed claim to be one of the great milestones in cartography. Drawn to a scale of 1 : 86,400 and published in one hundred and eighty sheets (it was 33 feet wide by 34 feet high) the *Carte de Cassini*, as it was always known, was without parallel at that time and was greatly admired. Like many early surveys, however, its accuracies were soon outdated; in 1817 work was begun on a re-survey of France to produce the famous *Carte de France de l'État Major* at 1 : 80,000 (finished in 1880) which in turn promoted detailed maps at 1 : 10,000 and smaller scale maps at 1 : 200,000.

The many delays experienced in France were paralleled in Britain. Parliament had toyed with the idea of a national survey from 1763, and was continually urged to undertake one by a group led by William Roy, a military surveyor who had worked on the map of the Highlands and had risen to become 'Surveyor General of Coasts and Engineer for Making Military Surveys'. Nothing came of this, however, until 1783 when an opportunity was presented in a joint Anglo-French project, suggested by Cassini de Thury. Cassini's idea was to measure the difference in latitude and longitude between the Greenwich

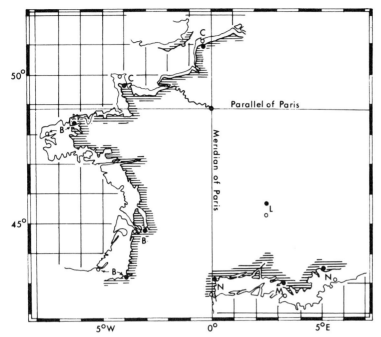

**Fig. 20:** The improved outline of France (shaded) after the early surveys under Cassini and Picard in 1681, compared with that on Sanson's map of 1679. Towns shown are (anticlockwise) C, Calais; C, Cherbourg; B, Brest; B, Bordeau; B, Bayonne; N, Narbonne; M, Marseilles; N, Nice; L, Lyons. (Redrawn from Lloyd A. Brown, *The Story of Maps*, 6th edition, Little, Brown & Co., Boston, 1949.)

and Paris observatories by triangulation and since this suggested to Roy a means of obtaining the necessary instruments, experience and initial work for a possible national survey he enthusiastically undertook the direction of the project once it had received official approval. Work on the British section could not be started until 1787, due to tedious delays in obtaining new and sufficiently accurate instruments, but after that date triangulation was steadily pushed forward from a base on Hounslow Heath to the Channel coast, and ultimately linked to the French work by night observations onto blinking white lights across the Straits of Dover. Computation of the cross-Channel distances showed that British and French estimates differed by only seven feet, a remarkably accurate observation for that time.

Roy's untimely death soon afterwards might have allowed interest in a national survey to lapse, had it not been for his friend and supporter the Duke of Richmond. As Master General of His Majesty's Ordnance,[1] the Duke held a key position in this matter and in 1791, a good deal on his own initiative though stimulated no doubt by the threat of war with France, he bought Roy's instruments and initiated the *Trigonometrical Survey*, soon to become the Ordnance Survey. Its immediate preoccupation was a triangulated framework (not finished until 1853) and a one-inch map covering the whole country, but these are described in Chapter 7.

[1] 'Ordnance' is the department responsible for military stores and equipment, hence the rather odd title of the British national survey organization.

There were many lessons to be learnt from these early surveys. They were slow and costly and made unprecedented demands on staffing, accuracy and equipment, leading ultimately to many new developments. As early as 1669 Picard had fitted telescopic sights to his instruments to improve accuracy: Roy used glass tubes (to counteract expansion) to measure his crucial Hounslow Base and a giant theodolite to measure the angles of his triangles, some of which had 50-mile sides. In another field the calculation and plotting of the results of such accurate work both demanded and prompted greater knowledge of the size and shape of the earth, ultimately establishing, in the 1730s, the existence of the flattening of the sphere at the poles.

Other countries quickly followed France's example usually by using the army, but occasionally bringing in a national scientific society, almost the only other body with the potential to undertake such work. Denmark was surveyed and mapped at 1 : 120,000 scale by its Royal Society between 1768 and 1841 and again (as in France) more accurately by the General Staff after 1830; Sweden's 1 : 100,000 map was begun in 1815; the Austrian Empire was officially mapped between 1760 and 1860, and between 1830 and 1864 General Dufour, in Switzerland, produced his brilliant and artistic 1 : 100,000 map of most difficult terrain (see Fig. 42C, p. 86). Something of the implications of such surveys in larger nations can be seen in Russia; the famous 1 : 126,000 map of European Russia and Poland begun in 1816 occupied no less than eight hundred and fifty-one sheets, and there were smaller-scale military maps of the Caucasus, Turkey, Turkestan and Siberia too. By 1900, therefore, much of Europe was covered, or being covered, by properly triangulated surveys which gave maps at scales of from 1 : 50,000 to 1 : 100,000 generally, though often larger than this in the smaller countries; and in all this work military considerations had formed a strong, perhaps even the strongest, stimulus.

The relatively simple European picture of steadily advancing systematic national surveys was not necessarily imitated elsewhere – for reasons which are not difficult to perceive. Quite apart from obvious financial and technological problems the governments of many countries were no quicker than earlier European ones had been to acknowledge the potential value of a comprehensive *national* survey. On the other hand they were often acutely aware of the need for specific, more localized surveys to fulfil urgent requirements in various parts of their often patchily developed territories. Surveys for land division and registration, frontier delimitation and defence, resource exploitation, or railway construction frequently made stronger claims on scarce resources than, say, the establishment of a national triangulation to which all maps could be related, and situations like this could easily result in maps produced by assorted Government departments and/or private organizations, quite lacking in uniformity of style, scale, standards and arrangement. Additional deterrents to a 'uniform' approach were the huge size and often only partially explored and/or controlled nature of national territories, together with extremes of climate and terrain rarely encountered in Europe.

Not surprisingly therefore, in this type of situation, rather more individual solutions to the problem of providing national mapping emerged. In the United States, for example there was the Survey of the Coast (established 1807), the Corps of Topographic Engineers (formed in 1813 and working largely in the West) and, after 1879, the Geological Survey, also working at first west of the 100th meridian. Fortunately in 1878 the Survey of the Coast was given the task of establishing throughout the whole country a basic triangula-

**Fig. 21:** Typical products of African and European cartography. **A:** Part of sheet 190/III (Voi) of the Kenya 1 : 50,000 series (SK 61). (Reproduced by permission of the Survey of Kenya, Nairobi). The style and content are typical of those of many maps covering former colonial territories. Though reproduced here in black and white, colour on the original is limited to blue (water), brown (contours, roads), and black; grey areas are cultivated land, the background symbols refer to different types of vegetation. **B:** Part of sheet 255 (Sustenpass) of the Swiss 1 : 50,000 series. Longer survey history, larger resources and markets and smaller territory allow a more sophisticated end product which is, nevertheless achieved with a minimum of colour in the original. Only green (forest) and the hill-shading are additional to the blue, brown and black of the Kenyan map. (Reproduced with the permission of the Topographical survey of Switzerland.)

tion network on which the Geological Survey could base detailed *topographical* maps. These were, initially, incidental to geological requirements but so great was public demand for them that funds were voted for this specific purpose, and the Geological Survey subsequently became the basic national topographic mapping agency, its truly geological work being an important but minor activity. This twofold organization still remains, the 'framework' being provided by the Coast and Geodetic Survey [2] (as the old Survey of the Coast had been more suitably renamed in 1903), the detailed maps by the Geological Survey. With so late a start and so extensive a territory map coverage was for many years rather short of European Standards. A basic scale of 1 : 62,500 was envisaged, with 1 : 125,000 sheets for areas such as the deserts and semideserts of the west, but the latter is now discontinued and the 1 : 62,500 series becomes the basic scale everywhere; it is now complete for the whole country (Fig. 23). In addition recent years have also seen the rapid development of maps at 1 : 24,000 scale which now cover most of the country, often replacing old 1 : 62,500 and 1 : 125,000 sheets which were decades out of date.

In some federal or semi-federal states the position was often made worse by the individual states as well as the various federal government departments each having their own mapping programme. In Brazil, for example, it was not until 1937 that the federal government created the Conselho Nacional de Geografica to coordinate all cartographic work, avoid duplication and initiate a national triangulation network. In Canada not until 1947 were all civilian agencies engaged in surveying and mapping consolidated in the Surveying and Mapping Bureau, and all civilian mapping on scales of 1 : 250,000 and larger assigned to the Topographical Survey Division; in addition there still remains (as is the case in many countries) a separate Army Survey establishment. Not surprisingly in so large a country with extensive barren areas the most complete national map series is the 1 : 253,440/1 : 250,000, though there is 1 : 50,000/1 : 63,360 cover for virtually all the more developed areas (Fig. 23).

If progress was slow and imperfect at first in the larger, but often more developed, non-European nations it might be expected that smaller, poorer countries would make an even worse showing, and this was in fact the case up to 1939 in most *independent* states, with certain notable exceptions such as Japan and Thailand. There was however another class of territory where matters were rather different – the colonial possessions of European powers. Stimulated by various motives, among which the discovery of potentially exploitable areas and resources and the more complete delineation of boundaries against possible counter-claimants are two obvious ones, most European nations with colonial possessions carried out various surveys in them, often very actively. At first both the maps themselves and the bodies that produced them were rather varied. Military survey organizations, such as the British GSGS (Geographical Section, General Staff) and the French Service Géographique de l'Armée were active in this field, but so too were survey departments set up for individual territories, e.g. the Survey of India and the Service Géographique du Maroc, as well as organizations with a wider coordinating role, such as the British Colonial Survey Committee, established in 1905 and later to become the Directorate of Colonial Surveys, now the Department of Overseas Surveys. Early surveys in these territories usually produced reconnaissance-type maps at about 1 : 200,000 scale, relying on a

[2] Geodesy – the study of the size and shape of the earth. The Coast and Geodetic Survey itself has now been renamed the National Ocean Survey.

framework of astronomically determined positions rather than triangulation, but as estab-
lishments became formalized a more typically 'European' approach began to produce
triangulated surveys with maps in the 1:50,000 to 1:100,000 scale range (Fig. 21A). In
some areas very high standards were maintained from the start, for example in India
where excellent maps at one, two, or four miles to an inch were produced. Certainly by
1939 both the quality and extent of mapping in colonial areas contrasted sharply with
that in independent states, and nowhere was this more apparent than in the contrast
between 'colonially-dominated' Africa and 'independent' Latin America.

The mapping activities of the major powers were not, however, confined to their
colonial territories, the very existence of which had left them with global rather than local
strategic preoccupations. As the global scale of warfare increased to match these, in 1914–
18 and even more so in 1939–45, the military organizations of the great powers naturally
became concerned to provide themselves with reliable and complete maps for most parts
of the world. Such maps, of course, could only rarely be based on direct survey operations,
at least until the air-photograph permitted extensive recording of 'forbidden' areas; the
alternative was to produce them by *compilation*, a technique which involved piecing
together the best possible map from all kinds of sources. The most basic source was, of
course, the largest-scale existing map series covering an area of interest, but since this was
often incomplete and/or sadly out of date it would need to be amended where possible by
adding detail relating to more recent changes such as new settlements, communications,
dam sites, etc. If detailed plans of these features were available revision could be quite
complete but less full descriptive accounts, such as newspaper reports, might necessitate
features being marked 'location' or 'alignment uncertain', again until the air photograph
appeared to alter the situation. Where no full national map cover existed compilation
might have to be made from whatever other sources *were* available – good but local
surveys, cruder surveys and traverses made by exploring parties, naval charts of coastlines
and astronomically fixed positions. Fig. 22 refers to maps produced by these means
though, as the caption emphasizes, changes in world mapping are rendering them some-
what less necessary than was once the case.

Quite often, with military-scale resources behind them, maps made by agencies such as
the American Army Map Service (AMS) and the British Directorate of Military Survey
are among the best maps available for many parts of the world, especially at medium and
smaller scales where they may provide a consistent mapping style over wide areas for
which nationally produced maps are 'not available', e.g. the USSR and China. Unfor-
tunately, and for obvious reasons, most of these militarily produced maps series are also
'not available' to the general public but 'escapes' (albeit rarely of the most recent ver-
sions) may still be found in various map collections.

Luckily the need to rely on military sources for reliable maps of many areas has
decreased considerably in recent years, thanks to a dramatic improvement in the state of
world topographical mapping. There are a variety of reasons for this. World War II, for
example, brought new or improved mapping to many areas. So too did the post-war
search for minerals, especially oil and uranium, and most governments have at last
accepted the fundamental role of a national map series in planning national resource
development, as well as the ultimate wastefulness of attempting to cater for this through
piecemeal, uncoordinated mapping.

**Fig. 22:** Compilation sources for two Latin American maps. **A:** Sheet NC19 (Caracas) of the American Geographical Society's 1:1,000,000 series of Hispanic America, published 1945. **B:** 1:1,000,000 map of Ecuador, compiled by the Instituto Geografico Militare, 1971. *Note*: The national boundary indicated here is that customarily shown on official maps printed in Ecuador, although the area marked X is 'normally' mapped as part of Peru. Since 1945 much of Venezuela has been surveyed and mapped at 1:100,000 and 1:250,000 scales.

The biggest single factor responsible however is surely a technical one. The development of *photogrammetry* – the technique of producing maps from air photographs – has completely revolutionized the practice and potential of surveying and map production, allowing the *rapid* production of much more detailed maps than could ever have been envisaged using old ground-survey methods.

So important are these recent contributions from photogrammetry to contemporary mapping that the next chapter is devoted to a consideration of them. For the moment however let us anticipate both their contribution and their achievements by referring to Fig. 23 which shows the present state of mapping in certain parts of the world. Even in the nine years since the first edition of this book was written there have been important changes in the mapping of those areas. Almost all areas now have maps at 1 : 300,000 scale or larger, and the darker tone of large-scale coverage is being continually extended across the areas of more concentrated population.

As more and more of the world's surface begins to be covered by systematic map series preoccupation at international levels can begin to focus on the need for uniformity, standardization and unification quite as much as extension of area – exactly the same sort of reassessment as just been described at national scale transferred to global dimensions.

Attempts at international cooperation and uniformity in cartography have not, of course, been confined solely to recent years. Half a century or more ago the first international venture into a *world* map series produced the sheets of the International Map of the World at 1 : 1,000,000 scale, of which a fuller account and description is given in Chapter 7. Unfortunately the venture proved somewhat abortive. More noticeable successes of the cooperation of the post-World War II period have been the production of World Air Charts at various scales (again described in Chapter 7) and the less spectacular tendency increasingly to produce map series at standard metric scales such as 1 : 250,000, 1 : 50,000, 1 : 25,000 even in countries such as Canada which have not yet adopted the metric system. In Europe Norway, Sweden, France, the Netherlands, the United Kingdom and Eire are all producing (or have produced) series at 1 : 250,000 scale to replace former series at 1 : 300,000, 1 : 200,000 and $\frac{1}{4}$ inch to a mile (1 : 253,440). A standard grid reference system – the UTM (see p. 165) is also already adopted by many countries, as is the Universal Transverse Mercator Projection from which that grid springs. One other great international cartographic achievement, not at all obvious on the final maps, has been the gradual linking together of individual national triangulation and levelling systems into a world system. The latest and most spectacular development in this direction has been the setting up and measuring, by satellite observations, of a network of huge triangles covering the whole globe. This will not only help to establish more accurately the size and shape of the earth (some half dozen or so differing measures for this are currently in use as a basis for survey calculations) but will also allow the position of individual triangulation systems to be more accurately established on that surface.

Not surprisingly too, with all this international cooperation, organizations such as the Cartographic Office of the United Nations, The International Union of Geodesy and Geophysics and the International Cartographic Association have been established to nurture and further both work of this kind and the fortunes of cartography generally. Here indeed is a very different situation from that at the end of the previous chapter where we left the private surveyor debating whether a thorough basic triangulation for his new county map could really prove to be 'commercial'.

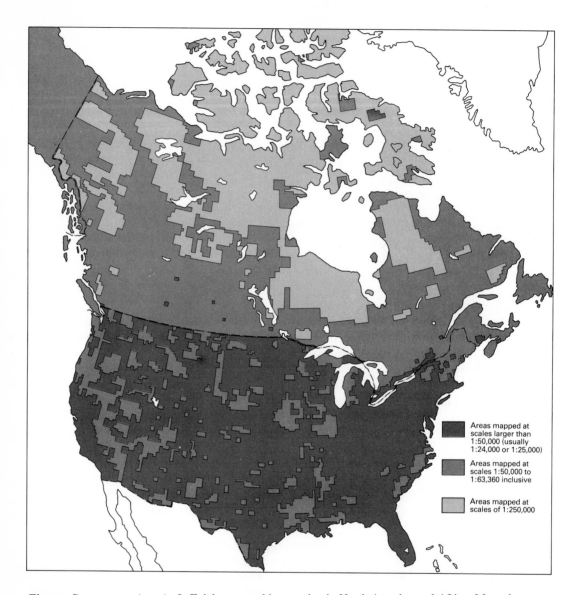

Areas mapped at
scales larger than
1:50,000 (usually
1:24,000 or 1:25,000)

Areas mapped at
scales 1:50,000 to
1:63,360 inclusive

Areas mapped at
scales of 1:250,000

**Fig. 23:** Current state (1977) of official topographic mapping in North America and Africa. Maps shown are those which form part of systematic series. To avoid rapid obsolescence, sheets *known* to be in preparation are marked as completed. **A:** Despite a late start and enormous territorial extent the current state of mapping in the USA and Canada bears comparison with major European countries and the now substantial coverage at 1 : 24,000 scale in the USA probably represents the world's largest area consistently and systematically mapped at that scale. Some generalization has been necessary of scattered areas at 1 : 62,500 scale in the USA. (Source: Maps supplied by US Geological Survey and Canada Map Office.) **B:** The important legacy of

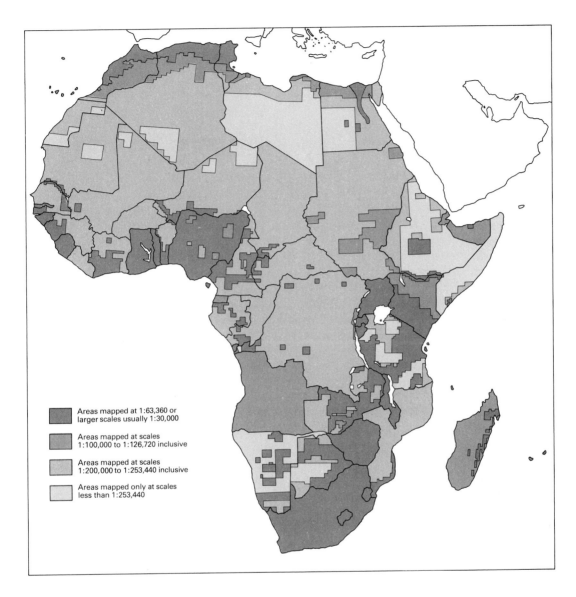

Areas mapped at 1:63,360 or larger scales usually 1:30,000

Areas mapped at scales 1:100,000 to 1:126,720 inclusive

Areas mapped at scales 1:200,000 to 1:253,440 inclusive

Areas mapped only at scales less than 1:253,440

surveys established during the colonial period makes a noticeable (if variable) contribution to the relatively well mapped state of Africa. Many of these surveys have been actively pursued by the new nations since independence. Situations in Zaire, Libya and Egypt are only approximate. Outside the towns and cities hardly any extensive area of Africa is mapped at scales larger than 1 : 50,000. (Source: Basically *International Maps and Atlases in Print*, 2nd edition, Bowker, London, 1977, amended and updated from various sources including Directorate of Overseas Surveys, Annual Report for the year ended 31 March 1976, HMSO, London, 1977.)

# Chapter 4

## The 'New Cartography' – From Photo to Map to Orthophotomap

During the last 40 years the derivation of maps from material recorded on air photographs has transformed the state of world cartography as dramatically as did the entry of the state into the field of map-making 150 years ago. However, unlike the latter, which merely tended to enlarge the scale and scope of surveying techniques which had been understood in principle for hundreds of years, the use of air photographs ushered in a whole range of new technologies, making possible developments in mapping which could hardly have been dreamed of using earlier methods.

It is not difficult even for the layman to see where some of this potential lies. For example two problems which drastically reduced the speed of earlier ground surveys were the enormous tedium of taking the literally hundreds of measurements needed to fix the shapes of irregular features, such as roads, streams and vegetation boundaries (see Fig. 19B), and the movement difficulties associated with surveying operations in certain types of terrain, e.g. jungle, swamp, mountains. Both of these problems are overcome by the air photograph which, given cloud-free conditions, instantly records in minute detail all the visible features of the landscape, producing what seems to be a 'map' drawn by a camera rather than a cartographer.

Unfortunately, though the potential is real enough, the matter is not quite as simple as that; an air photograph is *not* a 'map' and the difference lies not just in the style of representation but in the basic geometry as well. The shape which particular features take on an air photograph is *not* usually the same as their shape in reality, nor is it even constant from one air photo to another. Compare, for example, the shapes of the fields in the top left-hand corner of Fig. 24A and B. Not only are there marked differences from photo to photo but neither corresponds to the shapes which the fields would have on a map 'at the same scale'.[1]

The science of *photogrammetry*, which is concerned principally with the making of maps from measurements taken from air photographs, has developed from the need to remove these distortions of shape and extract from them true forms and dimensions which can be incorporated into maps. It is the concern of this chapter to describe, in relatively simplified terms, how this can be done. But first, since air photographs are rather less familiar

---

[1] It will be shown later (Chapter 8) that there is no such thing as a map 'at the same scale' as an air photograph, but the argument can be put in this simplistic way at this stage without being rendered invalid.

**Fig. 24: A & B:** Part of Brown Clee Hill, Shropshire on portions of two air photographs taken from two different positions. Differing amounts of distortion cause the block of fields to assume noticeably different shapes on the two photographs – visual proof that an air photograph is not a map. Scale *c.* 1 : 40,000. (Sortie no. CPE/UK/2512 (14/3/48), print nos. 5103 and 5148, reproduced by permission of the Ministry of Defence, Crown copyright reserved.)

than maps, it will be necessary to describe some of their general characteristics. When these are understood the main theme of the chapter can then be taken up.

# General Characteristics of Air Photographs

### 1 *Types of Air Photograph*

There are two great classes of air photograph, (a) *verticals*, in which the camera is intended to point vertically downwards[2] so producing a view resembling a plan of the ground, and (b) *obliques* where the camera axis points at an angle to the ground, producing a view not unlike that obtainable from a vantage point or very high building. If the camera is tilted sufficiently to allow the horizon to be shown, the photograph is said to be a *high oblique*; other obliques are *low obliques* (for example Fig. 25), or the photograph which would result in Fig. 61D.[3]

The air photographs most often seen by the layman are low obliques taken for illustration or publicity purposes (for example, of a town or factory), but in fact the great majority of air photographs are verticals and it is this class of photograph which forms the main concern of this section. Oblique air photographs with their retention of at least some aspects of the elevation of objects (see Fig. 25) present fewer problems of interpretation and, since they cover a larger ground area than the same size vertical photograph, may

[2] In practice it is impossible to *guarantee* absolute verticality (see p. 60) but photographs where this was the intention and the camera axis is within two or three degrees of the vertical are usually considered as verticals.

[3] Notice that the terms 'low' and 'high' here have nothing to do with the altitude of the camera.

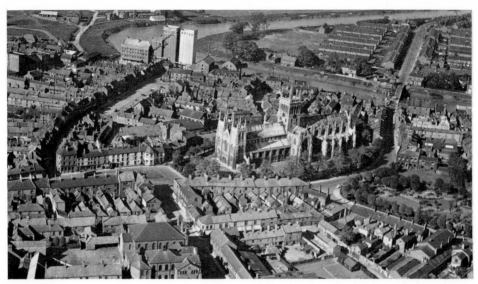

**Fig. 25:** Oblique air photograph of Selby, North Yorkshire. Compare this view with that in Fig. 125; identification of many features is easier from this more familiar viewpoint. (Reproduced permission of Yorkshire Post Newspapers Ltd.)

often cover an area more cheaply; but this advantage is only gained at the expense of extensive dead ground, wide variation of scale and much more complicated properties from a mapping point of view, so that verticals are usually preferred. Something of both worlds is obtained with photographs taken by multiple camera installations, the chief aim here being to reduce cost or time by increasing the area photographed during each run. Examples are the 'F21–F22' type (Fig. 26A), sometimes found in official post-war cover of Britain (and apt to look disarmingly like true verticals, which they are not), and the American *Trimetrogon* type where one vertical camera is flanked by two high oblique cameras giving continuous cover from horizon to horizon at each exposure (Fig. 26B). Less common are photographs taken by five- or nine-lens cameras, where a central vertical lens is surrounded by four or eight outward-pointing lenses. Unlike the previous examples all five or nine photographs are printed fused together into one image, the obliques being 'transferred' or *rectified* into vertical views before printing. However the development in recent years of better lenses with a wide angle of vision, and of 'scanning' types of photography (see Chapter 16, p. 320), has much reduced the need for multi-lens cameras of this type. Multi-lens cameras *are* still frequently used today but for the totally different objective of multi-band spectral analysis (see p. 324) rather than extension of the field of vision.

### 2 *Arrangement of Air Photographs*

The inclusion on an air photograph of printed information (see p. 58) enables one to distinguish between its top and bottom, but unlike maps, which maintain north at the top, *an air photograph has no consistent orientation.* A plane taking systematic air-photograph

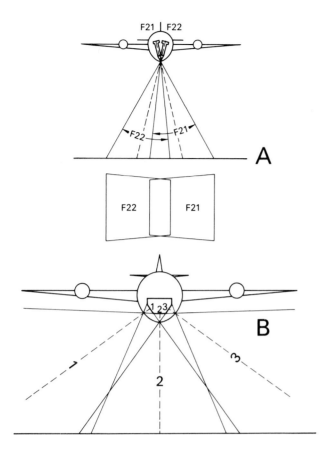

**Fig. 26:** Multiple camera installations for taking air photographs. **A:** twinned near-verticals of the 'F21–22' type. **B:** 'Trimetrogon' type arrangement. Pecked lines mark the axes of the cameras.

cover of an area does so by making successive trips back and forth across it, so that air photographs are usually arranged in long strips or runs[4] whose direction is conditioned by factors such as navigational considerations and the size and shape of the area which is being covered. The orientation of the prints is at 90° to that of the runs, and since the plane turns at the end of each run the orientation of photographs in adjacent strips will differ by 180° (see Fig. 27).

Fig. 27 also illustrates the very considerable overlap which normally exists between adjacent vertical photographs, usually about 60% overlap fore and aft (i.e. between successive photographs in the same strip), and 25% lateral overlap (i.e. between adjacent strips). Overlaps as large as this are imposed by the requirement of stereoscopy (Chapter 5, p. 92) and photogrammetry and greatly increase the cost of photographic cover for an area; if continuous but non-stereoscopic cover is satisfactory this can usually be obtained by purchasing only alternate prints in each strip (see Fig. 27).

Not surprisingly, as with maps, considerable variation of size and scale exists among air

---

[4] These runs are usually intended to be straight, though curved flights are sometimes found where radar has been employed to keep the aircraft on a chosen course.

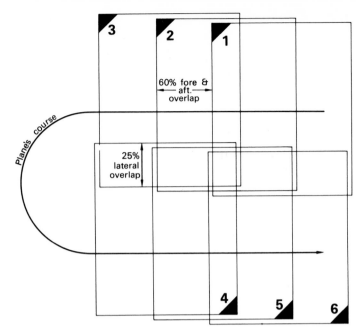

**Fig. 27:** Typical arrangement of six air photographs at the end of two 'runs'. Notice the very considerable amount of duplication: the areas of 2 and 5, for example, are entirely covered by 1, 3, 4 and 6 respectively. The black triangle represents the top left-hand corner of each photograph as indicated by the titling strip.

photographs. The commonest sizes are 7″ × 9″ and 9″ × 9″, and scale is often quite large, particularly when the photographs have been taken as a basis for subsequent mapping. Scales of around 1:10,000, 1:20,000 or 1:40,000 are quite common (much British cover is at 1:10,000 scale, much American 1:20,000) but for specialized purposes scales as large as 1:1,000 or 1:3,000 may be used. A recent, and quite opposite trend has been the appearance of a great deal of small-scale cover, taken from satellites, so that many parts of the earth now have air photographs at scales as small as 1:1–2,000,000. In this book however we shall be concerned mainly with photos at more 'conventional' scales such as 1:60,000 and larger.

Printed along the top or bottom of each photograph, sometimes in the form of a continuous *titling strip*, will be found certain items of information relevant to it. This will include certainly the print and sortie[5] numbers, and possibly the authority or body responsible for the sortie, generalized location, date,[6] time of day, focal length of the camera and flying height. By no means all of this information is given on each photograph, but it is relatively easy to recognize which items are referred to; some examples are given below:

| 093 | 11/FJ 17 | Viti Levu | August 1954 | 152·72 m/m | 20,000 ft | 6″ |
|---|---|---|---|---|---|---|
| (print no.) | (sortie no.) | (Location) | | (focal length) | (flying height) | (focal length) |
| 0174 F22: | 82/RAF/1107 | 11 Mar 55: | 12·05Z: | F 20″ // | 18,500′ | Rest'd |
| (print no.) | (sortie no.) | | (Time GMT) | (focal length) | (flying height) | (restricted—security) |
| 8–5–41 | B006. 23b | – | 1/6 | | | |
| (date) | (sortie No.) | | (print no.) | | | |
| 5226 | V(Pt 3) 3G/TUD/UK 204 | | 12 May 46 | | | |
| (print no.) | (sortie no.) | | | | | |

[5] A set of photographs taken during one flight is usually known as a *sortie*.

[6] Notice that 3rd May, 1965 would be written 3.5.65 in British notation but 5.3.65. in American notation.

### 3 *Distortion of Shape on Air Photographs*

The distortion of shape found on an air photograph is produced by two main causes (1) deviation of the camera axis from the absolute vertical, producing *tilt displacement* and (2) variations in the altitude of the surface being photographed, producing *height displacement*. Each of these will be considered in turn.

### *Tilt Displacement*

Tilt displacement is the easier of the two to comprehend since it can be seen in extreme form on any oblique air photograph such as Fig. 25. There we recognize instinctively that the shapes of buildings, streets, the river bend, etc. are not true but are distorted by what we normally call *perspective*, but what, in photogrammetry, is referred to as *tilt displacement*. Fig. 28 takes this idea a step further. When the grid of squares in Fig. 28A is viewed at an angle of 40° it becomes distorted by tilt (or perspective) into the shape of Fig. 28B. This is easy enough to envisage. What is less expected is that there is order and rule in

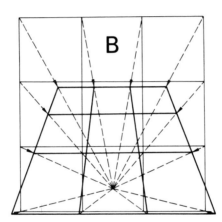

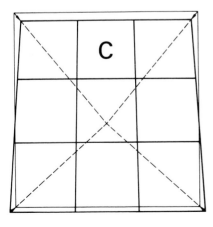

**Fig. 28:** Effect of tilt on the appearance of a grid of squares. **A:** Grid in plan. **B:** The same grid viewed with 40° tilt. **C:** The same grid viewed with a 10° tilt. Notice that in both **B** and **C** the 'new shape' is obtained from the plan shape by moving all points radially inwards or outwards from a 'perspective centre' or isocentre.

this distortion. As Fig. 28B proves, the shapes in Fig. 28A have been turned into those in Fig. 28B simply by displacing all points radially inwards or outwards about a fixed point known as the *isocentre*, so that we can formulate a rule that *tilt displacement is radial from the isocentre*. Any displacement of a point from its true (i.e. plan) position due to tilt, will therefore be radially towards or away from the isocentre.[7]

A moment's reflection will make it apparent that the amount of displacement increases with the amount of tilt. In Fig. 28C, where tilt is only 10°, distortion of shape is a good deal less marked but it is still there, and will always be there so long as the camera is not truly vertical: even with only a 1° tilt some distortion of shape will be present. Unfortunately it is impossible to guarantee that a photograph is truly vertical. Mounting an air camera on gimbals[8] will enable it normally to hang vertically but cannot prevent momentary and slight deviations due to swing caused by centrifugal forces resulting from any climbing or banking in the plane's flight. Tilt displacement is therefore always a possible hazard even on 'vertical' photographs.

*Height Displacement*

The effect of this, too, can also be appreciated in Fig. 25, though we shall usually be more concerned with its effect on vertical rather than oblique photographs. On a true plan the position of any vertical surface, such as a wall, is represented by a single line. On Fig. 25 this is not so. Walls, whether of houses, abbey church or flour mill, now occupy an *area* because the top of the wall has been displaced relative to its foot. This effect is not confined to obliques. It can also be seen in the vertical photo of the St Paul's area of London (Fig. 29), especially in the tall buildings near the edge of the photograph. Once again there is a hint of order in this displacement. The top of a wall is always displaced *outwards*, relative to its foot and where buildings of different heights adjoin the top of the taller one has a greater displacement than its smaller neighbour. Position relative to the centre of the photograph can also be seen to play a part. In St Paul's itself, which is very nearly at the centre of the photograph, there is hardly any of this displacement (though the cupola of the dome does appear slightly to one side); the displacement is also quite small in the front walls of buildings facing the cathedral yet is much more noticeable in buildings of similar height near the river.

Fig. 30A illustrates how the amount of this displacement is related to both the height of an object and its distance from the centre of the photograph, or *principal point* as it is referred to in photogrammetry.[9] Fig. 30A shows a section through a camera taking a

---

[7] Towards the isocentre for points lying to the rear of that point; away from the isocentre for points lying in front of the isocentre.

[8] A device which enables the camera to hang vertically whatever the tilt of its mounting. A similar device is used, for example, to preserve the horizontality of a ship's compass.

[9] The principal point (p.p. for short, usually marked p on diagrams) of a photograph can be defined as the point where a line drawn through the centre of the lens at 90° to the film, meets the film, e.g. the points P on Figs. 30A and B or 38A. To the layman this line is the 'centre-line' of the camera and the principal point is therefore the 'centre' of the photograph. Its position is dependent only on the camera and it can be located on the photograph by joining the opposite pairs of *collimating marks* (alternatively called fiducial marks), examples of which are shown in Fig. 61F (p. 151) and which are almost always present on vertical photographs, as well as on some obliques.

**Fig. 29:** A vertical air photograph of the area around St Paul's Cathedral, London (south at top). Original photo scale 1 : 2,600 here reduced to about 1 : 4,300. Tall buildings provide ample evidence of height displacement but even at such a large scale, building use is difficult to determine. The photograph shows many construction sites and emphasizes the usefulness of shadows as indicators of building height, elevation (dome and west front of cathedral), and the presence of objects such as lamp standards, monuments and tower cranes. Traffic and parking densities are also indicated. (Reproduced by courtesy of Meridian Airmaps Ltd. Reference Film 590, France 13231.)

vertical photograph of two chimneys AA′ and CC′ both of height h. As with any point on an air photograph we can find where these chimneys will appear on the film by drawing straight lines from the top and bottom of each through the lens to the film. A′ will therefore appear on the photograph at b whereas A will appear at a, making the chimney appear as a line, not a point as would be the case on a map; the images of the top and bottom of the chimney have become separated on the photograph so that the top appears further away from p than does the base, and in fact on the photograph the top occupies the same position as would a point B on the horizontal surface beyond A. On the

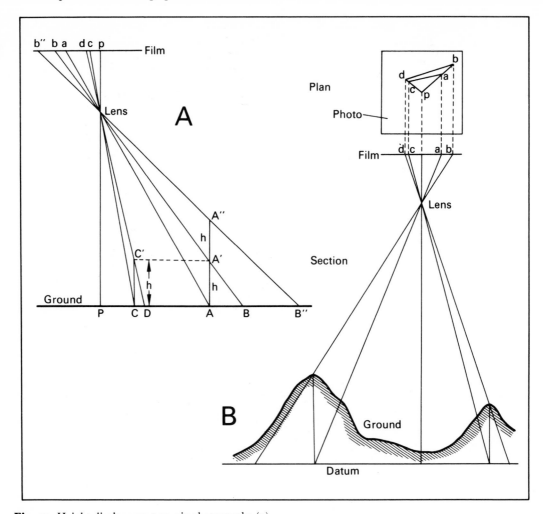

**Fig. 30:** Height displacement on air photographs (1).

photograph therefore A′ appears to be at b, i.e. displaced a distance ab from its true (plan) position, and this displacement is called the *height displacement* of the point A′.[10]

Notice that the chimney CC′ only produces the height displacement cd whereas chimney AA′ of *the same height* produces the much larger displacement ab, showing that height displacement increases with distance from the principal point. Similarly chimney AA″ of height 2h produces the displacement ab″. ab″ is obviously more than two times ab showing that the greater the height of an object the more increasingly marked will its height displacement be. Conversely it is easy to see that increasing the height of the plane

[10] For simplicity's sake we will assume the ground in Fig. 30A to be at 'sea level'. In cartography the true position of a point is its position transferred to the datum plane (i.e. 'sea level'). This idea is incorporated into Fig. 30B.

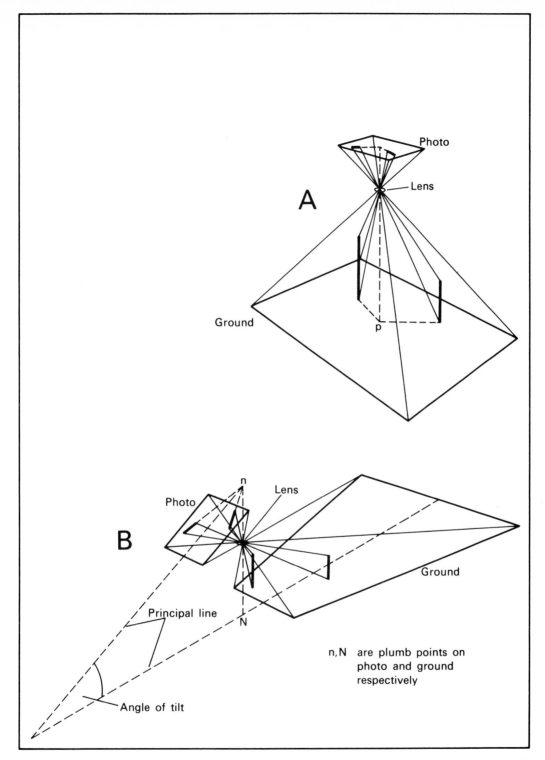

**Fig. 31:** Height displacement on air photographs (2). These figures show how two chimneys standing on a flat surface would appear, on a true vertical (**A**) and oblique (**B**) air photograph.

would reduce the displacement. In fact it is not difficult to prove that the height displacement of a point (i.e. its displacement from its true plan position) $= \dfrac{hD}{H}$ where h = the elevation of the object above datum; H the height of the plane above datum and D the distance of the photograph image of the point from the principal point of the photograph.[11]

So far we have considered only the amount of displacement involved; what of the direction of that displacement? Fig. 31A, which represents a model of two chimneys being photographed with a vertical camera, shows that both chimneys appear on the photograph as straight lines (this is already known from Fig. 30A), and that these appear to radiate from the principal point. On a *truly* vertical photograph therefore *the direction of height displacement is radial from the principal point*. Fig. 32A provides further 'real life' evidence in support of this, and a greatly enlarged sketch of the relevant detail is shown in Fig. 33; the two mill chimneys and the piers of the viaduct all appear as lines radiating from the principal point. Notice that although tall objects illustrate height displacements clearly it is not 'tallness' but elevation above datum which is really critical. On a vertical photograph the position of the principal point cannot be affected by height displacement (e.g. p in Figs. 30A and B) but as Fig. 30B indicates the position of all other points will be, unless by chance they happen to be at sea level.

Implicit in all the above reasoning and diagrams is a situation of *absolute verticality*, but since it is impossible to guarantee such a situation in practice, when taking 'vertical' photographs, it is instructive to see what happens when tilt is involved. Fig. 31B illustrates such a case. As in Fig. 31A the two chimneys again become straight lines, but this time they are radial not from the principal point but from another point n, lying in the plane of the photograph (it often lies off the actual photograph) and vertically above the camera lens. Such a point is called the *plumb point*, or *nadir point*, and has its counterpart N on the ground. In this case then *height displacement is radial from the plumb point*, and indeed it is sensible to adopt *this* as the general rule governing height displacement since on a truly vertical photograph the point vertically above the centre of the lens is *both* principal point *and* nadir point.

If a 'vertical' photograph contains even the slightest tilt this coincidence will cease. Principal point and plumb point will now separate slightly and it is about the latter that height displacement will occur. It may be useful, as will be seen later in certain simple plotting situations, to assume that a 'vertical' photograph is a true vertical and that therefore height displacements are about the principal point. But in real situations it may be *no more* than an assumption and slight errors may be introduced as a result of it.

When height displacement is produced by relief features rather than chimneys the effect may be quite marked. Using the formula for displacement mentioned earlier, it can be calculated that a hilltop, 200 metres above datum and appearing 9 cm from the principal point on a vertical photograph taken from 3,600 m altitude, will appear displaced $\dfrac{hD}{H} = \dfrac{200\text{m} \times 9\text{cm}}{3,600\text{m}} = 0.5$ cm from its true position. Displacements of this kind obviously affect both shape and angular direction (bearing) on a vertical air photograph,

[11] The proof is dependent upon similar triangles.

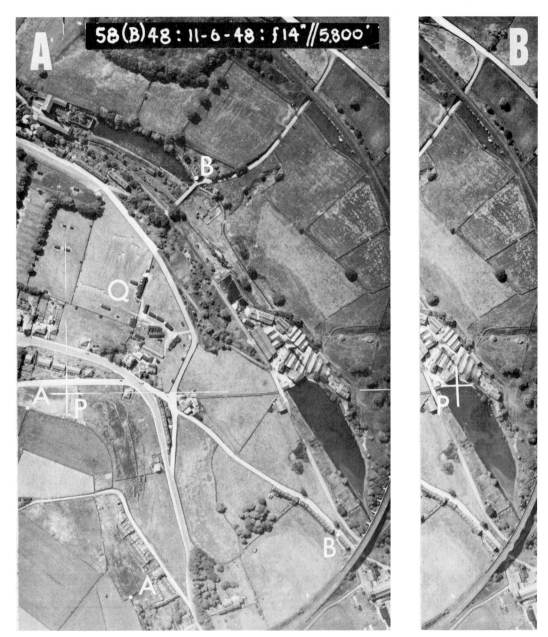

**Fig. 32: A:** Part of an air photograph of the valley of the Hebble Beck near Halifax, West Yorkshire. There is little *direct* indication on the photograph of the nature of this deep, steep-sided valley, though its presence and form can be inferred from several features. Scale *c.* 1 : 5,000. (Sortie no. 58 (B)48 (11/6/48) print no. 5032, reproduced by permission of the Ministry of Defence, Crown copyright reserved.) **B:** Part of the detail of **A** taken from the adjacent photograph in the strip (P is the principal point in both cases). Instructions for using the strip as part of a stereo-pair are given on p. 92. (Sortie no. as for **A,** Crown copyright reserved.)

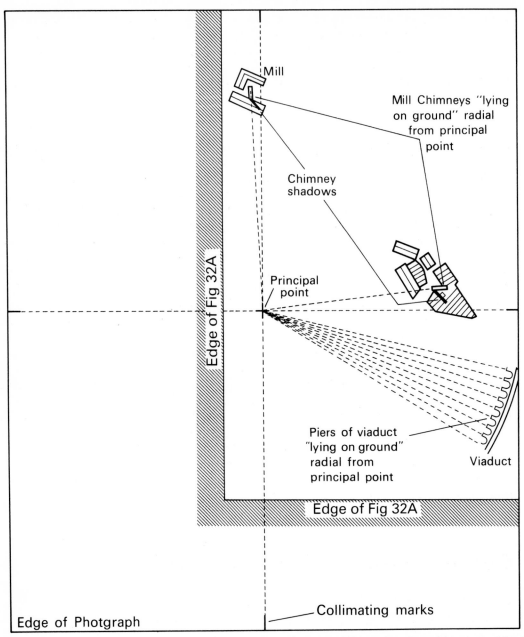

**Fig. 33:** Height displacement on air photographs (3). This drawing shows (much enlarged) portions of detail on Fig. 32, which manifest obvious evidence of the effects of height displacement. Notice that in each case the top of a vertical object is displaced relative to its base and that, since Fig. 32 is a vertical photograph, displacement is radial relative to the principal (= also plumb) point.

distorting them from their true form. It is not difficult now to see why the same block of fields appears so differently in Fig. 24A and B, and Fig. 30B makes the same point. Due to displacement of the hilltops from a to b and c to d the true shape pac has become the photograph shape pbd. Similarly the real angle at c, angle acp, has become distorted into the photograph angle bdp. Notice however that because absolute verticality is involved displacement is radial from p and *angles (bearings) at p have not become distorted*; angle dpb (photo) = angle cpa (ground). This has important applications in mapping, as will be shown later.

So long as tilt displacement is considered only on a dead level surface, and height displacement only on a truly vertical photograph, neither raises unsurmountable problems since in both cases a point exists – the isocentre in the first case, the principal point in the second – where angular bearings remain correct. If both are present, however, much more complex circumstances arise. Consider Figs. 34A to D, which also illustrate several points made earlier in this chapter. Fig. 34A represents a plan of a group of radio masts of varying heights standing on a level surface, Fig. 34B an oblique air photograph of the area with masts removed. Only tilt displacement is now present and its radial nature, maintaining correct angles at the isocentre but distorting them elsewhere, for instance at the principal point P, can be seen. In Fig. 34C masts have been erected and height displacement radial from the plumb point is introduced: angles measured from the *top* of the masts to the isocentre are now incorrect. Suppose now that for the radio masts we substitute a more normal situation treating the mast tops as 'spot heights' and stretch a 'skin of country' over them as in Fig. 34D. If this landscape is divided into square lots each with a corner at a 'spot height' (i.e. mast top), we know that on the oblique photograph these positions will be those of the mast tops in Fig. 34C and the area would therefore appear as in Fig. 34E. Notice that because two displacements are present there is no simple relationship between the true plan position of a point and its photograph position; the latter position results from the interaction of two components which may sometimes partly augment, sometimes partly contradict one another. Quite obviously in mapping from air photographs this is a difficult situation to analyse and resolve, and it is not surprising that the simple techniques for constructing maps from air photographs are derived from the simpler situations which occur on *vertical* air photos. From now on we shall confine our attention to that category of photo only.

# Getting from Air Photo to Map

*Mosaics and Photomaps*

To get from a vertical air photograph to a map some means of overcoming height displacement must be found. There is more than one way of doing this but the simplest, though least accurate, is simply to ignore it and make a *mosaic* of photographs which can be rephotographed and reproduced as a *photomap*.

It has been shown above (a) that height displacement is at its most noticeable at the edges of photographs (Fig. 30A) and (b) that vertical air photographs are usually taken

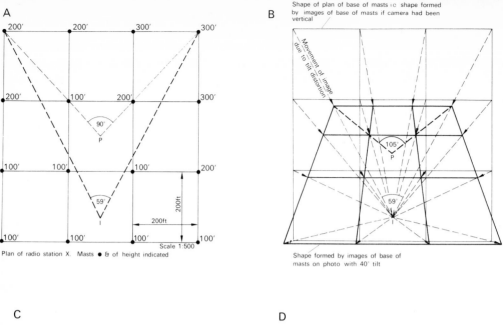

A

200'  200'  300'  300'

200'  100'  200'  300'

90°
P

200'  100'  100'  200'

59°
I

100'  100'  100'  100'

200ft

200ft

Scale 1:500

Plan of radio station X. Masts ● & ℓ of height indicated

B

Shape of plan of base of masts is shape formed by images of base of masts if camera had been vertical

Movement of image due to tilt distortion

105°
P

59°

Shape formed by images of base of masts on photo with 40° tilt

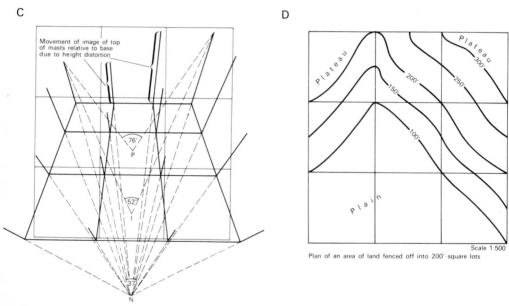

C

Movement of image of top of masts relative to base due to height distortion

76°
P

52°
I

37°
N

D

Plateau
Plateau
300'

Plateau
150'
200'
250'

100'

Plain

Scale 1:500

Plan of an area of land fenced off into 200'-square lots

**Fig. 34:** A practical illustration of the effects of height and tilt displacement on oblique air photographs using, as a model, a group of sixteen radio masts of varying heights arranged in a square grid on a horizontal surface. **A:** Plan of the group. **B:** Appearance of the square grid only on an oblique air photograph with 40° tilt. Notice that the distortion of shape produced by the tilt (tilt displacement) is not haphazard but *regular*, all points on the old shape (plan) being displaced radially inwards or outwards about the isocentre to their new position. This proves that tilt displacement is radial from the isocentre. **C:** A similar oblique photograph with the masts in position, introducing an additional element of height, and hence height displacement, into the photograph. Notice that height displacement is *not* radial from the isocentre, but from the plumb point, N, and that its effect is to separate the position of the top of a mast from that of the bottom by a varying amount: on plan of course both top and bottom of the mast occupy the same position. If angles are now measured from the tops of the masts, *none* remain true (compare with the angle at I in **B**) because of the compound effect of both displacements. **D:** A situation more akin to reality can be produced by stretching a 'skin of topography' over the tops of the masts in **A** and marking out the grid on this surface. The relative positions and heights of the intersections of the grid remain the same as those in **A**.

with very considerable overlap both laterally and fore-and-aft (Fig. 27). If desired, therefore, a continuous picture of an area could be made by piecing together only portions cut from the *centres* of photographs, discarding the outer areas of each. Since height displacement is at its least serious close to the principal point (i.e. in the centres of photographs) if conditions are 'good' i.e. only low relief and low buildings, the displacement, though still present, might be reduced to minute amounts. When the centres of photographs are cut out, matched to give the best possible fit with their neighbours [12] and subsequently mounted on a base board, the result is called an *uncontrolled mosaic*.

One would not expect such a mosaic to have a high degree of accuracy. When many things, each themselves slightly 'inaccurate', are pieced together it is not difficult to get good fit over small areas, but as the area grows accumulated small errors may build up to the point when tolerable fit can no longer be achieved. To a large extent this situation can be obviated if any form of *ground control* exists, that is if there are points occurring on the photographs whose ground position is accurately known, either from ground surveys or by plotting from the photographs themselves using methods to be described later such as a slotted template assembly. In this case the positions of these control points can be plotted on the mosaic base board and the photographs placed so that the images of these points exactly overlie their plotted positions. In this way the resultant mosaic will 'grow' from several centres, the areas over which errors can accumulate will be reduced, and the result is known as a *controlled mosaic*. Under ideal conditions, with plentiful ground control, flat terrain, low structures, and prints carefully rectified (see Fig. 36) to remove the effects of tilt and scale variations, the accuracy of the resultant mosaic or photomap can come close to that of a normal topographic map, but there are many situations where

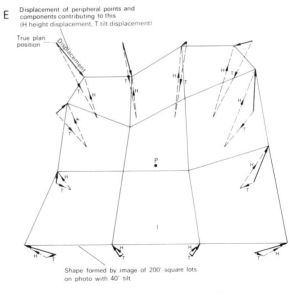

E | Displacement of peripheral points and components contributing to this (H height displacement, T tilt displacement)

True plan position

Displacement

P

Shape formed by image of 200'-square lots on photo with 40' tilt

**E:** Shows the same landscape when photographed with a 40° tilt (as in **B** & **C**). The positions of the grid intersections are identical with those of the tops of the masts in **C**, and the displacement of these grid intersections from their true (plan) position (**D**) is the result of the varying interaction of the two factors of height and tilt displacement. **E** makes it obvious that oblique air photographs which contain height displacement present difficult problems as a basis for mapping. If no height displacement is present, as in **B**, the problem is less difficult, but such situations are virtually unknown.

[12] The photographs are also carefully matched for tone as well so that the joins are not conspicuous.

conditions are *not* ideal and some more generally applicable and reliable solution than mosaics and photomaps is obviously needed.

*Photomaps* may be no more than 'straight' copies of the appropriate mosaic but usually they will have had other information added or overdrawn, e.g. settlement and street names or symbols for main roads and railways. It is important to remember, however, that even when derived from a controlled mosaic the photomap contains the errors implicit in that origin and it should not be confused with the *ortho*photomap, described later in this chapter, with which it has certain superficial similarities of appearance.

### Radial Line Methods

The basis for a much more satisfactory way of getting from photo shape to map shape has already been met in Fig. 30B where it was shown that on a truly vertical photograph the effect of height displacement is to disturb all bearings and angular relationships *except those measured from the principal point*. In Chapter 2 Fig. 19 showed how in *ground* surveying the position of points can be fixed by *intersection* if their angular relationship relative to both ends of a common base line is known. If therefore in a *pair* of photographs the line between their two principal points is regarded as such a base line we can regard each photograph as a *visual statement of the angular relationship of points on the photograph to one end of that line*; these two statements can be 'slid together' along their common element to fix the position of many points by intersection. Fig. 35 should make this idea clearer. Because of the very large overlap between photos (Fig. 27) any one photo will usually contain the positions of the principal points of its neighbours so that the common base line between these can be established quite easily on a pair of photos. Notice that varying the extent to which the two bearing sets are slid together will alter the *scale* at which the intersections emerge but it will not alter the *basic shapes* produced in this way.

In practice there are both bonuses and difficulties with this basic idea. On the bonus side it is obvious that there is no need to stop at a pair of photographs. The same ideas could link together a whole strip of photographs and, because there is lateral overlap between photos in adjacent strips, if some of the points to be plotted are selected in this lateral overlap, plots from adjacent strips could be fitted together using these common points, making a plot of a whole area out of a series of strip plots. The difficulties arise because in practice it is impossible to guarantee absolute verticality and if even the slightest tilt is present this will make height displacement radial from the plumb point, and will cause slight errors in the photograph's representation of bearings from the principal point. The effect of such errors does not become noticeable until plotted points are fixed by rays from 3 or more principal points. If errors are present either the required trisections can be obtained but the lines between the principal points will not coincide, or the latter can be achieved but trisections cannot (Fig. 35). As with controlled mosaics these dilemmas are resolved by including in the plot *control points* whose positions, fixed by ground survey, can therefore be used to adjust the small errors present and prevent them accumulating to irreconcilable amounts.

This interlocking of ground-survey framework and air-photograph detail is essential if accurate maps are to be produced from air photographs. Fortunately in many areas, such a framework was already in existence, even before they were photographed for the first

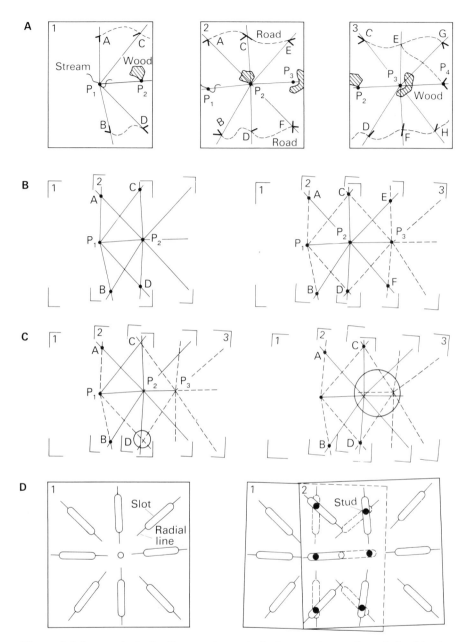

**Fig. 35:** The radial line method. **A:** On a truly vertical photograph angular relationships between the principal point and adjacent principal points and points in the common overlap are correctly shown. **B:** Sliding two sets of these together along their common line (P1–P2) fixes A, B, C and D by intersection. With a truly vertical photograph adding a third set along P2–P3 confirms C and D by trisection and fixes E and F. **C:** If tilt is present distorted angular relationships show by loss of trisection at D (left) or loss of co-linearity (right). **D:** (left) a slotted template (right) two overlapping templates with studs passed through intersections and principal-point holes.

time, considerably speeding up the resultant mapping. For their part the photographs added to this framework detail far greater in quantity, and far more accurately and consistently recorded, than the old ground-survey methods could ever have hoped to provide.

## Developments of the Radial-Line Idea

A simple adaptation of the radial-line idea is the use of *slotted templates* to provide mapping at small or medium scales. In this method a square of transparent plastic replaces the photograph and accurately punched slots and holes in this plastic replicate the positions of relevant radial lines (slots) and the principal point (hole). Positions which would have been fixed by intersections of radial lines are now indicated by intersections of slots and can be marked by pushing a stud through these intersections and pinning the stud to the base-board beneath. Alternatively studs representing the position of known points (e.g. from ground survey) can be properly placed in position first and the templates adjusted until all necessary intersections fall over the plotted stud.

Unfortunately the slotted template system has only a limited capacity to absorb errors introduced by tilt and to avoid this most modern plotting systems attempt to reproduce exactly the angular relationships which existed between a pair of photographs at the time when they were taken, before examining intersections of rays from them. When this correct setting has been established (i.e. after reconstructing exactly the amount and direction of tilt (if any) relative to one another) intersection of rays from the two photographs can be achieved either by optical projection, or by a mechanical simulation of this using space rods. If projection is used one image is usually projected in red, the other in green light so that, when viewed under appropriate conditions, the observer sees, surprisingly, *a three-dimensional* or *stereoscopic* image of the area common to both photographs. The origins and characteristics of this image (which exists only in the eye and mind of the observer) will be discussed further in Chapter 5; its importance here lies in the manner in which it overcomes the problem of displacements. By using a projection of the photo-image, rather than the photograph itself any displacement due to tilt can be removed by 'projecting back' the image into its 'correct shape', a process known as *rectification* (Fig. 36).

Nor is height displacement a problem either, for in the three-dimensional stereoscopic image it too has been 'transformed back' into the vertical component which caused it in the first place, so that all detail in the image now lies vertically above its true plan position.

Plotting position from this three-dimensional image is achieved by scanning it with a small screen in the centre of which is a measuring mark, which in turn lies vertically above a pencil plotting point. The height of the screen is adjusted until the measuring mark appears to be exactly on the surface of the three-dimensional image at any particular feature e.g. a road or stream. If the measuring mark is now moved to follow the image of this feature, with the height of the screen being continually adjusted so that the mark *always* appears to be on the surface of the image, the pencil below will automatically trace out the projection of the movement onto a horizontal plane, i.e. it will trace out the true ground position (Fig. 37). What one is really doing is plotting position from a 'scale model' of the terrain – the three-dimensional image – and not from a two-dimensional abstraction of it – the photograph. Ground control, i.e. predetermined positional know-

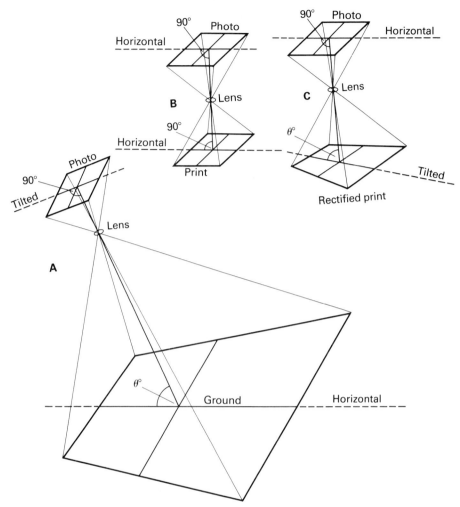

**Fig. 36:** The principle underlying rectification. **A:** A tilted photograph distorts *trapezoidal* ground shape into a *rectangle* (photo). **B:** Normal printing of photograph preserves these distortions. **C:** Projection onto a suitably tilted surface 'distorts back' rectangle into true trapezoidal shape. *Note:* (1) Such projection does *not* also remove height displacements, (2) the correct setting ($\theta°$) is not known automatically but can be determined from ground control.

ledge about key points in all three dimensions, is of course still needed, both to set up the photographs and to detect and/or resolve errors which inevitably accumulate from the piecing together of information from many small units.

More recently plotting machines have been devised which reconcile the data from pairs of photographs neither optically nor mechanically but by calculation. If a pair of photographs can be set up correctly relative to each other, and the coordinates of the same piece of image detail be accurately measured on each photograph in all three dimensions, the position of 'the intersection of the rays from the principal points to this detail' can be calculated without any need to create that intersection in space. Needless to say com-

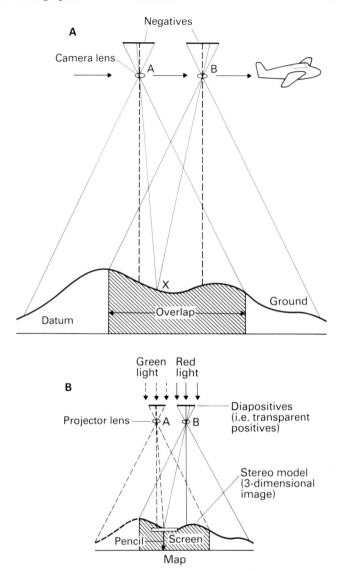

**Fig. 37:** Basic principles of a stereoscopic plotter (after Wolf and Dalgleish). **A:** Actual photography. **B:** Stereoscopic plotting instrument.

puters are involved to perform these calculations, which can be extended to include rational adjustment following detected errors between calculated and known positions of ground control points. The computer-produced results can also be used to drive plotting machines which will actually draw the resultant map, an idea which is considered further in Chapter 6.

Whatever type of plotting machine is involved all have, in their simple 'image-following' potential, an immense advantage for fixing the position of intricate detail over the tedious 'repeated-measurement' approach of traditional ground-survey methods. The

complex shapes of the air photograph may not be *exactly* those of the map, but they can easily be transformed into them, and it is not difficult to see why, equipped with this new technology, world mapping has advanced faster in the last 30 years than ever before.

### *Orthophotomaps*

The methods just described have one main drawback; costly and time-consuming draughting processes lie between the photograph and the resultant map. A much neater idea would be somehow to transform the original photograph directly into the end-product. The *orthophotomap*, the principles of which have been known for many years but which has only come into widespread use during the last decade or so, represents the realization of such an ideal. In orthophotography, as with many techniques in surveying and cartography, the principle is not difficult to understand, even though realization in practice demands highly complex machinery; as elsewhere in this book it is the principle and its potential rather than the technical process which are considered.

In Fig. 38A a camera has photographed terrain containing two hills A and C which therefore appear on the photograph at a and c. If this negative is then projected back through an identical lens onto a sheet of sensitive film placed in a projector the same

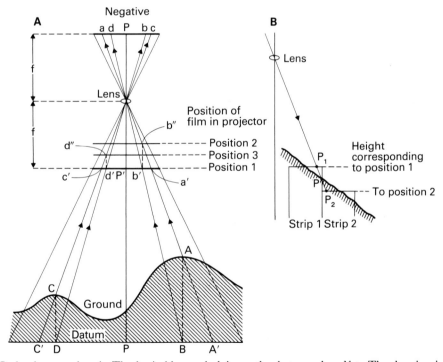

**Fig. 38:** Orthophotography. **A:** The basic idea underlying orthophotography. *Note:* The drawing is a composite representing both conditions during the taking of the photograph and the reprojection of the diapositive. **B:** Errors at strip edges arising with optical projection (after Löscher). P will appear at $P_1$ with the projection set for strip 1 and at $P_2$ with the setting for strip 2. P will thus appear *twice* on the orthophotograph as will a small area around it; conversely with the ground slope reversed P would not appear at all on either strip.

distance (f) away from the lens (position 1) an an exact replica of the original photo would be produced with the hilltops at a′ and c′. Both a′ and c′ are incorrect, since they represent the plan positions A′ and C′ not B and D which are the *true* plan positions of the hilltops. If however the film in the projector were moved to position 2, a would now appear at b″ at a distance from the principal point equal to p′b′, which is the true distance required for the hilltop in position 1. Unfortunately to get this correct distance everything else has been shrunk and all other distances are now too small. In the same way at position 3, d″ would be at the correct distance from the principal point but all other distances would not. There is, however, the basis of an idea here. If the film at position 2 was screened, except for a minute window of only a few square millimetres around b″ exposure would produce a distortion-free print of the area around b″.[13] Similarly moving the window to d″ and the film to position 3 would give a correct picture of hilltop C, and the same technique could be applied anywhere on the photograph, though it would obviously make sense to do so systematically, in a scanning motion not haphazardly as described here. This is the basis of the *orthophotograph*. It is produced by systematically exposing a film, a small rectangular area at a time with, at each exposure, the projection of the film being

**Fig. 39:** Two examples of the orthophotomap. **Fig. 39A.** Part of a 1 : 25,000 orthophotomap series of the Sydney area produced by the Central Mapping Authority of the New South Wales Government. On the original background detail is printed in green, water in pale blue, houses in brown and roads in red. Contours are at 10 metre intervals. There is also a 1 : 100,000 orthophotomap series of the north-western part of the state. Reproduced by permission of the Central Mapping Authority, Bathurst, NSW.

[13] This is true only if the area within the window were absolutely flat, otherwise any differences in height *within* the window area would still produce real but minute errors. The point will be taken up later.

**Fig. 39B.** Part of an orthophotomap at 1:2,500 scale of the area of Stonehouse New Town, Scotland. Produced by Fairey Surveys Ltd, this is a representative example of orthophotomaps produced by this, and similar, commercial firms to provide rapid, up-to-date, large scale maps for major engineering projects. The contour interval is 1 metre. Dark figures indicate tree heights. Reproduced by permission of Fairey Surveys Ltd.

adjusted to correspond to the altitude of the section of the terrain being covered, so virtually removing the element of height displacement.

An orthophotograph is therefore really a compound product where thousands of photographs, each of a small area and each differentially rectified, appear as one. Because of this it is *free from the distortions inherent in normal air photographs* and in its portrayal of the earth's surface its accuracy will stand comparison with more traditional map-producing technologies. In practice the apparently complex problem of setting the film surface at the right distance (as in positions 1, 2 and 3 in the example above) can neatly be solved by again forming a stereoscopic (i.e. three-dimensional) image of the area under study and using this as a guide. At first, when optical projection of the image was used, variations in height within the 'window area' presented difficulties (already referred to above and illustrated in Fig. 38B) whereby some points could appear twice and others not at all. This difficulty has now been resolved by using not the direct projected image of one film, as implied in the brief general description above, but a computer-transformed version of images derived from both photographs of a stereo-pair; indeed the introduction of a computer into the process allows the *whole* operation to be mechanized so that we have here a workable process for accurately representing all the visible features of the earth's surface and in which both the gathering of the information (photography) and its presentation (orthophotography) are largely achieved by machines rather than men. Only in the accurate setting up of the machines, using pre-established ground control points, do we find much that resembles the traditional human-oriented map-making process.

The addition to the orthophotograph of important but non-visible features – names, a grid, contours (though these too can be provided semi-mechanically, see Chapter 6, p.

**Fig. 40:** The hidden distortion of the normal vertical air photograph revealed by the orthophotograph.
**Fig. 40A.** A normal vertical air photograph of Mt Rose, Nevada (original scale 1 : 80,000) on which a regular rectangular grid has been inscribed.

111), road numbers and classification, perhaps some symbols for clarification – produces an *orthophotomap* (Fig. 39). The result is not unusually striking, indeed the layman may be hard put to distinguish photo from orthophoto, or photomap from orthophotomap, though the differences are real enough as Fig. 40 shows. Yet the orthophotomap obviously represents a significant point in cartographic evolution. Have we encountered here the map of the future?

The answer to this question is far from being a simple 'yes'. It is true that in almost all cases orthophotomaps are more quickly produced than conventional maps and in many situations, especially at larger scales such as 1 : 20,000 and above, they may also be markedly cheaper.

Their fuller detail may be greatly appreciated by such people as foresters, geologists or engineers, though conversely it may prove somewhat confusing to the more general map user; certainly at very small scales it will become increasingly difficult to read. At *very* large scales abrupt changes in height, such as occur with tall buildings, may still give rise to problems whose origins are related to the kind of situation shown in Fig. 38B, and it is

**Fig. 40B.** The same transformed by the Gestalt system into an orthophotograph to remove height and tilt displacements which were present on the original. The distorted grid indicates the *true plan position* of lines which appeared so straight and neatly regular on Fig. 40**A**. (Photo and orthophoto by courtesy of Atlantic Air Survey Ltd, Dartmouth, Nova Scotia.)

for all these reasons, as well as others given below, that orthophotomaps are, as yet, hardly commonplace. Though well adapted to rapid, limited mapping for special projects, e.g. road or reservoir construction, there are few extensive orthophotomap *series*, though the 1:20,000 Economic Map of Sweden has been so produced since 1966,[14] a 1:50,000 series of Saudi Arabia is in progress and, most ambitious of all, a 1:100,000 series covering all of Australia is being produced and will ultimately involve no less than 3,000 sheets. How the map/orthophotomap debate is ultimately resolved in different countries, even in different areas, will depend on the interplay of many complex factors. Even so simple a 'basic' issue as cost difference is, in practice, affected by a multitude of other considerations – who is to use the map, what does the user want it for, what scale is proposed, is colour required, is the area concerned a completely unmapped area or one where considerable map cover already exists, is future revision envisaged, and will this be

[14] The series began as a *photomap* series in 1937 (a rare example of the use of this technique for an extensive series) but changed to orthophotomaps in 1966.

regularly or rarely? We might also ask whether conventional maps have produced any 'automated answer' with which to counteract the threat from this new rival.

These are rather different issues to the ones we have been concerned with so far, which have concentrated on the simple problem of extending map coverage by various means. To understand them we shall need to look in rather more detail at certain aspects of map design. That is the concern of Part II of this book.

# Part II
# Finishing Off the Image – A Closer Look at Style and Content

# Chapter 5

## What is there to see? – Scale, Style and Content

If, as Part I has shown, images of the earth's surface are becoming increasingly wide-spread it is pertinent to ask what these images, whether map or air photo, are like. How do they differ from each other and what differences exist *within* each category? Within maps as a group potential differences are obvious, leading to questions such as 'Are the end products produced by different mapping agencies similar or dissimilar, and if the latter, how and why?' 'Can one use a foreign map easily, and are there any cartographic conventions so widespread that they make the map an "international language", at least for the description of landscape?'

This concern, fundamental to mapping, of *what* must be shown and *how* it must be shown appears to be absent from an air photograph, where the camera impersonally records all it sees 'exactly as it sees it'. But in practice, particularly if one considers the wider field of *remote sensing* (which includes all techniques used to produce an automatic image of the earth's surface and is not restricted to light on film reactions) a surprisingly wide range of end-products is possible. However, the unfamiliarity of remote sensing techniques, and even the unfamiliar detail and viewpoint of the conventional air photograph, suggest that it may be better in this section to consider only the most general aspects of the latter. More specific aspects, such as content and its interpretation, will be dealt with in Part III of this book. Part II will therefore concentrate predominantly on maps and this chapter in particular is concerned in a very general way to provide answers to the kind of questions about style and content outlined above. It does so firstly by considering the effects of certain overriding factors which must inevitably affect the design and content of maps as a whole, and secondly by considering in more detail specific classes of feature, the extent to which these have been shown on maps and the manner in which this has been achieved.

*Scale and Content*

The scale of a map inevitably controls its design to a very great extent. On very large-scale maps almost all of the permanent features of the landscape can be shown truly to scale, in plan form, and named as well if their importance warrants it:[1] at smaller scales

[1] Maps of this kind where everything is shown correctly to scale are often called '*plans*' rather than maps.

not only must the greater part of this detail be ignored, but even that important enough to remain must be shown *conventionally*, with symbols, colour or abbreviation, to preserve legibility in the very limited space available.

Fig. 41 illustrates just how difficult this problem of redrawing detail to smaller scales is, and how very radically it affects the content of the resultant maps, particularly in urban areas with close detail. Not many of the crowded features of a capital city have weathered the reduction from 1 : 10,000 even to a 1 : 50,000 scale, and almost all of these have had to be rendered more distinctive to avoid them getting 'lost'. The churches and railway stations now have conventional signs to mark their presence; the parks and principal roads (on the original maps) rely on colour: but for most other features the problem of specific representation has been abandoned,[2] sometimes in a rather puzzling way, as with the awkward 'blanks' which mark the squares and formal gardens of the planned New Town. At scales as small as 1 : 250,000 both reduction of content and generalization of detail have been pushed very far indeed, and maps at scales like this normally tell us very little about any particular place or area.

In the originals for Fig. 41 colour is also used to help distinguish and emphasize detail, but the typical relative colourlessness of large-scale maps is not entirely explained by lack of this need. Large-scale maps are essentially maps to be worked *on* rather than *with* and since engineers, planners, etc., may wish to add to them their own (usually coloured) detail, colour in the map itself would be a nuisance. For the same reason many authorities publish outline versions even of small-scale maps.

The relationship between scale, content and clarity is no less fundamental on air photographs. Few large-scale maps can match the detail of a typical large-scale photo of an urban area (say 1 : 2,000 to 1 : 3,000 scale) which will embrace greenhouses, swimming pools, trees, cars, even roof repairs. Unfortunately the camera's attempt to record this *same* mass of detail at much smaller scales may produce only confusion and illegibility and to many people the legibility of a 1 : 60,000 photograph compares badly with that of a 1″ to 1 mile map, though magnification can sometimes help here.[3] At still smaller scales quite fundamental landscape details, e.g. settlement, communications, may become surprisingly distinct on photographs and at all scales the absence of names proves a notable handicap.

*Landscape and Content*

The type of landscape to be represented must also have quite an important influence on map design. Rugged or broken relief, for example, may cause a map to be so filled with hachures or hill-shading (see below) that it is difficult to portray other detail satisfactorily against such a background, and particularly was this so on the old 'black and white only with hachures' type of map. Colour printing helped but did not entirely remove this problem, and it is perhaps significant that the Dutch, with less relief detail to show than anyone else in Europe, manage to represent land use as well as topography on their 1 : 25,000, 1 : 50,000 *and* 1 : 200,000 maps.

[2] This is perhaps something of a British failing. Conventional signs are not highly developed on British (or United States) maps: a European map at similar scales would probably have attempted rather more.

[3] Commercial magnifiers such as the 'Polaron' which produce ten-times magnification, are invaluable for detailed examination of photos at all scales. The question is taken up again in Chapter 16.

**Fig. 41:** A portion of central Edinburgh at 1 : 10,000; 1 : 25,000; 1 : 50,000 and 1 : 250,000 scales (6.34, 2.53, 1.27 and 0.25 inches to a mile respectively). The sequence emphasizes vividly the extent to which detail must be omitted, simplified or conventionalized at the two smaller scales. Part of the 'New Town' can be seen in the northwest corners of these maps. (Reproduced from Ordnance Survey maps with the sanction of the Controller of H M Stationery Office, Crown copyright reserved.)

Quite apart from relief the total sum of what needs to be shown is important. In less developed areas there is less to show and more space to show it, so that almost everything of importance can be marked (and often named) even on maps at small scales. The Icelandic 1 : 100,000 map marks farms, deserted farms and sheepfolds; the South African 1 : 50,000, kraals, stockades and dipping tanks; the Bahamas' 1 : 25,000, clubs, hotels, jetties, and so on. Since the reverse problem occurs in dense urban areas awkward problems of design and content arise when the same series has to cover both types of environment.

One further point might also be noted here. Alongside the great mass of 'normal' landscape detail many maps portray, additionally, features of peculiar importance to that nation or locality. Three typical examples are the inclusion of considerable detail relating to waterways on Dutch maps;[4] native location boundaries on the South African 1 : 50,000 series; and the cane fields, field tramways and sugar factories of the sugar industry on many West Indian sheets.

In contrast an air photograph cannot make conscious choice or emphasis of this sort but must record what the camera 'sees', which may be a great deal. Even in 'empty' landscapes, such as desert, forest, dunes, moorland or tundra, the details and features visible on photographs at scales such as 1 : 25,000 to 1 : 40,000 go far beyond the content of similar-scale maps and may also form the basis of important commercial applications, as is further described in Chapter 16.

### Map User, Map Maker and Map Design

The entry of the state into the mapping field on a grand scale has done nothing to break the centuries-old link between potential map user and map design. Official mapping agencies are just as keen as the old private map-makers to see that their products appeal to the enormous market provided by tourists and travellers of all kinds, and in this respect at least, there is still plenty of competition from privately produced maps to keep them on their toes. So it is that we find on maps features such as continually improved road classifications and isolated telephone boxes and public conveniences to help the motorist (British 1 : 50,000 map); youth hostels, camping places, mountain refuge huts, ski routes, lifts and jumps to cater for the more active recreationalists (Swiss or German 1 : 50,000 maps) as well as landmarks such as high chimneys, radio masts and churches of various sorts which, in part at least, may serve to guide the general traveller. For the more important tourist areas many countries publish specially attractive sheets which in style and content may go well beyond the standards of the normal series, e.g. the hill-shading, layer-colouring and sites for cycling, canoeing, caravaning, camping, climbing, skiing, parking, viewing and pony trekking all included on the Ordnance Survey Cairn Gorms 1″ Tourist Sheet.

Important though they may be today, however, it was not the needs of tourists which first prompted the state to enter the field of map making. From the very first military considerations had a strong influence on the design of officially produced maps, and continue to do so, particularly in the many countries where official map production is still

---

[4] Locks, sluices, culverts, earth culverts, weirs, draw-bridges, bascule bridges, swing bridges and footbridges are all differentiated on the 1 : 50,000 map.

in the control of a military authority. Though all might claim a place on the map as elements of landscape, it is significant that features such as areas with trees (vineyards, orchards, woods), cemeteries or the differentiation between fenced and unfenced roads also have military importance because of the varying amount of cover which they afford: all of these are particularly well represented on European maps. Similarly the rather pedantic distinction between bridges of concrete, wood and iron, suspension, lifting or transporter type (French, German or Portuguese 1 : 50,000 maps) must surely have its origins in this sector of interest.

The situation where the map maker is also an important map user is not of course confined to official surveys operated by quasi-military bodies. Governments and their agents are generally important users of maps, and one is not surprised therefore to find on official map series detailed representations of many of the offices and 'end products' of national and local government. The Survey of India $\frac{1}{4}$″ map, for example, marks circuit houses, inspection bungalows, rest houses, police stations, jails, post and telegraph offices and reserved, state and protected forests. The widespread practice of marking official boundaries on maps is another example of the same tendency.

# The Content of Maps

The preceding pages have outlined some of the principle factors which affect map design as a whole. The final section of this chapter examines rather more specifically the kinds of features which are shown on maps and the manner of their portrayal. The enormous variety of detail concerned will be described under five headings – relief, communications, settlement and buildings, land use and vegetation, and other information.

The methods which the cartographer uses to represent relief on maps can be divided basically into qualitative and quantitative ones. The terms are almost self-explanatory, *quantitative* methods being those concerned with the representation simply of specific altitudes whilst *qualitative* ones try to indicate quality (i.e. kind) of relief, giving an impression of altitude, ruggedness, slope, etc., but no specific information. The qualitative methods are therefore essentially 'pictorial' or 'vivid' in their approach, and in their attempts to make the relief look three-dimensional may be considered as the direct descendants of the 'sugar-loaf' hills of early maps.

*Hachures,* which were the earliest sophisticated method of representing relief in plan form, remained in use until surprisingly recently on some important map series, for example the German and Swedish 1 : 100,000 maps, until these were replaced by new editions or series post World War II. The hachures themselves are short lines running down the slope of the land and drawn closer together, and sometimes thicker too, where the slopes are steepest; collectively they build up dark tones on steep slopes, often producing surprisingly vivid 'three-dimensional' results, as in Fig. 42 which shows examples of hachured maps, including some with variations on the basic principle.

At its most exact hachuring demands that both the number of hachures per centimetre and their thickness be strictly related to slope, but less precisely drawn versions are more

**Fig. 42:** Examples of hachured maps. **A:** 1st edition 1″ Ordnance Survey map of England: part of sheet 102. **B:** Germany, Topographische Karte, 1 : 100,000: part of Grossblatt Nr 73. **C:** Topographische Karte der Schweiz (Carte Dufour), 1 : 100,000: part of sheet XXIII. **D:** France, Carte de l'État Major, 1 : 80,000: part of sheet 178. All of these maps have now been replaced by other series. Notice the *oblique* hachuring in **C**, which gives light and dark sides to hills, and the difficulty in dealing with the very gentle slopes of the Plaine de Bièvre in **D**.

usual. An advantage of the method is that it can pick out quite small relief features (see Figs. 42A and B) and very rugged or broken terrain usually comes out well; conversely gently undulating or flattish areas are much less easily represented (see Fig. 42D). The vividness of well-drawn hachuring made it a popular method for showing relief, but it was slow to execute and expensive and consequently has largely been replaced by later devices.

*Hill-shading and shadowing* are cheaper successors to hachuring and seek to produce the same 'solid' effect by adding 'shadows' to the map so that it takes on the appearance of an illuminated relief model (see Figs. 21 and 52). There are two possible approaches. The first gives the effect of a model illuminated from above, so that all level surfaces are light and slopes become darker with increasing steepness (as with hachures); this is *vertical* hill-shading.

The second, *oblique hill-shading*, assumes light falling onto the surface of the model at an angle to the horizontal (usually 45°) and also coming from a particular direction, usually the northwest.[5] The lightest areas are now steep slopes facing the source of light, the darkest steep slopes falling away from it, so that relief features stand out because of differential illumination of different sides. Strictly followed, however, the method demands that level areas (where the light is less direct than on 'facing slopes') should still carry *some* degree of shading. Since this may be rather a nuisance – flatter areas tend also to have the largest amount of other detail to show as well, and shading may render this less legible – many map series use *shadowing*, a hybrid effect in which *all* slopes are shaded (as in vertical hill-shading) but those facing away from the light source are more heavily shaded than those facing it. A similar idea has also been used in the so-called *oblique hachuring* (see Fig. 42C).

Generally speaking these methods resemble hachures in effectiveness, but a disadvantage with shading is that its effect may be confused by other areas of solid colour on the map, especially woods and vineyards, where these sometimes, but not always, occupy characteristic positions relative to relief.

Medium-scale maps, say 1:25,000 to 1:100,000, seem to be most suitable for hill-shading. Larger scales demand an enormous amount of work and on small-scale maps the shading rarely does more than emphasize the main features (see Figs. 21 and 52), unless it be a reduced version of that prepared for a larger scale map, a process which works quite well but is only rarely possible. Automation (see Chapter 6, p. 111) may however help in both these cases.

*Depiction of Relief on Maps (2) Quantitative Methods*

The last fifty years have seen a very considerable displacement of qualitative relief methods on maps by quantitative ones, and for good reasons. Quantitative methods not

[5] This is the 'natural' direction in that a right-handed person examining a map would preferably sit with the light coming from his left and slightly in front of him, i.e. from the northwest corner of the map, so accentuating the illusion of solidity produced by shadowing based on a northwest source of light. It is usually best to orientate a shadowed map with the shadows cast towards the observer as otherwise a strong illusion of inverted relief may be obtained. Variations on the northwest-light rule may have to be used where this does not suit the grain of the country.

only obtrude far less on the general design of the map, but also by dealing in specific altitudes allow many more features, such as slopes, profiles, and other devices described in Chapter 12, to be derived from them. Unfortunately, on the debit side, quantitative methods are often less graphic in their portrayal of relief than are the qualitative ones.

*Spot-heights.*    Little need be said about this simplest quantitative method of showing relief. Ineffective when used alone spot-heights are a most useful adjunct to other methods, though their distribution on maps is frequently very uneven, and they are often found only on crests and summits or along roads, where they may sometimes be misleading, e.g. on embanked roads across floodplains. On British maps spot-heights should not be confused with *bench marks* which do not indicate ground level and are recorded on maps merely as a basis for further levelling.

*Contours,*    which appear first to have been used in submarine form on a map of the Golfe du Lion made by Marsigli in 1730, are now the most widely used method for representing relief on maps. Even so it may be prudent to view the familiar contour with a degree of caution. Establishing an accurate contour, using traditional surveying methods, was even more tedious and expensive than fixing irregular lines generally, since both height *and* position were involved, hence the preference of many early map series for hachures. Where contouring was envisaged the work of establishing this third dimension could be almost as time-consuming as the original two-dimensional survey and it is not surprising that much-needed maps of many countries have often appeared first as provisional editions, showing relief by rather crude means (e.g. Fig. 43E) or not at all, with a fully contoured version following much later. The Preliminary Plots of the 1:50,000 series of many African countries, produced in the immediate post-war years, have only recently begun to be replaced by fully contoured maps.

This difficulty in establishing contours is also reflected in their reliability. On *older* maps the only really precise contour may be one that has been *instrumentally surveyed*, i.e. had its position determined by levelling, been pegged out on the ground and the positions of the pegs surveyed in [6] – the schoolboy's 'imaginary line joining all points which are the same height above sea level' given brief reality. Even in intensely surveyed map series, such as the British 6″ to 1 mile, expense limited the number of *surveyed* contours which could be provided and detail between these is provided by *interpolated* or *sketched* contours. These may be of varying reliability, the best ones being those produced from careful and detailed sketching in the field, supplemented by other more limited types of survey observations.

Where contours are needed for precise calculation or deduction it may therefore be useful to check their pedigree. This will usually involve referring to background literature [7] for few maps distinguish between the two types, preferring instead to distinguish either contours at fixed intervals (for clarity) or additional as opposed to regular contours on some map sheets.

Fortunately contouring a modern map series presents far less difficulty, for it is now

---

[6] The many dots which occur along the contours of the first edition of the British 6″ map presumably mark the positions of these pegs.

[7] e.g. for British maps see either J. B. Harley (1975) pp. 77–80 or H. St J. L. Wintherbotham (1934) pp. 43–8.

possible accurately and quickly to establish contours using the three dimensional stereo-scopic image available from air photographs. The basis of this method is described later in this chapter but it is worth noting here that the degree of fine detail possible using this technique has often revealed the substantial amount of generalization present in contours (and other features) on older maps (see Fig. 43B).

Although contours are widely understood several aspects of their significance are not always fully appreciated. For example their effectiveness in representing terrain is closely controlled by the *vertical interval* (usually written simply VI) between adjacent contours; it must be stressed that the ground does not necessarily slope evenly from one contour to the next, and that any feature of height less than the VI will probably not be discernible in the contour pattern, and, exceptionally, one of height up to almost twice the VI may not be either (see Fig. 43). Conversely in areas of very gentle relief it does not follow that anything observable will occur at a contour line; there *may* be an isolated hill or the ground may merely rise imperceptibly above a critical level. A very gently undulating plain lying between 97 m and 99 m above sea level would appear flat to the eye and con-tourless even on a map with a 5 m VI. Had it lain between 99 m and 101 m it would prob-ably carry an intricate pattern of the 100 m contour. In contrast well-drawn hachures are much more positive in recording the presence or absence of small features.

The all-important vertical interval between contours is naturally a very variable quan-tity, controlled jointly by cost, terrain and scale. On small scale maps there is less room for close contours and several rough rules are available as guides to indicate what to expect, for example (1) VI = 20–25 × miles per inch or (2) VI = 50 ÷ no. of inches per mile; but even these show considerable latitude (one gives almost twice the answer of the other), and almost certainly other factors besides scale will influence the final choice. In mountainous areas the VI is kept large to avoid overcrowding but in gentle relief it may have to be small to pick up subdued but important features. Alternatively it may be attuned to need: maps of irrigated areas often have contours at 5′ VI, and the Dutch 1 : 25,000 map has a VI of $2\frac{1}{2}$ m (*c.* 8′).

Within a particular map series VI may be irregular over all the series (usually fewer contours at high altitudes) or from sheet to sheet according to terrain. Thus, the new British 1 : 10,000 map will use either 5 m or 10 m VI, the United States 1 : 62,500 series has VIs ranging from 20′ to 100′ and some European series occasionally add inter-mediate contours which, rather disconcertingly, may not even be present over the whole map sheet. In all cases it is necessary to safeguard against the misleading visual impres-sions which may be produced by variations of this sort, or by the tendency, still not eliminated among British-trained map users, to regard *all* contour numbers as referring to heights in *feet*. To avoid another possible source of confusion contours marking *enclosed depressions* are usually differentiated by ticks or arrows pointing into the depression (Fig. 104A, p. 252). Finally it should be appreciated that, to preserve legibility, the contours on small scale maps will be *grossly simplified* versions of those on larger scale series (Fig. 43C and D).

The zero altitude to which contours refer is known as *datum* and is usually the mean level of the sea as determined by that survey authority. There is no consistency here and contours across a national boundary may not join: for example the Germans and Dutch use the same datum, but the Belgians take a value 2.32 m below this. It is, in fact, an

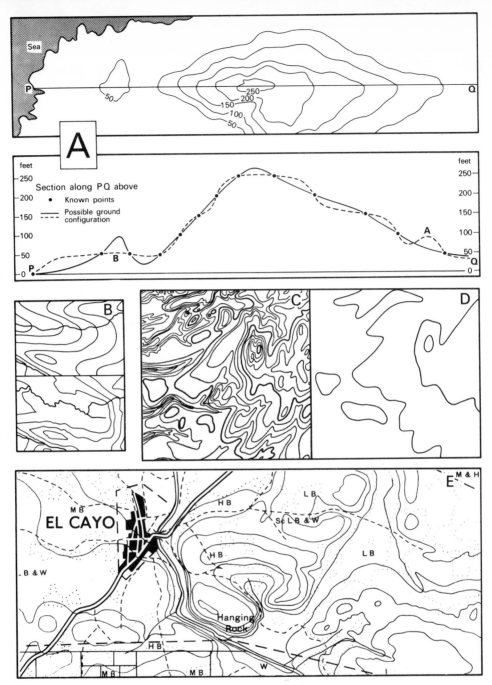

**Fig. 43:** Aspects of contours. **A:** Two possible configurations of the ground both producing the same contour pattern; a smoothly sloping surface should not necessarily be expected between contours. **B:** Contours relating to the same area on an old (*top*) and more recent (*bottom*) Swiss 1 : 50,000 sheet. **C:** Contours from a 1 : 62,500 map of part of the Hudson Valley, USA. **D:** The same contours generalized on small-scale maps. **E:** Representation of relief by form lines; part of sheet 16, British Honduras 1 : 50,000 Sketch Map (*sic*). (**B, C** & **D** are reproduced here from A. J. Pannekoek, 'Generalization of Coastlines and Contours', *International Yearbook of Cartography* II, by permission of the publishers, Kartographisches Institut Bertelsmann, Gütersloh. **E** is reproduced from Directorate of Overseas Surveys Map D C S (Misc.) 8, first edition 1955, by permission of the Controller of H M Stationery Office: Crown copyright reserved. A new series based on new sheet lines (E 755 DPS 4499) is available: to compare this with **E** above, see sheets 23, 24, 28 & 29.)

important world cartographic need today to accept and establish a uniform datum over wide areas. Submarine contours need watching too. They may be referred to normal datum, or to a mean low water mark, and may be in feet, fathoms or metres; lake contours may be either 'flooded' land contours or referred to lake level, which should be marked on the map.

*Layer colouring.* Because intricate contour patterns do not necessarily present an easily assimilated impression of the overall relief of an area [8] they are often supplemented by layer colouring: i.e. the area between selected contours is differentially coloured according to altitude. Layer colouring is widely used in atlases, and on small scale topographical maps up to about 1:100,000 scale. Above that scale it needs to be kept to very restrained colours and wide VI if it is not to interfere with the clarity of other detail and for these reasons, where it does occur, it is usually combined with hill-shading, as in the current British 1″ Tourist maps. The colours for layer colouring can give a strong 'visual image' to a map and though the conventional sequence, which follows spectrum order from violet through shades of blue, green, yellow and orange to red (or more commonly brown), accords well with the psycho-visual properties of colours – blues for submarine areas are 'recessive', reds for hills 'stand out' – there can be unfortunate suggestive overtones. Green, for example is most misleading in lowland desert areas, and brown hills tend to look bare though in fact they may be forested or cultivated. [9] Unfortunately the usage is enshrined by tradition and will be difficult to replace by some less misleading system such as monochrome layer colouring.

*Form lines.* This is really a qualitative method but is so analogous to contouring that it is discussed here. Form lines are lines which behave like contours but are not tied to any specific altitude: i.e. they show the shape of features but not their vertical extent, as in Fig. 36E where the depth of the valley or the height of the hill cannot be judged. When supplemented by spot heights they can be remarkably useful since, unlike contours, they always indicate observable features, and on early maps they were a welcome cheaper substitute for contours. Today they are rare, having largely been displaced by contours derived from air photographs.

*Combinations of methods.* Although described separately above most methods are encountered in combinations, particularly of qualitative and quantitative types to get the best of both worlds. Hachures with spot-heights were an early combination, replaced by hachures, contours and spot-heights, and later by hill shading, contours and spot-heights; but there are more elaborate systems than these. The fifth edition 1″ map of Great Britain employed no less than four superimposed methods, namely (1) contours at 50′ VI plus spot-heights, (2) hachures in very pale brown, (3) the same hachures printed again in

---

[8] Elementary textbooks on the subject continually suggest the opposite. This is nonsense. *Simple* forms may be apparent from contour patterns but to envisage much beyond this (or even to translate it into an expectation of slope in reality) is beyond most people's ability.

[9] This impression can be very strong. The author has two editions of a Bartholomew's $\frac{1}{2}$″ map of Surrey; on one the change from green to brown occurs at 100′, on the other at 400′. The former gives the impression of a dreary upland area with little of 'Lowland Britain' about it.

grey on the eastern and southern sides only of features to give a shadowed effect, and (4) layer colouring (fine brown hatching above 1,000' and cross hatching above 1,500'). Another common combination is vertical hill shading in one tone plus oblique hill shading in another, but with complex methods of this sort the full combination is often not deducible by casual inspection. Unfortunately expense of drawing and printing tends to restrict such attractive combinations to sheets of popular areas only.

### Relief on Air Photographs

There is a paradox here. Few vertical air photographs give a distinct impression of relief, yet it has proved possible to derive from them a more complete record of relief than could ever have been obtained from traditional survey methods. The key to this situation lies in the fact that if two slightly different photographs of an area are available we can apply to them our normal viewing-process of *stereoscopic vision*, and obtain a full *stereoscopic* (i.e. three-dimensional) impression of the area common to both photographs. We have already encountered this image and some of its applications in the previous chapter; this seems an appropriate place to examine its origins and characteristics.

### Stereoscopes and Stereoscopic Vision

The three-dimensional impression which we obtain in normal vision derives from the fact that with two eyes, set about 65 mm ($2\frac{1}{2}$ inches) apart, each eye is able to present to the brain a slightly different image of an object that is being observed, and from the difference between these two images the brain is able to assess 'depth' and build up a three-dimensional picture. By the same line of reasoning if we take two slightly different views of the same area, for example two adjacent air photographs with a considerable overlap, let the left eye see one of these and the right eye the other, the brain will react as it normally does and from the slight difference between them will produce a three-dimensional image of the area.[10] This is the property of stereoscopic vision which is inherent in our natural viewing mechanism, as the following experiment will show. Place a piece of stiff card or a slim book about 250 mm (9″) high vertically between the sections A and B of Fig. 32 (p. 65) and lower the face slowly downwards until the nose is resting on the card. As the face is lowered the images of points of detail (for example the reservoir) common to both photographs will be seen to slide together forming a fused image which will, however, be out of focus; with a little practice it will be found possible to focus this fused image when a clear three-dimensional impression will be obtained.[11]

The use of a *stereoscope* merely makes this same process of fusion and focusing simpler and much less of a strain to the inexperienced observer. In the commonest and cheapest version, known as the *lens* or *pocket stereoscope* (Fig. 44A), a pair of lenses carried on a frame assists the focusing, separates the line of sight of the two eyes and usually magnifies slightly too, so that fusion is immediate and effortless provided that the photographs are of the right type and properly positioned. Photographs of the right type will be what is known as

---

[10] Notice that the two views must be different. Two copies of the same photograph will not do.

[11] The three-dimensional nature of the fused image is normally already apparent even when out of focus and blurred.

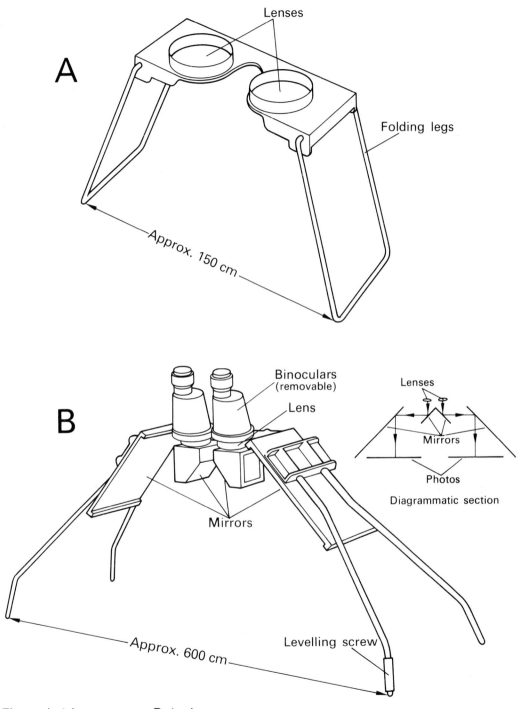

**Fig. 44: A:** A lens stereoscope. **B:** A mirror stereoscope.

a *stereo-pair* i.e. two adjacent photographs from a run, taken so that there is a considerable overlap between them; while proper position implies that the photographs will be placed under the instrument overlapped so that detail common to both is in line horizontally but separated laterally by about 65 mm (2½ inches). The photographs should also be arranged so that any shadows on them fall towards the observer. If on looking into the lenses a double image is observed slide the uppermost photograph up, down or sideways slightly, until fusion occurs.

The main disadvantage of the lens stereoscope is that because of its restricted width photographs must be overlapped when placed beneath it and only a limited area can therefore be examined at one time. The more expensive *mirror stereoscope* (Fig. 44B) uses pairs of parallel mirrors to 'spread' the line of sight, thus permitting whole photographs to be placed underneath it and enabling the whole of the overlap to be seen three-dimensionally at one go. Binoculars may also be attached to the mirror stereoscope to give greater magnification.

When examining photographs under a stereoscope it will usually be apparent that the vertical component of the image, and hence all heights and slopes, are greatly exaggerated. This is easily explained. Two eyes 65 mm (2½ inches) apart looking down at Halifax from 5,800 feet (as in Fig. 32) would obtain impressions differing by such infinitesimally small amounts (except in the case of major features such as relief) that the brain would be unable to produce from them any impression of depth, except perhaps an imagined one ('I know a house is "solid" so I *see* a house as solid'). In this case, however, two 'camera eyes' 300 m apart are presenting to the brain quite different views of (say) the same house or tree. Since the brain is still receiving these images through our own eyes it reasons that such different impressions, derived from viewing positions only 65 mm apart, could only be found with very tall objects – and builds an image accordingly. Fortunately this exaggeration is quite regular so that though slopes, for example, are distorted comparative or relative heights are not.

*Using the Stereoscopic Image to Determine Relief*

Little interpretative skill is needed to appreciate relief when photographs are viewed in this way. Given a stereo-pair and an understanding of the vertical exaggeration present, the full picture is revealed in minute detail which no map representation could possibly match. Even tiny features are apparent, the exaggeration actually helping here, and items such as river terraces, small overflow channels or breaks of slope, which can easily be missed by contours, will be plainly visible on photos of reasonable scale such as 1 : 20,000. The potential ambivalance possessed by contours and illustrated in Fig. 43A has no counterpart here.

But this is not all. Although the stereoscopic image is intangible it has an *apparent* position in front of the viewer so that devices can be placed so as to appear 'within' it and be moved to follow features of it, an idea which has already been encountered in Chapter 4 and Fig. 37B (p. 74). In that instance it was shown that the effect of displacements characteristic of vertical air photographs could be overcome by using the three-dimensional stereoscopic image as a basis from which to plot position, and the example previously described envisaged plotting a topographical feature, such as a road, by follow-

ing its course with a 'floating mark' whose altitude had continually to be raised and lowered as it followed the feature across the surface of the three-dimensional image.

In contouring a rather different version of this idea is used. Using as a guide the image 'heights' of points whose true altitude is already known from ground survey the height of the floating mark is adjusted until it exactly corresponds to a desired contour altitude,[12] at which point the mark is 'locked' in position vertically but remains free to be moved in the horizontal plane. If the mark is now moved horizontally until it reaches a point where it appears to be resting exactly on the surface of the image it follows that the ground altitude of that point will correspond to that of the required contour. The mark can then be moved horizontally around the stereo image, always ensuring that it appears *exactly to rest on the surface* when it will obviously trace out and plot the position of the contour. Because the stereo image emphasizes all the small relief features of the ground surface such a contour can be very closely related to these and the result is usually much superior to contours interpolated or sketched from normal ground surveys (Fig. 43B); in the same way the relative ease and speed of contouring from air photos in this way allows far greater frequency of contours and narrower VI than was customary on earlier maps contoured from ground survey.

### Depiction of Communications and Linear Features on Maps

The relatively few and world-wide techniques for representing relief lend support to the idea of the map as an international language. So too, at first sight, do symbols used for communication. Railways, for example, would be recognizable even on a map printed in Japanese (Fig. 46); so would roads, even possibly different classes of road, but beyond that, as the following sections show, there are finer detailed points of meaning which may be impossible to grasp without the aid of a dictionary and things are not usually quite so deceptively simple as they seem to be.

*Railways.* Within this group there are usually distinguished not only differences of gauge (either by writing as on the Indian  ″ map or by symbol), but also the number of tracks and the type of line – 'industrial',[13] electrified, rack, funicular, cable railways for goods and/or passengers, street tramways, inter-urban railways, underground lines (though these are often omitted) and so on; the symbols used for the various types, are rarely recognizable on sight (see Fig. 45).

*Roads.* Because of their greater potential variety road types present the cartographer with rather more problems than do railways. Early road classifications were often crude

---

[12] The setting can be done exactly using a procedure based on the property of stereoscopic parallax. This is related to the principle that the greater the ground altitude of a point the greater will be the horizontal distance between the two images of that point in any stereo-pair of photographs when these are properly positioned alongside one another. From the horizontal distances which separate the image of points of known altitude in the stereo-pair the separation corresponding to a given altitude can be calculated and the setting made accordingly.

[13] i.e. works 'tramways' or light railways: in English the terminology is uncertain, let alone the map representation.

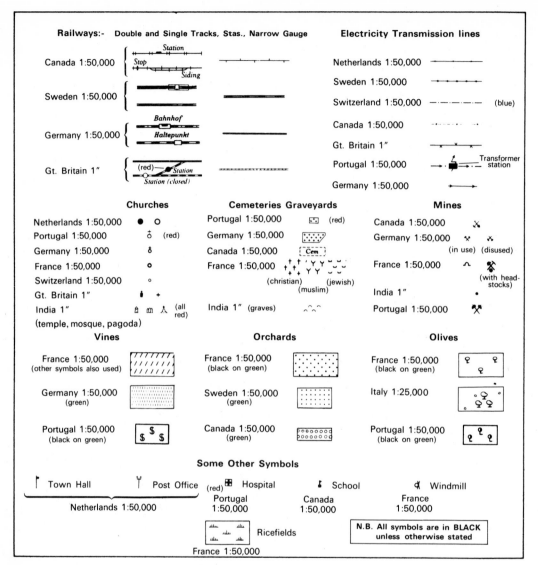

**Fig. 45:** A selection of conventional signs taken from recent European and foreign official map series at about 1 : 50,000 scale. All signs and symbols shown are actual size.

enough, for example 'main roads, other roads', but as motor traffic developed there was a tendency to introduce useful, strictly objective, classifications related to surface and width. Unfortunately this trend was cut across in the 1920s and 1930s by the development of an official classification and numbering of roads which, because it was fundamental to sign-posting, directions, etc. had also to be shown on the map. In many countries the representation of this official classification has now become the dominant cartographic element, though in practice such a designation often relates more to a road's position in a com-

Table 2

| PORTUGAL 1:50,000 | FRANCE 1:50,000 | GT BRITAIN 1:50,000 | SABAH 1:50,000 | CANADA 1:50,000 |
|---|---|---|---|---|
| *'Highways'*: <br> 1. 'Autoroutes' <br> 2. National (with no.) <br> 3. Municipal and others <br><br> *'Roads'* <br> 1. Municipal and others <br> 2. Local <br> 3. Paths and Tracks | *'Routes Nationales'* <br> 1. Excellent viability <br> 2. Good viability <br> 3. Average viability <br> (all numbered) <br><br> *'Routes Départementales'* <br> 1. Good viability <br> 2. Average viability <br> 3. Mediocre viability | *Classified Roads* (all are numbered and roads with dual carriageways differentially marked) <br> 1. Motorways <br> 2. Trunk Roads ⎫ Class A <br> 3. Main Roads ⎭ <br> 4. Narrow Trunk and Main Roads with passing places <br> 5. Secondary Roads (Class B) | 1. All-weather road, bound surface <br> 2. As above loose surface (1. and 2. marked either one-lane or two-lane traffic) <br> 3. Dry weather road, loose surface <br> 4. Track, jeepable <br> 5. Footpaths, jungle paths, bridle-paths | 1. Hard surface all weather road (subdivided into more than 2-lane, 2-lane and less than 2-lane) <br> 2. Loose surface road all weather (subdivided into 2-lane and less than 2-lane) <br> 3. Loose surface road, dry weather <br> 4. Cart tracks and trails |
| NIGERIA 1:50,000 <br><br> 1. Main Roads <br> 2. Secondary Roads <br> 3. Minor Roads <br> 4. Main paths <br> 5. Minor paths | *Other Roads* <br> 1. Regularly maintained. <br> 2. Not regularly maintained <br> Field and Forest Roads <br> Mule Tracks <br> Footpaths | *Other Roads* <br> 1. Roads with 4.3 m of metalling and over <br> 2. Roads with less than 4.3 m of metalling (divided into tarred and untarred) <br> 3. Minor roads in town, drive or track (unmetalled) <br> 4. Paths | | |

Road classifications from recent maps in six countries. Notice the transition from almost completely 'administrative' approaches (for example, Portugal, Nigeria) through to strictly objective ones (Sabah, Canada). Free translations or untranslated terms are in inverted commas.

munications hierarchy than to its physical characteristics: many a British 'A' road is surpassed in surface and width by others classified only as 'B' roads. Alternatively map makers have frequently settled for the official classification modified slightly in some objective way, usually by reference to road width. In less developed countries where roads may be more variable a strictly utilitarian or objective classification seems even more desirable, though it is not always found. Table 2 gives an idea of some of the solutions adopted, and shows their weakness as a group: common elements are rare and are often of the broadest type, for example motorways, metalled and unmetalled roads. Unfortunately the map's key will not always help either. It is not uncommon to find there some national terminology, virtually untranslatable and meaningless without actual experience, like the Dutch '*kunstweg*' and '*landweg*', the first, literally, 'artificial road' i.e. made road (but not given in an ordinary dictionary), the second, literally, 'country road' which could mean anything but is near to 'occupation road' in English.[14]

[14] The term *kunstweg* is not used on the present series which also very conveniently incorporates a tri-lingual key (Dutch, French, English) as well, eliminating all possible difficulties.

British and American map users might note here two common European practices relating to the representation of roads on maps, which sometimes cause confusion. The first is the use of *single* black lines only for minor roads; the second that of placing dots at intervals along roads (or streams) to mark, conventionally, sections bordered by trees.

*Other forms of communication, communication detail.*    Canals are usually more summarily treated on maps than roads and railways: navigational, drainage and irrigational types are only rarely distinguished; on the other hand it is not unusual to find telephone lines marked on maps of less developed countries, partly for their intrinsic importance and partly perhaps as landmarks. The various minor features of communications such as bridges, embankments, cuttings, stations, mileposts, ferries, locks, etc., are usually distinguished, often in considerable variety, on many European map series.

*Boundaries.*    Not surprisingly the map is the place, *par excellence*, for recording boundaries and though their terminology may be local and confusing their position is usually clearly indicated. The German practice of adding also a small marginal inset of the boundaries of administrative divisions found on the map is extremely useful, and could be emulated with advantage by other countries.

*Depiction of Settlement, Buildings, etc., on Maps*

As Fig. 41 has already hinted here is a tough nut to crack, so much so in fact that (unlike communications) all that can be attempted at small scales (say 1 : 200,000 and less) is virtually a diagrammatic representation – some indication of shape, a few really important features and perhaps differential printing of names to emphasize population size or administrative function.[15] At slightly larger scales the presence of certain important urban features can be indicated by symbols or letters, either adjacent to the town, as on the Indian ¼″ and Sierra Leone 1 : 50,000 series, or properly located within the town. The latter process, which demands small yet legible symbols is helped enormously where some colour other than black is used for general settlement detail: red is the most frequently encountered choice, for example on the Spanish, Portuguese, French (some sheets) and Dutch 1 : 50,000 series and the Indian 1″ and ¼″ maps; the pale orange-brown of the British 1 : 50,000 map though less emphatic of rural settlement patterns also works very well in urban areas. Black symbols show up much more clearly against such backgrounds, but even so it is best not to attempt too much and items shown are usually confined to such important public buildings as churches, town halls, hospitals, head post-offices and barracks. Places like factories or power stations which are fully recorded in rural areas may or may not be so treated in towns, and one of the greatest difficulties in obtaining information about urban areas from maps is the inability to determine whether patterns shown are actual and complete or generalized. At smaller scales this problem may not be confined to urban areas e.g. on the Swiss 1 : 100,000 map the number of buildings shown represents about 40% of the actually existing single houses.[16] Some United States and

[15] Differential printing of names is widely employed at larger scales as well, of course. On the French 1 : 50,000 map the population (in thousands) of each place is conveniently printed under the name – a useful addition which takes up little space.

[16] Huber, E. 'The National Maps of Switzerland', *International Yearbook of Cartography*, II, London, 1962.

Canadian maps show city blocks coloured pink where only 'landmark' features are marked (even minor streets may be omitted); but many maps consistently shade city blocks either solid or merely peripherally, irrespective of their actual building pattern.

Great space and less congestion assist the more complete rendering of settlement detail in rural areas, so that quite small features such as post-offices, schools, windmills and windpumps, monuments, inns, mines and quarries are often recorded. Oddly enough distinction between permanent and temporary settlement is rarely made, nor is that between farms and other buildings, though Scandinavian maps form a notable exception on both counts (see however p. 276). It is irritating to realize that though a map may satisfactorily establish the pattern of *buildings* in an area it may be impossible from it to establish the pattern of *settlement*.

### Depiction of Land Use and Vegetation on Maps

On most topographical maps of scales of 1 : 100,000 or larger, a greater variety of land use is distinguished than many people expect. Man-made land use is perhaps the easiest to record and most categories which have any permanence may be marked – for example: tree crops (vines, olives, hops, nuts, orchards, osiers, tea, rubber, coffee, coconuts, cacao); specialized 'croppings' such as rice, sugar cane, glasshouses, bulb fields, oyster beds, salt pans, and other 'permanencies' such as water meadows, moors and heaths, bogs, cemeteries and urban parks.

'Natural' vegetation presents more problems, partly because of the great variety possible within broad categories such as 'forest' or 'grassland' and partly because of the lack of sharp boundaries. It is here also that interpretational difficulties begin. Areas marked as 'forest' in, say, England, Spain, Ghana and Siberia would have very different connotations, yet it is not easy for the map to be precisely objective without embarking on a very detailed classification. Nevertheless today, thanks to the ease with which vegetation may be identified and plotted from air photographs, many maps can be quite ambitious in this respect, and topographical maps in some areas may be regarded almost as vegetational maps as well: the Kenya 1 : 50,000 map distinguishes nine types of natural vegetation, the British Honduras 1 : 50,000 series nineteen.

### Conventional Signs on Maps

The ability of the map to record the enormous variety of detail described in the preceding sections rests very largely on the successful use of symbols and colour: so much so that the *conventional signs* which are used really comprise the essential vocabulary of any international cartographic language, and their range and complexity has been sufficient to form the subject of particular studies, e.g. M. Couzinet (1947, 1948) '*Etudes Comparatives des Signes Conventionelles: (1) France 1 : 20,000 and Germany 1 : 25,000: (2) France 1 : 20,000 and Italy 1 : 25,000*', Paris, or Istituto Geografico Militare (1954, 1955) '*Segni Convenzionali e Norme Sul Loro Uso*', Florence. All of these are excellent introductions to the subject and have texts which are not at all difficult to follow without complete translation.

As for the signs themselves ease of drawing, compactness, distinctiveness and resemblance to the object are all desirable characteristics, but the first three often take preference

over the last, so that instant recognition is by no means assured. Fig. 45 illustrates these points with a sample selection. Particularly noticeable is the range of signs which may exist, internationally, to represent the same feature and it is disappointing to realize, as Fig. 46 emphasizes, that the international language of the map exists, perhaps, only so far as broad categories of feature (settlement, forest, railway, etc.) are concerned and not at the level of detailed interpretation.

Not surprisingly there have been moves towards the devising of an international set of conventional signs, but such efforts seem doomed to failure because of the sheer range of features involved, variations of meaning within specific terms (e.g. 'forest') and, not least, existing 'investment' in their own particular signs by the various countries. As with international mapping (see Chapter 7) any successes seem likely to arise in response to *practical* needs not theoretical ones and international symbolization has already been adopted, for example, for aeronautical charts and topographical maps specially prepared for orienteering.

A much simpler solution would be to adopt bi- or trilingual keys (legends), as has already been done on several Dutch series and partially at least on the *second* series of the British 1 : 50,000 map. It should be noted however that the inclusion of even a mono-

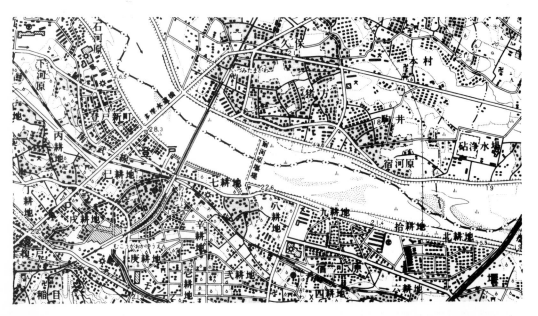

**Fig. 46:** The limitations of the map as an international language quickly become apparent in this portion of a Japanese 1 : 25,000 map of Fuchu in the western suburbs of Tokyo (Sheet NI–54–25–7–3). The original map, which is in black, blue and brown, is quite ambitious in showing urban details but the meaning of much of the symbolism is not immediately obvious to western eyes. Among symbols encountered on this series are National Railway ▬◻▬ Private (i.e. non-National) railway ╫◻╫ Shinto Shrine Ⅲ Buddhist Temple 卍 School ✕ Factory ☼ Post Office Ⓣ City Hall ◎ Paddy (blue) „"„ Coniferous Woodland ∧^∧ Orchard ◌̣◌̣ Waste land ⱳ Embankments (brown) +++ Power line ┼┼┼ tree'd residential areas ▦ . Many of these, and some others, occur on this excerpt. Contour VI 10 m. (Reproduced by permission of Japanese National Surveys.)

lingual key on a map *is by no means universal practice*, some countries preferring to rely on a separate 'conventional signs' sheet.

### Other Information on Maps and Air Photographs

The most neglected part of a map is normally that portion lying outside the main frame line. This is unfortunate for there is often much recorded there which may enhance or qualify what is shown on the body of the map or which may be essential to its practical use. The margin of the map *should* indicate, for example, who published the map, the date of survey, the date, extent and perhaps method of any subsequent revision, and information regarding latitude and longitude, magnetic variation, the reference system (if any) and the projection. There will also be such obvious features as the scale, a line scale, the sheet number and the numbers of adjoining sheets. Most of these items are either self-explanatory or dealt with elsewhere in this book, but a possible exception is sheet numbering, of which quite a variety of systems is in use. The essential ideas, however, are all simple and are explained in Fig. 47. Unlike maps air photographs have only a narrow *titling strip* rather than a margin. The information found there is, however, no less essential to their proper use and has already been described in Chapter 4, p. 58.

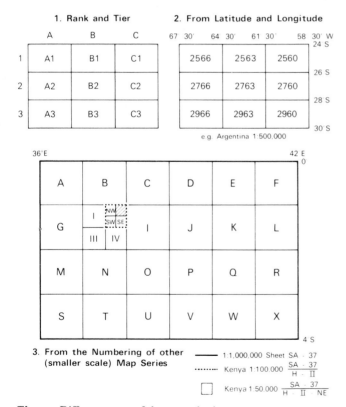

**Fig. 47:** Different types of sheet numbering.

# Chapter 6
## Map Drawing and Reproduction

Map-drawing and printing have always strongly influenced map design, appearance and cost, and never more so than today when the application of the computer to map-drawing bids fair to introduce yet another 'cartographic revolution' no less remarkable than that introduced by the air photograph half a century ago. This is the reason that the processes described in this chapter, highly technological though they may be, warrant a place in this book. However the concern is still essentially with their potential contribution to the finished product, and treatment will therefore be both brief and selective. Anyone who would know more about these intricate and often fascinating aspects of map production will find fuller treatment in works described under Suggestions for further reading (p. 333).

*Map Drawing*

Until recently developments in the technology of map drawing were relatively unspectacular and focused on attempts to reduce the heavy time/cost element implied by traditional manual draughtsmanship. A promising, and old established, line of approach here was to replace elaborate hand-drawn detail by a printed version which, in the case of symbols, was originally stamped but today is simply cut from pre-printed self-adhesive transparent sheets. With lettering, which demands more individual and varied solutions, names can be projected, a letter at a time, onto narrow strips of photographic film which are then developed, cut and applied.

Another rather different approach to the problem is represented by *Scribing*, introduced in the 1940s as a quicker and less skilled alternative to traditional 'ink-on-paper' techniques, though in map work today paper and various other traditional drawing surfaces have generally been replaced by more dimensionally stable polyester plastic films.

For scribing the drawing medium is a transparent plastic sheet carrying an opaque coloured coating, the map being 'drawn' by scratching away this coating to produce a negative-style image of clear lines on a coloured background, though this must of course be transformed into a positive image at some stage in the map-production process.

In comparison to these comparatively simple developments, which do no more than marginally reduce the manual contribution to map drawing, the introduction of computer-drawn output offers the possibility of virtually removing it altogether. However so

new is this last development, which is only now beginning to emerge from the experimental stage in many mapping establishments, that it seems more logical to review the more traditional areas of map printing before examining what may be the map production techniques of the future.

# Map Printing

*Engraving and Lithography – the Basic Principles*

Although the majority of topographical maps are today printed by *lithography*, until the mid-nineteenth century the most common printing process was *engraving*, a technique which had changed little since it began to replace manuscript maps in the fifteenth century. The essential stages in the engraving process are shown in Fig. 48A and the end product was often a map of considerable beauty, for very fine line work indeed could be produced whilst the lines still remained sharp and clear because each was formed of a tiny ridge of ink. There are disadvantages too, however. The cutting of each letter, line, hachure etc. as an individual groove in a copper plate was a slow, highly skilled and expensive process (consider, for example, the work involved in producing even the small areas of Figs. 42A and C, both of which come from series which originally were engraved) and the relatively soft copper wears fairly quickly in use. Printing by this method is slow, corrections involving erasures from the plate are difficult to make, and the method is not really suited to colour reproduction; coloured line work, for example for rivers, comes out well enough but coloured areas are too easily 'wiped thin' during the wiping of the plate.

In the mid-nineteenth century the introduction of *electrotyping*, which allowed the production of duplicate plates by electrolytic deposition of copper and preserved unworn the valuable originals, removed one difficulty but the others remained and it is not surprising that engraving has been almost entirely superseded by later developments.

The principle of *lithography*, reputedly discovered accidentally in 1790 by Senefelder, is described in Fig. 48B. Its most obvious implication for cartography lay in the fact that it allowed large areas of colour as well as line work to be reproduced satisfactorily, thus permitting the 'modern' coloured map to replace more traditional black and white one. Other advantages were easier drawing of the map on the 'plate' and less rapid wear of the plate in use. However so long as the printing 'plate' was a prepared stone surface (hence the name) there were problems in drawing, printing speeds and storage (bulk and fragility) and the *offset lithography* used in modern map printing has diverged somewhat, in detail if not in principle, from the simple process illustrated in Fig. 48B.

Four main developments have contributed to this transformation. They are:

(1) The replacement of stone by much cheaper prepared metal plates – zinc, aluminium or bimetallic.

(2) Wrapping of these flexible plates around a cylinder allowing much more rapid 'continuous' rotary printing processes.

(3) Reduction of wear on the printing plate surface by introducing a rubber coated *offset cylinder* between the printing plate and paper. The printing plate prints the map onto

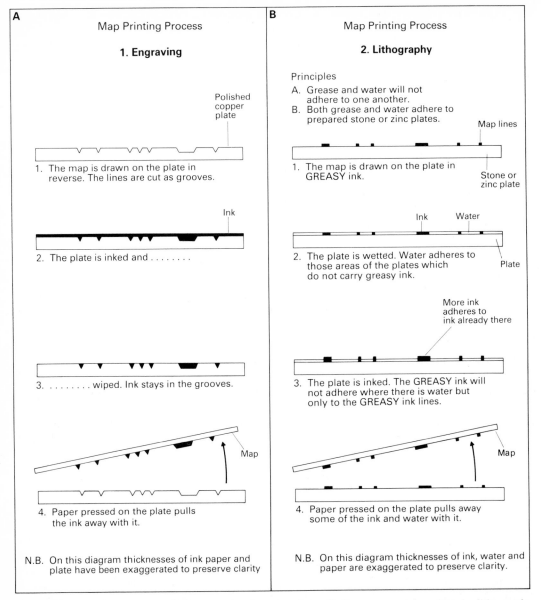

**Fig. 48:** Map printing processes: **A:** from engraved copper plates; **B:** from stone or zinc plates by lithography.

the rubber which in turn prints it onto the paper, so that the essential elements of a rotary offset printing machine resemble those illustrated in Fig. 49. Worn offset cylinders are more cheaply replaced than worn printing plates.

(4) Application of photosensitive coatings to the metal plates so that the drawing of the map can be transferred to the plate photographically, hence the term *photolithography* which is sometimes used to refer to this type of printing process.

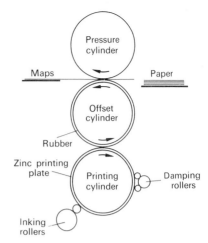

**Fig. 49:** The main elements of a rotary offset printing machine. (*Note*: this illustration is intended to show the main features and components involved. It does not represent an actual machine.)

## Colour Printing of Maps

The development of lithographic techniques greatly facilitated the incorporation of colour into map design; but the full implications of this can only be understood when something is known of the main considerations in the colour-printing process. In particular one fundamental principle stands out above all others – only one colour can be printed at a time. An eight-colour map will need eight trips through a printing process, with consequent increase in cost, and though many modern presses print two or more colours in the same trip or 'pass' the principle still applies, each colour being printed at a different place in a more elaborate and expensive machine. This factor indicates clearly why maps of many countries are printed in only two or three colours and why, in those of others, the number of colours may have been reduced recently. Alternatively for maps of areas of special interest and which sell in larger numbers than usual more elaborate colour systems can be attempted.

The second point follows quite obviously from the first. If only one colour is printed at a time a set of plates will be needed in which each carries only the detail to be printed in one particular colour. That detail must also be in perfect *register*: must, in other words, fit exactly, in respect of both shape and position on the map, with detail from other plates once this is superimposed: the coloured filling of a road, for example, must fit exactly into the printed black outline.

The perfect register needed between a set of such printing plates was traditionally ensured by deriving them from prints of a drawing carrying all the map content and from which detail not to appear in that colour had been 'removed'. There are various ways in which this can be done. With *blue pulls* the prints of the complete map are in pale blue over which the detail for a particular colour is drawn in in black.[1] When this drawing is photographed the pale blue detail does not reproduce and the resultant image therefore carries only the detail appropriate to a particular colour, yet in its correct position relative to all other detail. For relatively simple maps a set of *opaqued negatives* can be used

---

[1] In all colour processes the actual colour is not introduced until it is applied as coloured ink in the press during the last stage in the process.

i.e. negatives of the complete map from which all lines referring to detail not needed in a particular colour have been painted out. Alternatively with scribing the scribing coat can be made photosensitive too, so that a print of the whole map detail can be made on it. Only lines relating to a particular colour are then scribed and much better quality line-work is possible than with opaquing from the whole negative.

To ensure, as printing proceeds, that each plate prints its detail in exactly the right position relative to the others, certain *register-marks* are always incorporated on all plates. These are usually small ticks marking the corners of the sheets, and each must be superimposed on those already printed for perfect register between plates. The resultant brownish or greyish superimpositions are easily seen in the corners of many coloured maps.

The description above is no more than the briefest outline of essential parts of the colour-printing process, but it will suffice to re-emphasize the point that, attractive though coloured maps may be, colour printing increases the cost of a map very considerably, especially because of the greatly increased amounts of draughtsmanship that are needed. With colour itself it should be remembered that several shades can be obtained from one colour by using variations from solid colour through different types of shading and stipple to almost white, in the same way that several shades are obtained using only black and white in some of the maps in this book, for example Fig. 98, p. 235. In the North York Moors 1″ Tourist Map the Ordnance Survey use a sequence of solid pale green, hatched buff, cross-hatched buff, solid buff, hatched orange on buff, cross-hatched orange on buff and solid orange to obtain 7 altitude tints from only three colours.

### Half-tone, Photo-tone and the Printing of Orthophotographs

The *gradual* change of tone which occurs on photographs or shaded drawings does not lend itself to *direct* reproduction by lithography but must first be rendered in *half-tone* i.e. broken up by screening into a regular pattern of fine dots – as can be verified by examining any newspaper 'photograph'. With conventional maps hill shading is virtually the only element which needs treating in this way but with orthophotographs the whole image is involved. Unfortunately half-tone is less satisfactory here, reducing legibility and interpretational potential, whilst normal photographic copying is too expensive. A possible alternative is *photo-tone*, a more complex process producing an image not unlike a half-tone but with less regular structure since it is derived from the tonal characteristics and patterns of the original photographic image itself rather than a regular half-tone screen.

### Map Production on Microfilm

A major limitation of all lithographic printing processes is that economy is only effected when a large number of copies is printed at a time. With popular quick-selling maps, e.g. at small scales, this presents no problems but with very large-scale series which may comprise several thousand sheets the matter is not so simple. In this case a 'minimum run' of a particular sheet may sell quickly if it covers a rapidly changing urban area, but may take 20 years to dispose of in a more rural context – with consequent problems of storage, capital investment and so on. Such considerations are equally as valid at retail outlets as at mapping organizations and the British Ordnance Survey has recently responded to this

situation by producing its large scale map series (1 : 1,250 and 1 : 2,500) in *35 mm microfilm format* as well as in conventionally printed sheets. The microfilm is sold mounted in standard aperture cards known as *copycards*.

Reduced storage space is an obvious advantage of this format (copycards need one-thirtieth as much space as the equivalent maps) but even more useful possibilities are their use with projecting apparatus for viewing in committee, conferences, etc. and, given suitable apparatus again, instant and cheap copying, either projected back true to scale or reduced or enlarged, the whole process being made much more feasible by the black-and-white-only nature of the maps. Printouts of this sort from copycards are now available at a series of retail outlets throughout the country at prices considerably cheaper than conventional lithographically printed sheets.

## The Application of Computers to Cartographic Drawing and Reproduction

The possible transition from printed sheet to copycard-microfilm is one, rather unspectacular, example of a tendency recently exhibited by maps to cut loose from their traditional forms and launch out into totally new directions. The orthophotomap is, perhaps, another example of this trend but far more impressive and drastic developments are those which seem likely to ensue from the potential consequences of the application of computers to map-drawing, compilation and reproduction. Developments of this sort had scarcely begun 20 years ago and, since much early work was of necessity experimental, definitive end-products are few as yet, particularly in the field of topographic mapping. The potential implications however are enormous, as the brief account which follows hopes to make clear. As in earlier chapters where complex and specialized processes are involved, only a simplified description, with emphasis on potential, will be provided; there will be no attempt to elaborate technical details nor to describe the many problems which had to be overcome before these techniques could be made possible or practicable.

## Computer Recording and Redrawing of the Position of Features on a Map

The concise way to define the position of any *point* on a map is to specify its coordinates within some reference system – usually by giving either a grid reference or latitude and longitude (see Chapter 9). We do not normally, however, consider using such a process to define the position of a *line*. If the line were irregular a tedious stream of references would be needed, and the effect would only be approximate, unless these could be given at minute intervals and very accurately. Fortunately modern automatic recording devices now make such a process feasible and since the results are also recorded in computer-manageable form, we have here a development which has important potential contributions to mapping.

Imagine a tracer point free to move over a surface designed in such a way that details of this movement (coordinates of the points passed through) are automatically and very accurately recorded at fine intervals, such as every one-tenth of a second. Such a process is known as *digitization*. If a map is placed on this surface and the grid references of its corners are also recorded all subsequent position-recordings can be made in the same system as that of the map, so that the coordinates recorded when the tracer point follows a

line are, in fact, grid references (or latitude and longitude if it is preferable to work in those units). Furthermore when the position of any line is being recorded in this way the record can also include, in coded form, a complete description of that line, for example a unique filing number and details of thickness, character (dotted, pecked, double etc.), colour (on the finished map) and function (river, meridian, one boundary of road with red filling etc.).

This process can later be reversed. A computer uses the recorded positional information to control the movement of a drawing point, directing it to pass through all recorded points producing a replica of the original line. Instruments which produce such an output are known as *vector plotters* and vary widely in sophistication and end product. At the simplest end of the range are the *drum plotters* or *graph plotters* provided as standard output devices for use with computers and which may reproduce the lines with a perceptibly stepped appearance because of the resolution of all movements into horizontal and vertical components, albeit of very tiny dimensions. For cartographic work the finer resolution of high accuracy *flat-bed electromechanical plotters* produces output indistinguishable from conventional hand-drawn work. Nor is this all. In machines used for cartographic work the controlled drawing point can be a pencil, pen, scribing tool or fine beam of light (for drawing on photosensitive surfaces) and, since the drawing-head is usually compound, lines of different width or style can be produced, using the recorded description of the line as instructions without any need for human intervention. Similarly if a coded record was made of a point feature, e.g. a symbol and its location, the drawing head will reproduce this following a sub-routine already stored in the computer.[2]

### Some Applications of the Idea

The possibility of *digitizing* (i.e. recording as just described) the nature and position of every feature on a map and recreating this at will has several obvious applications. Since both recording and redrawing can be done with a very high degree of accuracy, programming the computer to redraw only lines which refer to a particular colour offers one solution to the problem of preparing colour separates in perfect register.

Alternatively new maps could be drawn showing only one feature or selected features from the original map e.g. contours only, contours and drainage, settlement. The resultant drawing would be in black and white, of course, but if this were acceptable, and particularly if only a few copies were needed, it might be considerably cheaper to produce such a map by these means rather than by conventional lithography.

The idea of selecting map detail at will, omitting irrelevant material, is particularly attractive with large scale maps, which are often needed simply as bases for recording further information and are frequently in black and white only anyway. A customer who can buy not a conventional map sheet but a magnetic tape on which is digitized the whole of that information, can create from it, at will, using his own computer, whatever map detail he requires for the whole sheet, for only part of it, or as a *single* drawing for an area straddling sheet boundaries (assuming other tapes are held), always a troublesome situation using conventional maps. Multiple copies can also be produced on demand obviating

[2] Alternatively if 'drawing with light' is being used the drawing head is supplied with an image of the symbol which can then be projected onto the appropriate position.

the need to maintain a stock of printed maps. With these ideas in mind the British Ordnance Survey is already able to supply some 5,000 sheets of its 1 : 2,500 scale maps in magnetic tape form, if desired, and since 1973 has been producing lithographically printed maps at both these scales from original drawings which were produced by plotter from digitized information (Fig. 50).

Revision is another obvious field where application of this digitization-computer-drawing idea is possible. To delete an item on revision simply requires that the digitized information for certain lines/features be removed from the tape; information for new features can be added at the end.

Operations such as those just described, which merely retrieve and reproduce information, are only a beginning. If the computer is programmed to use its calculating ability as well it can modify the stored information before reproducing it, for example by changing the scale of the drawing. There are enormous possibilities here. If details of large scale maps were digitized smaller-scale map series of the same area could be produced by computer – though the idea is a good deal less straightforward in practice than in theory, not least because in most mapping programs smaller-scale maps tend to be produced first, with the large-scale series lagging behind. In any case scaling everything down proportionately would often produce illegible clutter and the necessary editing and generalizing problems have not been easily solved. It is not too difficult to ensure that road widths and symbol sizes remain legible, under such reductions, but it is less easy to indicate *which* minor roads be retained at, say, 1 : 250,000 or how an intricate feature – contour, coast-line, settlement detail – should be simplified whilst retaining important characteristics. The simplification of contours necessary in Fig. 43D was manually achieved, for example; it is far less easy to program a computer to follow the same sort of process, except where the straightforward omission of lines is required. At larger scales, however the problems are less difficult to resolve and experimental sheets at 1 : 2,500 and 1 : 10,000 derived from digitized 1 : 1,250/1 : 2,500 scale information have already been produced at the Ordnance Survey.

A much needed feature of all such transformations is manual checking and editing of the computer-produced result preparatory to final drawing for printing, and this is most commonly done by displaying the output first on a *cathode ray tube* or video-display, which resemble a conventional TV screen. Output is very rapid and usually allows any necessary modifications to be made at that stage but the resultant video-map is used only for information being neither fine enough in image nor accurate enough to stand as an end-product in its own right, at least in topographic work.

### Cartographic Data Banks and Further Technological Developments

Since computer-transformation of digitized data for output onto a totally different *map projection* is just as feasible as scale transformation, this leads naturally to the idea of complete cartographic *data banks* which would contain, in digitized form, all information likely to be needed in the mapping of an area, not only for topographic maps but for air and marine charts, and possibly thematic maps as well with suitable programming. Retrieval from this data bank could produce on command a map of virtually any content, of any area, at any scale and on any projection.

Not surprisingly such an automated 'instant mapping' service (or even one envisaging considerable editing) remains, as yet, only a theoretical possibility. Not only would the cost of digitizing the vast amount of material be substantial but this would involve 'writing off' much investment in material prepared for traditional techniques of production, a dilemma always present in this sort of situation. Two developments which may ultimately contribute substantially however are (1) direct and automatic digitizing of new map material as and when it is plotted for the first time from air photographs and (2) more automated digitizing of material already incorporated in existing maps using *scanners* or '*lock-on*' devices. In the former the existing map, usually wrapped round a drum, is scanned in a series of parallel lines along which, at very fine intervals, some property of the map is measured and recorded. This property may be the amount of light reflected from the surface, establishing the presence or absence of a line, or the wavelength of that light, establishing its colour as well. Again 'playing back' this recorded information should reproduce the stored image, but technical problems are still considerable, the method working better for simple line drawings (e.g. of parts of map detail) than for complete maps.

The essential characteristic of a 'lock-on' device is an ability to identify and follow, exactly and automatically, a certain line which is recognized by the reaction it produces

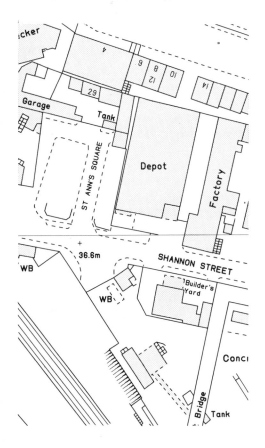

in a photocell. As with the scanner there are still many technological problems to be overcome however and use is at present confined to recording line work already abstracted from a map (e.g. a contour drawing) rather than the map itself.

## Computer Production of Hill-Shading and Contours

In theory hill-shading derives from the principle that the intensity of illumination of an area on a map is a function of the relationship between its slope and the direction of illumination, though what is normally produced is no more than a pencil or air-brush drawing showing an *estimation* of these values. The continuous tone of this separate hill-shading drawing is then broken down by a half-tone screen into the dot form suitable for rendering by lithography (p. 106).

An ingenious process which will produce, by computer, an equivalent pattern of dots, of varying density according to light intensity, was devised by Yoeli in 1965 and elegantly illustrates the computer's potential for performing such tasks. The map to be shaded was

**Fig. 50:** Three different applications of the computer to cartography. **A:** A modern digital 1 : 1,250 Ordnance Survey map of part of Leeds. On the drawings from which this map was made all detail shown here (including names and numbers) was drawn by a digital plotter, and the map can be purchased as information recorded on a magnetic tape as well as on a paper sheet. Notice the great detail recorded at this large scale: the close parallel lines are railway lines, each *rail* being shown separately. (Reproduced with the sanction of the Controller of HM Stationary Office, Crown copyright reserved.) **B:** Automated Hill Shading produced by a line printer. For each tiny segment of the area a dot of varying size has been printed according to the calculated intensity of the illumination of the surface under given conditions. (Original plot by K. Brassel based on a Swiss 1 : 25,000 map.) (Reproduced by permission from the Association of American Geographers' Map Supplement Series No. 17, 'Automated Relief Presentation', 1974, Brassel, Little and Peucker.) **C:** A portion of a line-dropped contour map produced in the GZ-1 orthoprojector. As the stereoscopic image is scanned during the production of an orthophotograph the scanning line is plotted and changes thickness each time the altitude of the surface coincides with a contour height. Joining up the ends of lines of the same thickness, as has been done here, (this joining is *not* done automatically) produces the contours. (Reproduced from P. R. Wolf, *Elements of Photogrammetry* © 1974. By permission of the McGraw-Hill Book Company.)

first envisaged as divided into $\frac{1}{4}$ mm-side squares, i.e. areas equivalent in size to a normal half-tone dot. Then, using existing contours as a guide, the computer calculates, by interpolation, first the altitudes of each corner of each $\frac{1}{4}$ mm square, then the slope implied by these and finally the intensity of illumination according to an exact formula. It then allocates this intensity value to one of 20 categories and on a separate output-sheet prints an appropriately graduated dot symbol to represent it, thus building up a pattern representing the whole relief surface. Since the 'dots' are actually much larger than required[3] the output produced in this way is photographically reduced to give a result which compares quite well with the normal half-tone effect, as also does the example in Fig. 50B using a rather coarser type of 'dot' than described here.

There are several potential applications of the computer to contouring. At the simplest level given the digitized positions of a network of 'spot heights' the computer can calculate (and draw) accurately, by interpolation from these values, the positions of contours lying between them, a method with obvious applications to submarine contouring where repeated traverses of an area produce a string of mechanically-recorded soundings as input material.

For land areas more sophisticated techniques are available derived from the computer's ability to set up and 'measure' the stereoscopic image produced by a pair of photographs. The use of this image as a basis for contouring (already described in Chapter 5, p. 94) depends upon a tracer point first identifying and then following a given altitude on its surface, thus tracing out the position of the contour. Traditionally this process was carried out by human hand and eye but the advent of machines such as the *stereomat* allows the task to be entrusted to a computer so that contours can be produced by machine.

Contours derived in this way might, for example, be overprinted onto an orthophoto to provide much needed relief information (one of the orthophoto's more noticeable content-weaknesses) but there are also processes which allow contour plots to be produced automatically at the same time as the orthophotograph itself is being produced. When the conversion from photo to orthophoto is being made by computer-controlled machines, such as the stereomat, the regular scanning of the photograph produces continual knowledge of the elevation of the surface and its direction of slope. If the elevation of this surface is continually monitored it is possible, each time its altitude coincides with that of a contour, to activate a separate printing device which prints a short line whose direction is normal to the slope at that point, so that the line actually runs along the contour. Because the scanning for the orthophotograph is at such close intervals these short line segments will eventually amalgamate to form contours, though a slight degree of over-drawing may be needed for clarification.

An alternative, and slightly less sophisticated, approach is produced by *line dropping*. As the photograph is being scanned each time the elevation of the image coincides with a contour altitude a pencil is automatically lowered onto a separate sheet and draws a line (representing the position of the scanning line) continuously until the elevation of the next

---

[3] Yoeli's original 'dots' were merely letters or characters from the computer's normal line printed output, chosen to produce a graded range of blackness. More sophisticated forms of output have since been employed, including plotting by laser-beam on a photo-sensitive surface. The surface is exposed a minute area at a time and in each case the intensity of the beam is modulated to conform to the amount of light which would in theory be reflected from the sloping surface at that point.

contour is reached. At that point the pencil is raised but descends again when the next contour altitude is reached, and so on. Obviously contours occur at each end of these *dropped lines* and can be obtained by joining them. To avoid confusion in deciding which line-ends correspond to which elevation this simple pencil-dropping process is usually replaced by a photographic one where the scanning line is continuously printed but is made to *change thickness* each time a contour line is crossed, as is the case in Fig. 50C. Such dropped-line contours do not have the accuracy of those produced by 'line following' using a stereoplotter but are acceptable for some purposes.

Knowledge of the direction (and degree) of slope within the scanning window has also obvious echoes of the inputs needed to produce automatic hill-shading (above) and not surprisingly a linkage of the two processes – orthophoto production and contemporaneously produced automated hill-shading for subsequent overprinting – has already been achieved.

These descriptions, however brief and simplified, leave a powerful impression that if the coming of the air photo transformed the potential of cartographic representation of the earth's detailed surface, the harnessing of the computer may help enormously in the realization of that potential. If we can write that 'the whole surface of Mars is now more completely mapped than large areas of the earth were a century ago'[4] the potential to record and map, often by machine rather than by human agency, is indeed truly ours, though it remains to be seen whether we can afford to use it. This is no small qualification. Cartographic output has always reflected the *practicable* rather than the *possible* and technological forces are not the only ones involved.

There is no better way of illustrating this than by examining the history and end-products of some actual mapping enterprises; and that is the preoccupation of the next chapter.

---

[4] C. I. M. O'Brien, *Cartographic Journal*, 11 (1974), p. 133.

# Chapter 7

## The Image in Reality – the example of some international and one national map series

Chapters 1 to 6 have been concerned to describe the many factors which have been able to leave their mark on the representation of the earth's surface at any given time, and the most obvious way to illustrate and summarize the reality of these factors is by a description of some actual maps themselves. This, in fact, is what this next chapter is concerned to do – but with the proviso that in a book of this nature such treatment must be highly selective. Two basic themes only have been chosen therefore to illustrate the many aspects of this situation. The first theme relates to attempts to produce world-wide map series by international cooperation, at the same time neatly emphasizing the problems of small-scale, basically compiled, maps in series which must cope with the whole range of terrestrial landscapes as well as the very varying pre-existence and reliability of world mapping.

By contrast the second theme considers the complexities of producing a range of maps adequate for contemporary life within the more constricted circumstances of a national territory, national need and national resources and standards. Many series could have made a justified claim for consideration here but, with limited space available, only one, the range of British Ordnance Survey Maps, will be considered. Amongst the oldest-established national map series, and arguably the fullest ever produced, its members are particularly well suited to exhibit through their changes in style, format and content, the impact and interplay of the technological, political, economic and social forces which have been mentioned in earlier chapters. Although such an account has an obvious and additional practical utility for British map users it is surely not without cartographic interest to a much wider audience.

*International Map Series at Small Scales*

(1) The International Map of the World (IMW) at 1 : 1,000,000 scale.[1]

International cartographic cooperation, as described at the end of Chapter 3, has not solely been confined to recent years. As long ago as 1891 Penck, the geographer, outlined

[1] Originally known as the Carte du Monde au Millionème and occasionally still listed as such in library catalogues etc. The abbreviation IMW is however fairly generally recognized today.

proposals for a uniform map of the world at 1 : 1,000,000 scale and specifications for such a map ultimately emerged from a conference in Paris in 1913. The world-wide projection that was needed was to be a modified polyconic,[2] sheets were to be uniformly six degrees of longitude by four of latitude (though with amalgamations of the narrow sheets poleward of 60 degrees) and only important features were to be shown – relief using contours and layer colouring, hydrography, towns, main roads, railways, political boundaries, etc.

Rather surprisingly the results have emphasized the weaknesses inherent in such a project as much as its virtues. Actual mapping was left to national agencies, each sheet being the responsibility of the country occupying the greatest portion of it, but both response and cooperation were very varied and the absence of any central *executive* body proved a major weakness, only marginally removed by a Central Bureau established *for liaison only* at the Ordnance Survey and transferred to the UN Cartographic Office in 1953. Progress was very patchy, varying from rapid compilation from existing maps, e.g. in Europe, to slow and often reluctant participation by countries which felt burdened enough by enormous backlogs of routine mapping in their own map series. Other difficulties came from the rigid sheet lines (which often made the map inconvenient to use, as in Britain which appeared on portions of *seven* sheets), from transliteration of names into the western alphabet, and from content, especially relief which was often poorly portrayed on existing maps, sometimes in metres, sometimes in feet. In any case uniformity of content was virtually impossible in so wide-ranging a series so that road classes, of which three were permitted, varied from 'roads passable by automobiles'; 'wagon roads'; 'pack-roads, trails and paths' on the Caracas sheet to 'main roads' and 'other roads' on the Amsterdam sheet.

To overcome some of these difficulties sheets which did not comply fully with official specifications were acceptable as provisional editions but even in the 'normal' sheets uniformity of appearance was not easily achieved due to the lack of a central printing agency. Where response from national governments was slow other agencies took up production, for example the British General Staff and the Engineering Club of Brazil, but the figures tell their own story. In 1949 out of just over 2,000 possible sheets only 405 had been completed, only 232 of these met full specifications and no less than 107 had been produced as the *Map of Hispanic America* by the American Geographical Society (Fig. 51).

Nor has progress since been spectacularly better, not least because of competition from further international cartographic ventures, particularly air charts (see below). In an attempt to reconcile these conflicting demands new and modified specifications for the IMW map were laid down at the Bonn conference in 1962 but even these could not disguise the fact that the viability of the *map* no less than the *project* was increasingly being questioned. What was such a map needed for? Many countries have seen its scale as still too large for rapid generalization, yet too small to show really helpful detail, and in any case its former role as a general reconnaissance map is increasingly being usurped by, for example, developing (or complete) series at about 1 : 250,000 scale in many countries. What remains is an incomplete map, a set of sheet lines used in many countries as a basis for arranging and numbering their own map series (see Fig. 47, p. 101) and a possible base

[2] Each 6° wide pole-to-pole column of sheets has its own central meridian but this, instead of being its correct length, is shrunk to make the meridians 2° east and west of it become correct. Resultant scale errors are less than 1 : 1,300.

**Fig. 51:** Part of sheet NC–19 (Caracas) of the 1:1,000,000 International Map of the World (IMW). (Reproduced by permission of the American Geographical Society of New York, 1945). The sources from which this map was derived are shown in Fig. 22 (p. 50). The style and content should be compared with Fig. 52.

map for further world-wide mapping ventures in the field of population, vegetation and land use – a commendable result but not quite the basic world representation which was envisaged 60 years ago.

## (2) The Karta Mira Map of the World at 1:2,500,000 scale

A noticeably more successful international cartographic venture, which has escaped many of the IMW pitfalls, is the Karta Mira produced from Budapest by a consortium of eastern European countries and the USSR. With a close approach to centralized production, and only 234 sheets in all, production has proceeded rapidly since 1964 and the whole series is approaching completion in uniform and attractive style, including no less than 12 colours and with bilingual marginal information in Russian and English.

## (3) The ICAO World Aeronautical Chart Series

The uniform world-wide series of charts which are needed for air navigation developed from the 1:1,000,000 World Aeronautical Chart (WAC) project of the United States Air

**Fig. 52:** Part of sheet K–27 of the Operational Navigation Chart at 1:1,000,000 scale. (Reproduced by permission of the United States Department of Defence: USAF chart copyright.) Notice the subjugation of detail to navigational requirements and the overprinting of aeronautical information. Like Fig. 51 this is a compiled map and on at least three occasions – the railway from Palma Sola, drainage north of Temerla and lakes near Maracay – the maps contradict each other.

Force and which in turn had been placed at the disposal of the International Civil Aviation Organization (ICAO) when this was set up. The sheets of the resultant ICAO World Aeronautical Chart Series at 1:1,000,000 scale have some superficial resemblances to the IMW map but far more differences. Many sheets are six degrees by four degrees but both size and arrangement are varied to suit land shapes and converging meridians and two projections are used – the stereographic poleward of 80° and an interrupted Lambert's conical orthomorphic with two standard parallels (see p. 24) elsewhere.[3] Detail shown is concerned with or subordinated to assisting air navigation rather than resource development and economic planning, and content therefore differs a good deal from IMW maps in nature, amount and style (see Figs. 51 and 52).

Practical considerations and immediate need have tempted many governments to produce ICAO charts rather than IMW sheets and also to revise them relatively frequently, a refinement often denied to the IMW series. Not surprisingly therefore one of the aims of the Bonn conference in 1962 was to modify some of the IMW specifications to allow some material to be used in common by both series. Thus the Air Charts' Lambert

[3] 'Interrupted', since each tier of maps has its own pair of standard parallels.

projection may now be used for both series (the difference between it and the polyconic would not be noticeable on casual inspection anyway), and IMW sheet lines may be treated less rigidly, but even so the earlier series still lags noticeably behind its later and more practical rival.

(4) Military Map Series

The usefulness of a uniform extensive map series is no less apparent in military than in civil aviation circles and here again a practical need has produced responses several of which are the result of international cooperation.

At 1 : 1,000,000 scale a joint British/US series covers almost the whole world and at 1 : 500,000 scale a further joint venture was begun about 1950. Accepting from the start that one map could not serve two purposes both air navigation and terrestrial versions of the 1 : 500,000 map were envisaged, but lessons learned at 1 : 1,000,000 scale were not ignored and the two versions, though quite dissimilar in appearance, are still able to make use of much common material; even further versions, adapted to other specialized uses, have been prepared experimentally in West Germany but again all incorporate mainly redrawn versions of the same basic material.

The most ambitious and recent attempt to cover the world in a new series, designed to meet the requirements of both ground and air forces in joint operations is the *Land Map and Air Chart, 1 : 250,000 (Joint Operations Graphic)*. Begun in 1966 both map and air chart have the same topographical detail but with contours in metres for the ground version and in feet for the air version, which also carries a full range of other information needed in aviation.

International map series such as those just described, whether of civil or military origin, are of course the modern examples, *par excellence*, of maps produced by compilation. Examples of the material incorporated in sheets of two of these series have already been given in Fig. 22 (p. 50), though with good quality local map cover increasing rapidly in many areas, and with systematic air and satellite photography to supplement this, consistency and revision are a good deal easier to achieve today than was formerly the case.

*A National Map Series – the Ordnance Survey Maps of Britain. General development of the Survey and Map Series*

The initial aims of the official survey newly established in 1791 were modest enough – to establish a national triangulation framework and produce a basic map of the country at 1″ to a mile. Work on both was slow, and the triangulation was not finished until 1853, but fortunately the parallel progress of the detailed mapping allowed a map of Kent to be published by 1801, and from there coverage spread gradually westwards and northwards.

Military considerations were important to this early venture, as they were to mapping elsewhere in Europe, but promptings of a civil kind soon began to affect development. In 1824 a House of Commons committee recommended that a survey at 6″ to a mile be undertaken to help the recording and assessment of local land taxation in Ireland, and since no other body could undertake such a task the work was entrusted to the Ordnance Survey. Large numbers of personnel were immediately despatched to Ireland, and on the

completion of the work in 1846 that country became the first portion of the globe to be mapped fully on such a scale: the cost was £800,000.

Once the great usefulness of this Irish map became apparent Parliament was naturally urged to provide a comparable one for the rest of Britain, and in 1840, when the 1″ mapping had progressed as far north (roughly) as the Hull–Preston line, consent was given to the mapping of the six remaining northern counties of England[4] and all Scotland at the 6″ scale – though not without misgivings about the cost in the years that followed.

Meanwhile a considerably body of opinion was agitating for even larger-scale maps in both rural and urban areas. Maps of this kind were certainly much in demand from bodies concerned with activities as varied as urban building, mineral exploitation, land registration and conveyancing, tithe commuting or the laying out of land drainage, water mains, sewers and railways; and so long as no uniform national map series was available this demand continued to be met by innumerable, expensive local surveys, unsatisfactory because they lacked any uniformity of style, scale or reliability. In circumstances such as these tacit acknowledgement of the need for an official very large-scale map series was not long delayed, though unfortunately this triggered off a protracted dispute as to the best scale for the series, the so-called 'Battle of the Scales'. Eventually in 1853 a survey of County Durham was authorized at 1:2,500 scale (approximately 25″ to a mile) and in 1856 this was adopted as the basic scale for all parts of the country except mountainous and moorland areas. A resurvey of the country, lasting from 1853 to 1893 was needed to produce the new 25″ map and the 6″ and 1″ scales were then derived from it by reduction.

1:2,500 was not, however, the largest scale adopted by the Ordnance Survey. When the 6″ map of Lancashire and Yorkshire was being made in the 1840s towns with more than four thousand population were mapped at 1:1,056 scale (5 feet to a mile), and in the next ten years further developments (for example the need to plan sanitation schemes following the Public Health Act of 1848) led to the decision to produce a 1:500 map of all towns of four thousand population and over throughout the country.[5] More than four hundred towns were mapped in this way before the series was discontinued in 1894, even the state forbearing to undertake so costly and protracted a piece of work.[6] After these remarkable 'Town Scales' anything else was anticlimax, and from the turn of the century until after World War II (see below) the 1:1,056 map of London and enlargements of some of the 1:2,500 sheets to 1:1,250 scale were the largest scale maps produced by the Ordnance Survey.

So far as mapping at scales smaller than 1″ to a mile was concerned the state was slow to enter a field already competitively supplied by private publishers, (often of course with maps based on the Ordnance Survey's products) and the official series often had specific and utilitarian beginnings. For example a ¼″ to a mile map was begun in 1859 as a base

---

[4] Lancashire, Yorkshire, Durham, Westmorland, Cumberland and Northumberland.

[5] 1:500 equals just over 10 feet to a mile. The Ordnance Survey had already prepared, on private contracts, surveys of some towns at 1:528 scale (10 feet to a mile) and both groups are sometimes termed the 'ten-foot plans'.

[6] Until 1908 the Ordnance Survey would *revise* any such plans at the local authorities expense and a few towns took up this option. London was exceptional in all this. The basic scale was 1:1,056 (not 1:500) and the maps *were* revised at intervals until their replacement by the modern 1:1,250 series.

map for indexes of the larger scales, but it received low priority and was not finished until the 1880s when it was also needed as a base for the $\frac{1}{4}''$ Geological map series. Similarly the little known Ordnance Survey $\frac{1}{2}''$ series was begun in 1902 in response to a War Office demand for a map at this scale for military training purposes. Private competitors however were both well established and effective – Bartholomew's $\frac{1}{2}''$ map of Britain was begun in 1888 and is claimed to have been the first map series in the world to show relief by contours and layer colouring – and though the $\frac{1}{4}''$ series was popular enough the official $\frac{1}{2}''$ map series never really established itself and eventually was discontinued.

Two other maps, at 10 miles to 1'' (1:633,600) and 1:1,000,000, completed the Ordnance Survey's small-scale maps. The former, much used as a general and motoring map, is now replaced by similar maps in the 1:625,000 'planning series'; the latter grew from the International Series, recast onto more convenient sheet lines.

In 1935, for a variety of reasons (see below) Parliament established the Davidson Committee to investigate and review many aspects of Ordnance Survey maps. The range of maps available for their inquiry has just been described, but oddly enough this was, perhaps, one of the few occasions on which it had been looked at as a whole. The range had developed, as we have seen, in rather an *ad hoc* fashion and, though the Committee's inquiry showed that there was little fundamentally wrong with the maps, these betrayed their separate evolutions in minor but irritating ways. Following the committee's recommendations Britain obtained for the first time a fully integrated national map series; but this involved so many fundamental changes in map design and layout that it will be as well to consider the 'pre-Davidson' maps first, as a group, before bringing the story up to date.

### The 1'' and Small-scale Ordnance Survey Maps

Between 1801 and 1935 the 1'' map ran to no less than five editions, the first two, from 1801 to 1890, covering a period of fairly static design, and the final three one of much more rapid response to technological change and to public interest and demand. The maps of the first edition or *Old Series* were relatively simple and unsophisticated productions. Drawn on a Cassini projection (see p. 11) they covered England and Wales in 110 sheets (mostly 36'' × 24'') printed in black only from engraved copper plates and showing relief (by hachures), together with the general features of the landscape (see Fig. 53). Lack of colour (any colour found is hand-applied), and the hachures, clearly distinguish them from modern maps, but so do other less obtrusive features. Conventional signs, for example, are virtually absent (important detail is usually named) and so too are footpaths, most boundaries, information relating to magnetic variation and any reference system other than marginal markings of latitude and longitude. Characteristically a key is neither needed nor provided. Because it was a pioneer state production, antedating its successor by half a century or so, the Old Series has considerable historic as well as cartographic significance, though this presents some difficulty and is briefly discussed in Chapter 13 (p. 240).

After 1840 the 1'' map was obtained by reduction from the 6'', and in consequence sheets 87 to 110 not only show a more finely drawn, precise style but are also found, from the 1850s onwards, published additionally in a *contoured* version, the contours being taken

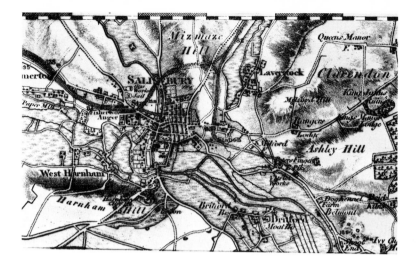

**Fig. 53:** The Old Series (or 1st edition) 1″ Ordnance Survey map: part of sheet 15, published 1811.

from the 6″ map. The advantage of these later sheets over the cruder earlier members of the series led to a decision to produce a second edition, similarly derived, for the rest of the country. This was the *New Series* which, though it contains certain additions, for example parish boundaries,[7] still closely resembles the Old Series. The most striking changes are the reduction in sheet size to 18″ × 12″ entailing 360 sheets to cover the country (see Fig. 55)[8] and the introduction of two styles, one contoured only, the other carrying contours and hachures though still in black and white only. Historically the coexistence of the more detailed 6″ map renders the New Series of less significance than the Old. Publication ran from 1872 to the mid-1880s and, as with the Old Series, some reprinting and revision occurred. This is usually fully recorded on the map, but even so doubt exists as to whether such revision was complete or confined to major items only.

Between 1893 and 1898 a new revision, at 1″ scale only, heralded the appearance of the complex third edition which was to begin the transformation of the 1″ into a modern map.[9] In its earliest form this third edition was simply a black and white outline map, beautifully printed from engraved copper plates and using only contours to show relief, but a second version was available with the same detail, plus hachures in black or brown. This marks the first application of lithographic colour-printing techniques to the 1″ series, and an even wider incorporation of colour into the design was an obvious further develop-

[7] In the north of England these are ecclesiastical parish boundaries. The township boundaries (equivalent to parish boundaries in the south of the country) are not shown.

[8] Many sheets of the Old Series had been published as quarter-sheets at this size and in the north of England the sheet lines of the New Series and the quarter-sheets of the Old Series coincide. Whereas in southern England there were *two* 1″ maps produced from *two* surveys (the first for the original 1″ scale, the second for the 25″ and 6″ scales), in northern England there was only *one*. The Old and New Series here coincide, the same detail and sheet lines being used but differently numbered.

[9] There is some disagreement about the nomenclature of this edition. Harley and Phillips (1964) treat this as another printing of the New Series, but the Davidson Committee's Report regards it as the third edition. In view of the many changes derived from it the latter terminology is to be preferred.

Sheet 10 (1810)

An asterisk indicates that the sheet was published as ¼ - sheet

**Fig. 54:** The sheet lines of the Old Series (or 1st edition) of the 1″ Ordnance Survey map of England and Wales. Dates given are those of *publication*: either of the whole sheet, or the range of dates of the publication of the quarter-sheets. Towns are indicated by their first two letters. County boundaries are as pre-1974.

ment. This would increase the map's appeal against privately produced competitors as well as meeting a contemporary demand from the Army for a clearer map; and the series soon appeared in a fully coloured version at first in five, later in six colours. The popular market was further cultivated by the production of a cheap version (usually in only two colours) on special sheet lines covering the areas round major towns.

These 'modern' trends were amplified by changes in the detailed design of the map itself, which became far more specific and practical. For the first time much of the detail is rigidly classified: a crude road classification is used, railways are differentiated into double-track, single-track and mineral lines, churches into 'with spire', 'with tower' and 'without'. New details such as orchards, footpaths and a full range of *civil* parish boundaries appear,[10] whilst for the map user there are village postal facilities, magnetic variation and marginal markings for a reference grid of 2″ squares. One consequence of the adoption of multi-colour printing was that the small sheet size became uneconomical to produce (though it was retained in *outline* form), leading to the appearance of the so-called 'Large Sheet Series', 152 sheets, mainly 27″ × 18″ and derived from a further revision of 1901–12. There were also a few special tourist sheets, even more elaborately coloured and with contours, hachures and layer colouring to show relief.

Great hopes were centred on the elaborate use of colour at this time. Stimulating French experiments had been matched, in 1913, by an Ordnance Survey trial sheet of Killarney in no less than thirteen colours, but unfortunately the 1914–18 war and the post-war economy drive put an end to such hopes. There was no money for extended colour processes and no time to prepare elaborate printing plates (revision had already been seriously delayed); and when the first post-war sheets of the new fourth or *'Popular'* edition appeared many map users saw in them a retrograde step. Parish boundaries, for example, had gone, and so too had the hachures, though the contour vertical interval was stepped up everywhere to 50 feet to offset this, a marked improvement on the former 100 feet VI up to 1,000 feet and 250 feet VI above that. On the positive side there were slightly better sheet lines (see Fig. 56) and a much more detailed and objective road classification with which to woo a rapidly increasing motoring public. With its lavish use of colour to emphasize the communications system the Ordnance Survey might well claim that 'Motorists, cyclists, pedestrians, tourists and travellers generally will find these maps indispensable.'[11]

Indispensable or not better things were hoped for, and when the fifth edition appeared after 1931 it was available in 'normal' (relief by contours only) and 'relief' versions. As its name implied, the most striking feature of the latter was the elaborate representation of relief by contours, hachures, hill-shading and layer-colouring (p. 91) but for both versions the whole map was improved by redrawing, including altered lettering and many changed or improved conventional signs. Quarries, wireless masts, isolated telephone boxes and electric power lines filled out the landscape detail; new symbols for Youth Hostels and National Trust property reflected a growing tourist market; parish boundaries came back, latitude and longitude intersections were marked by crosses on the face

---

[10] The Civil Parish was introduced in 1871 to replace the Ecclesiastical Parish for many purposes. After 1879 Ecclesiastical Parishes, Hundreds and Wapentakes were discontinued on Ordnance maps and replaced by Civil Parishes.

[11] *A Description of Ordnance Survey Small Scale Maps*, second edition, 1920, p. 3.

**Fig. 55:** Sheet lines of the New Series (or 2nd edition) and of the outline and *small* coloured sheets of the 3rd edition of the 1″ Ordnance Survey map of England and Wales. These sheet lines are *still* used for the 1″ Soil Survey map and the 1″/1:50,000 Geological map. Towns are indicated by their first two letters. County boundaries are as pre-1974.

Shaded areas are overlaps.

**Fig. 56:** Sheet lines of the 4th (or Popular) edition of the 1″ Ordnance Survey map of England and Wales. These sheet lines were also used for the maps of the *first* Land Utilization Survey of England and Wales. Towns are indicated by their first two letters. County boundaries are as pre-1974.

of the map and, most important of all, a grid was added. Even if references had to be by cumbersome full coordinates (in yards, see p. 160), a modern reference system was there at last. Unfortunately the fifth edition extended only as far north as Birmingham when war intervened, and post-war 1″ map series developed on rather different lines.

Although their smaller scales left less room for variation in content, the style of most of the other small-scale maps showed similar trends towards popular appeal. Each series began unprepossessingly with a coloured hill-shaded form, which was not too successful in representing gentle English topography, and was replaced in the 1920s by a contoured, layer-coloured edition on better sheet lines. Later versions particularly sought to appeal to the motoring public; road networks and classification were given priority among detail, and folded versions of the ¼″ maps eventually included detailed plans of the centres of the larger towns, a very useful attraction in a highly competitive field.

### The 6″ and Large-Scale Ordnance Survey Maps

In contrast to this fluid picture the designs of the larger-scale maps were remarkably static, yielding, if at all, to technical rather than popular considerations. The 6″ map, for example, changed very little in its first century from 1840, the true-to-scale representation and naming of virtually all important public and industrial buildings reducing the conventional signs needed to those for double-track railways, boundaries and various 'unusual' land uses (woodland, rough pasture, furze, marsh, osiers, reeds, sand, mud, pits and quarries). A very similar style and content was found on the 1:2,500 maps (see Fig. 57A). From time to time minor changes occurred on both series: for example hedgerow trees and gates were not shown after 1892; certain public buildings were coloured solid black on the 6″ after 1897; various types of 'filling' were used for buildings on the 1:2,500 maps. But these were of small importance and the impression given is of two map series whose design was little affected by the passage of time.

In one important respect, however, the two series differed; there were no contours on the 1:2,500 maps, only bench marks and spot heights. Contours were one of the great innovations of the 6″ map, though no constant vertical interval was maintained throughout the country and the variation in the relative numbers of the 'instrumental' and 'sketched' varieties was considerable.[12] Until 1912 altitudes on both scales were referred to the *Old* or *Liverpool Datum*, but from that date relevelling onto the new and more satisfactory *Newlyn Datum* was begun, and from 1929 onwards a factor allowing conversion from one to the other was printed on all revised maps.

If contours were the distinctive feature of the 6″ map, the peculiar prerogative of the 1:2,500 scale was the numbering and recording of the area of each 'parcel' of land, at least in rural and 'open' built-up areas (the practice is impossible in 'close' development). Parcels were numbered in each parish[13] and the method is further described in Chapter 9 (p. 189); it need only be noted here that areas given are for whole parcels until 1922, but to the plan edge only after that date.

[12] 50 feet or 100 feet VIs were the most common. A full statement of practice can be found in either Harley (1975) pp. 77–80 or Winterbotham (1934) pp. 46–8.
[13] Only the parcel numbers were shown on the maps until 1886, the areas being listed in 'Parish Area Books' until 1872 and 'Books of Reference' from 1872 to 1886.

Representation of boundaries formed an important consideration of both scales. Many sorts are shown, for example those of all local administrative units as well as parliamentary divisions, wards, poor-law unions and catchment areas,[14] and on the 1:2,500 scale they are 'mered' as well, i.e. their position is exactly defined relative to detail shown on the map, often in rather cryptic form, '4 ft RH' for example indicating that the boundary lies four feet from the *R*oot of the *H*edge on the side shown. Unlike many European counterparts the large-scale British maps are not *cadastral* plans: they do not show property boundaries. They have always concerned themselves entirely with the physical details of the landscape – walls, hedges, buildings, for instance – and where property boundaries run close to, but not co-incident with these, the onus of defining their position is left to the landowner, not the survey.

In design both series eschewed colour. Hand-coloured 1:2,500 sheets were available until 1892, and 6″ sheets with water hand-coloured blue for a while after that; but the 1:2,500 maps remained devoid of printed colour, and the 6″ used it only for contours (from 1909) and later for classified road numbers. An exception was the series of special plans of the major towns at 6″ scale which appeared in the 1920s; a welcome change from the normal 'black and white' sheets, they had yellow roads, red buildings, blue water, green parks and purple boundaries and tramways. The last-named was unusual as the only attempt to mark *all* tramways on a British map series at a scale smaller than 1:2,500.

The detail and completeness of the 6″ and 1:2,500 scales naturally makes them of considerable importance as historical records, and fortunately their history is better known and recorded than that of the early 1″ series. Both are national in coverage but, for technical reasons, were organized on county lines. In 1840, because no projection was then known which could carry a 6″ map of the whole country without showing appreciable distortion near the edges, the map was prepared in sections, all on the Cassini projection but with each county or group of counties havings its own central meridian. Sheet size of 6 miles × 4 miles (36″ × 24″) was uniform, but sheet *lines* were unique to the county or group, which formed a complete cartographic unit. Any areas on the maps beyond the county or group boundary were left blank at first, though later the area was filled in by 'adjusting' detail from the adjoining county or group. Numbering was everywhere by counties, for example Dorset XXXIII, and when the 1:2,500 series was added and eventually envisaged as a *national* map (it was published by individual *parishes* until 1873) it was arranged so that sixteen 1:2,500 sheets covered the same area as one full 6″ sheet and could be numbered from it, i.e. Dorset XXXIII.12.

After the adoption of the 1:2,500 scale the same survey formed the basis for both this and the 6″ maps, though the 1:2,500 was usually published first. The 6″ was then made by reduction and redrawing and it was the introduction of photographic reduction in 1891 which caused the 6″ to appear in the familiar quarter-sheets (i.e. NW; NE; SW and SE); the camera could not take the sixteen 1:2,500 maps needed for a full sheet and, with a few exceptions, publication in quarter-sheets became standard. Between 1912 and 1919 the institution of a scheme to reduce the number of county meridians from forty-three to eleven resulted in the sheets for six counties (see p. 130) being redrawn on new sheet lines

---

[14] Poor law unions and their boundaries are now discontinued; catchment area boundaries are not on the 1:2,500 scale and the elusive ward boundaries were marked on 6″ maps only until 1889.

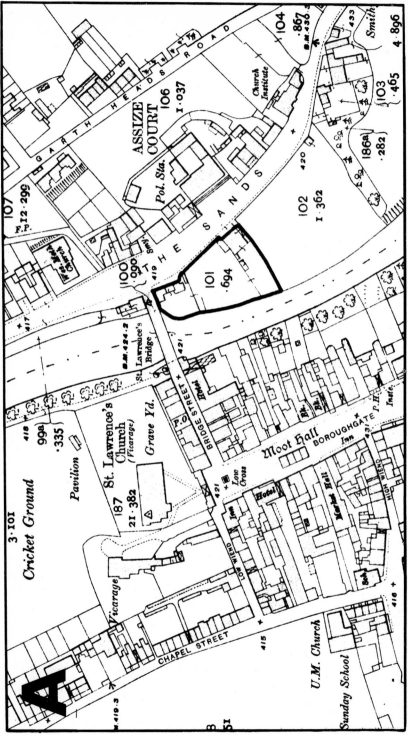

**Fig. 57:** Examples of two large-scale map series produced by the Ordnance Survey. **A:** Part of the 1 : 2,500 (25″) sheet Westmorland IX.15, edition of 1916 (County Series). In larger towns and urban areas this series has usually been replaced by modern sheets of essentially similar design but arranged on National Grid sheet lines (see p. 136) but in a few rural areas (which may include some small towns) County Series sheets such as this may still form the largest-scale cover available and may be decades out of date. This Appleby sheet itself was eventually replaced by a National Grid series sheet in 1970, the first revision at this scale for years. The dark line in **A** encloses parcel 101 in Appleby Municipal Borough. **B:** (*below*) Part of the 1 : 500 sheet Yorkshire (West Riding) Knaresborough CLIV.12.12. Something of the amazing potential of this series can be deduced here: each bush, tree, flower bed, etc. is correctly shown, even boundary walls need double lines, and a considerable amount of 'urban information' is included as well.

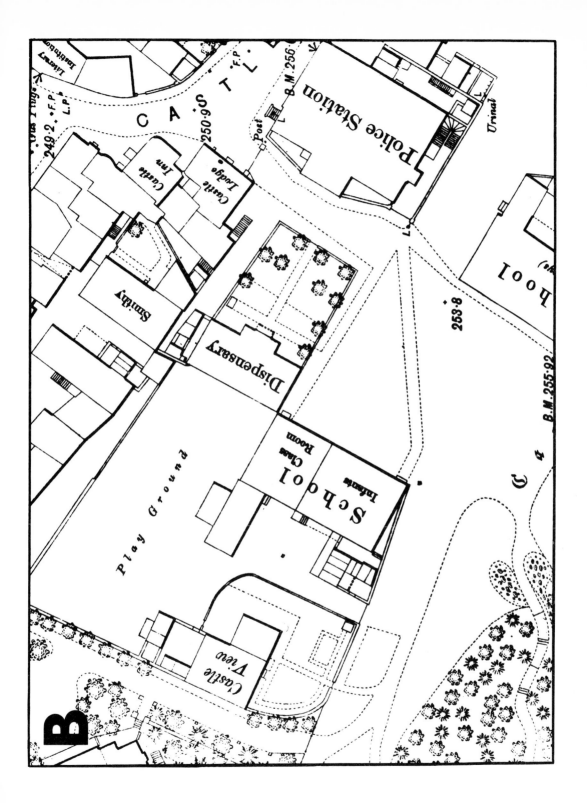

to fit with their neighbours, but no more were so treated after the economy cuts of the early 1920s.

To maintain the usefulness of large-scale series such as these, a systematic programme of revision was of prime importance, and in 1886 therefore, when the initial survey was nearly complete, the principle of *cyclic revision* was laid down, the maps for each county being revised every twenty years. Two revisions were attempted under this programme: the first took from 1891 to 1914, the second was started in 1904 but was interrupted by the War and never finished.[15] In 1919 in an attempt to cope with economics, staff shortages and accumulated backlog it was decided to revise the more sparsely populated counties only every forty years; but by 1922, with the situation little improved, revision in the 'twenty-year counties' was being confined to urban areas only, and after 1928 even this degree of order was abandoned, sheets anywhere being selected for revision simply according to need. The enchanting prospect of a long-continued twenty-yearly cartographic representation of the British landscape has thus never materialized, but that portion which does exist provides an enormously important and complete record that is of great value for research purposes. An account of its progress county by county, will be found in the table below.

| COUNTY (pre-1974) | SURVEY | 1ST. REVN. | 2ND. REVN. |
|---|---|---|---|
| *England* | | | |
| Bedfordshire | 1876–82 | 1898–1900 | 1921–24 U |
| Berkshire | 1866–83 | 1897–1899 | 1909–12 |
| Buckinghamshire | 1867–81 | 1897–1899 | 1918–24 U |
| Cambridgeshire | 1876–86 | 1896–1901 | 1924–26 U |
| Cheshire | 1870–75 | 1896–1898 | 1904–10 |
| Cornwall | 1859–88 | 1905–1907 | a |
| Cumberland | 1859–65 | 1897–1900 | 1922–24 U |
| Derbyshire | 1871–82 | 1896–1900 | 1913–21 |
| Devonshire | 1855–89 | 1902–1905 | a |
| Dorset | 1862–88 | 1900–1902 | 1926–29 U |
| Durham | 1854–57 | 1894–1897 | 1912–19 |
| Essex | 1861–76 | 1893–1896 | 1911–22 N |
| Gloucestershire | 1873–85 | 1898–1902 | 1912–22 |
| Hampshire | 1856–75 | 1894–1897 | 1906–10 |
| Herefordshire | 1878–87 | 1901–1904 | 1924–28 U |
| Hertfordshire | 1865–85 | 1895–1897 | 1912–23 |
| Huntingdonshire | 1882–87 | 1899–1901 | 1924–5  U |
| Kent | 1858–73 | 1893–1897 | 1905–10 |
| Lancashire | 1842–49* | 1888–1893* | 1904–12 |
| Leicestershire | 1879–86 | 1899–1902 | 1912–30 U |
| Lincolnshire | 1883–88 | 1898–1906 | 1928–32 U |
| London | 1862–72 | 1891–1895 | 1912–14 |

[15] The reason for the overlapping dates is only partly obvious. Revision took twenty-three years, and the second revision should therefore have started in 1911; the 1904 start was caused by the need to revise Yorkshire and Lancashire which had been *re-surveyed* to bring them up to 1 : 2,500 scale in the late 1880s but not therefore included in the first revision.

| COUNTY (pre-1974) | SURVEY | 1ST. REVN. | 2ND. REVN. |
|---|---|---|---|
| Middlesex | 1862–68 | 1891–1895 | 1910–13 |
| Monmouthshire | 1875–85 | 1898–1900 | 1915–19 |
| Norfolk | 1879–86 | 1900–1906 | 1925–27 U |
| Northamptonshire | 1880–87 | 1898–1900 | 1923–28 U |
| Northumberland | 1856–64 | 1894–1897 | 1912–22 N |
| Nottinghamshire | 1876–85 | 1897–1899 | 1912–19 |
| Oxfordshire | 1872–80 | 1897–1900 | 1910–24 |
| Rutland | 1883–84 | 1899–1903 | 1928–9 U |
| Shropshire | 1873–84 | 1899–1902 | 1924–6 U |
| Somerset | 1882–88 | 1900–1903 | a |
| Staffordshire | 1875–86 | 1897–1902 | 1912–23 |
| Suffolk | 1875–85 | 1900–1904 | 1924–26 U |
| Surrey | 1861–71 | 1891–1896 | 1910–13 |
| Sussex | 1869–75 | 1895–1898 | 1907–10 |
| Warwickshire | 1880–88 | 1898–1904 | 1922–23 U |
| Westmorland | 1856–59 | 1896–1898 | 1910–13 |
| Wiltshire | 1873–85 | 1898–1900 | 1921–24 |
| Worcestershire | 1880–88 | 1898–1904 | 1925–27 U |
| Yorkshire | 1845–54* | 1888–1893* | 1901–14 |
| *Wales* | | | |
| Anglesey | 1886–87 | 1899 | 1913–23 |
| Brecknockshire | 1875–88 | 1902–1904 | a |
| Cardiganshire | 1885–88 | 1900–1904 | a |
| Carmarthenshire | 1875–87 | 1903–1906 | a |
| Caernarvonshire | 1885–88 | 1898–1900 | 1910–14 |
| Denbighshire | 1870–75 | 1897–1899 | 1909–12 |
| Flintshire | 1869–72 | 1897–1898 | 1909–11 |
| Glamorgan | 1867–78 | 1896–1899 | 1913–16 |
| Merionethshire | 1873–88 | 1899–1900 | a |
| Montgomeryshire | 1874–87 | 1900–1901 | a |
| Pembrokeshire | 1860–88 | 1904–1906 | a |
| Radnorshire | 1883–88 | 1901–1904 | 1926–7 U |
| *Scotland* | | | |
| Aberdeenshire | 1864–71 | 1899–1903 | 1923–26 U |
| Argyllshire | 1862–77 | 1897–1898 | a |
| Ayrshire | 1854–59 | 1893–1896 | 1907–09 |
| Banffshire | 1865–70 | 1900–1903 | a |
| Berwickshire | 1855–57 | 1896–1898 | 1905–06 |
| Buteshire | 1855–64 | 1895–1896 | 1914–15 |
| Caithness | 1870–72 | 1904–1905 | a |
| Clackmannanshire | 1859–63 | 1895–1899 | 1920–21 |
| Dumbartonshire | 1858–61 | 1894–1898 | 1912–14 N |
| Dumfriesshire | 1854–58 | 1898–1899 | a |
| Edinburghshire | 1852–54* | 1892–1894* | 1905–06 |

| COUNTY (pre-1974) | SURVEY | 1ST. REVN. | 2ND. REVN. |
|---|---|---|---|
| Elginshire | 1866–71 | 1903–1904 | a |
| Fifeshire | 1852–55* | 1893–1895* | 1912–13 |
| Forfarshire | 1857–62 | 1898–1902 | 1920–23 |
| Haddingtonshire | 1853　* | 1892–1893* | 1906 |
| Inverness (Mainland) | 1866–74 | 1899–1903 | a |
| Inverness (Outer Hebs.) | 1876 | 1901 | a |
| Inverness (Inner Hebs.) | 1874–77 | 1898–1901 | a |
| Kincardineshire | 1863–65 | 1899–1902 | 1922–23 U |
| Kinross | 1852–55* | 1893–1895* | 1913 |
| Kirkcudbrightshire | 1848–51* | 1893–1894* | 1906–8 |
| Lanarkshire | 1856–59 | 1892–1897 | 1908–11 |
| Linlithgowshire | 1854–56 | 1894–1896 | 1913–14 N |
| Nairnshire | 1866–69 | 1903–1904 | a |
| Orkney | 1877–78 | 1900 | a |
| Peebleshire | 1855–58 | 1897–1898 | 1906 |
| Perthshire | 1854–64 | 1894–1900 | a |
| Renfrewshire | 1856–58 | 1892–1896 | 1908–12 |
| Ross & Cromarty | 1868–75 | 1901–1905 | a |
| Ross & Cromarty (Isle of Lewis) | 1848–52* | 1895–1896* | a |
| Roxburghshire | 1857–60 | 1896–1898 | 1916–19 N |
| Selkirkshire | 1856–59 | 1897 | a |
| Stirlingshire | 1858–63 | 1895–1896 | 1913–14 N |
| Sutherland | 1868–73 | 1903–1905 | a |
| Wigtownshire | 1846–49* | 1892–1895* | 1906–07 |
| Zetland | 1877–78 | 1900 | 1928–29 U |

*Notes*

a　Counties marked *a* do not appear to have had a *systematic* second revision of their maps either wholly or in part (i.e. urban areas only).

U　2nd revision confined to urban areas

N　2nd revision redrawn onto new central meridian.

*　No. 1 : 2,500 scale at original survey. '1st revision' is therefore a resurvey at 1 : 2,500 scale.

General Note: Revision information is much less definitive after 1914. Many counties had extensive revision after the last dates shown, but it was usually patchy rather than systematic. Scottish counties were originally mapped under former names, as listed here.

If the older editions of the 6″ and 1 : 2,500 series are a historian's delight, the even larger 'Town Scales' are surely his dream. The incredibly complete urban detail recorded on these maps (see Fig. 57B) deserves to be far better known than it is, and it is unfortunate that few sheets, other than in areas which commissioned revision after the cessation of the series in 1894 (p. 119), appeared more than once. Idiosyncratically the towns of Lancashire and Yorkshire *were* surveyed twice, first at 1 : 1,056, later (1888–92) at 1 : 500 scale. Sheet lines were individual on the 1 : 1,056 scale, but the sheets of the 1 : 500 series in Yorkshire, as elsewhere, were arranged twenty-five to each 1 : 2,500 sheet giving num-

bers such as Yorkshire (East Riding) Gt Driffield CLXI.12.17 – 'CLXI.12' being the number of the 1:2,500 sheet of which the larger-scale map was part.

*The Davidson Committee (The Departmental Committee on the Ordnance Survey)*

A review of the styles and scales of the range of Ordnance Survey maps which has just been described formed one of the main terms of reference of the Davidson Committee when it was set up in 1935; the other was to consider how to accelerate and maintain revision. Almost all the Committee's recommendations were, in fact, later adopted and it will be convenient in many cases to review the proposals and the results of their implementation together.

The first item to be dealt with was a technical one. Evidence was forthcoming that the 1:2,500 series could now be carried throughout the whole country on one projection without serious error or distortion, and it was consequently recommended that a new *National Projection* be adopted and that all map series be redrawn onto it.[16]

The second recommendation was almost a corollary of the first, namely that a new grid, the *National Grid*, should be derived from that projection and superimposed on all maps; for a variety of technical reasons it was suggested that the metre, not the yard, should be the basic unit of the grid. Both recommendations have been adopted, and in addition a useful 'shorthand' method of giving grid references has superseded the cumbersome full coordinates of the 1930s (see p. 160).

The implied necessity of ultimately redrawing all the large-scale series onto the new projection with its new grid led to some very interesting possibilities. Not the least disadvantage of the county arrangement of the 6″ and 1:2,500 series had been that a whole book of index diagrams was needed to cover the country; to avoid this it was suggested that all redrawn series should consist of square sheets bounded by grid lines so that the grids on the smaller scale maps, for example the 1″, could act as indexes, and the sheets could be numbered by a version of the grid reference of their southwest corner (see below).

Here then were three basic principles of map design which might be applied to the whole range of Ordnance Survey maps, but the Committee had first to consider just what scales that range should be composed of. Arguments in favour of changing from easily visualized 'British' scales to metric-type 'natural' scales, for example 1:50,000, were sensibly (at that time) resisted and a 'no change' verdict ensued, save for the suggestion that two new scales might be considered, one at 1:25,000 scale, to fill the rather large gap between the 6″ and 1″, the other at 1:1,250 to provide a better map for urban areas than the enlargements of the 1:2,500. Both proposals were later adopted. A War Office version made by photographically reducing blocks of 6″ maps had already proved the usefulness of the former scale, and a variety of circumstances helped the introduction of the latter. By 1945 many of the old 1:2,500 sheets were so out of date that virtual resurvey rather than revision was necessary, and the cost of surveying in sufficient detail to carry the

[16] The National Projection was in effect simply a transverse Mercator projection (centre 49°N, 2°W), modified by shrinking the central meridian by 1/2,500 of its correct length, thus obtaining a better balance of the very small errors found throughout the projection. The principle is the same as that used in the modified polyconic of the IMW map at 1:1,000,000 (p. 115).

larger scale was not so greatly in excess of ordinary resurvey. Moreover a new primary triangulation of the country, to modern standards, had been begun in 1935, and from this the complete resurvey of the 1:1,250 areas could be undertaken.

So far as details of style rather than scale were concerned the Committee were prepared to leave matters largely in the hands of the Ordnance Survey themselves, though two points warranted special recommendations. One was for more contours. The relative novelty of contours had caused them to be rather sparingly introduced onto the 6″ maps of the 1840s, and though additional ones had been added after recommendations made in 1893, many witnesses requested that still more be provided, especially on the larger-scale maps. The other point was that the old system of numbering parcels on the 1:2,500 map should be discontinued (it had been much confused by patchy revision), and some other system of reference substituted instead.

With styles and scales disposed of the Committee was left with the difficult problem of revision. For the smaller scales (1″ and less) the existing method was adequate. Since 1893 these scales had been revised separately from the larger series every fifteen years or so, with further revision incorporated at reprintings, but for the larger scales it was recommended that the old 'cyclic' revision be replaced by 'continuous' revision, i.e. that any sheet should be revised as soon as the amount of new detail warranted it. By and large the innovation has been most successful, and though the historian may complain that he has lost his complete record of an area at a given moment in time, almost all other map users have benefited by obtaining much more up-to-date maps.

### *The Post-Davidson Range of Ordnance Survey Maps* (i) *Scales Smaller than 1 : 25,000*

The implementation of sweeping changes along the lines recommended by the Davidson Committee was not achieved overnight but progress has been steady and production of a fully integrated range of national maps is well on the way to being complete. Not surprisingly post-war changes were most rapid with the smaller-scale series. At $\frac{1}{4}$″ scale the National Grid was soon added to the existing Fourth Edition map but this was replaced after 1957 by the current Fifth Series,[17] which emerged as a 1 : 250,000 map to conform to agreed standard scales (p. 51 – the old $\frac{1}{4}$″ scale was 1 : 253,400). The scale change also allowed complete redrawing of the map; in particular roads are given as much detail and prominence as possible, hill-shading now supplements contours, spot heights and layer-colouring and the series was recast as a continuous one for the whole of Britain.[18] Revision is also unusually frequent, being in full every 3, 4 or 6 years (according to likelihood of change) but with an intermediate reprinting incorporating any special revision, e.g. any major road developments.

At the 1″ scale innovation was equally rapid. The economy War Revisions – rapidly produced versions of fourth or fifth-edition sheets in limited colours and heavily over-

[17] Ordnance Survey terminology has changed here. Until World War II the word '*edition*' usually referred to maps (at a given scale) made to a common design. Its use in this context is now replaced by '*series*'; edition is now used to define a *re-edited* version of a published map, not a *redesigned* version as formerly.

[18] Previously England and Wales, and Scotland had been in separate series. A similar separation was true of the Scottish 1″ series until the advent of the Seventh Series (see below). The history of the Scottish 1″ map is recorded in Harley and Phillips (1964).

printed with the 'War Office' or 'Cassini' Grid[19] – were quickly replaced by a stop-gap sixth or 'New Popular' edition, derived from revised portions of fourth or fifth-edition maps, reissued on new sheet lines and carrying the National Grid. Almost immediately, however, authorization was given for a definitive replacement, the Seventh Series, and the first sheets of this, redrawn onto the National Projection and incorporating many popular innovations,[20] appeared in 1952. Colour was used fairly lavishly (eight at first, later reduced for economy to six) but sheets were *not* square, as were those of all larger-scale series, since at 1″ scale complete indexing, e.g. on the sheet binding, presented no problem. As mentioned earlier a range of 9 special tourist sheets were also published in more elaborate form.

The announcement in 1965 of a Government programme for metrification spelt the ultimate end of the 1″ map series in Britain and its replacement by a new map at a metric scale. After considerable market research into user opinions and requirements the scale of 1 : 50,000 was finally chosen (others were considered) but to prevent a difficult transition period the First Series of this map was envisaged as a 'stop-gap' measure, essentially based on a photographic enlargement of the 1″ series but including certain basic changes which could be retained in the redesigned and redrawn definitive Second Series. The most notable of these changes related to sheet lines and colour. Sheets are now 40 km square (though unrelated in lineage to the sheet lines at larger scales) whilst the rather striking colour changes represent a move away from traditional blacks, greys and browns to greater use of low intensity colours in the blue to yellow range which interfere less with other detail – e.g. the use of orange for 'house-fillings' instead of the previous grey.

As a result of this derived origin the complete transition to the First Series 1 : 50,000 was rapidly effected in the period 1974–6 and already 51 sheets (out of 204) are available in the new Second Series form. Reflecting popular demand this Second Series incorporates many of the symbols for outdoor leisure pursuits formerly found only on special tourist sheets (p. 84), improved motorway symbolization and the addition of French and German explanations in the key. Less spectacular changes are the eradication of the last hand-drawn ornament (e.g. dune symbols) and a new type-face chosen as much for its robustness in printing as for its aesthetic qualities. A less satisfactory feature is the contours which are, in most cases, simply the old 50 foot contours awkwardly relabelled with their metric heights e.g. 137 m, 183 m. However where metric contouring has been completed for larger-scale series, e.g. the Southern Highlands and the London area, Second Series sheets will appear with fully metric contours at 10 m VI and this will gradually be extended until metric contouring is ultimately completed about the mid 1980s.

Many old-established map users will also no doubt regret the removal of civil parish boundaries from the Second Series sheets though these will continue to be shown on the *outline* edition.

---

[19] Though based on the metre this grid is *not* the same as the National Grid; it was derived from the old Cassini projection, not the National Projection.

[20] e.g. new or improved symbols for National Trust property, Bus Stations, Town Halls, AA and RAC telephone boxes, Golf Course Club Houses, etc. Unlike the ambitious fifth (relief) edition, however, only contours and spot heights were used to portray relief.

*(2) Maps at 1 : 25,000 scale and larger*

The new 1 : 25,000 map series recommended by the Davidson Committee was quickly put in hand in the post-war period and by 1956 the First Series covered the whole of Britain except the Highlands and the Isle of Man. More usually described as the 'Provisional Edition' this series was prepared by redrawing from existing maps and appeared as a map with plentiful detail portrayed in only 4 colours – grey, blue, black and orange brown – and with contours at a regular 25 foot VI.[21]

This First Series of the 1 : 25,000 was also the smallest-scale map to have its sheets appear in the recommended square format, the size being 10 km square with the numbering taken from the full 10 km (two-figure) grid reference of the southwest corner (Fig. 59).

Because it is roomier than the 1″, provides a 25′ contour interval, and contains virtually all of the detail of the 6″ map at a fraction of the price of the latter the 'two-and-a-half-inch' map (the scale is actually 2.534″ to a mile) has become extremely popular, not least as a working 'field' or 'record' map. Since 1957, as opportunity arose, sheets of a Second Series have been published, the key factor here being the pre-existence of completely resurveyed 6″/1 : 10,000 maps from which the detail is obtained by photographic reduction or, recently and experimentally, using computer-drawn reduction. The main differences from the older series are the inclusion of a green colour, for woods and rights-of-way (where known, in England and Wales only), a conventional-signs panel and, more noticeably, publication in double format presumably for economy. Sheets of the Second Series therefore appear in joined east–west pairs carrying *both* sheet numbers (e.g. Sheet SK 83/93), the western sheet of the pair being the one whose number begins with an even digit. Publication of the Second Series is, as yet, only partly complete but has extended this scale into parts of the Highlands not previously covered; the remaining area not yet mapped at 1 : 25,000 scale is indicated on Fig. 58. In addition slightly more elaborate versions have been published as Outdoor Leisure maps in certain very popular tourist areas.

The post-Davidson transformation of the 6″ series, as with the 1″ map, has been somewhat complicated by metrication. The first post-war development of the 6″ map was a reissue of the old county sheets in 'Provisional' form, i.e. revised and with the National Grid 'adjusted' (see p. 167) onto them, but these have now been replaced everywhere, except in part of the Southern Highlands (see Fig. 58) by sheets of the National Grid Series, each 5 km square, covering a quarter of the area of one 1 : 25,000 sheet and numbered therefrom (see Fig. 59). Within this series however there is variation. About half the country is still covered by 'Provisional' National Grid series sheets, which are no more than the old County Series cut up into new sheet lines, revised and republished with a minimum amount of redrawing; in other areas where there has been resurvey for larger-scale maps (or at 6″ scale itself in areas such as the Highlands where there are no larger-scale maps) there have appeared the fully redrawn sheets of the 'Regular' series which, from 1969, have appeared at 1 : 10,000 scale rather than the former 6″ (1 : 10,560). Style and content of these Regular sheets is not dramatically different from that of the old County series, except with regard to contours. The variability of these on the County Series has already been referred to (p. 88) and on Regular sheets the old contours have

---

[21] The lack of contours over large areas of the 6″ maps in the Highlands was, apparently, one reason why the First Series did not extend into much of that region.

been supplemented and/or revised (usually using air photography) to produce *surveyed* contours at 25 foot VI. On the 1:10,000 series however, these have their heights labelled in metres not feet and on recently produced sheets, where new contour information is available, a 'new generation' of contours is found at 10 m VI in mountainous areas, 5 m VI elsewhere.

At 1:2,500 scale the transition has not proceeded quite so far. In the areas shown on Fig. 58 resurvey, by a combination of aerial and ground techniques, has led to the production of the new *National Grid Series* sheets, 1 km square and numbered by the 1 km (four figure) grid reference of the southwest corner, though they are usually published in double format (see Fig. 59). Changes in style from the older maps are negligible; house-numbers were included (from 1959), spot heights are given in metres (from 1969) and parcels, renumbered from the national grid and not by parishes, show areas in both hectares *and* acres. For certain areas, however, (see Fig. 58) the old county series still remains in use and, since these are almost always rural areas, sheets may be forty years or more out of date.

The same resurvey which has produced the new 1:2,500 sheets has also been used to produce a new 1:1,250 series for most urban areas of more than about 10,000 population (Fig. 58). Sheets are 500 m square with grid lines at 100 m intervals but in style these series closely resemble the 1:2,500 except that parcel numbers and areas are not included.

The transition to a (by now) 30-year-old vision of an integrated series of maps, with interrelated sheet lines, one projection and one grid is the dominant, but by no means the only, current theme in British official mapping. No less important for its ultimate implications, perhaps, is another emerging trend formalized in a Parliamentary Statement in 1973 and involving a reappraisal of the financial aspects of Ordnance Survey production. Implicit here is the aim of increasing revenue from users and limiting Exchequer support, and several developments arising from this new approach have already been encountered. For example there is now no general obligation on the Ordnance Survey to publish maps at 1:1,250 and 1:2,500 scale *printed on paper*; publication in other forms is now permissible, having regard to the needs of users, income and proper economy, and maps issued in magnetic tape or as printouts from microfilm are one result of such a policy (though as yet traditional paper forms continue to be available as well). Another result is even sharper reaction to market demand and potential. More intensive market research and improved content at small scales reflect this, so too does the introduction of SUSI – Supply of Unpublished Survey Information. Adoption of continuous revision of large-scale maps as recommended by the Davidson Committee (p. 134), has already done much to ensure the availability of more up-to-date maps, at least in urban areas, but users may now obtain, on demand – and of course on payment adequate to cover the full cost of providing the service – printouts of additional more recent information, e.g. partial revision, where this has been carried out and is already available for internal use though not yet published.

The types of change described in this account of the history and recent developments of British official map series are not unique to Britain. Changes similar to those related here could be found in the histories of many other map series, particularly in areas such as Europe where the pressing need to establish 'basic' cover at scales of 1:100,000 or larger, was usually met some while ago. The change from hachures to contours and hill-shading, the increased use of colour and 'popular' symbols, the integration of sheet lines and the change to a more accurate projection and its associated grid are widespread and in some respects further advanced than in Britain, e.g. the adoption of the UTM grid (see p. 165).

1:25,000 Cover in these areas

Key to Large Scale Cover

| 1:2500 Cover | 1:10,000/1:10560 Cover |
|---|---|
| Natl. Grid | Natl. Grid |
| County | Natl. Grid |
| County | County |
| None | Natl. Grid |
| | County |

 1:1250 Cover also

* 1:2500 County series will not be replaced by 1:2500 National Grid series in these areas

No 1:25,000 Cover 'beyond' (i.e. generally to west of) this line or in area marked 'N'

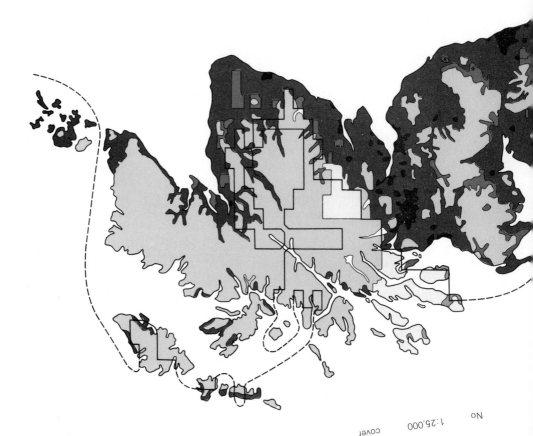

No 1:25,000 cover

N

**Fig. 58:** Coverage of Great Britain by Ordnance Survey maps at scales greater than 1 : 50,000, 1977. County Series will be gradually replaced by National Grid series except where indicated. (Compiled and redrawn with some generalization from Plate 1 of the Annual Report of the Ordnance Survey 1976–7 with the sanction of the Controller of H M Stationery Office, Crown copyright reserved.)

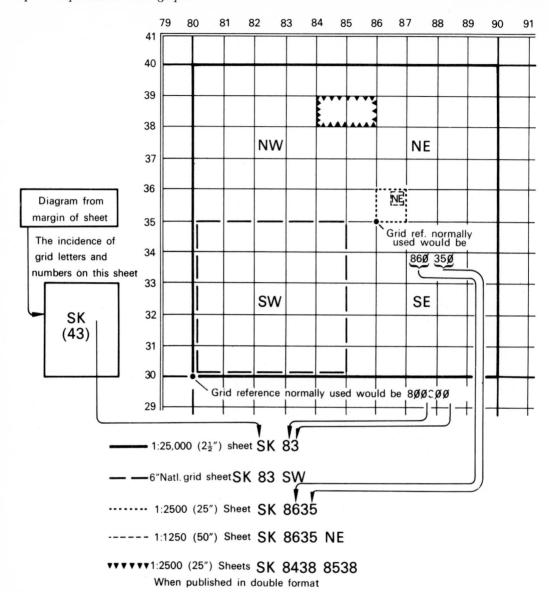

**Fig. 59:** Sheet lines and method of numbering of 1 : 25,000 (2½″ to a mile), 6″/1 : 10,000, 1 : 2,500 (25″ to a mile) and 1 : 1,250 (50″ to a mile) National Grid Series Ordnance Survey maps.

But let this one national example suffice. If the first two sections of this book have any single main comment to make it is that representation of the earth's surface is never a static subject, nor can it be so long as technologies improve and users continued to expand and vary their demand. Enough has been said here to give an understanding at least of the principles and forces underlying these changes. Let us now reorient our investigations, and take a look instead at the usefulness of the finished products rather than their evolution.

# Part III
# Using the Image – Working with Maps and Air Photographs

# Chapter 8

## Scale and Scales

*A Preliminary Note – Purchase of Maps and Air Photographs*

Before one can work on maps or air photographs one must first obtain them. Maps of one's own country are easily obtained, either via local agents or, in case of difficulty, from the national mapping agency itself. Maps of foreign countries can also usually be purchased direct from the national mapping agency of that country, but to avoid unaccustomed foreign currency transactions it is often easier to obtain them through internationally known map agencies such as Edward Stanford Ltd., 12–14 Long Acre, London, WC2 or Geocenter, International Landkartenhaus, D 7000 Stuttgart 80, Honigwielstr. 25. The catalogues published by both firms – *International Maps and Atlases in Print* (2nd Edn, 1976) and *GEOKatalog* (2 volumes) respectively – provide the most comprehensive guide available to both official and privately published map series for all the countries of the world.

Obtaining air photographs is not quite so straightforward a procedure since coverage is divided much more significantly than with maps into that flown by commercial firms, on contract to particular clients (who usually in consequence impose royalties), and government departments including official mapping agencies and military or air-force authorities.

In Britain details of both Ordnance Survey and Royal Air Force photo coverage can be obtained from the Department of the Environment (England and Wales) and the Scottish Development Department. Current addresses are:

Air Photo Unit,                     Air Photographs Library,
Prince Consort House,         Room 1/21,
Albert Embankment,   and   New St Andrew's House,
London, SE1                       St James' Centre,
                                    Edinburgh

Prominent commercial firms, who may be able to provide privately flown cover both of the UK and of extensive areas abroad are:

BKS Surveys Ltd, Cleeve Road, Leatherhead, Surrey;
Fairey Surveys Ltd, Reform Road, Maidenhead, Berks;

Hunting Surveys Ltd, Elstree Way, Boreham Wood, Herts;
Meridian Airmaps, Marlborough Road, Lancing, Sussex.

A map 'Status of Aerial Photography' showing coverage of all areas of the United States photographed by all the various government agencies, together with a limited number of state, city and private agencies, is obtainable from Map Information Office, US Dept of the Interior, Geological Survey, Washington, DC 20242, though the cover itself must usually be obtained from the agency responsible.

In a wider context it is worth remembering that maps produced from air photographs usually give some details of these (e.g. date, scale, agency) in the margin, while many maps produced by the British Directorate of Overseas Surveys actually mark, with a cross, the principal point of each photograph together with sortie and print numbers, so that the map acts additionally as an index diagram.

Enquiries to any agency concerning air-photo coverage should indicate the range of dates or scales which are acceptable and clearly define the area of concern, either by providing a sketch map or adequate grid references.

Before planning extensive use of maps or air photographs it is also sensible to look ahead at the cost. Large-scale maps are attractive for many purposes but the large number of sheets involved may make them very expensive, and at any scale air photographs are usually a good deal more costly than maps, especially if full stereo cover is required. Whilst prices in Britain cannot necessarily be regarded as 'typical' the table below gives some indication of the cost-variation which may occur.

*Approximate Comparative Cost of Map and Air Photo Cover at different scales
for a 10km × 10km area in the United Kingdom (1977)*

All costs are expressed as a ratio of the cost of map cover at 1 : 50,000 scale.

| Map Scale | No. of sheets | Comparative Cost | Air Photo Scale | Estimated No. of Prints 9″ × 9″ | Comparative Cost |
|---|---|---|---|---|---|
| 1 : 50,000 | 1 | 1.00 | 1 : 60,000 | 1 | approx   1.00 |
| 1 : 25,000 | 1 (20 km × 10 km) | 0.88 | 1 : 20,000 (a) | 6 | approx   6.00 |
| 1 : 10,000 | 4 | 9.50 | 1 : 10,000 (a) | 15 | approx  15.00 |
| 1 : 2,500 | 50 (2 km × 1 km) | 375.00 | 1 : 10,000 (b) | 9 | approx   9.00 |
| 1 : 1,250 | 400 | 2,100.00 | | | |

(a) full stereoscopic coverage
(b) non-stereoscopic coverage

Note: Table for maps assumes 'paper flat' format and either 1 full sheet or the minimum possible number of sheets after that. Table for air photos assumes minimum possible number of 9″ × 9″ prints with overlap as in Fig. 27, p. 58 for stereoscopic cover, and is based on current cost of official cover. Privately produced cover may be up to twice as expensive, or even more. It does not follow that cover exists at the scales shown everywhere in Britain.

# Scale and Scales

No other single feature of a map or air photograph is so important as its scale. With maps, as Chapter 5 shows, scale controls the area available for representation of detail and so affects design and appearance, and a similar relationship exists in air photographs, though working through legibility rather than total content. Even more importantly scale expresses the relationship between the size of an object on the ground and its image on the map or photograph, enabling measurements made on one to be restated in terms of the other. It is with these practical 'measuring' implications of scale that this chapter is primarily concerned.

# Scale on Maps – Varying Methods of Expression

The scale of a map may be expressed in two ways, either in *figures* or in *words*, for example $\frac{1}{63,360}$ and 'one inch to a mile' are merely alternative ways of stating the same thing; to take another example so are 1 : 80,000 and 'one and a quarter centimetres to a kilometre'. The best course is to have the scale of a map expressed in both ways for both have their uses.

The scale in figures, when written as a fraction, clearly indicates that on a particular map all features (unless they are shown conventionally, see Chapter 5) will appear as that fraction of their true size. On the other hand a scale in words may provide a helpful yardstick with which to judge the implications of scale at times when a fraction conveys little: thus $\frac{1}{253,440}$ appears complicated and contrived but when expressed as '$\frac{1}{4}$ inch to 1 mile', puts the average map-user much more clearly into the picture.

Though the fraction is more indicative of the meaning of scale, the scale in figures is commonly encountered written as a ratio, for example $\frac{1}{100,000}$ is written as 1 : 100,000, and it is useful to remember that the latter is merely a more convenient way of writing the former. Whether written as a fraction or a ratio, this means of expressing the scale is called the *representative fraction* (RF for short) of the map. Unfortunately the dual form of the scale in figures, whereby it may be written as a fraction on one hand and as what seems to be a whole number on the other, may cause some confusion when calculations involving scale have to be made and for this reason this book introduces a new device, the *scale factor*.

*The scale factor is the number which must be used in all calculations concerning scale*, and can be defined as either *the denominator of the scale written as a fraction* or *the second part of the scale written as a ratio*: for example in maps at scales $\frac{1}{40,000}$, and 1 : 75,000 the scale factors are 40,000 and 75,000 respectively.

*Converting a Scale in Words to a Scale in Figures and Vice Versa*

If a map does not carry its scale expressed in both figures and words it may be necessary to convert from one form to the other. The process is simple and is derived from what is perhaps the most 'fundamental' map formula of all namely

Ground distance = Map Distance × Scale Factor (GD = MD × SF) *so long as map detail is shown true to scale and is not conventionalized in any way.*

This formula can of course be rearranged as either

$$\text{Map Distance} = \frac{\text{Ground Distance}}{\text{Scale Factor}} \text{ or Scale Factor} = \frac{\text{Ground Distance}}{\text{Map Distance}}$$

(Note: There need never be any confusion about these formulae if it is remembered (i) that the scale factor is a number *not* a fraction and (ii) that the map distance will always be smaller than the ground distance. The arrangement of the three elements in the first formula then follows automatically. Notice too that though SCALE (as a *fraction*) is obviously $\frac{\text{Map Distance}}{\text{Ground Distance}}$ SCALE FACTOR is the inverse of this i.e. $\frac{\text{Ground Distance}}{\text{Map Distance}}$

*In any scale conversion two of the three basic elements in the equation will always be known and the proceedure is simply:*

Step 1. Identify the two known elements and define them *in the same unit of length; choose the smaller of the two units if they are expressed differently.* This will also identify the unknown third element.

Step 2. Insert these two known values into the appropriate formula and find the unknown third one. Some examples will make the point clear.

1    *Converting a Scale in Words to a Scale in Figures*

*Example:* Express 4″ to 1 mile as a scale in figures

Step 1:    Expression means 4″ on *map* = 1 mile on *ground*

∴ map distance = 4″
ground distance = 1 mile = 63,360″
missing element is Scale Factor

Step 2:    Scale Factor $= \dfrac{\text{Ground Distance}}{\text{Map Distance}} = \dfrac{63{,}360''}{4''} = 15{,}840$

Scale in figures is therefore 1 : 15,840 or $\dfrac{1}{15{,}840}$

It does not matter if the scale in words uses 'mixed' units

*Example:* Express 1 centimetre to 1 mile as a scale in figures
Step 1:    Reasoning as above

Map distance = 1 centimetre
ground distance = 1 mile = 63,360″ = 63,360 × 2.54 cm = 160,934 cm
(1 inch = 2.54 cm)
missing element is scale factor

*Step 2:*   Scale Factor = $\dfrac{\text{Ground Distance}}{\text{Map Distance}} = \dfrac{160,934 \text{ cm}}{1 \text{ cm}} = 160,934$

Scale is therefore 1 : 160,934 or $\dfrac{1}{160,934}$

2   *Converting a Scale in Figures to a Scale in Words*

Notice (a) that when the scale is expressed in words the ground unit may sometimes come first, sometimes second, and (b) that it is *still necessary to express everything in the same units*. The process is otherwise identical:

*Example:* Express 1 : 1,000,000 as so many (*x*) miles to an inch
*Step 1:*   Expression means so many miles on *ground* to 1 inch on *map*
∴ *ground* distance is *unknown* = *x* miles = 63,360 *x*″
map distance = 1″
scale factor = 1,000,000
*Step 2:*   Ground Distance = Map Distance × Scale Factor
63,360 *x*″ = 1″ × 1,000,000
$x = \dfrac{1,000,000}{63,360″} = 15.8$

The scale is therefore 15.8 miles to an inch

*Example:* Express 1 : 1,000,000 as so many (*x*) inches to a mile
*Step 1:*   Expression means so many inches on *map* to 1 mile on *ground*
∴ *map* distance is *unknown* = *x* inches
ground distance = 1 mile = 63,360″
Scale factor = 1,000,000
*Step 2:*   Map Distance = $\dfrac{\text{Ground Distance}}{\text{Scale Factor}}$
*x* inches = $\dfrac{63,360″}{1,000,000} = 0.06336$
Scale is therefore 0.063″ to 1 mile

*Scales in Common Use*

The scales most commonly used for maps in different parts of the world derive essentially from two groups. In countries using British linear units scales are commonly based on so many inches to a mile, which give awkward numbers when expressed as a representative faction; in countries using the metric system scales of so many centimetres to a kilometre usually also give RFs with convenient round numbers, for example 2 cm to 1

km gives an RF of 1 : 50,000. As the accompanying table shows, many scales common on one system are only roughly comparable with those on the other.

*Comparison of Common 'British' and 'Metric' Map Scales*

| METRIC SCALES | BRITISH SCALE | INCHES TO A MILE | | KM TO 1 CM |
|---|---|---|---|---|
| 1 : 1,000,000 | | 0.063 | (15.78  miles to an inch) | 10 |
| | 1 : 253,440 | 0.25 | ( 4      miles to an inch) | 2.534 |
| 1 : 250,000 | 1 : 250,000 | 0.2534 | ( 3.95   miles to an inch) | 2.5 |
| 1 : 200,000 | | 0.3168 | ( 3.156  miles to an inch) | 2.0 |
| | 1 : 126,720 | 0.5 | ( 2      miles to an inch) | 1.267 |
| 1 : 100,000 | | 0.6336 | ( 1.578  miles to an inch) | 1.0 |
| | 1 : 63,360 | 1 | | 0.6336 |
| | | | | CM TO 1 KM |
| 1 : 50,000 | | 1.267 | (0.789   miles to an inch) | 2 |
| 1 : 25,000 | 1 : 25,000 | 2.534 | (0.395   miles to an inch) | 4 |
| | 1 : 10,560 | 6 | (0.167   miles to an inch) | 9.49 |
| 1 : 10,000 | | 6.336 | (0.158   miles to an inch) | 10 |
| 1 : 2,500 | 1 : 2,500 | 25.34 | (0.0395  miles to an inch) | 40 |

*Using Scale to Measure and Plot Distance*

This is one of the principal uses of scale on a map. Once again the basic formulae used above are needed:

Ground distance = map distance × scale factor
**Map Distance** = ground distance ÷ scale factor

and as before it will be found best to convert everything into the same small units, for example inches or centimetres, if an accurate answer is required.

*Example:* How wide should a 40 foot roadway appear when shown on a 1″ to 1 mile map?

*Step 1:*    Express the scale of the map in figures = 1 : 63,360.

*Step 2:*    Using the formula: map measurement = ground measurement ÷ scale factor we get map measurement = 40′ ÷ 63,360 = 480″ ÷ 63,360.

The answer, 0.008″, emphasizes incidentally the extent to which roads must be shown conventionally on all but large-scale maps, and serves again as a reminder that the formulae used so far are only correct so long as map detail has *not been conventionalized.*

In using the second of the two formulae, to convert from map measurements to ground measurement, difficulties sometimes arise if distances on the map must be measured along a sinuous line such as a winding road or stream. If the line is not too sharply curved it can be measured by treating it as a series of straight or nearly straight sections whose length can be accumulated on a piece of tracing paper by the method described below.

Draw a straight line on a piece of tracing paper and place it over the map with one end

of the line at the beginning of the section which is to be measured and the line itself lying along the first section. Place a sharp pencil at the point where the first bend occurs and, holding this steady, pivot the paper round until the line lies along the second section; transfer the pencil point to the next marked bend, and so on until the whole distance has been measured.

For more sharply curved lines it may be easier and quicker to use a map measurer or *opisometer* which can be bought at most good shops which sell drawing equipment. Two types are in common use, both requiring a small wheel to be pushed along the route which needs measuring. In the first type the wheel drives a pointer which moves round a dial, recording the distance travelled in inches or centimetres; in the second the movement of the wheel propels it along a threaded axle. With the latter when measurement is complete the distance traversed is found by placing the opisometer on a ruler or scale line and pushing it in the opposite direction until the wheel has returned to its starting point at one end of the axle.

Even with aids of this kind it is in fact not at all easy to make accurate measurements along very sinuous lines on maps of small scale and it is a sensible precaution to obtain the very largest-scale map possible so that curvatures are reduced and measurements made more accurately.

### Scale Lines (Scale Bars)

On most well drawn maps it will not be necessary to calculate ground distance, for the map will carry a scale line enabling this to be read directly. An example of such a scale line, which may be single or double, i.e. calibrated in more than one unit of length (in miles and kilometres for example), is shown in Fig. 60A, which illustrates also the manner of subdivision. Notice that two types of division, *major* and *minor*, are usually found but that only one major division is actually subdivided. This is at the left-hand end of the scale line; zero is placed at the right-hand end of this division – one unit in from the end of the scale – and the subdivisions are numbered to read *backwards* from zero, so that map distances which are not a whole number of major units long can be read off directly.

For decorative reasons scales are often shown 'diced', as in Fig. 60A, but this is not essential and a simple calibration, as in Fig. 60B will often give easier and more accurate readings.

### Construction of a Scale Line

It is sometimes necessary to add a scale line to a map which does not already have one, or to provide a loose scale for use on several maps of the same scale. The essential steps in this procedure are indicated in Fig. 60B but it should be noted that a small preliminary calculation is necessary before work can begin. This is needed to determine the overall length of the scale line in major units. In most cases a maximum length for the scale line will be set by the space on the map which is available to contain it, and the calculations are made to determine the greatest *whole* number of major units which will fit into this space. The process is perhaps best illustrated through an example.

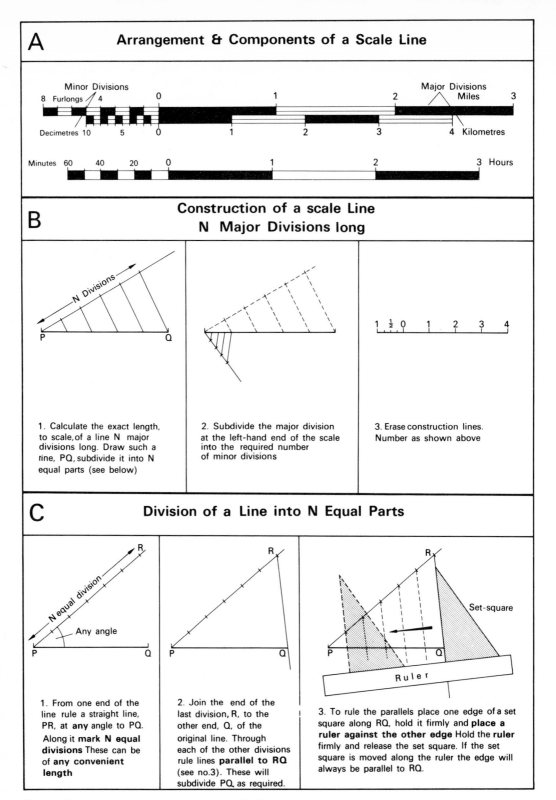

**A**

## Arrangement & Components of a Scale Line

Minor Divisions

Major Divisions

8 Furlongs 4    0        1        2    Miles   3

Decimetres 10   5   0     1     2     3     4   Kilometres

Minutes 60   40   20   0     1     2     3   Hours

**B**

## Construction of a scale Line
## N Major Divisions long

N Divisions

P        Q

1. Calculate the exact length, to scale, of a line N major divisions long. Draw such a line, PQ, subdivide it into N equal parts (see below)

2. Subdivide the major division at the left-hand end of the scale into the required number of minor divisions

1 ½ 0   1   2   3   4

3. Erase construction lines. Number as shown above

**C**

## Division of a Line into N Equal Parts

R

N equal division

Any angle

P        Q

1. From one end of the line rule a straight line, PR, at **any** angle to PQ. Along it mark **N equal divisions** These can be of **any convenient length**

R

P        Q

2. Join the end of the last division, R, to the other end, Q, of the original line. Through each of the other divisions rule lines **parallel to RQ** (see no.3). These will subdivide PQ as required.

R

Set-square

P        Q

Ruler

3. To rule the parallels place one edge of a set square along RQ, hold it firmly and **place a ruler against the other edge** Hold the **ruler** firmly and release the set square. If the set square is moved along the ruler the edge will always be parallel to RQ.

**Fig. 6o:** Construction and arrangement of scale lines.

*Example:* Preliminary calculation for drawing a scale line with major units of one mile for a map at 1 : 40,000 scale. The space available for the scale line is 8″ long.

*Step 1:* Calculate *roughly* the length, to scale, of one major unit (i.e. one mile in this case). Using map measurement = ground measurement ÷ scale factor, we get map measurement = 1 mile (63,360″) ÷ 40,000 = 1.5″ approximately.

*Step 2:* Decide how many major units the space will contain. At about 1.5″ per mile an 8″ space will take only five *whole* units; the scale line must therefore be five major units, i.e. *five miles long.*

*Step 3:* Calculate *exactly* how long this will be at the scale of the map. The same formula as in step 1 gives us:
Map measurement = 5 miles (316,800″) ÷ 40,000 = 7.92″.
Rule a line this length and proceed as in Fig. 60B.

This method of construction introduces a most important principle found in many aspects of accurate map work, namely that for accuracy's sake it is important to work from the whole to the part. By setting out the complete length of the scale and subdividing it, the only *measuring* error could be one in setting out the original length, and subdivision would reduce its effect in individual units. A scale line should never be drawn by calculating the exact length of one major division, setting this on a pair of dividers and stepping off this measurement as often as is required. By so doing any error in the setting of the dividers will be repeated and will accumulate as the scale increases in length.

There is, of course, no virtue in following elaborate constructional techniques when the major divisions of a scale are simple quantities which can be marked off from a good ruler, for example on a 1 : 50,000 map major divisions of 1 km would be exactly 2 cm long and could be marked out directly in this way.

*Time Scales*

If a uniform rate of travel can be assumed it may sometimes be more useful to measure journeys on a map in time rather than distance and particularly so where the average speed is not a convenient whole number, for example $3\frac{1}{2}$ miles per hour, which is a reasonable walking speed. For this purpose a time scale can be constructed, similar to a line scale but with major divisions of one hour instead of a unit of distance. The construction procedure is very similar to that of a line scale and needs the same preliminary calculations:

*Step 1:* Calculate *approximately* (a) the length of 1 mile on the map and then (b) the *approximate* map distance equivalent to 1 hour's travel.

*Step 2:* Use this approximate length to decide how many major units (i.e. hours) the space for the scale can contain.

*Step 3:* Calculate *exactly* the ground distance equivalent to this number of hours' travel and the exact length of this ground distance on the map. Mark off this distance and subdivide as in Fig. 60B.

An example of a time scale is illustrated in Fig. 60A.

# Scale on Air Photographs – some general considerations

Scale on an air photograph is not quite so straightforward as scale on a map, a fact which has already been suggested in Chapter 4 when displacements present on air photographs were discussed. These displacements were originally termed 'distortions' and the term reminds us that we do not talk about *distortions* on a *map*: if we did we should automatically assume that this implied that the scale of the map differed from place to place – and so it is on an air photograph. It is not difficult to see why. In real life the 'scale' at which we see anything depends on how far away it is, so that a man 100 metres away appears smaller than a man 10 metres away. Similarly on an air photograph, since hill tops are nearer the camera than valley bottoms they will appear at a slightly larger scale.

*Determination of Scale on Vertical Air Photographs*

The corollary of all this, of course, is that *there is no such thing as constant scale on a vertical air photograph*, unless it be one covering a completely flat area. When, therefore, we refer to an air photograph as being at (say) '1 : 20,000 scale' it must be understood that this is no more than a generalization and that on the photo itself scale will vary somewhat about that figure. Fortunately it is a very simple matter to determine what this *general* scale is. Simply use the formula:

$$\text{Approx. photo. scale } (\textit{as a fraction}) = \frac{f}{H} \text{ or better (if possible) } \frac{f}{H-h}$$

where $f$ = focal length of the camera lens, $H$ = altitude of the aircraft and $h$ = mean or approximate altitude of the area within the photograph. Both $f$ and $H$ are usually recorded on the titling strip at the top of the photograph; $h$ of course is not and would have to be known from other information such as a map. In using the formula it is important to ensure that *all elements are in the same units*, e.g. inches or centimetres. $f$, the focal length of the camera, is (in general terms) the distance within the camera from the lens to the film, and is usually measured in inches or millimetres; $H$ and $h$ are more usually in feet or metres, hence this word of caution. Fig 61A shows how the formula has been derived: since ground length $G'G''$ has been reduced to photograph length $P'P''$, the photograph scale (as a fraction) will be $\frac{P'P''}{G'G''}$. Because the triangle $P'P''L$ and $G'G''L$ are similar triangles we shall get the same fraction as $\frac{P'P''}{G'G''}$ by comparing *any* pair of corresponding lengths in the two triangles – the perpendicular heights for example – so that we can write $\frac{P'P''}{G'G''} \quad \frac{PL}{GL} = \frac{f}{H}$. Since $H$ is derived from the aircraft's altimeter it refers, of course, to the *absolute* height of the plane, whereas the geometrical relationship just calculated really refers to the height of the plane above the ground, hence the preferable modification

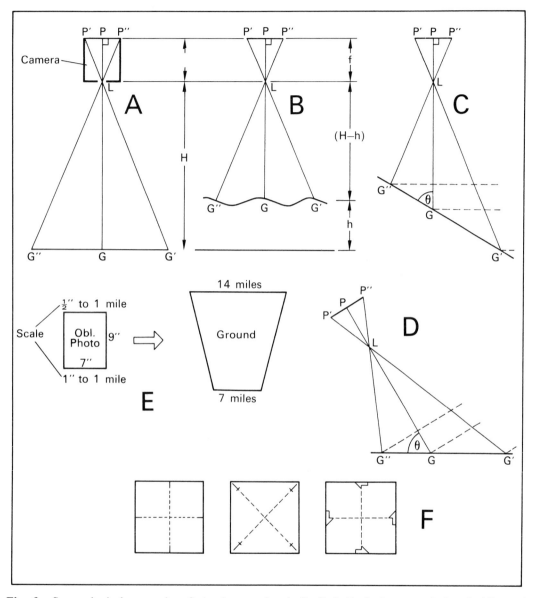

**Fig. 61:** Some physical properties of air photographs. **A, B, C** & **D:** Scale on vertical and oblique air photographs. **E:** Ground coverage of oblique air photographs. **F:** Principal point, plumb point and isocentre on oblique air photographs. **G:** Examples of collimating marks.

to $\dfrac{f}{(H-h)}$ as shown in Fig. 61B. In Fig. 32 the titling strip gives the information $f = 14''$, $H = 5,800'$ whence

$$\text{approx. photo. scale} = \frac{14''}{5800 \times 12''} = \frac{1}{4971}$$

the obvious intention here being to produce an air photograph of about $1:5,000$ scale.

If a more exact impression is needed of scale in any part of an air photograph (or alternatively if some indication of range of scale variation is needed) this can be determined by comparing the measured distance between two points on that photograph with the distance separating these same two points on the ground or (more conveniently) on a map of known scale. Consider length AA which measures $0.188'$ on Fig. 32A and $0.084'$ on a $6''$ ($1:10,560$) map of the area. Since:

ground distance = map distance $(D_m)$ × map scale factor $(S_m)$

and also, by analogy,

ground distance = photo. distance $(D_p)$ × photo. scale factor $(S_p)$

We can write therefore:    $D_m \times S_m = D_p \times S_p$, or

$$\text{photo. scale factor } (S_p) = \frac{\text{map distance } (D_m) \times \text{map scale factor } (S_m)}{\text{photo. distance } (D_p)}$$

In this case then $S_p = \dfrac{0.084 \times 10,560}{0.188} = 4,718$, and

the scale of the photograph obtained by measuring AA is therefore $1:4,718$.

For length BB in Fig. 32A, however, the corresponding values are $D_p = 0.336'$, $D_m = 0.157'$, giving $S_p = 0.157 \times 10,560 \div 0.336 = 4,934$ – a photo. scale of $1:4,934$ produced by the fact that BB is measured along a valley floor some 200 feet below the length AA on the hillside above. In comparisons of this sort the results will be more useful if (as here) measured lengths run *along* relief features rather than across them.

### Scale on Oblique Photographs

So far only vertical photographs have been considered but we can reason from these to what happens on an oblique. As Fig. 61D shows the scale relationships on an oblique will be exactly the same as those on a vertical photograph of a steeply sloping hillside (Fig. 61C), i.e. scale at $G''$ (foreground) is greater than scale at $G$ (middle ground) which is also greater than scale at $G'$ (background). In the case of an oblique, however, the scale differences may be very large indeed, far more than those on a vertical, and this has important effects on the area covered by an oblique photograph (Fig. 61E). Suppose that the foreground scale of an oblique is about $1''$ to a mile while the background scale is only $\frac{1}{2}''$ to a mile, then a $7'' \times 9''$ *rectangular* photograph would cover an area 7 miles wide in the foreground but 14 miles wide in the background, marking out a *trapezoidal* area on the

ground. This trapezoidal coverage makes oblique air photographs instantly recognizable on sortie plots and visual proof of its existence can be seen in Fig. 31B (p. 63).

*Practical Measurement of Distance from an Air Photograph*

For reasons just described this is, strictly speaking, impossible unless map cover of the area exists to provide exact scale determination, in which case there would probably be no need to derive scale measurements from the photographs anyway. However since many, if not most, air photographs are flown to produce a 'general scale' corresponding to some round number e.g. the 1 : 5,000 example above, one simple method, so long as near approximations to distance will suffice, is to use a scale line at this general scale value. Such a scale line can either be constructed directly as above or copied from a suitable map.

The elimination of scale variation, and the resultant possibility of making measurements as accurately as on any map, is of course one of the fundamental features of the orthophotograph.

# Chapter 9
## Defining and Determining Position

The need to define position is a frequent requirement when maps are used and the various methods by which this may be achieved occupy the greater part of this chapter; in the last portion of the chapter methods of locating an unknown position are described with respect to both maps and photographs.

## Defining Position on Maps

*Latitude and Longitude*

The familiar ideas of latitude and longitude have been used for centuries to locate the position of a point on the earth's surface or on a map. Latitude is defined as the angular distance of a point north or south of the equator, and is represented on a map by the east–west lines known as *parallels*; longitude is the angular distance of a point east or west of a particular meridian, and appears on maps in the form of the north–south lines of the *meridians*. International or world maps commonly use the meridian of Greenwich Observatory in Great Britain as the basis from which longitudes are reckoned, but many other meridians have been, and still are, used for this purpose on national and local maps. Two examples will suffice. The official Italian topographical maps, published by the Istituto Geografico Militare, show longitudes based on the meridian of Rome (Monte Mario) which is itself 12° 27′ 08″.40 east of the Greenwich meridian. As late as 1914 sheets of the famous Austrian-produced 1:75,000 map series, the foundation of much of the modern mapping of central Europe, were being published with longitudes reckoned from Ferro (the westernmost island in the Canaries), a practice which had been widespread in medieval times and which may have originated in Ptolemy's maps almost 2,000 years earlier when the Canaries formed the westernmost known land.

If a local meridian is used its precise relationship to the Greenwich meridian is normally given in the margin of the map so that conversion of longitude to the international standard can be made; on some maps the margins may be found marked with *two* sets of longitudinal graduation, one referring to a local meridian and one to Greenwich.

One further point needs watching. On maps of French origin latitude and longitude may be found reckoned in *grades*,[1] which are units of angular measure consisting of one hundredth part of a right angle. Each grade is subdivided into 100 *minutes centesimales*, and each minute centesimale into 100 *secondes centesimales*. Angles measured in grades are written with a small $^G$ instead of the $^\circ$ used for degrees, so that it is easy to misread one for the other, particularly since the markings for minutes and seconds are identical on both systems. Apart from this possible confusion the use of grades causes little difficulty. Where they occur map margins are often calibrated in degrees as well, and longitudes may be marked in grades from Paris but in degrees from Greenwich.

### *Defining Position by Latitude and Longitude*

This is done by giving both values. Latitude first is the normal practice and the basis of the longitude should be stated if this is not the Greenwich meridian. For example the position of the Eiffel Tower in Paris may be variously defined as:

| Latitude | Longitude |
|---|---|
| $54^G$ 28′ 60″ N | $0^G$ 04′ 60″ W (of Paris) |
| 48° 51′ 30″ N | 2° 17′ 40″ E (of Greenwich) |

In this example position has been defined not only in minutes but in seconds of arc, which will normally be the case where any degree of precision is necessary. A degree of latitude is an almost constant quantity of about 69 miles, making one minute of latitude rather more than a mile in length and one second of latitude about 34 yards, so that to obtain accuracy of definition comparable to a normal grid reference on a 1 : 50,000 or one inch to one mile map (see page 162), where position is indicated to the nearest 100 metres (109 yards), latitude would have to be given to the nearest 3″ of arc. Longitude is rather different, for a degree here is a variable quantity declining from about 69 miles at the equator to half that distance at 60° N and to zero at the poles, but even so in most parts of the globe definition to about the nearest 5″ would be required.

Defining position by latitude and longitude has several advantages. The system is simple and can be applied without variation to any part of the earth's surface, it is unaffected by map projection, and most topographical maps carry some indication of latitude and longitude whereas not all have a grid, which is the principal alternative method of defining position. (See page 160.)

### *Practical Difficulties in Using Latitude and Longitude to Define Position*

In the field of navigation the ability to determine latitude and longitude astronomically, or by other means, renders them invaluable for locating unknown positions, but outside this sphere of activity they are surprisingly little used. There are several reasons why this is so.

In the first place graduations along the margin of the map are rarely in finer units than a minute of arc, rendering further estimation into rather awkward sixtieths necessary to

---

[1] Sometimes written *grads*, especially in American literature.

get down to seconds. This is not helped by the fact that on many maps indications of latitude and longitude are confined to the margin, and even where lines are ruled across the map these are at intervals too coarse to be of much use; e.g. every 5′ on the United States 1 : 62,500 series and every 10′ on current French 1 : 50,000 maps. On a very few series, such as the British 1″ and 1 : 50,000 maps and the Danish 1 : 100,000 the intersections (only) of selected meridians and parallels are marked on the face of the map by a fine cross. Furthermore, because of the effect of projection, parallels, meridians, or both may appear on the map as curved lines with curvature so slight as to be unnoticeable at scales such as 1 : 25,000 but becoming an increasing nuisance as scale decreases. A final defect of latitude and longitude lies in the rather cumbersome way in which the two-part reference has to be stated; the grid reference is much 'snappier' and more convenient.

### Georef

The disadvantages listed above tend to favour the use of other methods for defining position, but interest in the use of latitude and longitude for this purpose has recently been restimulated, particularly on account of aircraft movements which often range beyond the limits of any one grid. This has led to the evolution of the *World Geographic Reference System*, more commonly known as Georef, which simplifies positional references based on latitude and longitude by omitting the tedious north, south, east and west, degrees, minutes, and seconds of the old description.

The basic ideas of Georef are extremely simple. The world is divided into vertical and horizontal bands each 15° wide and designated by a letter as shown in Fig. 62A. This produces 228 15° quadrangles, each of which is defined by the two sets of letters, the longitudinal letter being taken first, so that Newfoundland and the eastern tip of Labrador, for example, lie in the square JK (see Fig. 62A).[2] Each 15° quadrangle is itself divided into 225 1° quadrangles by vertical and horizontal bands, one degree wide, lettered from A to Q starting at the *southwest* corner of the quadrangle, see Fig. 62B. A 1° quadrangle is identified by four letters, those of the 15° quadrangle in which it lies followed by two letters from the 1° bands, the longitudinal letter being first again. The tiny French island of Miquelon, for example is in the 1° quadrangle JKDC, neighbouring St Pierre in JKDB (see Fig. 62B). Within each 1° quadrangle position is defined by giving the number of minutes of arc by which the point lies first east then north of the southwest corner. Notice that to avoid confusion single figures must be preceded by 0, i.e. 8′ must be written 08′, and that distances are always measured in this way even when the quadrangle lies west of Greenwich or south of the equator. The reference to Cap Miquelon (Fig. 62C) thus becomes JKDC 3908 but if further accuracy is needed another figure, representing tenths of a minute, may be added to each pair (giving JKDC 392088) or, for very precise location, two figures representing hundredths of a minute may be added instead; such accuracy will only rarely be necessary.

[2] The longitudinal letter is taken first in accordance with a principle, fundamental to all modern map reference systems, that *when horizontal and vertical components are present in a reference the horizontal one is taken first*, in normal mathematical usage. The principle has been usefully summarized by Raisz in the mnemonic phrase 'Read RIGHT UP' and is widely used in grid references. It is stressed here particularly because it runs counter to the traditional method of presenting latitude first.

A

B C D E F G H J K L M N P Q R S T U V W X Y Z

CAP MIQUELON JK DC 392088

(39 2 Minutes of Longitude)

(08.8 Minutes of Lat.)

C. Miquelon

MIQUELON

Grand Etang
de Miquelon

Isthmus of
Langlade

LANGLADE

St. Pierre

**Fig. 62:** The GEOREF reference system.

B  Miquelon : 1° Square JK DC

# Grids and grid references

For many map users today the most effective way of defining position is by means of some form of grid reference. Although grids may be found marked on certain older maps, e.g. the famous *Topographischer Atlas der Schweiz* series at 1:50,000 scale, their purpose there was to help the cartographer plot surveyed positions; oddly enough their now widespread use to help the map user define position is little more than half a century old, but they are now being incorporated into most topographical maps, and once this has been done definition of position is speedy and simple.

### Principle of the Grid Reference

Anyone who wishes to use maps, other than those of his own country, should understand the principle from which the grid-reference system is devised. Many map-users fail to realize that the type of grid reference which they normally use may be a purely national device, inapplicable to grids on foreign maps and unfamiliar to a foreigner. Once the principle of the grid reference system is known it will always be possible, using any grid, to produce an internationally intelligible form of reference.

The principle of the grid-reference system could hardly be simpler. Within any rectangular area, such as a blackboard, the position of a point can be defined by giving the distances which it lies in from the left-hand edge of the board and up from the base of the board, as Fig. 63A shows. The idea is an effective one and can obviously be applied to much larger areas than this – the map of a country for example. All that is needed are two lines, one north–south and the other at right angles to it; these correspond to the edges of the board and provided that they intersect somewhere southwest of the area covered by the map, the position of any point can be fixed by giving the distance which it lies *east* of the first of these lines and *north* of the second. All grid references are derived from this principle.

Many of these simple components of a grid have technical names, of course. The two base lines are the *axes* of the grid and their intersection its *origin*; the distances east and north are called the *eastings* and *northings* respectively, whilst the eastings and northings of a point are collectively called its *coordinates*.

### The Spacing of Grid Lines on Maps

To enable coordinates to be read off easily, lines are ruled at regular intervals on the map, marking distances east and north of the origin, and it is the intersection of these two sets of lines which produces the network of squares which most people think of as the grid. The spacing of these grid lines will vary according to the scale of the map, for example contemporary British Ordnance Survey maps use the following spacings:

Map Scales larger than 1:10,000 (i.e. 1:2,500 and 1:1,250 series) – grid lines 100 metres apart.

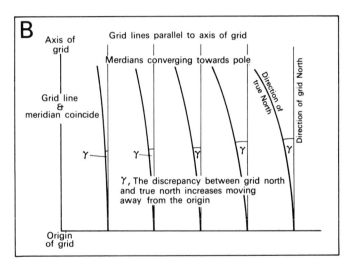

**Fig. 63:** Aspects of grids. **A:** The principle underlying grid references. **B:** Relationship of grid north and true north. **C:** Grids on British military maps of Europe. Several different grids are necessary partly because of the extent of the area which must be covered, but partly also because of the different projections on which the map series covering Europe are constructed. (**C** is reproduced from the *War Office Manual of Map Reading, I, Map Reading* (War Office code 8868), Crown Copyright reserved.)

Map Scales between 1:63,360 (1″ to a mile) and 1:10,000 inclusive – grid lines 1 kilometre apart.

Map Scales smaller than 1:63,360 (1″ to a mile) – grid lines 10 kilometres apart.

The change to the coarser spacing on the smaller-scale maps is necessary to prevent the grid lines producing a 'graph paper effect' and is reflected on Continental maps by a transition from one-kilometre to 10-kilometre spacing at or around the 1:100,000 scale.

For a variety of reasons the metre is usually used as the basis for grid measurements, even in countries which do not use the metric system, but there is no *a priori* reason why this should be so, and other units have been and still are used. The first British Ordnance Survey map to carry a grid (the fifth edition of the 1″ map, published in the 1930s) had grid lines every 5,000 yards, and a similar grid has been designed in zoned form to cover the United States. Alternatively in that country many states have their own grids as well, and these are normally calculated in feet with grid lines every 10,000 feet.

### Grid References

*Giving a grid reference by full coordinates.*   The position of any point on a grid can always be defined by stating its full coordinates, i.e. the full distance which the point lies first east, then north, of the origin. The distance is given in any unit convenient for the markings of the grid. The result may be rather lengthy (see below) but the method works for *any* grid, and will be universally understood.

In practice most grid lines carry only a shortened version of their distance from the origin (usually simply as one, two or three figures for use with grid references, but see below), though the full version is often given against each tenth line or at the corners of the map so that the shortened form can be 'translated'. The distance from the relevant grid line to the point may often be estimated but for accurate work it should be measured, either by using the scale line at the foot of the map or, more conveniently, by means of a *romer*, which may be supplied with the map. Fig. 64 shows a romer and how it is used, the vertical edge parallel to the vertical grid lines, the horizontal edge lying along the horizontal grid line; of course a different romer is needed for each scale.

In Fig. 55 the full coordinates of point X can be seen to be 288,400 m E, 801,600 m N, obtained as follows:

| (1) | Appropriate grid line east | $= {}^{2}88 =$ | 288,000 m E of origin |
|---|---|---|---|
|  | Distance from grid line east | $=$ | 400 m |
|  | Full easting coordinate |  | 288,400 m E |
| (2) | Appropriate grid line north | $= {}^{8}01 =$ | 801,000 m N of origin |
|  | Distance from grid line north | $=$ | 600 m |
|  | Full northing coordinate |  | 801,600 m N |

This method of fixing position by full coordinates was, for example, the standard German method, and instructions for doing this and a romer were printed on each map; there was no equivalent of the British form of grid reference on German maps until UTM grid references were introduced (see below).

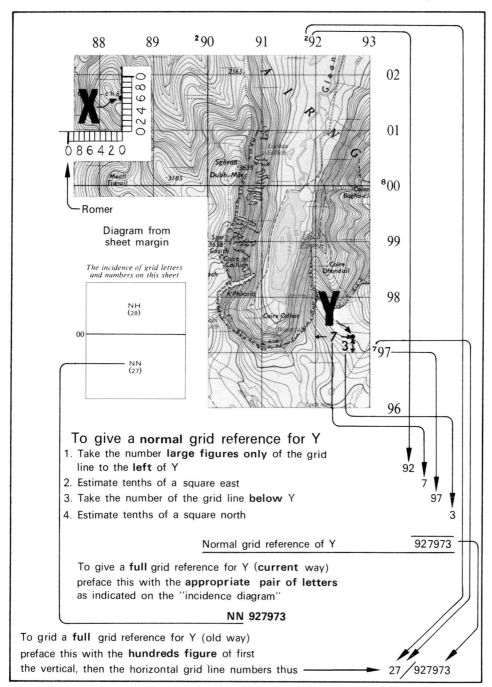

To give a **normal** grid reference for Y

1. Take the number **large figures only** of the grid line to the **left** of Y
2. Estimate tenths of a square east
3. Take the number of the grid line **below** Y
4. Estimate tenths of a square north

Normal grid reference of Y      927973

To give a **full** grid reference for Y (**current** way) preface this with the **appropriate pair of letters** as indicated on the "incidence diagram"

**NN 927973**

To grid a **full** grid reference for Y (old way) preface this with the **hundreds figure** of first the vertical, then the horizontal grid line numbers thus ⟶ 27 / 927973

**Fig. 64:** Definition of position by the British method of normal and full grid references, as used on Ordnance Survey maps. (Reproduced with the sanction of the Controller of H M Stationery Office, Crown copyright reserved.)

Because position defined in terms of full grid coordinates is just as long and tedious to write as a detailed latitude and longitude position, shorter and simpler versions have been devised. These are the ordinary grid references. The method described next is the one current in Britain but other methods are developing and will be described later.

*The British method of giving a normal grid reference.*     This is illustrated and summarized in Fig. 64. Though written as a single number all grid references are essentially composed of two parts, the first half deriving from an easting and the second from a northing – a fact which should be remembered whenever a grid reference has to be read back or modified.

How effective in defining position is the method in Fig. 64? For example, how accurate is it? On the 1″ map, which forms the basis of Fig. 64, grid lines are one kilometre apart and since estimation was made to the nearest tenth of this the result will be accurate to the nearest tenth of a kilometre, i.e. to the nearest 100 metres. The accuracy of a reference is often indicated in its description, and this might be described as the normal 100-metre grid reference of point Y. With a 1 : 250,000 map, where grid lines are at 10-kilometre intervals, estimation would produce the normal one-kilometre grid reference.

As a further test of effectiveness we may ask if the normal grid reference is unique, and here the answer is obviously no. As Fig. 55 shows, the large figures printed against the grid lines increase only to 99, reverting then to 00, so that every one-hundred squares (in this case 100 kilometres) east and west of point Y there will be other grid lines numbered 92 and the same with grid lines numbered 97 to north and south of Y as well. At any of these points there could be a position whose grid reference would be 927973; in the whole of Britain there might be perhaps twenty places with a normal grid reference of 927973[3] but none will be nearer to point Y than 100 kilometres (62 miles) and unless there is any serious danger of confusion, the normal reference will suffice.

*The British method of giving a full grid reference.*     If it is essential to define the position of a point uniquely then the full and not the normal grid reference must be used. To do this the current practice in Britain is to use the '00' grid lines to divide the country into squares of 100 kilometre side; each of these squares is then allotted two letters (Fig. 65) which, when placed in front of the normal grid reference turn it into the full form. Point Y in Fig. 64 lies in square NN and its full grid reference is therefore NN 927973. The letters appertaining to all 100-kilometre squares in the area covered by a map are given in a small diagram in the margin of the map[4] and this diagram has been incorporated into Fig. 64. The rectangle represents the area of the map and shows that all points above the 00 line (representing the 00 grid line on the map) are in square NH, those below it in square NN.

Fig. 65 also shows how the 100-kilometre squares get their two letters. Blocks of twenty-five such squares form 500-kilometre squares within which each square is lettered A to Z, omitting I, and the 500-kilometre squares are themselves envisaged as part of a 'super-

---

[3] Oddly enough at only two of these places – a church at Guide Bridge near Manchester and a suburban street in Wolverhampton – does the 1″ OS map show any definite feature.

[4] Military maps often have the letter printed boldly on the face of the map as well as in a marginal diagram. Speed and elimination of possible error underlie this practice.

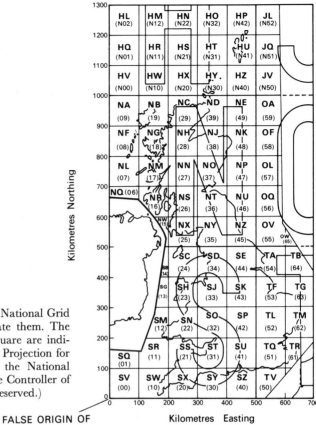

**Fig. 65:** The 100-km squares of the British National Grid and the letters which are used to designate them. The figures formerly used to designate each square are indicated in brackets. (Reproduced from 'The Projection for Ordnance Survey Maps and Plans and the National Reference System', with the sanction of the Controller of H M Stationery Office, Crown copyright reserved.)

FALSE ORIGIN OF
NATIONAL GRID

block' of twenty-five squares each of which also has a letter. For example, most of Scotland and Northern England are in 500-kilometre square N whose letter prefixes that of each constituent 100-kilometre square, giving NN, NH in the example above. For reasons to be explained later no grid is likely to extend beyond this 'super-block', and the method also explains why, for example, square NZ should have squares NU, NY, OV and SE as its neighbours.

*Former method of giving a full grid reference.*    Using letters is one way of stating in which 100-kilometre square a point lies. An alternative way would be to incorporate into the reference some aspect of the hundreds figure relating to each grid line, thus differentiating [2]92 from all the other 92s and so on. This idea was the basis of the method formerly used in Britain for full grid references; but instead of adding the hundreds figures directly to the normal reference, they were treated separately first so that the full grid reference of point Y would have been written 27/927973 and *not* 29277973.[5] A moment's thought will show

[5] This latter form was in fact used several years ago but was dropped to avoid confusion between a *full* reference from a grid with 10-km squares and a *normal* reference from a grid with 100-m squares.

that within each 100-kilometre square the same two figures will always occur in such a grid reference and these figures, which also defined each 100-kilometre square, are shown in brackets in Fig. 65. They may also be found similarly printed in the sheet numbers of some Ordnance Survey maps, for example many of the post-war 1 : 25,000 sheets.

### Grids on Maps

Just as Georef has provided a world-wide reference system based on latitude and longitude, so the UTM system does the same for the grid reference; but before the basis of UTM can be fully understood, we must consider what happens when a grid is imposed on a map series covering a wide area. There are only a few points to be noted and they are easily understood.

*Grid lines and north.*　　All grids begin with a north–south line from which eastings are measured, but this is, in practice, the only true north–south line of the grid, i.e. the only line to correspond with a meridian. Fig. 63B shows why this is so. The parallel form of the grid lines and the converging form of the meridians produces a small difference between the direction of grid north (i.e. the direction of the 'vertical' lines of the grid) and true north, this difference increasing as one moves away from the origin of the grid. This is not a serious handicap but it is inconvenient. It will be explained later that it is very convenient to have grid lines which run nearly north–south, and if the discrepancy between grid north and true north is to be kept within reasonable limits, a grid cannot go on indefinitely. It is for this reason that, when a grid is applied to a map series covering a large area, one grid cannot cover it all; instead when the discrepancy between the two norths becomes intolerable one grid stops and another, based on a new origin further east or west, begins. Only the east–west extent of the grid is critical and therefore grids for large countries such as the United States are broken into a series of narrow north–south *zones*. Fig. 63C shows the extent and arrangement of some of the many grids which were used on British Military maps of part of Central Europe.[6] Because grid boundaries do not necessarily coincide with sheet lines it is quite possible to find a map on which two grids meet, though this causes no difficulty. A line on the map marks the junction and references are given on whichever grid is used in that part of the map. Most grids have a name, for example Danube Zone Grid in Fig. 63C, and it is always wise to give the name of the grid used in any reference; in Britain we do this automatically when we speak of the National Grid reference.

*False Origin.*　　The increasing discrepancy between grid north and true north as one moves away from the origin, makes it desirable for the origin to be in the centre of the area covered by the grid. Unfortunately, if the origin is to have coordinates 0,0 only a quarter of the area of the map could then lie north and east of it and negative values would have to be introduced for points lying south or west of the origin. To avoid this

---

[6] It also provides another example of the arrangement of letters for the 100-km squares. For reasons best known to the military authorities the lettering of the twenty-five 100-km squares in each block does not always start with A, e.g. lettering starts with L in the Italy Zone grid (see square wL) and with F in the Nord de Guerre Zone grid (see square wE at the bottom right-hand corner of the block).

happening, the grid is drawn exactly as above but the origin is given coordinates large enough to ensure that, working back from these to the new 0,0 lines, all the area covered will lie north and east of them. The new point 0,0 is called the *false origin* of the grid, but for all grid reference purposes it behaves exactly as if it were the real origin. In the British National Grid the true origin was given coordinates of 400,000 m E and 100,000 m N and it is the 400 km east grid line which runs truly north–south; the false origin lies somewhere south and west of the Scilly Isles (see Fig. 65) and it is on this point that all British grid references are based.

### Grids and Projection

Grids are closely related to the projection on which a map series is drawn. Chapter 1 showed that projection influences the shape of an area as it appears on a map, whereas a grid at any given scale has a constant shape. If, therefore, two identical grids were placed over two maps of the same area and scale, but drawn on different projections, the grid lines would pass through different places on each map and grid references on each would be quite dissimilar. Wartime one-inch maps of Britain carried a grid looking very much like the National Grid but related instead to the Cassini projection on which those maps were drawn; when post-war redrawing of the maps onto the Transverse Mercator projection began, the New National Grid, based on this projection, brought different grid references which were useless on the old maps, and vice versa. This is a further reason for including the *name* of the grid in any grid reference.

### UTM, The Universal Transverse Mercator Grid System

This recent attempt to provide a world-wide grid-reference system is little known as yet in Britain, for there has been no attempt to incorporate it onto British Ordnance Survey maps which have such a fundamental relationship to our own National Grid. However elsewhere, and especially on the Continent, its influence is spreading rapidly and instructions for giving references in this form are now incorporated into many European topographical maps.

The preceding section has indicated that no one grid could cover the whole world, which must consequently be divided into narrow zones six degrees of longitude wide. The sixty zones are numbered and, as Fig. 66 shows, each is divided, between 80° north and south, into twenty lettered bands eight degrees of latitude high (see Fig. 66). The quadrangles of 6° longitude by 8° latitude which these produce are designated by a number and a letter, for example 18R, and these form the first element in any full UTM reference.

The second portion of the reference is derived from two letters given to a 100-kilometre square which is formed by drawing a map of each zone[7] on the transverse Mercator projection and constructing on it a grid of 100-kilometre squares. The rather complicated manner in which these squares are lettered is shown in Fig. 66; the arrangement is due to a desire to increase the distance between squares with identical letters which, in practice, recur at distances of 18° longitude (approximately) and either 4° south or 14° north

[7] Not, it should be noted, for each 6° × 8° quadrangle. In fact two grids are drawn for each zone, one covering the area north, the other south, of the equator.

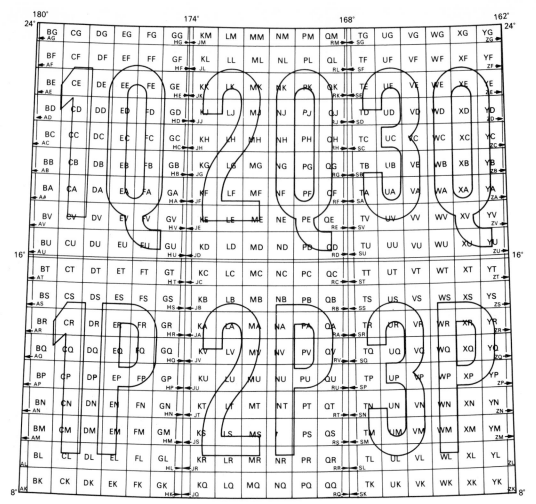

**Fig. 66:** The 'numbering' of squares in the Universal Transverse Mercator Grid. (Reproduced from E. Raisz, *Principles of Cartography*, 1962, by permission of McGraw-Hill Book Company.)

latitude (approximately). All maps on which the UTM system is incorporated indicate in the margin both the designation of the zone and the letters appropriate to the 100-kilometre squares appearing on that map.

The third portion is simply a grid reference given in the normal way within the 100-kilometre square. An example will suffice. For the map which forms the basis of Fig. 70 (p. 173) the marginal information indicates that the sheet falls in zone 18R and that the letters of the 100-kilometre squares are TE west of the 300 m E grid line and UE east of that line. The full UTM grid reference of Grunt Cay (Fig. 70) is therefore 18R TE 936377. The first portion 18R prevents any possible confusion arising from the repetition of the letters of the 100-kilometre square but it is often omitted where no confusion would arise and the normal UTM reference of Grunt Cay would be TE 936377.

The Polar Regions, which are not included in the UTM system, are treated on similar lines but using a grid based on the more convenient stereographic projection; this is properly called the Universal Polar Stereographic Grid system.

*Adjusting maps onto UTM.*    At first sight it would appear that before the UTM system can be introduced all maps must be redrawn onto the transverse Mercator projection. This would be an expensive and time-consuming task, and it is fortunate that the necessity for it can be overcome by a slight technical adjustment. It is possible to calculate through which points the grid would pass if the area *were* re-mapped on the transverse Mercator projection, to plot these points on the existing map, whatever its projection, and to draw in through them the 'adjusted' grid lines. Of course the 'adjusted' grid lines are not straight lines because they are distorted by the existing projection, but curvature is so slight that it is neither noticeable nor troublesome. The maps of several West European countries and of the United States are beginning to be amended in this way and the margins of these maps often carry markings for two grids, one the original grid based on the maps' own projection and the other an 'adjusted' UTM grid. Naturally only one (sometimes neither) is marked on the face of the map but care is always needed to prevent the 'mixing' of grid references or the use of the wrong grid.

### Grids at Different Scales

When the maps of a country at different scales are all drawn on the same projection it is a simple matter to impose the same grid on all of them. Even where projections differ, however, the same grid can still be imposed on all map series by 'adjustment', as has just been described and as in fact was done to impose the British National Grid on the early post-war 1″ and ¼″ maps. Either way this produces the important result that, with slight qualification, grid references made on one map will be equally intelligible on maps of other scales as well. 'In practice the grids on the various maps will not be identical, for we have seen on page 158 that on smaller-scale maps the grid-line spacing is increased. Even so a grid with the same axes and origin will be used, and so far as a reference by full coordinates is concerned there is no reason why identical answers could not be obtained from all maps, though it would be difficult at small scales to match the accuracy of coordinates measured on large-scale maps.

Although differences in the spacing and numbering of grid lines prevent identical grid references being obtained from all maps, we obtain instead references which are similar and easily adapted for use on other maps. Fig. 67 illustrates some of these points. Examination of the portion of the 1:10,000 map covering the same area as the one-inch map in Fig. 67 would reveal that the grids on each are identical in numbering and position and would therefore give the same grid reference for any point. With the 1:250,000 map however the grid is different – it has ten-kilometre squares not one-kilometre squares – but inspection shows that the grid line '2' of the 250,000 map in Fig. 67 is identical in position with grid line '20' of the one-inch, just as the '7' is with the '70'; in other words this is the grid of the one-inch and 1:10,000 maps but with only every tenth grid line shown and numbered with one figure instead of two in the margin.

Consider now the grid reference to Halliman Skerries (Fig. 67); on the 1:250,000 map

**Fig. 67:** Grids and grid line numbering at different scales: portions of the Ordnance Survey 1″ to a mile and 1 : 250,000 maps of Lossiemouth, Grampian. (Reproduced with the sanction of the Controller of H M Stationery Office, Crown copyright reserved.)

this would be either 2172 or 2272.[8] Because there are ten grid lines on the one-inch map to every one on the 1 : 250,000 map, the 'two and one-tenth east', which we estimated on the 1 : 250,000 map will be represented by the line '21' on the one-inch; in the same way the 'seven and two-tenths north' becomes '72' so that the positions 2172 and 2272 on the 1 : 250,000 map are represented by points X and Y on the one-inch. The reference to these points we should give at 1″ scale as 210720 and 220720. It is clear now why there was a choice of reference on the quarter-inch map; Halliman Skerries is at neither point, the greater accuracy of the one-inch map allowing us to place it at 214722, at least so far as its approximate centre is concerned. The references are then:

| | |
|---|---|
| 1 : 250,000 | 2172 or 2272 |
| one-inch | 214722 |

They are similar, but not identical and simple rules can be devised to allow conversion from one form to the other.

(1) To convert from a reference made with ten-kilometre squares to one suitable for use with a grid with one-kilometre squares, divide the reference into two halves and add 'o' to each half. The new reference will only rarely represent the actual point in question but it will be within half a kilometre of it and will usually allow identification; for example 8643 becomes 860340.

(2) For the reverse operation again, divide the reference into two halves and bring each to two significant figures; thus 616323 becomes 6232.

*Identifying a Position from a Grid Reference*

Again the rules are simple.

(1) If the reference is a *full* one, identify the 100-kilometre square by its letters or numbers. This may need an index map of the grid for the whole country if the general position is not known (index diagrams of this sort are sometimes included on small scale maps, e.g. on the folded cover of former British 1″ and ¼″ maps); it will then be necessary to obtain the appropriate topographical map covering this 100-kilometre square.

(2) Divide the reference into two halves and ignore the last figure in each half. The remaining figures, whether one, two or three in number, will be found written against first a vertical and then a horizontal grid line and these should be identified.

(3) When these are found, use the last figure in each half to estimate tenths eastwards and northwards.

(4) If the map being used for identification has grid lines spaced differently to the map which provided the original reference, then its grid lines will have either less or more figures written against them than will be produced in stage (2) above. If this is so, the original reference will have to be modified according to the rules just described immediately before this section.

*Other methods of defining position – squares.*　　A network of squares of any convenient size and with rows lettered and columns numbered (or vice versa) is often drawn on maps to

---

[8] Where it is difficult to decide which reference may be the correct one, either may be given with little danger.

help the defining of position. Nothing more can be said, of course, than that a point lies in square L7 or P3, satisfactory enough if the object is unique or relatively prominent but of little use in other cases. Two-inch squares of this kind formed (apart from latitude and longitude) the only means of defining position on Ordnance Survey maps before a grid was introduced in the 1930s.

*Range and township.*     In much of the United States west of Pennsylvania, Kentucky and Tennessee, another form of reference system is sometimes found, arising from the method used by the General Land Office to survey and divide the land which at one time formed part of the public domain. In these areas, arranged around a base meridian and base parallel, land was divided into six-mile-square blocks known as *townships*, each of which was subdivided into one-mile-square *sections*, numbered 1 to 36 in zig-zag fashion as shown in Fig. 68. Section and township boundaries are marked on United States topographical maps, as too are section numbers. The six-mile-square townships are

**Fig. 68:** The Range, Township and Section method of defining portions of land, as used in certain parts of the United States. Rather similar systems are also used in parts of Canada.

regarded as being arranged about the base meridian and parallel in vertical rows called *ranges*, and horizontal rows called, rather confusingly, *townships*; so that a six-mile-square may be designated as Township 6 North, Range 1 West, or T6N R1W for short, these designations being also marked in the margin of the map.

*Bearings.*    A simple, and certainly very ancient way of defining the position of a point is to state its relationship to some other known object. Two components are needed – direction and distance. Distance may be stated in any convenient unit (metres, miles, hours' march, etc.) and direction was, for centuries, related to the points of the compass: the four cardinal points were further subdivided into 32 minor points thus allowing definition of direction to within $11\frac{1}{4}°$, or within $2°\ 49'$ if quarter-points were used.

Compass-point directions are too coarse for accurate work however, (to say nothing of their awkward and rather confusing terminology), and they have largely been replaced today by bearings, in which direction is indicated as *an angle measured clockwise from north.* Other variations on this theme are obsolete and should be avoided. For example, $30°$ E of N is today simply a bearing of $30°$ whilst $40°$ W of S and $5°$ W of N become $220°$ and $355°$ respectively.

*True north.*    The phrase 'measured clockwise from north' in the above definition needs some qualification, for in practice three different 'norths' are commonly used for this purpose. Strictly speaking there is only one north, the *true north*, which can be defined as the *direction of the North Pole at any point*, or, since the meridians run from pole to pole, the *direction of the meridian at any point*, this latter definition being the most suitable one for map work. Bearings measured relative to true north are called *true bearings*.

*Magnetic north.*    The true north has one great defect – there is no convenient way of determining its position in the field.[9] When bearings must actually be measured in the field true north is supplanted by another north, magnetic north, which may be defined as *the direction in which the compass needle sets at any place.* Bearings given relative to magnetic north are called *compass bearings* or *magnetic bearings*.

*Grid north.*    When bearings have to be plotted on a map it is convenient to have the direction of 'north' marked as often as possible on the face of the map. For this reason the lines of the grid are often used as a third north, grid north, defined as *the direction of the 'vertical' grid lines at any point.* Angles measured relative to these lines are called *grid bearings*.

*Magnetic variation (or declination).*    Because the earth acts as a gigantic magnet whose north (magnetic) pole is somewhere in northern Canada, the direction of magnetic north and true north rarely coincide at any point. Instead they differ by a small angle called the magnetic variation (or sometimes the magnetic declination). On Fig. 69 lines called *isogonal lines* join places of similar magnetic variation and indicate its amount throughout the world in 1965. Notice that magnetic north may lie east or west of true north and that the difference may be up to $26°$ in certain parts of the world, and much more than this in the Polar regions where the compass is a relatively unreliable indicator of the direction of north.

Furthermore the earth's magnetic pole is not fixed but moves about slowly over a period of time. As it moves the direction of magnetic north throughout the world moves with it, so that magnetic variation changes not only from place to place but from time to

[9] In the northern hemisphere the pole star is only a crude guide and may be up to $1\frac{1}{4}°$ away from true north.

**Fig. 69:** World distribution of curves of equal magnetic variation (Isogonal lines), 1965. (Drawn after Admiralty Chart, 5374, Crown copyright reserved.)

time as well. The change in the direction of magnetic north due to this movement is somewhat irregular at any point over prolonged periods of time, but over short periods it is small and fairly predictable.

There are then two pieces of information which are needed before magnetic north can be used on any map. These are (1) the magnetic variation, which will be given for the date at which the map was drawn, and (2) the annual change in this to allow the present magnetic variation to be calculated. This information should be found in the margin of the map: Fig. 70 indicates how it is used.

*Variations in grid north.*    The varying relationship between grid north and true north has already been studied (see Fig. 63B). The small inconstant angle which separates them is sometimes called the *convergence* and its amount will also be indicated in the map margin.[10] If it is not, draw in any meridian which cuts a vertical grid line and measure the angle between them.

*Sheet north.*    On some maps a fourth north, sheet north, is defined. It is the direction of the east and west margins of the sheet where these are formed neither by grid lines nor meridians. Its relationship to at least one other form of north will be stated in the margin.

[10] It is sometimes given the symbol *γ*. Current practice on British OS maps is to give the value four times, i.e. for each corner of the sheet. Values for any position may be found by interpolation, though differences in practice are very small. Note that it is increasingly becoming the practice on European maps to relate magnetic north *directly to grid north*.

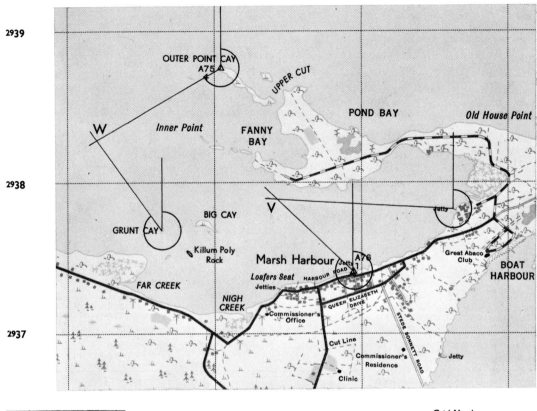

**Fig. 70:** Determination of position by bearings: the map used is a portion of the Grand Bahama and Abaco, sheet 26, Bahama Islands 1 : 25,000 Series. This illustration is also used to indicate the information (which is also printed on these maps) relating to the UTM grid reference system. (Reproduced with the sanction of the Controller of H M Stationery Office, Crown copyright reserved.)

*Plotting bearings on maps.*    Many map users appreciate the theoretical differences between the three types of bearing but fail to see the practical implications of this. The matter is simple. Magnetic bearings come from field observations and are not usually used for plotting on maps; for this purpose they should be converted to grid bearings, or true bearings if the map has no grid.

It is essential therefore to know how to convert one form of bearing into another form for any map sheet, and this is almost always best achieved by means of a diagram as illustrated in Fig. 70. The difference between the various norths is not difficult to establish; confusion begins for many people in deciding whether to add or subtract this amount when going from one north to another. The easiest way to settle this is to add to the diagram the direction of a theoretical point X. Mark in the bearing to X from all three norths and it will be obvious which bearing is biggest and whether to add or subtract the difference (see Fig. 70).

Before bearings can be plotted or measured at any point on the map, the direction of a suitable north through that point must be known. For grid north draw in through the point a line parallel to the nearest vertical grid line (see Fig. 70); for true north draw in from marginal markings the two meridians nearest to the point, and then add through the point a line 'parallel' to these, making any necessary allowance for convergence or curved lines.

### Defining a known position by bearing and distance

The procedure is simple. Plot the position on a suitable map and join it by a straight line to any other point which can act as a 'reference' e.g. some nearby rapidly identifiable point feature. The bearing of this line can easily be identified as the angle at which it crosses *any* north–south grid line (grid bearing) or any merdian (true bearing).[11] The distance can simply be measured off against the scale line in the margin of the map.

# Determining Position on Maps and Photographs

Closely related to the processes just described is the parallel requirement of determining on a map the *unknown position* of a point which is being occupied, for example for field observations, or is of interest because it appears on a photograph. Several methods are available to fit particular situations.

### Determining position by cross bearings

In theory any unknown position can be fixed as above by bearing and distance; its bearing is observed from some known reference point, from which its distance can also be measured. In practice such a simple solution is rarely possible; distances are always difficult to measure, sometimes impossibly so, e.g. across water, and a much simpler approach

[11] Provided some *nearby* reference point is chosen the convergence of the meridians can be ignored.

is to use *cross bearings*. Bearings onto the object in question must be taken from *at least two* points (simultaneously if the object is moving), and when these are plotted on a map their intersection fixes the position of the object.

Fig. 70 provides an example of this and also of the stages needed to convert from one type of bearing to another: it should be remembered that bearings taken in the field will usually be magnetic bearings, while those plotted on a map will usually be grid bearings.

*Example:* In January 1966 a vessel approaching Marsh Harbour jetty was simultaneously observed from there and the jetty near Great Abaco Club. The compass bearings taken onto the vessel were 314° 30′ and 275° 0′ respectively. What was the position of the vessel?

*Step 1:* Determine the relationship between magnetic north and grid north for this map in January 1966. This is best done as recommended by drawing a diagram and gives magnetic north as lying 1° 40′ W. of grid north. Bearings to X marked in this diagram indicate the formula: Grid Bearing (GB) = Magnetic Bearing (MB) − 1° 40′.

*Step 2:* At Marsh Harbour rule a line through the jetty parallel to the nearest vertical grid line. This marks grid north at the jetty. Convert the 314° 30′ magnetic bearing to a grid bearing by subtracting 1° 40′ and plot the resultant bearing of 312° 50′ relative to grid north.

*Step 3:* Repeat this process at the second jetty where GB will be 275° 0′ − 1° 40′ = 273° 20°. The vessel lies at V, the intersection of the two lines.

*Determining position by back bearings.*     This is perhaps a commoner requirement than the fixing of position by cross bearing, but the method is derived directly from that process using back bearings. Whenever a bearing has been taken along a particular line, the back bearing is the bearing which would result by looking along the same line of sight but from the opposite end. It is therefore 180° different from the bearing and the formula is *back bearing = bearing ± 180°*.[12]

From any unknown point bearings to known positions can be observed but not plotted; if, however, we convert these to back bearings, we shall get the bearings looking along these lines of sight in the reverse direction, from the known position to the unknown, and can then fix the unknown position by cross bearings. An example will suffice.

*Example:* In January 1966 compass bearings were taken onto Outer Point Cay and Grunt Cay from a vessel approaching Marsh Harbour. The bearings were 62° 0′ and 145° 30′ respectively: what was the vessel's position?

*Step 1:* Establish the appropriate relationship between magnetic north and grid north as in the previous example giving the formula: GB = MB − 1° 40′.

*Step 2:* Convert the bearing to Outer Point Cay to a back magnetic bearing: in this case we must add 180° giving back MB = 62° 0′ + 180° = 242° 0′.

*Step 3:* Convert this back magnetic bearing to a back grid bearing by subtracting 1° 40′ thus back GB = 242° − 1° 40′ = 240° 20′.

[12] The ± sign need cause no confusion. In effect it means 'to obtain a back bearing from a bearing, subtract 180° if this can be done without giving a negative result. If not add 180° instead.'

Establish grid north at Outer Point Cay as in the previous example and plot this bearing relative to it.

*Step 4:*    Repeat Steps 2 and 3 for the bearing to Grunt Cay giving back MB = 145° 30′ + 180° = 325° 30′; back GB = 325° 30′ − 1° 40′ = 323° 50′.

The vessel's position is at W, the intersection of the two lines.

*Determining position by observations.*    If no compass is available the position of an observer (or that from which a photograph was taken) can often be identified by observation. The method depends on the simple rule that objects which are in line *on the ground* (or *vertically* in line on an 'ordinary' photograph i.e. one taken on the ground with the camera pointing horizontally) will be in line *on the map*. If two pairs of such objects can be identified on both map and ground (or photograph), straight lines through these pairs of points can be drawn in on the map and the observer's position will be at the intersection of the two lines. In Figs. 71A and B identification of hill A, viaduct B, church C and bridge D on the map allows the lines AB (produced) and CD (produced) to be drawn in; the observer lies at their intersection P. Alternatively the rule can be applied in the reverse direction and used to identify unknown positions observed from a known viewpoint. Fig. 71C shows the essential features of a view up Borrowdale from Castle Head, near Keswick, and Fig. 71D selected features from the 1″ map of the area. An attempt to identify the main summits in the view might proceed on these lines, fixing first the right hand edge of the view and working round:

There are 4 large islands in Derwentwater, the view appears to show only one. This would be impossible, therefore the feature LI in the right foreground must also be an island, Lord's Island, cut by the edge of the photograph; feature X is therefore the unnamed island, and the edge of the photograph can be established fairly certainly: it cuts one island and passes just to the right of the other. The slopes HS beyond the lake must therefore be the craggy flanks of High Spy.

At their foot these slopes pass into a prominent wooded conical hill CC, which must surely be Castle Crag. If this is so, the distant Summit GE vertically above must be in line with it on the map and is therefore Great End (*check*: Great End has a craggy north face and is fronted by a lower rather flat-topped area, Seathwaite Fell. These features – the deep shadow of the crags and the preceding fell SF – can be identified in the view). A vertical line drawn through the furthest summit in the view passes through the edge of SF, just to the left of the wood Z and just to the right of wooded knoll Y. Identification of all of these on the map fixes the line which indicates that the summit must be Scafell Pike.

Working left again similar reasoning identifies the prominent, wooded conical hill KH to the left of Castle Crag as Kings How (checked by its position relative to the wooded twin summit hill W), and alignment with KH identifies the more distant summits G and AC as Glaramara and Allen Crag.

Unless the features are unusually distinctive in shape, identification of distant hills in a view is much more complicated a process than the layman normally envisages, and may well need reasoning and construction lines of this sort before the answers can be obtained with certainty.

**Fig. 71: A & B:** Determination of position by observation and map comparisons. **C & D:** Identification of distant features by observation and map comparison. **C** shows the principal features in the view up Borrowdale from Castle Head, near Keswick in the English Lake District. (Outline traced from a postcard published by J. Arthur Dixon.) **D:** *Selected* detail from the 1″ Ordnance Survey map of the area (Crown copyright reserved).

*Determining the position on a map of detail recorded on an air photograph*

Since air photographs commonly record much more detail of the landscape than do maps, e.g. vegetation boundaries on moorland areas, it is often necessary to transfer positions recorded on one onto the other. However in this case we are usually dealing with *multiple* unknown positions rather than a single unknown position (which has been the general concern of this chapter) and this problem is therefore more appropriate for consideration under 'Amending Maps' in Chapter 11.

# Chapter 10

## Measurement of Area

It is often necessary to measure areas on a map, and for many people this will involve using one of the several manual methods described in this chapter. Such methods are, however, undeniably slow and tedious and it is strongly recommended that if large numbers of areas have to be measured access should be sought to mechanical means such as a planimeter or even a digitizer. Not surprisingly, because of the distortions they contain, air photographs (other than orthophotographs, of course) are not normally used as a basis for area measurements.

*General Aspects of the Measurement of Area on Maps*

Three general points should always be remembered whatever method is used. The first of these is concerned with map projections. Chapter 1 showed that although some map projections (the equal-area or equivalent projections) are specifically designed to represent areas correctly, many other projections distort areas to maintain other properties instead. Most of the projections used for topographical maps (for example the British modified transverse Mercator projection) are not of this equal-area type, but fortunately, at scales such as 1:1,000,000 or larger, discrepancies in area due to projection influence are unlikely to be large enough to cause any difficulty. With atlas maps, however, where both map sizes and scales are smaller, the effect of projection may be quite marked, and with maps of this sort areas should only be measured on equal-area type projections.

The second point centres on discrepancies between map area and ground area. The *true* area of a piece of land is its extent *projected into the horizontal plane*, i.e. as represented on a map; if the land has any slope at all, distances measured on the ground will be greater than those computed from the map[1] and areas will be affected similarly. For example, with a uniform slope of 10°, an area of 1 square mile on the map would have a superficial extent of 1.015 square miles on the ground, and if the slope were 30° the ground area would be 1.155 square miles, which is almost one-sixth more than the map area. This effect, which is only pronounced in very hilly areas, is usually ignored, the 'official' or

---

[1] In surveying, distances measured along slopes are corrected to the horizontal equivalent before being plotted.

map area of a piece of land being always used when areas, densities or similar figures are required.

Conventionalized or generalized detail (such as roads and contours on smaller scale maps) is yet another source of potential map/ground area discrepancies. Where possible therefore areas should be measured on maps which show detail true to scale; in any case larger scales minimize the effects of typical errors in area measurement.

The last sentence anticipates the final point. Whether manual or instrumental methods of measuring are used small errors are inevitable even with careful work. Standard practice is to measure each area at least two, usually three times, and to take the mean of the measurements *provided there is close agreement*. It may also be sensible to shift the measuring 'base' between successive measurements, e.g. with 'strips' or 'squares' and to incorporate overall checks if several individual areas fill a sheet or form a continuous block.

### Manual Methods of Measuring Area on Maps

1 *Straight-sided figures.*     Where boundary lines are entirely straight, additional lines may be added to divide an area into triangles whose areas are calculated from the formula: *Area of triangle* = $\frac{1}{2}$ (*base* × *perpendicular height*). The sum of the areas of the triangles gives the area of the whole figure. Perpendiculars must be constructed in each triangle but the use, as base, of lines common to two triangles will slightly reduce the amount of measurement (see Figs. 72A and B).

2 *Give-and-take lines.*     This method attempts to substitute straight boundary lines for irregular ones by constructing give-and-take lines. These are drawn so that the portions of the original shape left outside them (i.e. 'given away') are balanced by portions of the surrounding area which are taken in (see Fig. 72B), the original shape being replaced by an equivalent polygon whose area can be calculated by method 1 above.

Where boundary lines are roughly rectilinear and not too irregular, quite reasonable results can be obtained from this method, if the give-and-take lines are drawn with care.[2]

3 *The ordinate rules.*     If a polygon is inscribed inside the area to be measured, there will remain around it a number of 'strips' with one straight and one irregular side. The areas of the strips can be found by one of a group of formulae called the Ordinate Rules. These require perpendiculars (the offsets or ordinates) to be drawn at equally spaced intervals along the base of the strip (see Fig. 72C) and their lengths measured. The simplest and most practicable formula for calculating the area of the strips is the trapezoidal rule[3] which gives

---

[2] The author was surprised to find that groups of students measuring an area by this method consistently produced answers very close to those of groups measuring the same area by strips and squares.

[3] Offsets must be numbered as in Fig. 72C, and $O_1$ and $O_n$ may or may not be zero depending on the shape of the strip. For the other formulae in this group, see Debenham, F. (1937) or Monkhouse, F. J. and Wilkinson, H. R. (1952). The method is rather tedious to use whatever formula is adopted, and the author has measured manually many hundreds of areas without ever once having recourse to it.

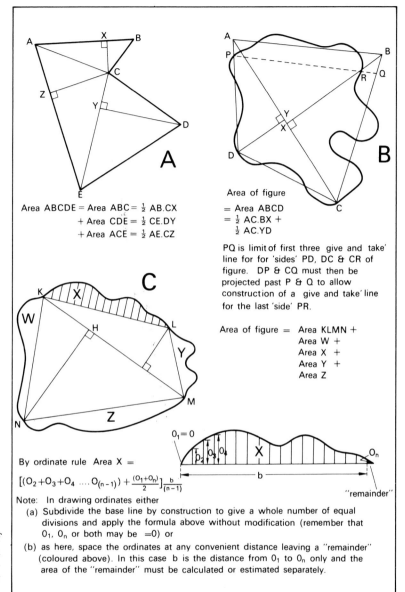

Area ABCDE = Area ABC = $\frac{1}{2}$ AB.CX
+ Area CDE = $\frac{1}{2}$ CE.DY
+ Area ACE = $\frac{1}{2}$ AE.CZ

Area of figure
= Area ABCD
= $\frac{1}{2}$ AC.BX +
$\frac{1}{2}$ AC.YD

PQ is limit of first three 'give and take' line for for 'sides' PD, DC & CR of figure. DP & CQ must then be projected past P & Q to allow construction of a 'give and take' line for the last 'side' PR.

Area of figure = Area KLMN +
Area W +
Area X +
Area Y +
Area Z

By ordinate rule Area X =

$[(O_2+O_3+O_4 \ldots O_{(n-1)}) + \frac{(O_1+O_n)}{2}]\frac{b}{(n-1)}$

Note: In drawing ordinates either
(a) Subdivide the base line by construction to give a whole number of equal divisions and apply the formula above without modification (remember that $O_1$, $O_n$ or both may be =0) or
(b) as here, space the ordinates at any convenient distance leaving a "remainder" (coloured above). In this case b is the distance from $O_1$ to $O_n$ only and the area of the "remainder" must be calculated or estimated separately.

**Fig. 72:** Measurement of area (1). **A:** by division into triangles; **B:** by 'give-and-take' lines; and **C:** by the ordinate rules.

$$\text{Area} = [\,(O_2 + O_3 + O_4 + O_{n-1}) + \frac{(O_1 + O_n)}{2}]\ \frac{b}{(n-1)}$$

b = length of base line
n = no. of ordinates

A large number of perpendiculars gives a more accurate result but will involve more work. The total area of the figure is the sum of the areas of the polygon and the strips.

4 *By strips.*     Carefully used this method will give quite accurate results. A number of parallel lines are ruled on a piece of transparent material and this is placed over the area to be measured, as in Fig. 73A–D.[4] 'Give-and-take' lines are now drawn at right-angles across each strip and the lengths of the strips measured. Where the boundary of the area cuts into, but does not cross a strip as at X in Fig. 73D, either special strips must be ruled and their areas individually calculated, or allowance must be made for such features when give-and-take lines are being constructed. The width of the strips is immaterial, but a narrow strip will give more work and more accurate results; for small areas strips wider than about $\frac{1}{2}$ cm or $\frac{1}{4}''$ would be rather too coarse for good work.

A device known as a *computing scale* is sometimes used to speed up measurement by this method. It consists of a scale along which may be moved a cursor containing a cross wire. The cross wire acts instead of drawn give-and-take lines, and as it is repeatedly moved along to the other end of a strip its progress along the scale line automatically adds up the lengths of the strips.[5]

5 *By squares.*     Many people find this the simplest of the manual methods of area measurement. The area to be measured is covered by a grid of squares, either drawn directly on the map or on a piece of transparent material laid over it and once again the smaller-size, greater-accuracy, more-work relationship holds good. $\frac{1}{10}''$, $\frac{1}{8}''$ or cm–mm graph tracing-paper are excellent for this purpose; alternatively the grid squares of the map may be used either directly or further subdivided for greater accuracy.

The aim is to discover how many squares the area occupies and this total, multiplied by the area of one square, gives the area of the figure. The difficulty and potential inaccuracy in applying this method arises from squares which are only partially occupied and four methods are available to deal with them. These are (1) count *all* partially filled squares and halve the total, (2) count as whole squares all those more than half-filled, ignoring the remainder or, better, (3) find pairs of squares (not necessarily adjacent) which together make a whole square; or (4) find blocks of squares across which the boundary forms a crude diagonal. The last two of these methods have been used in Fig. 73E. The first two methods may obviously produce significant errors if the number of partially filled squares is small.

6 *By counting dots.*     Although the basis of this method is deceptively simple, its successful usage involves some subtle considerations. A grid of dots, at regular, known spacing (sometimes referred to as a *dot planimeter*) is laid over the area to be measured and the number of dots lying within the area is counted; the count multiplied by the area corresponding to one dot gives the area of the figure. In the counting process dots lying 'on the line' can be alternately counted and ignored and the area corresponding to one dot is, in effect, the dot-spacing squared, i.e. for dots at 0.2 cm-spacing 1 dot $= (0.2)^2 = 0.04$ cm$^2$. Counting avoids the 'estimation of bits and pieces' involved with the squares method but in turn the accuracy of the results is obviously considerably influenced by both the spacing of the dots and the shape of the areas, linear shapes in particular being prone either to

[4] Alternatively lines can be ruled on the map itself, of course. The advantage of the transparent material is that the strips can often be re-used.

[5] For a fuller account of the computing scale and its use see Debenham (1937), p. 46.

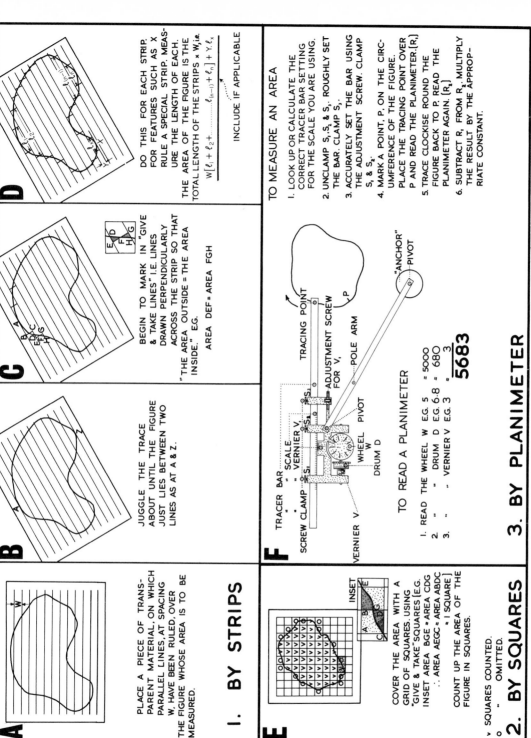

**Fig. 73:** Measurement of area (2): **A, B, C** & **D:** by strips; **E:** by squares; **F:** by polar planimeter.

'catch' or 'just miss' whole rows of dots under certain alignments. Fortunately these aspects have been investigated by Frolov and Maling (1969) who have suggested certain rules for guidance. Practically the most important of these is the need to have a rough minimum of 100 dots in any area to be measured, if comparable accuracy with methods such as polar planimeters (below) is to be maintained. This implies that dot grids of different sizes will be needed, rather than one of constant size, and also that these must be of very fine spacing if small areas are being measured. The table below suggests appropriate dot-grid sizes, which could often be prepared from graph paper. For small areas in particular much tedious counting may be involved, though electronic counting devices such as the Markounter and MK area calculator can help here.[6] However if the item being measured occurs in several discontinuous portions of which only the *total* area is required, e.g. the area under a particular land use or above a given contour, counting can be continuous across all portions of the area, a slight advantage over other methods which require each portion to be measured separately and the results added. Fig. 74 shows an example of the method in practice, and some of its possible weaknesses if 'improperly' designed.

| Approx. Size of areas being measured | Dot spacing | Approx. Size of areas being measured | Dot spacing |
|---|---|---|---|
| 1 sq. cm | 0.1 cm | 0.25 sq. in | 0.05 in |
| 4 sq. cm | 0.2 cm | 1 sq. in | 0.1 in |
| 16 sq. cm | 0.4 cm | 4 sq. in | 0.2 in |
| 36 sq. cm | 0.6 cm | 9 sq. in | 0.3 in |
| 64 sq. cm | 0.8 cm | 16 sq. in | 0.4 in |
| 100 sq. cm | 1.0 cm | 25 sq. in | 0.5 in |

*Converting Map Area to Ground Area*

Unless special precautions are taken (see below) the methods just described give the map area of an object in whatever unit of measurement has been used, for example square inches. This must now be turned into the ground area suitably expressed as acres, hectares, square miles etc. This is done using the formula:

*Ground area = map area × (scale factor)²*

Notice the squared term. We multiply by the scale factor not once but twice, giving an answer which is often literally millions of square inches or square centimetres. Proceed then as follows:

(1) For an answer in square yards or acres, divide the ground area in square inches by 1,296 to give square yards and again by 4,840 to give acres.[7]

(2) For an answer in square metres or hectares, divide the ground area in square centimetres by 10,000 for square metres and 10,000 again for hectares.

[6] The MK Area Calculator is in effect a mechanized version of the method in which the dots are replaced by the intersections of a grid of wires embedded in a plastic sheet. Counting of dots (intersections) is achieved by moving a pencil along a 'horizontal' grid line; a reaction is recorded each time the pencil crosses a vertical grid line.

[7] Land areas in the British system were formerly expressed in acres, roods and square perches. A square perch is $30\frac{1}{4}$ square yards and there are 40 square perches in a rood and 4 roods in an acre – a set of units guaranteed to make even a staunch 'traditionalist' bless the onset of metrication.

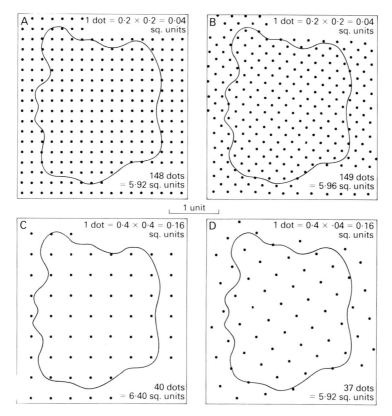

**Fig. 74:** Estimation of area by counting dots. The varying answers serve as a reminder that this is essentially a method for estimating areas by *sampling* and that to avoid gross sampling errors (as in Fig. 74**C**) fine grids which give numerous dots are needed. The error in Fig. 74**C** is also further aggravated by the coincidence of rectangularity between grid and shape.

(3)   For an answer in square miles, ignore the above formula, calculate the scale of the map as $x$ miles to an inch (see page 145) and multiply the map area in square inches by $x^2$.

If the map measurement is in the 'wrong' units convert the answers using the following relationships:

1 sq. mile = 640 acres = 2.588 km²
1 hectare = 2.471 acres; 1 acre = 0.4047 hectares

## Measuring Ground Area Direct

The calculations just described are tedious rather than difficult and they can be avoided. One way of doing this is to make all measurements direct as ground distances by using the map's scale line though this is not a particularly accurate method; the strips and squares methods may also be adapted as described below.

1 *Area direct from strips.*     The following table shows the ground area corresponding to different lengths of strip at various scales. Strips of other widths will give proportional amounts.

| MAP SCALE | ACRES PER INCH OF STRIP | | HECTARES PER CM OF STRIP |
|---|---|---|---|
| | STRIP $\frac{1}{10}''$ WIDE | STRIP $\frac{1}{8}''$ WIDE | STRIP $\frac{1}{2}$ CM WIDE |
| 1″ to 1 mile | 64.0000 | 80.0000 | 20.0803 |
| 1 : 50,000 | 39.8692 | 49.8365 | 12.5000 |
| 1 : 25,000 ($2\frac{1}{2}''$) | 9.9673 | 12.4587 | 3.1250 |
| 6″ to 1 mile | 1.7778 | 2.2222 | 0.5578 |
| 1 : 10,000 | 1.5942 | 1.9923 | 0.5000 |
| 1 : 2,500 (25″) | 0.0997 | 0.1246 | 0.0313 |
| Other scales | $\dfrac{64}{M^2}$ | $\dfrac{80}{M^2}$ | $\dfrac{50}{K^2}$ |

where M = no. of inches to a mile and K = no. of cm to 1 km

2 *Area direct from squares.*     The aim here is to make the squares represent an acre or a hectare in size and this is not difficult to do. An acre laid out as a square has sides 208.71 feet long, so that if the sides of the squares are made this distance, to scale, the squares will represent an acre; for a hectare the square has 100-metre sides.

In practice a small modification is necessary to introduce the principle, already encountered in constructing scale lines (see page 147), of working from the whole to the part to conserve accuracy. The aim is to produce a block of squares for measuring area, the size of this block being determined by the sizes of the area to be measured.[8] The first step, therefore, is to decide how large this block must be, and here it may help to have a rough idea of what an acre and a hectare look like at various map scales; this is given in the table below.

| MAP SCALE | SIZE OF ONE ACRE AS A SQUARE | | SIZE OF ONE HECTARE AS A SQUARE |
|---|---|---|---|
| | EXACTLY | ROUGHLY | |
| 1″ to 1 mile | 0.0395″ | $\frac{1}{25}''$ | 0.1578 cm |
| 1 : 50,000 | 0.0509″ | $\frac{1}{20}''$ | 0.2000 cm |
| 1 : 25,000 ($2\frac{1}{2}''$) | 0.1002″ | $\frac{1}{10}''$ | 0.4000 cm |
| 6″ to 1 mile | 0.2372″ | $\frac{1}{4}''$ | 0:9470 cm |
| 1 : 10,000 | 0.2504″ | $\frac{1}{4}''$ | 1.0000 cm |
| 1 : 2,500 (25″) | 1.0018″ | $1''$ | 4.0000 cm |

[8] It should be rather larger than most of the areas to be measured. Exceptionally large areas can be measured in two portions.

Roughly estimate from these dimensions the number of squares needed in each direction. Suppose a block of 15 squares by 20 squares is needed, then:

1　Calculate the size of this block on the ground if each square is 208.71 feet side (or 100 metres side if hectare squares are needed).
2　Calculate the size of this block on the map, using the formula: Map distance = ground distance ÷ scale factor.
3　Draw out a rectangle of this size on transparent material.
4　Subdivide the sides into the appropriate number of equal parts (see p. 148) and join across.

### *Mechanical Means of Measuring Area* – *(1) the polar planimeter*

A less tedious, and usually quicker, way of measuring areas is to use some mechanical device, of which the most commonly encountered is the polar planimeter.[9] The instrument is illustrated in Fig. 73F and consists essentially of three parts:

1　the *pole arm* at one end of which is a weight having underneath it fine pins that 'anchor' the instrument when pressed lightly into the paper. The pole arm pivots around the centre of the anchor weight.
2　the *tracer bar*, carrying at one end the *tracing point* resting just above the surface of the paper.
3　the *'works'*, i.e. the drum and dials used in reading the instrument. The 'works' portion is usually clamped onto the tracer bar and is attached to the pole arm by a loose ball-and-socket joint, so that the instrument will also 'hinge open' about this joint as it moves around the anchor pivot.

*Reading the instrument.*　　As the tracing point is moved about (see below), the drum, which rests on the surface of the paper, is caused to rotate either backwards or forwards.[10] This movement drives the wheel W by means of a 10:1 worm drive and from these devices a four-figure reading can be obtained as follows:

1　The first figure is read off from the horizontal wheel W graduated from 0 to 9, using the short pointer (see Fig. 73F); take the lower figure when pointer is between two graduations.
2　The second and third figures come from the drum itself, graduated from 0 to 99. The indicator here is the zero of the vernier V.
3　The fourth figure comes from the vernier V. A description of verniers and their use is included below for those not accustomed to these devices.

The makers of some planimeters introduce the term 'major divisions' for the figures obtained from the wheel and the *first* figure of the drum, requiring a decimal point to be inserted after the second of the four figures, but this policy is not universal and the

[9] One of the best descriptions and discussion of the polar planimeter, and some of its simpler 'relatives' rarely seen today e.g. the hatchet planimeter, will be found in Debenham (1937).

[10] Many people using the instrument for the first time are alarmed that the drum moves backwards as well as forwards and sometimes, for short distances, does not move at all. This is exactly as it should be and is allowed for in the theory of the instrument.

author's preference is to have a rough idea of the answer and insert any necessary decimal points at the end of the measurement.

*What a planimeter does.*      It is not at all easy to explain why a planimeter works, but it is very simple to explain how it is used and what it does. Take any irregular shape whose area is to be measured and place the tracing point anywhere on its perimeter, having first anchored the instrument by pressing the anchor-pins into the paper. Read the instrument and move the tracing point clockwise round the perimeter until the starting point is reached again; read the instrument once more and take the first reading from the second. The difference between the two is a number which is *proportional to the area of the figure*, i.e. suppose the difference obtained was 3294, then if the process was repeated with a shape half the area of the first we should get a difference of 1647, and so on.

*'Universal' method of using a planimeter.*      The number obtained above is not, normally, the area of the figure, although instructions with the instrument will often indicate how it can be made so. These instructions are described below, but it may be that they are not suited to the map scale being used, are unsatisfactory or have become lost [11] and whenever these contingencies arise it is worth remembering that any planimeter can always be used in the following manner.

Before measuring the areas concerned rule out carefully a known area, say 10 square inches, and run the planimeter round this. Suppose this gives, for example, a difference of 4620, then because this number is *proportional* to the area measured 1 square inch would have given 0462 and in subsequent measurements for every 462 [12] difference we have 1 square inch of area; therefore dividing the difference obtained by 462 will translate the results into square inches.

*'Correct' method of using a planimeter.*      The length of the tracer bar on most planimeters is not fixed but can be set to different lengths by releasing the clamp screws $S_1$, $S_2$ and $S_3$ (see Fig. 73F) [13]; this affects the readings produced by the instrument. For example the theoretical planimeter which gave 4620 difference for 10 square inches above might, with the same 10 square inches but with *a different length tracer bar*, give 1299 difference [14]; a third setting might produce a difference of 0734 and the possibility now suggests itself that if we could only find the right length for the tracer bar, we might get (still with the same 10 square inches) a difference of 1000, i.e. (if we add a decimal point) the *area direct*. To enable areas to be read directly in this fashion the manufacturers of planimeters therefore calculate the tracer bar lengths applicable to different scales and for different purposes, for example measuring acres or square inches, and supply these in the instructions with each instrument. To enable the length of the tracer bar to be set accurately a second vernier $V_1$ is

[11] e.g. the author regularly uses two planimeters. One is a continental one whose instructions are not concerned with acres or map scales in inches to a mile; in the other the formula given for calculating the settings is erroneous, having a ÷ sign where there should be a ×.

[12] This figure is, of course, purely imaginary and for the purpose of this example only.

[13] Fixed arm models do exist. They are usually designed to read the answer direct in square inches or square centimetres.

[14] The proportional rule will still hold good of course, e.g. for a figure twice the area we should get, with the new setting, a difference of 2598.

added to the instrument (see Fig. 73F), and its zero acts as the pointer for the correct tracer bar setting.

*General rules for using a planimeter*

1　*Always* read the makers' instructions first.
2　Work steadily and carefully. For accurate work, just as with hand methods, each area should be measured two or three times, but time can be saved here by using the second reading of the first measurement as the first reading of the second and so on.
3　Do not try to measure any area so big that the anchor weight must be placed *inside* the perimeter. Results obtained from this practice will be in error because of a feature, known as the datum circle, whose area is not recorded. Divide any such large shapes into sections by one or more straight lines and measure the areas of these separately.

*Vernier scales and their use.*　　A vernier is a small scale placed alongside a larger scale to enable the latter to be read more accurately. Verniers are found in measuring instruments of all kinds, such as accurate barometers, and in surveying instruments where graduations may be in circular measure. Fig. 75 explains their use.

## *Mechanical Means of Measuring Area (2) Digitizers*

The use of digitizers to describe a line by the production of a constant stream of computer-readable coordinates was described in Chapter 6, and it is obvious that if the line is a closed one this information could be used as the basis of a calculation of area by a computer. This is so, but it must be emphasized that ability to use the output to measure area is not an automatic feature of commercial digitizers and it may be necesssary to obtain or write a computer program to produce the necessary output. In some digitizers however measurement of area may be 'dialed direct' from output using an optional attachment.

## *Measuring Areas by Weight*

This rather unusual method may be worth considering if no other means is available and a large number of areas has to be measured; a great deal will depend on whether more than one copy of the base map exists or not, and on the care with which the areas are cut out.

Cut out the areas concerned and weigh them carefully on an accurate balance. Comparison of these weights with that of a known area cut from the same map will allow individual areas to be calculated by proportion.

## *Areas Already Measured on Maps*

Measurement of area can often be eliminated so far as two categories of land are concerned. The areas of administrative units are usually known and recorded in publica-

# Reading a Vernier

Always remember:-

1. That a vernier is a small device placed alongside a scale so that the latter can be read more accurately

2. That the **zero of the vernier acts as a pointer** indicating the point, P, on the main scale, whose value must be found

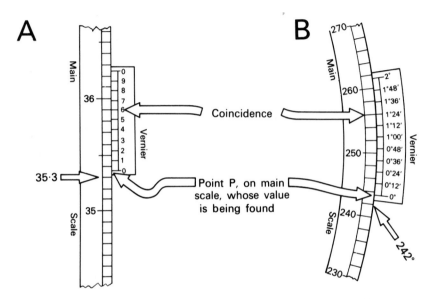

## To Find the Value of P

| | Example A | Example B |
|---|---|---|
| 1. Read the value of the last division on the main scale before the zero of the vernier | 35·3 | 242° |
| 2. **Find a point where a division on the vernier coincides with one on the main scale.** Calculate or read off the value of this division on the vernier | 0·06 | 1°24′ |
| 3. The value of P is the **the sum of the two readings** P = | 35·36 | 243° 24′ |

If the value of one division on the vernier is not obvious use the rule :-

$$\text{Value of one vernier division} = \frac{\text{Value of smallest division on main scale}}{\text{No. of divisions on vernier}}$$

Note: Verniers are usually quite small - often $\frac{1}{2}''$ or less in length

**Fig. 75:** Reading a vernier. The left-hand illustration represents a normal 'straight' vernier, the right-hand one a 'curved' vernier of the type often encountered in angle-measuring instruments.

tions such as national censuses, whilst in Britain the areas of individual fields and many other pieces of land are recorded, correct to two decimal places of an acre (and in addition, since metrication, to three decimal places of a hectare) on the 1 : 2,500 scale Ordnance Survey maps. Such pieces of land are known as *parcels* and each is numbered, on older maps (the rectangular County series) by a serial number commencing at 1 in each parish, and on the modern maps (the square National Grid sheets) by a four-figure-only [15] grid reference of the *centre* of the parcel. The former needs the parish name, the latter the sheet number for complete definition.

Where a parcel is divided on the map by a line of detail, either solid or broken, a brace (⌣⌐) drawn across the line indicates that the area beyond is included in the parcel (see Fig. 57A, p. 128). This idea is obviously unsuited to detail in closely built-up areas (far too many braces would be needed) and these areas are treated *en masse*, one composite area only being given. The boundary of these composite areas is marked by bands of colour, stipple or hatching on maps published before 1909 and by a repeated 'T' symbol on the most recent (square) maps.

Areas given are those to the plan edge only on maps published after 1922, but before that date they refer to the area of the whole parcel. Since 1958 the *numbering* of parcels cut by the map edge has followed slightly different rules [16] but *areas* of these parcels remain exactly as before.

[15] i.e. using only the last of the three digits written against the 100-m grid lines and estimating tenths in each case. No duplication can arise within each sheet as the sheets are only 1-km square.

[16] These are given in detail in J. B. Harley (1975), *Ordnance Survey Maps, a descriptive manual*, p. 69.

# Chapter 11

## Enlarging, Reducing, Amending and Copying Maps

Anyone who makes frequent use of maps for illustrative purposes soon finds that the map he wants is at the wrong scale, or that the map at the right scale is out of date or incomplete in certain essential features. This chapter deals with methods of rectifying such a situation. It begins by considering methods for enlarging or reducing maps generally, goes on to consider methods for amending and correcting maps, both from other maps and from air photographs, and concludes with a section on the slightly different, though equally frequent, requirement of copying maps.

## Enlarging and Reducing Maps

1. *Manual Enlargement*[1] – *by the Use of Squares*

When a whole map or large portion of a map needs enlarging, mechanical methods, and especially photography, are most usually used today. Even so such devices are not always available when they are needed and, more fundamentally, certain aspects of the manual 'squares' method may be needed to obtain accurate results with mechanical aids, so that there are good reasons for considering the manual method first.

The basic idea is simple. The map to be treated is covered with a grid of squares which is reproduced at the scale of the enlargement, detail being copied from each original square into its counterpart on the new scale. Squares of any size may be used, subject to the 'smaller-size, more-work, better-accuracy' rule, and existing grid squares either as drawn or further subdivided are often utilized for this purpose. Fig. 67 summarizes the practical stages in the work which, once again, involves the introduction of the 'from-the-whole-to-the-part' approach.

---

[1] To save tedious repetition of the phrases 'enlargement and reduction' and 'enlarging and reducing' only 'enlargement'/'enlarging' will be used in this chapter. The opposite idea is always additionally implied unless otherwise stated.

*General Means of Improving the Method*

In the rather crude form just described, the squares method would produce results of fairly poor accuracy but this can easily be remedied by the following means:

*Additional guide lines.*　　　Where detail lies in an unsuitable position for transferring accurately, for example in the centre of a square, further guide lines should be drawn in. Diagonals of the squares, drawn in as required, are an obvious choice but any straight line which can be reproduced on both grids may be used to help, for example the diagonal to a block of squares. In Fig. 76 point E has been accurately fixed by this means and two dozen or so lines of this sort may considerably improve the accuracy of the work.

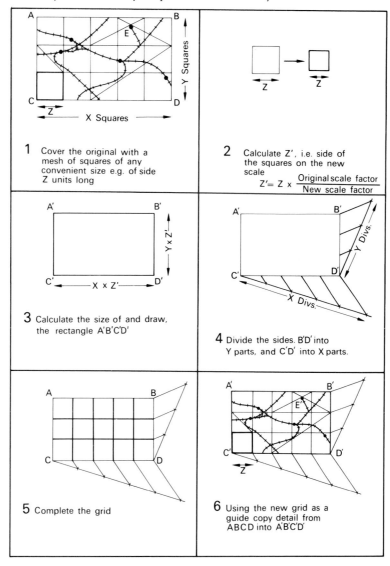

**Fig. 76:** Reduction or enlargement by squares.

*Proportional dividers.*[2]   These are the most important single asset for work of this kind and their use will increase accuracy enormously. They consist, as Fig. 77 shows, of two legs of equal length pivoting about a milled wheel attached to a slide-piece. If the wheel is unscrewed slightly the slide-piece can be moved along the slots in the centre of the legs, altering the position of the pivot and the proportion of the legs above and below it. Marked on the slide-piece is a fine line which can be set against the scales graduated on the legs. There are usually two, but sometimes four of these scales, used as described below.

**Fig. 77:** Proportional dividers (proportional compasses). (Drawn from F. Debenham, *Exercises in Cartography*, Blackie & Son Ltd, 1937.)

The scale of *lines* is the most important scale. The slide is set at any desired mark, say 3, and the wheel tightened. When the dividers are opened the distance between the large points will be three times that between the small points so that in reducing a map to one-third size, any distance measured on the original with the large points will automatically be correctly reduced by the small ones and may be plotted directly onto the new map. Enlargement to three times original size can be effected by reversing this process. For intermediate ratios – for example reducing from 1 : 50,000 to $\frac{1}{2}''$ to a mile which gives a ratio of 2.543 : 1 [3] – the correct setting must be found by trial and error, though the scale of lines will act as a rough guide.

The scale of *circles* is used to subdivide the circumference of any circle into a desired number of equal parts. When the large points are opened to the radius of the circle the small points show a distance which, stepped-off around the circumference, will produce the necessary subdivision.

The scale of *plans* is related in principle to the scale of lines but produces areas proportional to the value set, not lengths; [4] while the scale of *solids* similarly produces a drawing with volumes porportional to the setting. Neither of the two last-mentioned scales has much application in cartographic work and they are not found on all instruments.

The usefulness of proportional dividers in the squares method should now be obvious. Once they are correctly set for the work in hand, the point at which any detail, for example a railway, cuts one of the squares may be measured on the original and transferred exactly to the new drawing. Even if important detail only is treated in this manner the accuracy of the work will be much improved.

## 2 *Mechanical Enlargement and Reduction – Photography*

Although photography is the most obvious and simple mechanical method to use for enlarging maps or portions of maps there may be some slight difficulties. Not all establish-

---

[2] Also known occasionally as proportional compasses.

[3] For this purpose ratios must always be expressed as more than unity, e.g. 0.67 : 1 must be rewritten as 1 : 1.5.

[4] It follows from this, of course, that lengths will be reproduced as the square root of the set value (cube root in the case of 'solids').

ments are equipped to handle such large originals as map sheets [5] and in all cases very specific, and often awkward, ratios of enlargement are involved. The best way to ensure accuracy here is to provide a visual check using the method previously described. Rule out on the original a grid of squares [6] and redraw this, at the scale of the new map, on a separate piece of paper or, preferably, on stable plastic film. When the projected image in the enlarger exactly fits this check grid the correct setting has been achieved and a photographic copy can be taken. The new practice of supplying British Ordnance Survey 1:2,500 and 1:1,250 scale maps as 35 mm film mounted on copycards facilitates scale changing using the methods just described, and at official agents, where printout facilities from copycards are available, prints may be made at scales other than those 'intended' (i.e. 1:2,500 and 1:1,250) so long as these are within the capacity of the equipment.

*Digitization.*     Where the line detail of a map has been digitized (or, of course when it may be purchased in this form, as with some large scale Ordnance Survey Maps – see p. 109), the computer-drawn output can be obtained at any desired scale.

## 3 *Enlargement or Reduction using a Combination of Manual and Mechanical Techniques*

Unlike photographic techniques, which are widely available but often expensive, the methods described here are cheaper to operate (there are no expensive materials and the labour involved is usually one's own) but suffer from much more restricted availability of equipment.

*Pantographs*, once extensively used for enlarging/reducing, have now been largely superseded by photographic techniques. The more accurate drawing-office instruments, e.g. those of the Coradi type, were cumbersome and expensive; the much simpler ones sold as toys rarely possess either the accuracy or flexibility suitable for map work.

*Projectors.*     As the name implies these are commercially produced items of equipment which project a suitably modified image of an original onto a working surface. Several makes are available and projection may be either downwards from above (permitting seated operation usually) or upwards from below (demanding standing operation) (Hodgkiss, 1966, pp. 7–15); the working surface can sometimes be the map which is to be amended. However in the upwards projecting types, such as the Grant Projector and the Rost Plan-Variograph, the opacity of the map makes the projected image difficult to see, necessitating projection onto tracing paper or thin opaque film and subsequent transference to the map. In this case a check grid, drawn on the original and redrawn at the desired scale on the tracing paper/film will determine when the correct setting has been achieved. In general projectors work up to a ratio of about $\times 5$ or $\times 7$ and setting is achieved by *simultaneous* adjustment of two controls which determine image size and focus, a combination that newcomers to these instruments may find difficult to manipulate precisely at first.

[5] If this gives problems, e.g. with a small area of concern in the middle of a large sheet, it may be sensible to make a cheap copy only of the particular area and use that as 'original'.

[6] Very large squares may be used as they are only needed as general guides, and for small maps simply the rectangular frame line would suffice.

*Slide projectors and Epidiascopes.*     Because they are not designed specifically for this purpose these offer rather cruder methods which may, however, sometimes prove as successful as any other, e.g. for making really big enlargements or for making a wall map from a small-scale map. The main difficulty is to ensure that the projection surface is at right-angles to the axis of projection in both dimensions so that image distortion does not occur. With epidiascope material a check grid of large squares drawn on the original and reproduced at the appropriate scale on the projection surface (either paper or another map) can be used to determine and correct errors produced in this way. With slides a roughly recalculated version of the rectangular outline will serve the same purpose, though exactness of enlargement in this case is best checked against some more specifically measurable item, e.g. the scale line if the slide has one, some known length if it does not. The projected lines can then be drawn in.

# Amending and Correcting Maps (1) By enlarging and reducing detail from other maps

The need to enlarge a particular feature or a small area on a map is, if anything, a more frequent requirement than dealing with the whole map itself, and finds its most frequent expression in the amending or correcting of one map from another. In this type of work manual methods come into their own and several are available, some closely related to those already described.

1 *By squares.*     The squares method is equally adapted to dealing with detail, particularly where several items occur scattered over a small area. A portion only of the map is covered with the squares, and the only modification needed is that the grid *must be constructed on two rectangular base lines which can be imposed on both maps*, thus ensuring complete correspondence of position.

2 *Similar triangles.*     This is a method which is particularly suited to dealing with linear features such as lines of communication, contours, boundaries, etc., and detail close to them. Fig. 78 gives details of the procedure. The example shown there is of a reduction but the method can be used for enlargement as well, in which case the setting out of the length O units produces a point beyond X and the working is outside the triangle formed by X, Z and O, instead of inside it as in Fig. 78.

3 *Projected lines and proportional dividers.*     Adding new buildings to large-scale plans is one of the chief uses of this method but it may also be used for other work – adding a new road to a small-scale map for instance. On the drawing of the new detail, project any line until it reaches two other lines which are recognizable on the map, for example at A and B in Fig. 79A. Using proportional dividers measure AX and BY on the detail drawing, then establish A and B, and thus the line AB on the map. Other lines can be inserted in the same way or, with rectangular buildings, one corner can be fixed in this way and the

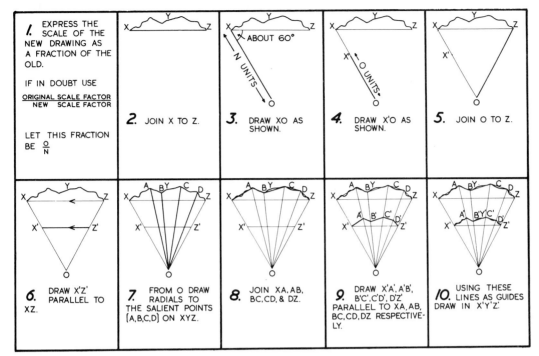

**Fig. 78:** Reduction by similar triangles.

other sides added in turn, using a set-square for the angles and proportional dividers for measurements.

4 *By radials.* For dealing with a small block of land with relatively simple boundaries, such as an area bounded by roads or a single large field, this rather simple method will often suffice. Calculate the ratio of the enlargement, and set this on a pair of proportional dividers. Mark any point near the centre of the area and from it draw radials through all salient points of detail; measure these distances with the dividers and step off, with the other points, the corresponding distance along the same radial. The detail can then be drawn through the new points. If distances are too large for the proportional dividers to take at one go, set them at *any* spacing and set this off 'n and a bit' times along each radial; reverse the dividers, step off n times again, and then deal with the 'bit' by separate measurement (see Fig. 79B).

*General Considerations of Enlargement and Reduction*

Whatever method is used, enlarging and reducing bring with them problems of a general kind. Reduction is the simpler and more successful operation; any errors present in the original will be reduced and the only difficulties arise from the style and content of the finished map. With severe reductions some of the content of the original map will almost certainly have to be sacrificed because of lack of space on the smaller scale; detail

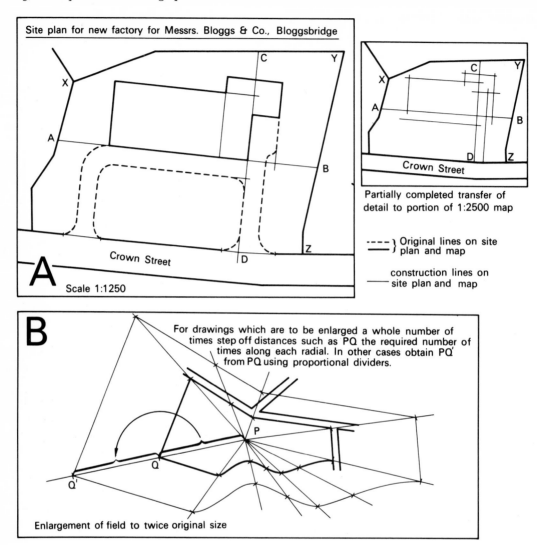

**Fig. 79: A:** Reduction by projected lines. **B:** Enlargement by radials.

may increasingly have to be shown by conventional signs, and many names omitted. Nevertheless the general standard of map design today will often permit photographic reductions to about half size without serious loss of legibility, for example the quite successful wartime reduction of the British six-inch map to the 1:25,000 scale.

The converse problems produced by enlargement to, say, double scale or larger are rather less soluble. Lack of detail appropriate to the larger scale becomes noticeable, not merely in quantity but in quality as well. Where features such as roads, churches, mills, etc., are shown conventionally on small-scale maps they should not be enlarged proportionately, for they are already too large on the smaller scale and the only solution is to

reconventionalize them in an appropriate way, even though they might normally be represented true-to-scale on maps of such a size. Thus whilst photographic reductions may be highly successful, photographic enlargements of any magnitude rarely are, lines and lettering in particular becoming unnecessarily coarse and large, a feature which was very noticeable on the photographic enlargements of the 1 : 2,500 scale plans to 1 : 1,250 scale sold in pre-World War II years by the Ordnance Survey. On the other hand slight enlargements may be very successful; the new 1 : 50,000 British maps seem very noticeably more spacious than the original one-inch and the same effect was noticeable with the German war-time enlargement of the British $\frac{1}{4}$ '' map to 1 : 200,000 scale.

# Amending and Correcting Maps (2) By transference of detail from air photographs

It is not uncommon to require new detail to be added to an existing map from an air photograph, either because the latter is more up to date or because it shows features not marked on the original map, e.g. archaeological remains, soil and vegetation boundaries. As was indicated in Chapter 4 (and quite apart from differences of scale) direct transference of detail from photo to map is usually inhibited by position displacement present on the photo and caused by relief and tilt. However where the area involved is small and there is existing map detail to act as guide a variety of relatively unsophisticated approaches can effect this transfer with acceptable accuracy. Exactly how accurate each technique is depends on the extent to which it recognizes or ignores these displacements, though this consideration is usually influenced further by the extent and position of the area involved within a particular photograph. For example, within a *small* area *differential* displacement of points relative to each other may also be small, and if this area lies close to the principal point displacements due to relief will be at a minimum; a straight line completely crossing a photograph (and not passing through the principal point) would almost certainly appear distorted by the effects of relief displacement if plotted on a map; a *short* segment of such a line would deviate much less markedly from the truly straight. Considerations such as these should be borne in mind when the methods below are described and used. It will be noticed that many of them have analogies to techniques just described for enlarging or reducing maps, or to methods of position determination described in Chapter 9; there are also often manual and 'mechanized' versions of the same technique.

1 *Transference by Eye-sketching*

Whenever the map shows considerable amounts of fairly close detail new material from the photograph may often simply be sketched in. If necessary short, straight lines running between corresponding pairs of points of detail on photo and map may be added as guides and used in much the same way as the additional lines added to Fig. 76.

## 2 *Transference by Grids*

Since these methods depend on the assumption that a straight line on the photograph will be a straight line on the map they are best applied to relatively small areas and to photographs where there is no pronounced relief. Transference is by polar, 'regular' or polygonal grids, all of which demand at least four points which are common to photograph and map and which should be as nearly as possible at similar altitudes to minimize differential height displacement.

(a) *The polar grid* is illustrated in Fig. 71A, identical constructions being performed on map and photograph. Let the four points used be A, B, C and D. AD and BC are produced to meet at E, AB and CD to meet at F. Through G, the intersection of AC and BD are drawn EGH and FGJ. Detail can now be copied from any triangle on the photograph into the corresponding triangle on the map. Where the triangles are inconveniently large for accurate work they can be subdivided by adding further straight lines, for example, HJ and HK until a suitable size is obtained.

(b) *'Regular grid'*. An alternative method of subdividing the area contained by the four points A, B, C, D in Fig. 80A is to construct a *'regular'* grid by subdividing opposite pairs of sides of the quadrilateral into any convenient number of equal parts, using the method illustrated in Fig. 60C, p. 148. Joining these subdivisions across forms a grid of 'squares' and detail can be transferred from a photo 'square' to the corresponding map 'square'.

(c) *Polygonal grid*. Where more than four points can be identified on photograph and map there is no need to construct external points as at E and F above. The points are simply plotted on both map and photograph and the area within the resultant polygon subdivided by joining each point to all the others in the first instance. Further subdivision can be made by drawing in any suitable straight lines through any pair of points or intersections on the grid (Figs. 80B and C). With all grids the plotting of detail which falls outside their boundaries can be achieved by adding construction lines produced beyond the original limits of the grid, for example at S in Fig. 80C.

## 3 *Transference by Projection*

(a) *Simple projection devices.* In all these methods an image of the photo is projected, suitably enlarged or reduced, onto the map which is to be amended. When detail common to both 'fits' the additional detail from the photo can then simply be drawn in. A Grant Projector, or some similar instrument as just described under the enlargement of maps, is often the most convenient means of achieving this, and it is best to treat the photograph in several small sections, resetting the instrument between each section if necessary to get the best fit. If the projected image of the photo lacks clarity a trace containing the detail to be transferred, plus adequate background detail, may be substituted for it. An ordinary epidiascope or even (with a slide of the photo) a slide projector can be used in the same way, though correct adjustment of the projected image is more tedious to achieve.

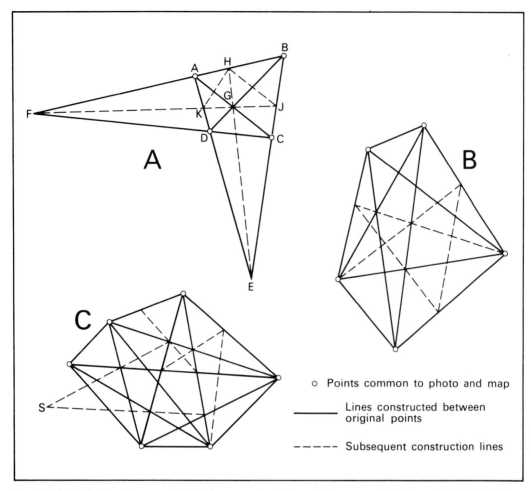

**Fig. 80:** Grids for transference of detail from an air photograph to a map. **A:** Polar grid. **B & C:** Polygonal grids.

(b) *Sketching instruments incorporating the Camera Lucida principle.* In these instruments only 'natural' vision is involved but the eye is enabled to see an image of the air-photo *apparently superimposed* on the map so that, once again, detail can be sketched in. This superimposition is achieved in various ways, for example by viewing the photo via a pair of mirrors (two are needed to prevent image reversal), the second of which, however, is only *half*-silvered so that the eye can also look *through* it at the map which is placed beneath it – the so called *Camera Lucida* principle.[7] Most instruments of this kind incorpor-

[7] A similar instrument, but incorporating a double-reflecting prism instead of mirrors and usually known simply as a Camera Lucida, is sometimes used for enlarging/reducing maps. In this instrument it is the *map* image which is projected onto the working surface – a blank sheet of paper; when the correct enlargement is obtained the lines of the projected image are drawn over on the paper. A fuller description is found in Debenham (1937).

ate adjustments so that the photo can be tilted relative to the axis of viewing, thus counteracting displacements caused by tilt, and by adjusting the distance from the eye to the photo the size of the apparent photo image can be reduced or enlarged until it exactly corresponds to the scale of the map. Fig. 81 illustrates the *vertical sketchmaster* which

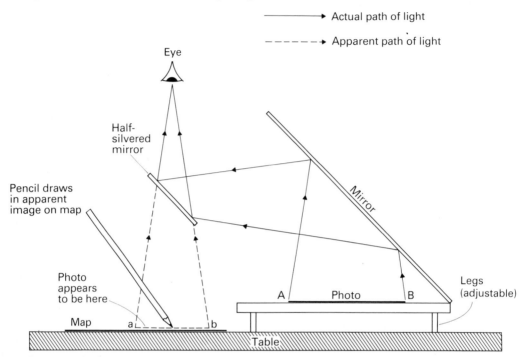

**Fig. 81:** The principle of the vertical sketchmaster (after Wolf). Notice the reduction of scale so that AB becomes ab. The brain 'ignores' the double reflection of the mirrors so that the photo appears to be at ab not AB.

operates on the principle just described but there is also a *horizontal sketchmaster* in which the photo is mounted on an easel,[8] whilst the Zeiss *aerosketchmaster* resembles the latter, though with slightly more complicated optics. A more sophisticated instrument is the Bausch and Lomb *Zoom Transfer Scope* which can superimpose either the image of a single photograph or the stereo image from a pair of photographs onto the map. It should be noticed however that only in the last-mentioned example where a stereo-pair is involved do any of these methods remove the effect of relief displacement from the projected photo image.

### 4 *Transference by Radial Line Methods (a) manually*

The radial line principle used here has already been described in Chapter 4 but the method will also be recognized as a multiple application of fixing position by intersection or cross bearing as described in Chapter 9, the bearings in this case being determined

---

[8] The 'vertical/horizontal' term refers to the direction of viewing not the position of the photo.

from air photographs rather than measured on the ground. Since the effect of height displacement means that on a (truly) vertical air photograph angular bearings are only correctly shown about the principal point (Fig. 30B, p. 62) each photo can yield only one set of bearings and the method demands two adjacent photos with the new detail located in the common overlap between them. The method is simple and is illustrated in Fig. 82. It involves marking the photos, making traces from them and using these to transfer detail to the map, as follows:

1 On each photo (1 and 2) mark its principal point ($P_1$, $P_2$) by joining opposed pairs of collimating marks (Fig. 61F, p. 151).

2 On both photos identify and mark the position of the principal point of the other, i.e. mark $P_2$ on photo 1 and vice versa. Vertical air photographs have sufficient overlap to allow this to be done (Fig. 27, p. 58). In case of difficulties use alignment (see below) to assist. Join the plotted positions on each photo by a line.

3 Select sufficient points within the new detail to allow it subsequently to be sketched in from them. Identify these points on both photographs and on each photo join them to the principal point by radial lines. Make a trace of the detail now marked in on each photo (Traces 1 and 2, Fig. 82A).

4 On the map identify and mark the position of the principal points of the two photos. Use resection (see below) if the map detail is inadequate to locate these accurately. Join the plotted positions by a line.

5 Place trace 1 over the map so that the position of $P_1$, and the line $P_1P_2$ on trace and map coincide. Prick through the position of the other radials from trace 1 onto the map and subsequently draw them in from $P_1$.

6 Repeat with trace 2, using $P_2$ as focus. The intersection of the two sets of radials fix the positions of the selected detail points and the new detail can be sketched in on the map using these as guides (Fig. 82B).

*Alignment.*    If the principal point of a photo falls in an area devoid of detail it may not be easy to locate it accurately on the neighbouring photo. Alignment (Fig. 82C) can help here. Place both photos underneath a straight-edge whose edge touches $P_1$ and $P_2$. Rotate the photos until the edge also cuts exactly the same detail on both and draw a line against the edge across both photos. There is now no need positively to locate the missing principal points since only the *direction* of each from the other (which this line established) is actually needed.

*Resection.*    Similar lack of detail may make it difficult to establish the position of $P_1$ and $P_2$ on the map. In this case they may be located by resection (Fig. 82D). Select at least three and preferably four or five points clearly identifiable on both map and air photo. On the photograph join these points to the principal point by radials and make a trace of these. Place the trace over the map and adjust it until each radial passes through the appropriate point. When this is achieved prick through the position of the principal point from the trace to the map. Note that if any tilt is present on the photo it will be impossible to obtain perfect fit with each radial when four or more points are used and the best approximate fit should be selected instead. Indeed the whole radial line method, though it

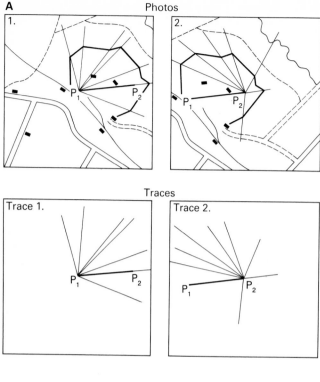

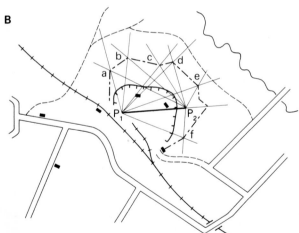

**Fig. 82:** Amending or adding new detail (altered quarry face) by radial line method. **A:** Traces of rays to salient detail points on photos. **B:** When traces are placed over map, aligned by common line $P_1P_2$, intersections fix positions of points a to f. **C:** Establishing line $P_1P_2$ on photos by alignment. **D:** Fixing position of principal points on map by resection.

corrects for height displacement, ignores the effect of tilt displacement and slight inaccuracies in the bearings and subsequent intersections would be introduced if this were present.

Quite apart from air photographs this same resection process can be, and often is, used to locate an unknown position in the field, the type of problem discussed in Chapter 9. Bearings are taken onto three or four identifiable points and a plot of these bearings is

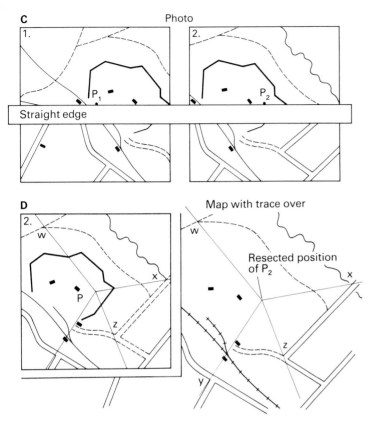

made on tracing paper. When this paper is placed over the map and located as just described the centre of the 'bearing rose' locates the unknown position on the map.

*Transference by Radial Line Methods: (b) by radial line plotter*

If much detail had to be plotted the manual technique just described would be tedious and slow even though, in more elaborate form incorporating ground control points as well, it was one of the early methods used to make maps from air photographs. A more rapid plot can be made using a *radial line plotter* which employs a relatively simple mechanized adaptation of the same radial line principle.

Fig. 83 shows an illustration of the instrument. Two circular tables each carry one photo of a stereo-pair whose principal point is pinned in position at the centre of that table, after first having been prepared and marked as in (1) and (2) of the manual method above. The photographs are then rotated until all four principal point images (two on each photograph) lie along the straight line joining the centres of the two tables, i.e. aligned in a similar manner to Fig. 82C. A transparent arm carrying a fine black line along its centre also radiates from and rotates about the centre of each table. If both black lines are now aligned towards the same chosen point of detail on each photograph their intersection would (in theory) fix the position of that point.

**Fig. 83:** The SB 100 Radial Line plotter. (Photograph by courtesy of Cartographic Engineering Ltd, Landford Manor, Salisbury, Wilts.)

To reduce this simple idea to manageable proportions the machine incorporates a mirror stereoscope. Using this the observer sees both photo images, each with its black radial line, superimposed to form a stereoscopic model in which the two black lines appear to intersect at the chosen point of detail. To transfer this apparent, visual, intersection to a plottable position the two arms are connected by a mechanical linkage which also carries a pencil. If the pencil is moved the apparent position of the intersection moves too. All that is needed therefore is to move the pencil in such a way that the intersection appears to move along any chosen feature of the stereomodel, when the pencil will automatically be plotting the outline of that feature. The scale of the plot can be varied by altering the length of the linkage arm by means of an adjusting screw, and a scale range of between 2 : 3 and 5 : 4 (plotting size : photo size) is possible.

The machine is intended principally to add detail to an existing map base or to a plot of control points derived either from ground survey or from a slotted template assembly. When placed in position over the map or plot, and properly oriented and adjusted, the pencil can draw direct onto the base material.

# Copying maps

*Mechanical Methods*

Here again is a field where modern methods are becoming so cheap, efficient and widespread that tedious hand-tracing has been superseded on many occasions. Several

methods are available and the ultimate choice among them may depend on availability, cost, number of copies needed and the nature and possible use of the finished product.

1 *Photography.*    Normal photographic processes will produce contact prints or enlargements from film or glass-plate negatives, but the method is highly expensive and the papers used are often unsuited for drawing on in ink or colour. The results, however, may be very 'black and white' and have a sharpness which will allow them to be used for making line-blocks for illustrative purposes.

2 *Photostats.*    Although somewhat ousted by xerography the photostat is still a common form of copied map, particularly where large size is involved, and many establishments such as large libraries or museums, as well as commercial firms, have a photostat camera. The process, which is much cheaper than ordinary photography, produces a paper negative from which further copies are made and enlargement or reduction can be effected at the same time without any difficulty. The paper too is easier to draw and colour on than photographic paper (though still far from ideal for this purpose), though copies made from rather dirty originals may have a slight or pronounced greyness in contrast to the photographic 'black and white'. A not dissimilar type of result is produced by the various document-copying machines, though these give true-to-scale copies only.

3 *Dye-line prints.*    Copies of *transparent* originals can be made very successfully and cheaply by the dye-line or diazo process, which gives only true-to-scale copies on paper, tracing cloth or a variety of transparent media. Additional advantages are the ease with which the paper used takes both ink and colour, whilst the machines can normally handle quite large originals. Opaque originals may be used either by painting them with a special fluid which renders them transparent or, better, by making a transparent 'negative'[9] first, though this increases the cost very considerably.

4 *Xerography* is a more recently developed process which produces results not unlike those of the previous methods but which employs an entirely different technical principle.

Coin-operated '*Xerox*' machines which will provide cheap and (if required) multiple copies of maps are now widely available, either at commercial firms or in libraries, schools, etc. but with the disadvantage that the standard machine used only provides true-to-scale copies up to a maximum size of 10″ × 15″ (25 cm × 38 cm). Nor does the design of these machines make it very easy to accommodate large originals even where one is prepared for the copying to be done in several pieces which can later be joined. The copies are, however, usually sharp and clear and there also exist more elaborate machines which will produce enlargements or reductions or cheap paper lithographic plates or 'masters', allowing unusually inexpensive copying in very large numbers by lithography.

The results produced by all the processes just described are normally in black and white only, though multicolour copying by Xerography is now technically feasible and beginning to be available. In black and white reproduction differentiation of colours found on the original must inevitably be as tones of grey (which may or may not be distinctive) and

[9] Actually a diapositive, i.e. black lines on transparent material.

in addition certain colours reproduce badly in various processes, e.g. blue which reproduces only weakly or not at all in the dye-line process. The advantages of the methods differ widely according to the type of variables already described, and it is often best to seek advice on any copying problem from commercial firms able to provide a wide range of processes; most firms will gladly supply this advice as well as literature and price lists.

*Manual Methods of Copying – tracing*

Mechanical methods of reproduction are unlikely to supersede the use of hand tracing for hundreds of smaller or less important jobs. The best asset for this purpose is a *tracing table*, which consists essentially of a sheet of plate glass with lighting and often a mirror as well arranged underneath. Light from this source is able to penetrate the original drawing laid on the glass and allows tracing direct onto opaque media such as cartridge paper. Where no tracing table is available, and the drawing to be traced is not too large, the author has found that a rather uncomfortable but surprisingly effective substitute can be made by taping both paper and original onto an ordinary window with fairly strong sunlight behind it.

If tracing paper itself is used for copying, it should be remembered that it is among the least stable, dimensionally, of common drawing media. A large tracing will change size slightly but noticeably over relatively short periods of time, and for this reason it is as well to try to complete large tracings at one operation.

*Copyright*

When copying maps it should not be forgotten that this may infringe copyright, which exists in them exactly as in other printed products. If multiple copies or commercial considerations are involved this will almost certainly be the case and permission, together with a statement of royalties due, should be sought from the map's publishers. Since royalties are usually dependent on the size of the area copied and the number of copies it is sensible to limit both of these as much as possible. However, at least in the United Kingdom, copyright on maps follows normal practice and expires 50 years after original publication so that for certain purposes, e.g. historic illustration or where only physical detail is needed, older maps may be copied without incurring such liabilities. Moreover these older maps may be in black and white only and therefore more suitable for reproduction; however in all such cases it is still sensible (and courteous) to check first to ensure that copyright is not being infringed.

# Chapter 12

## Bringing in the Third Dimension

Chapter 5 described both qualitative and quantitative methods of representing relief on maps and, though representatives of both groups are found on modern maps, they tend to be there for rather different reasons. Whereas quantitative techniques (and this means essentially contours and/or spot-heights) are regarded as indispensable on any map which has real pretensions to showing relief, qualitative methods are often employed only as an extra to add visual clarification and sales appeal.

The reasons for this distinction are not far to seek. Quantitative methods not only depict relief but *measure* it as well, and in so doing provide measurements which can be adapted by a wide range of map users to yield further information on many aspects of the relief of an area. This chapter describes some of the methods by which this further information may be obtained from a contoured map; it begins by describing techniques which seek to reconstruct the terrain and passes on to those which analyse more closely some of its characteristics.

## Techniques for Reconstructing the Terrain or Part of it

### 1 *Profiles*

The profile or cross-section,[1] with its reconstruction of the vertical qualities of the relief, forms a useful complement to the plan patterns emphasized by the contours on a map. Construction is simple, and is briefly described below and illustrated in Fig. 84A.

*Construction of a profile*

    1    Mark in the line of the profile on the map, and lay the edge of a blank piece of paper along it.

[1] The term 'profile' has now displaced 'section' for this type of drawing; the latter is used only when details of the features revealed by the cut (e.g. geological strata) are shown. The distinction is perhaps a little pedantic.

2   On the paper mark in the ends of the profile, the position and altitude of each contour crossing and any intervening ridges and 'troughs', for example the rivers marked 'R' on Fig. 84A.

3   Decide on a suitable vertical scale for the profile (see below) and, on a second sheet of paper, rule a base line and sufficient parallel lines above it to represent all altitudes included in the profile.

4   Place the marked paper along the base line and project verticals from each mark up to the appropriate point on the altitude scale. Join these points with a line which should also take account of any features on the map which indicate the nature of the surface between the contours.

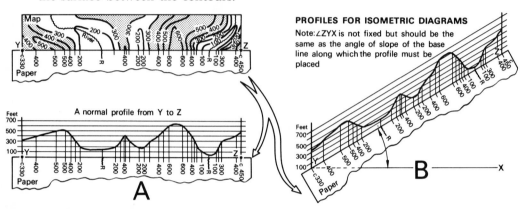

**Fig. 84:** Profiles. **A:** Construction of a normal profile. **B:** Construction of a profile for isometric diagrams.

Few cartographic techniques can be more widely known than this simple construction, yet in the author's experience several important points are usually overlooked in its execution. What constitutes a suitable vertical scale for example? If we draw a completely true-to-scale profile, as in Fig. 85A, employing the same scale for vertical and horizontal measurements,[2] the result may be rather disappointing; shown in this way relief even of Alpine dimensions can look insignificant and fundamental relief divisions, such as that of Switzerland into the Plateau, Alps and Jura, may become difficult to recognize. Most profiles are better for some exaggeration of the vertical scale but the question remains – how much? For probably nine out of every ten profiles drawn, this question is never answered consciously. Instead an arbitrary choice is made, derived solely from the type of lined or graph paper being used, giving more often than not very considerable vertical exaggeration and a profile which is misleading and sometimes grotesque, for example, Fig. 85C. Convenience of construction should *not* be allowed to take precedence over effectiveness and a vertical exaggeration suited to the purpose of the profile, the terrain and the map scale should be consciously selected.[3] For general purposes a vertical exaggeration of

---

[2] The easiest way to do this is to mark out the vertical scale from the scale line on the map.

[3] Convenience *did* use to loom large. With the old 1″ maps and a 50 ft VI it is a fair bet that about half the profiles ever drawn from these on graph paper adopted $\frac{1}{10}$″ = 50 ft or $\frac{1}{10}$″ = 100 ft for their vertical scale giving the rather large VEs of 10.56 : 1 and 5.28 : 1 respectively. The present situation with, in many areas, 1 : 50,000 maps with the old 50 ft contours translated into metres produces a real mix-up for profile drawers but VE should be considered sensibly just the same.

between 2 and 4 is often suitable (see Fig. 85B) but gentler terrain or smaller map scale may need greater exaggeration to give noticeable results; [4] in any event the vertical exaggeration (VE) should always be stated on a profile and is easily calculated as follows:

$$\text{Vertical exaggeration (VE)} = \frac{\text{scale factor of the horizontal scale}}{\text{scale factor of the vertical scale}}$$

*Example 1:*   Calculate the VE for a profile drawn with a vertical scale of $\frac{1}{10}$ inch = 100 ft on a 1″ to a mile map.

Vertical scale is $\frac{1}{10}$″ to 100′ = $\frac{1}{10}$″ to 1,200″

$\therefore$ Vertical scale factor $= \dfrac{\text{Ground Distance}}{\text{`Map' Distance}} = \dfrac{1,200}{\frac{1}{10}} = 12,000$ (p. 144)

Horizontal scale factor = 63,360

$\therefore$ VE $= \dfrac{63,360}{12,000} = 5.28$

*Example 2:*   Calculate the VE for a profile drawn with a vertical scale of 2 mm = 50 ft for one of the 'hybrid' British 1 : 50,000 maps with metricated 50 ft contours.

50 ft = 50 × 12 × 25.4 = 15,240 mm $\therefore$ Vertical scale is 2 mm to 15,240 mm

Vertical Scale Factor $= \dfrac{\text{GD}}{\text{MD}} = \dfrac{15,240}{2} = 7,620$

Horizontal scale Factor = 50,000

$\therefore$ VE $= \dfrac{50,000}{7,620} = 6.56$   (N.B. 1″ = 25.4 mm)

The nature and location of the line along which the profile is drawn is also worth some consideration. A straight profile line almost invariably hits awkward or atypical features somewhere in its length, for example X in Figs. 85A, B and C is no high plateau but an area where by chance the profile runs along local crests and not across them; alternatively should any feature be crossed obliquely its slopes will appear more gentle than if it had been crossed at right-angles, producing misleading and non-comparable results. An irregular profile line will sometimes overcome these defects and may improve results, particularly where a 'typical' profile is needed. Occasionally profiles may have to be drawn along extremely irregular lines such as a winding road or river and in this case direct construction is impossible; the distances between contour crossings must first be measured carefully (see p. 146), and then transferred to the profile base line.

*Profiles and intervisibility.*   The construction of a profile or partial profile (i.e. one containing only those parts likely to be critical or important as in Fig. 85D) is often suggested

---

[4] E. Raisz suggests the rule VE = $2\sqrt{\text{scale in miles per inch}}$ for hilly areas, less in mountains, more in plains (*Principles of Cartography*, New York, 1962, p. 71).

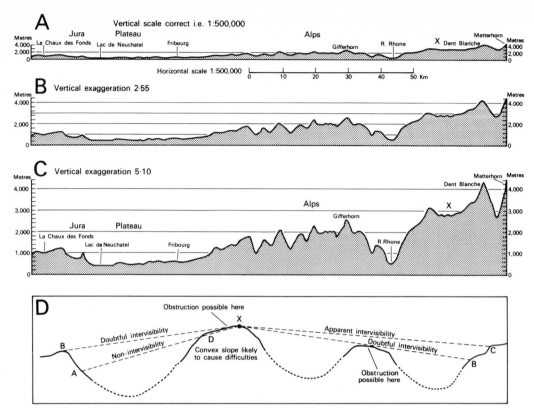

**Fig. 85:** Aspects of profiles. **A, B** & **C:** Effects of variation in the vertical scale of a profile across Switzerland from near La Chaux des Fonds to the Matterhorn. **D:** Profiles and intervisibility.

as a means of testing intervisibility between points, but the method has many snags and is perhaps best used *negatively* as a test of non-visibility (as at A, Fig. 85D), or doubtful visibility (as at B) rather than the other way round. Apparent visibility (as at C) may easily be interrupted, particularly by objects close to the observer; woods, buildings, and features of lesser height than the contour VI, are all troublesome, and particularly so are convex hillslopes as at D, since they are easily overlooked and it is difficult to draw sections accurate enough to determine their precise effect.

A complete three-dimensional picture of an area is often an asset in illustrating or understanding its features and terrain, offering far more insight into the latter, for example, than the limited view presented by a profile. Here again the quantitative portrayal of the contoured map offers hope of some sort of reconstruction and the remaining techniques in this section deal with ways of producing three-dimensional impressions from such a source. There are different possible approaches, though they often have characteristics in common – technical feasibility achieved at the expense of tedious (and often skilled) manual construction, and hence recent replacement by machine, or computer-drawn, equivalents.

In theory, of course, the same bird's-eye-view effect ought to be obtained with much less effort from an oblique air photograph or (better) from a trace prepared from one so that confusing, unnecessary detail can be eliminated. In practice this is rarely possible. Unlike verticals, oblique air photographs are often individual and sporadic and one would be fortunate indeed, even if such a photo existed, to obtain the right combination of scale, tilt, subject and viewpoint.

## 2 Block Diagrams

Several techniques are available for constructing block diagrams and they are, on the whole, more complex than most constructions described in this book. They are also far more difficult to complete successfully and it is not surprising that the recent availability of computer-drawn alternatives has been seen by some as rendering manually prepared versions largely unnecessary. There is of course a large measure of truth in this assertion but, as is always the case when 'mechanized' techniques replace manual ones, it is sensible to remember that everyone does not have access to such facilities; there is also the undeniable point that as a bonus for the effort involved in the manual technique one attains a far more intimate acquaintance with the terrain being represented than when the whole business is handed over to a machine.

Could this book then revive an interest in the construction, whether voluntarily or from sheer necessity, of manually prepared block-diagrams? If it can this may well result from two features (1) avoidance of a certain degree of evasion present in most existing literature and (2) encouragement of sensible attitudes towards the finished product from the very outset. In many works for example the description of the construction process is confused and incomplete [5] and, equally important, the simplified examples used as illustrations give no hint of the very considerable amount of effort which will actually be needed. Moreover the end result is not achieved entirely by construction. Really attractive block diagrams demand a good deal of artistic ability in the final stages of the drawing, and instruction in this aspect is often the weakest part of all so that would-be constructors of block diagrams are soon dismayed and deterred. So far as attitudes are concerned two basic ones are critical. The first of these is to accept, at the outset that block diagram construction is a *tedious* and *meticulous* task, but one which produces results very well worth the effort involved; [6] the second is to eschew all aims at highly artistic products and concentrate on simpler but still effective results more attuned to the average person's competence.

In all block diagrams the 'artistic' stage is the final one, and essentially involves drawing a 'skin of landscape' over a framework which has been constructed from the contours themselves. In this book the framework is always produced by drawing multiple profiles across the area. Alternative methods do exist: for example constructions which reproduce the contours themselves as framework, but profiles allow simpler and easier construction. [7]

[5] A major exception to this is Schou, A. (1964). This is well worth consulting by all who have block diagrams to draw and contains much more detail than is possible in this book.

[6] Meticulous working is essential to prevent confusion of lines arising during the construction process.

[7] The contour methods are described in Monkhouse, F. J. and Wilkinson, H. R. (1971), pp. 179–81 and Debenham, F. (1937), pp. 81–6. The simple examples shown look well enough but in practice it is very difficult to avoid an incredible confusion of lines.

An essential requirement therefore in all processes described in this section is that the area to be drawn shall have a rectangular frame with profile lines ruled across this parallel to either pair of sides. The profiles need not occur at regular intervals and indeed are best drawn selectively to pass through prominent features; more profiles mean more work yet easier drawing and better results. With frame and profile lines in position we are ready to start.

### 2A *Construction of a Perspective Block Diagram*

The normal way of drawing any three-dimensional object (and this would include both a relief model and a complete landscape) is in perspective. The idea of perspective is fortunately a familiar one to many people but Figs. 86A and B emphasize some of its particular properties which are relevant here. One of these is that all parallel lines *converge* towards vanishing points on the horizon, this convergence implying that in perspective drawing there will be no constant scale, no line will be its correct length, and all dimensions will be reduced by varying amounts.[8] Distances in the drawing cannot therefore be transferred directly from the map, but must be transformed by the relatively elaborate construction methods described below. Since these involve some of the most complicated constructions described in this book, it is sensible to consider first whether the easier *isometric* or *sham-perspective* constructions (see below) would not suffice equally well; the true perspective block diagram is, however, marginally superior to all other results, and where perfection is important the following construction may be used:

*Construction of a perspective block diagram of a rectangular area ABCD using multiple profiles. The rectangle is x cm by y cm and corner A will appear nearest to the observer.*[9]

*Stage 1:* Preparation of a base drawing containing the perspective version of the rectangular boundary ABCD (see Fig. 87 bottom right), a master scale for all altitudes and all vanishing points.

*Note*: a sheet of paper rather more than $4x$ cm wide and $2x$ cm high is needed. Fig. 87 should be consulted throughout this description.

(a) Rule a horizontal line HH and through its mid-point O rule EO at right-angles to HH. Fix F and E so that OF = $x$ cm and FE = $x$ cm.

(b) At F rule lines sloping upwards at 45° to FO. Fix G and K so that FG = $y$ cm and FK = $x$ cm. Use FK and FG to construct the rectangle FKJG, which is a replica of ABCD.

(c) At E rule lines sloping upwards at 45° to EO. These cut HH at $V_1$ and $V_2$ (alternatively fix $V_1$ and $V_2$ so that $OV_2 = OV_1 = 2x$ cm). Join $V_1$ and $V_2$ to F.

---

[8] There are two exceptions to these rules. Lines parallel to the horizon, i.e. lines at right-angles to the direction of view, do not converge and similarly the 'first' of the horizontal lines of this type (ST in Fig. 86B), and any verticals drawn from it are usually made true to scale.

[9] As many readers will realize the perspective rendering of an area is infinitely variable depending on the height and distance from which it is viewed (e.g. compare Figs. 86A and B). Space here does not permit construction details being given for *all* perspective renderings; instead only one has been chosen for description. It is a 'middle-of-the-road' version suitable for most purposes.

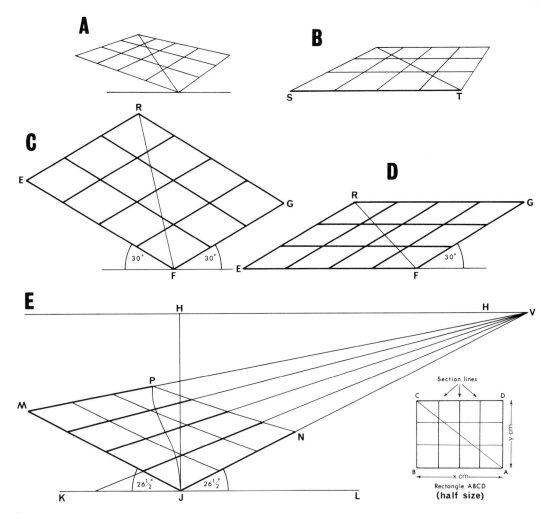

**Fig. 86:** True perspective, isometric and sham perspective renderings of a rectangular area ABCD (*see bottom right*). **A** & **B:** Two different true perspective renderings. **C** & **D:** Two different isometric renderings. **E:** A sham perspective rendering (*see text*). The thick lines in each drawing are those which remain their *correct length*: all other lines differ from their correct length.

(d) N is the intersection of KE and $V_1F$; L the intersection of GE and $V_2F$. Join N to $V_2$ and L to $V_1$. M is the intersection of $LV_1$ and $NV_2$. FNML is the perspective rendering of ABCD and forms the 'lid' for all subsequent constructions.

(e) Decide upon the vertical scale to be used (either true or exaggerated – see above under profiles) and mark off from F along FE sufficient of this scale to contain the maximum altitude in the area. Calibrate this scale upwards from the lowest point P.

(f) Join all points on FP to $V_2$ and Rule LQ vertically across these lines. This establishes FLQP a master vertical scale for all altitudes required.

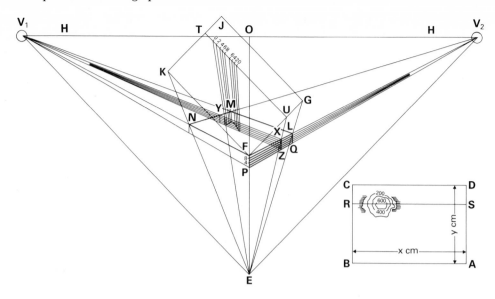

**Fig. 87:** Construction of a *perspective* block diagram of a rectangular map area ABCD using multiple profiles.

*Stage 2:* Transferring to the perspective drawing profiles taken along any line parallel to AB, for example RS.

(a) Measure DS and mark off this distance along GF and JK to fix U and T. TU occupies a corresponding position in FKJG to RS in ABCD. Join U to E.

(b) X is the intersection of UE and $FV_2$. Join X to $V_1$. Y is the intersection of $XV_1$ and $NV_2$ and XY the position of the top of the profile line in the perspective drawing. At X rule a vertical line XZ. Join each intersection of this line and lines on the master vertical scale to $V_1$. This establishes a vertical scale for the profile line.

(c) Transfer the contour crossings on RS to the corresponding positions on TU, using a piece of paper as in drawing a normal profile. Join each of these points on TU to E but rule in the lines only as far as XY. From the intersection of these lines with XY drop vertical lines to the appropriate line on the altitude scale and complete the profile in the normal way.

Any number of profiles can be drawn in this way, but to avoid confusion it is best to carry out all construction in stage 2 on a separate sheet of tracing paper laid over a drawing of stage 1, after which the completed profile only can be transferred to the master drawing. Little is lost and much construction work saved by keeping the number of points on each profile to a minimum, and supplementing these by interpolation and eye-sketching when the final perspective profile is being drawn. The drawing is completed by adding the 'landscape skin' to the multiple profiles in the manner described below under isometric block diagrams.

*Note:* If profiles are needed parallel to AD not AB the appropriate directions in the construction should be reversed, for example profile lines will emerge parallel to FG not JG, points on FP are joined to $V_1$ not $V_2$ and so on.

2B *Construction of an Isometric Block Diagram*

Block diagrams differing only slightly from perspective ones, but much more easily constructed, can be obtained using isometric drawing. This is a type of three-dimensional illustration much used in engineering, and which gives a perspective-like appearance by altering angles but keeping correct all dimensions parallel to two main axes. Fig. 86C and D illustrate the idea. In. Fig. 86C the forward corner F of the rectangle is 'opened up' from 90° to 120°, so that the sides slope upwards in perspective fashion. However dimensions along these sides are correct and remain so along all lines parallel to them. Thus RE is parallel to and the same length as FG, and the same applies to RG and EF so that the rectangle has been replaced by a parallelogram of similar dimensions. As with perspective drawing, isometric rendering is variable and the angle at F can be altered freely so long as ∠ EFG is not reduced much below 120°;[10] for example in Fig. 86D one angle has been reduced to zero and ∠EFG = 150°, an isometric form which corresponds to the perspective view in Fig. 86B above. For isometric block diagrams the 30°–30° form of Fig. 86C is both suitable and convenient, but Figs. 88 and 89 are drawn on a 15°–30° base to illustrate other possibilities. Unfortunately isometric drawings have the defect that the rear corner of the rectangle looks too high (cf. Figs. 86A and C) but in block diagrams this is not always a disadvantage as the 'lift' tends to decrease the amount of dead ground which may occur in the 'flatter' perspective.

*Construction of a 30°–30° isometric block diagram of a rectangular map area ABCD using multiple profiles. The rectangle is x cm by y cm and corner A is to appear nearest to the observer.*

Reference should be made throughout to Fig. 86C.

(a) Rule a horizontal line and on it choose a position F to represent the corner A. At F rule FE and FG inclined at 30° to the horizontal. Fix E so that FE = AB = $x$ cm and G so that FG = AD = $y$ cm.

(b) Draw RG parallel to EF and RE parallel to GF. FERG is the isometric rendering of the rectangle ABCD.

(c) Rule in on the map parallel to AD, the positions of all profiles which are needed and on a piece of paper mark the intersections of all these profiles with AB. Transfer these spacings to FE and GR and rule the profile lines across the parallelogram.[11]

(d) Construct an *isometric* profile for each of these lines as shown in Fig. 84B (p. 210). Two points should be noted: (i) the slope of the profile base line must be the same as that of the profile lines just constructed in stage (c) (in this case they will all slope upwards at 30°): (ii) whatever the slope of the profile base line, lines are drawn *vertically* from it to the appropriate altitude *not* at right-angles to it. The drawing would now resemble Fig. 88, but with a 30°–30° not a 15°–30° base.

*Finishing the drawing.* The addition of a 'landscape skin' to this framework constitutes the most difficult part of block diagram construction and, as stated earlier, only a relatively simple method will be attempted here. This is as follows:

(a) Mark in on the map the lines of all important watersheds and crests.

[10] If ∠EFG is reduced below 120°, the drawing becomes much more planlike and less effective.
[11] If profile lines run the other way they can be similarly transferred to FG and ER instead.

**Fig. 88:** The first stage in the construction of a 15°–30° *isometric* block diagram of a rectangular map area ABCD, using multiple profiles. The area shown is the Cartmel peninsula in north Lancashire.

(b) Lay a clean sheet of tracing paper over the finished drawing containing all the isometric profiles and using the profiles and map as guides sketch in the position of these crests, marking them continuously and boldly where they seem likely to form skylines and in dotted form where they do not.

(c) In similar fashion draw in the position of all coastlines, lakes, rivers, important breaks of slope and add also any other possible *skylines* which will occur where minor crests, knolls, spurs, etc., run *across* the direction of view. Fig. 89A shows the appearance of this 'crest-line' sheet at this stage.

(d) When all these features have been established, place a second sheet of tracing paper over both profile and 'crests' sheets and, using *both* as guides complete the drawing. This is most easily done by adding *hachure-like lines running down all slopes*; on longer slopes lines broken into two or three parts are easier to handle, though they may produce apparent breaks of slope if the breaks are too regular. Crests not forming skylines are best left bare and horizontal or level areas are very lightly shaded with broken lines parallel to the profile base lines (see Fig. 89B).

 *Note:* In drawing any block diagram a knowledge of the actual terrain helps enormously. Thus in Fig. 89B an attempt has been made to show the rocky nature of the Silurian fells, the 'smooth-summits-with-crags' of the limestone areas, for example Whitbarrow, the smooth *roche-moutonnée* form of Humphrey Head, and so on. At all stages the use of a 'finished drawing' sheet superimposed on construction sheets allows errors to be erased and redrawn without removing important earlier construction detail.

### 2C *Construction of a Sham-Perspective Block Diagram*

For those for whom the 'high corner' of the isometric and the elaborate constructions of the perspective methods are both unattractive, the author has devised a *sham*-perspective construction, which gets the best of both worlds in that profile lines converge to a vanishing point yet remain dimensionally correct. This can only be achieved at the expense of distorting other straight lines into slight curves (see Fig. 86E), but the effect is not noticeable on a block diagram.

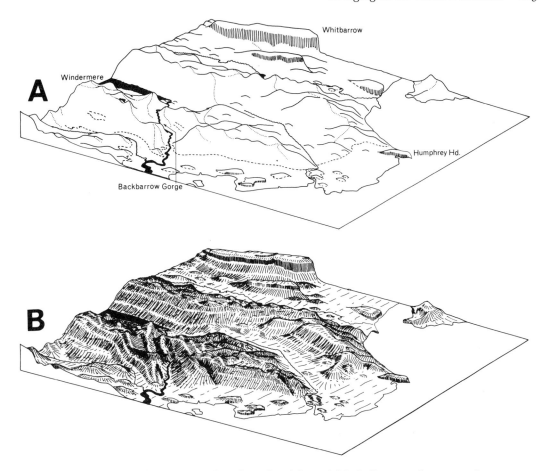

**Fig. 89:** The final stages in the construction of a 15°–30° *isometric* block diagram of a rectangular map area ABCD based on multiple profiles. The area shown is the Cartmel peninsula in north Lancashire. **A:** Drawing of crest lines and sky lines (*see text*). **B:** Finished drawing. This is not the most artistic result which could be achieved, but has been produced by adhering to the simple rules in the text.

*Construction of a sham-perspective block diagram of a rectangular map area ABCD using multiple profiles. The rectangle is x cm by y cm and corner A will appear nearest to the observer (see Fig. 86E)*

*Note:* a piece of paper just over 3x cm wide and x cm high is needed.

(a) Rule a horizontal line HH across the paper and about two-thirds of the way across rule HJ at right-angles to HH.

(b) Fix J and V so that HJ = x cm and HV = 2x cm. Fix N so that JN = y cm.

(c) Through J rule a horizontal line KJL. Rule in JM so that    MJK = $26\frac{1}{2}°$ and JM = x cm (*Note:*    NJL also = $26\frac{1}{2}°$ by construction). Join M to V and fix P so that MP = y cm.

(d) Along the edge of a piece of paper mark off the spacing of all profile lines on AB and transfer this spacing to JM. Join all points so marked to V. Mark off y cm along each of these lines and draw in PN as a smooth curve passing through the ends. JMPN is a sham-perspective rendering of ABCD.

(e) Profiles can now be drawn along each profile line in one of two ways either (i) using isometric-type profiles (see Fig. 84B), the only difference being that each will have a *base line of a different slope*; this slope can be found by projecting the profile lines until they meet KJL, or (ii) using perspective-like profiles obtained as follows. Project JM to cut HH produced at a second vanishing point and use this to establish a master vertical scale along JM as in the case of perspective block diagram, stages 1(e) and 1(f). In this case, however, it is easier to establish the master vertical scale above JM not below it: this scale can then be transferred to each profile line using V as vanishing point.

Notice that in both cases *linear* dimensions on the profiles remain unchanged since each profile base line is its correct length.

As in other constructions if the profiles run the other way the construction details should be reversed, with V established to the left of HJ, and so on.

### 2D *Mechanical Methods for Constructing Block Diagrams*

(a) *The Perspektomat P-40.* A truly mechanical means of drawing block diagrams in perspective is provided by the Perspektomat P-40,[12] though its potential has been somewhat eclipsed recently by the more widely available computer-drawn alternatives. After setting the machine for the scale of the map and angle of view desired a tracer point is made to follow each contour on a map of the area. A system of linkages transmits this movement to a pencil point causing it to reproduce these contours in the desired perspective, correctly placed relative to each other. It is, therefore, a mechanized version of the manual 'contour' technique referred to in footnote 7 above and, as in the manual method, a 'skin' of landscape has then to be added by hand to this machine produced framework.

(b) *Computer-drawn diagrams.* Fig. 88 shows that when successive isometric (or, of course,

**Fig. 90:** A computer-drawn 'fish-net' plot of the topography near Lawrence, Kansas, from the SURFACE II system developed by the Kansas Geological Survey. (Reproduced from *Display and Analysis of Spatial Data*, edited by J. C. Davis and M. J. McCullagh, by permission of John Wiley & Sons.)

[12] Made by F. Forster, 8200 Schaffhausen, Switzerland.

perspective) profiles are drawn across an area a strong impression of three-dimensional form begins to emerge, and this idea offers an obvious line of approach for computer-based methods. From the description of the potential of computer-driven drawing points, touched on in Chapter 6 (p. 107) it is not difficult to see that, given a series of positions and altitudes along a profile line, a computer could be programmed to draw a line passing through and joining those points to produce a profile. More than this it could use its calculating ability to transform these points into the positions they would occupy when viewed from any desired angle in isometric or perspective projection, and then draw the *transformed* profile instead. Repetition of this process forms the basis of the most commonly encountered computer-drawn block diagrams, though they may have either two sets of profiles, intersecting at 'right-angles' – the so-called 'fishnet' effect (Fig. 90) – or only one. The Natural Environment Research Council/Experimental Cartography Unit's program BDPMK 2, which allows the addition of contours to the finished drawing as well, is an example of the former type (Sprunt 1972); the better known SYMVU program, developed at the Harvard Laboratory for Computer Graphics is an example of the second (Fig. 91).

It will be noticed that, as with Perspektomat, the machine product is only a framework which (theoretically) needs 'clothing with landscape'. However where profiles are drawn

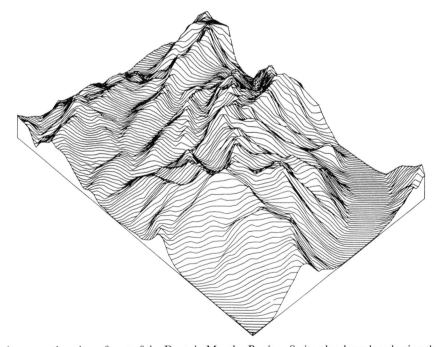

**Fig. 91:** A perspective view of part of the Dent de Morcles Region, Switzerland produced using the SYMVU program (original plot by J. Little, based on data taken from the 1 : 25,000 maps of Switzerland Sheets 1285 and 1305). The area shown by hill shading in Fig. 50B (p. 110) is seen here in perspective in the right hand corner of the drawing. (Reproduced by permission from the Association of American Geographers' Map Supplement Series No. 17, 'Automated Relief Presentation', 1974, Brassel, Little and Peuker.)

closely together, as in Fig. 91, the need for this is virtually eliminated and with SYMVU there is also the option (not used in Fig. 91) of adding to the plot up to 5,000 symbols representing the positions of features such as settlements, or even presumably positions along roads or rivers, greatly facilitating any subsequent sketching process. The possibility also of darkly shading any area 'not under consideration' e.g. the sea in coastal areas, further enhances the finished drawing.

A further feature of computer-produced output is that it allows experimentation, since there is usually a wide choice of form. SYMVU, for example, offers choice of viewpoint, angle of vision, distance of vision, scale, and isometric or perspective rendering so that with little effort different versions of the same area can be had, an unthinkable luxury with manual methods. Remember however that within these choices a suitable VE is still important; badly chosen it could render even the most detailed machine-drawn product ridiculous.

### 3 *Diagrams Derived from Professor Tanaka's Inclined Profile Method*

Multiple profiles also underly the method of terrain representation devised by Professor Tanaka in 1932 (Tanaka 1932) though important differences distinguish the result from block diagrams. Strictly speaking in its original form the method was not intended to produce a 'bird's-eye' view of an area but rather to indicate relief by differential shading on a planimetrically correct model (i.e. with no distortion of scale and shape and hence no dead ground). It is therefore perhaps best thought of as an attempt to produce, manually, the same impression of the differential illumination produced by oblique light falling onto a three dimensional surface that underlies Yoeli's computer-produced hill-shading described in Chapter 6, p. 111.

Unfortunately the original method, which relied on multiple *inclined* profiles involved a great deal of tedious work and was underpinned by rather complicated theory so that it remained little known or used, despite occasional attempts to revive it, e.g. in Robinson and Thrower (1957). Once again, as with block diagrams, the possibility of harnessing the computer to this repetitive drawing task has revived interest in the method, but it should be noted that computer-produced versions (Peucker, Tichenor and Rase 1975), when properly done (i.e. with closely spaced profiles) produce the three-dimensional looking *plan* view of Tanaka's original, akin to hill-shading, (Fig. 92), and not the type of bird's-eye view which results from the modified manual version now to be described and illustrated.

Tanaka's original method had one supreme attraction – the finished product was obtained *entirely by construction* and demanded no artistic 'finishing off' as block diagrams do. The appeal of this quality led the author to experiment with a modified version of the original method eliminating some of its tedium and still coming *near* to achieving a result by construction only,[13] demanding a bare minimum of artistic competence to finish off the drawing, which moreover appears in bird's-eye view rather than in plan. This modification will now be described; further consideration of the end product and its limitations is more intelligibly achieved when the constructional details are understood.

[13] Robinson and Thrower (1957) describe a very similar 'modified' approach to the one given here.

**Fig. 92:** A computer drawn representation of the topography of part of Banff National Park, Alberta using Tanaka's Inclined Profile (Orthographical Relief) method. (Reproduced from *Display and Analysis of Spatial Data*, edited by J. C. Davis and M. J. McCullagh, by permission of John Wiley & Sons.)

*Construction of inclined profiles on a map, using Professor Tanaka's method*

(a) Enclose the area to be treated in a rectangular frame and rule closely spaced parallel lines across it.

(b) Draw in the inclined profiles in the manner of FFF in Fig. 93A. These pass through the *intersections of the contours and the parallel lines*, starting with that of the lowest contour and the bottom horizontal line and *moving up one contour interval for each line* as they 'climb up' the area. When this condition can no longer be fulfilled, they turn and descend in the reverse manner. Thus FFF in Fig. 93A joins the intersections line 1, 100'; line 2, 200'; line 3, 300'; line 4, 400'

but since no 500′ contour intersects line 5 FFF turns and descends through the second intersection of line 4 and 400′ and so on.

When this line is complete a second line is started, based on the next series of contour-parallel intersections moving outwards. In Fig. 93A no other contour intersects line 1, pass on then to line 2 where GGG starts at line 2, 100′ and moves up to line 3, 200′, line 4, 300′ and line 5, 400′, there to turn and descend.

More and more of these profiles are constructed (the process is very rapid) until *every contour-parallel intersection has one* passing through it.[14]

So much for the construction: what are its implications? In Fig. 93A FFF at first moves upwards and backwards over the area, climbing one contour interval for each horizontal line. This is similar to the plane PP in Fig. 93D, since the slope at which PP cuts through the hill also makes it climb one contour interval in the distance between each pair of parallels. The line FFF is therefore being drawn out somewhere on the plane PP, and it requires little imagination to see that FFF is actually the profile made by the hill when it is cut by the inclined plane PP, hence the name *inclined profiles*.[15] The lines in Fig. 93A are therefore similar inclined profiles taken through the hill at regular intervals each having one of the parallel lines as its base (see Fig. 93D). Because they are profiles, each reflects the shape of the features it crosses, and in combination they may produce a three-dimensional visual effect (see Figs. 93A–C).

Let us now look a little more closely at some more of the details of the method – the spacing of the parallel lines, for example, and its effect. Figs. 93A to E show something of this. One obvious relationship is 'more lines = more work but more sections and a stronger suggestion of form', but this is not the only consideration. With closer parallel lines each profile must climb more quickly to the next contour, i.e. its slope increases in accordance with the relationship:

$$\text{gradient of inclined profile} = \frac{\text{contour vertical interval}}{\text{horizontal spacing of lines}}\text{[16]}$$

and, as this steepening occurs, the appearance of the profile becomes more flattened: compare, for example, Figs. 93A and D with 93B and E. The slope of the profiles is therefore very important and their shapes will vary with it. The extreme limits would be reached when profiles were vertical, when they would emerge simply as the parallel lines, or horizontal, when they would reproduce the contours; but between these limits profiles with low inclinations will give an exaggerated three-dimensional effect, whilst steeper ones will play down this aspect. Moreover, since the contour interval on a map is already fixed the slope of the profiles will be dictated by the spacing of the parallel lines, and it was here that Professor Tanaka's original specification proved unattractive. Tanaka suggested a profile inclination of 45° (i.e. perpendicular to sunlight incident at 45° elevation) implying parallel lines as far apart horizontally as the contours are vertically, i.e. only

[14] The rule is, therefore, that all intersections must be *trisections*, one contour, one parallel and one profile to each; there are no other intersections on the drawing.

[15] Tanaka called these 'inclined contours' which is both misleading and self-contradictory. The author has used 'inclined profile' throughout, as being a more descriptive term.

[16] Alternatively VI ÷ spacing of parallels = tangent of slope of the profile in degrees.

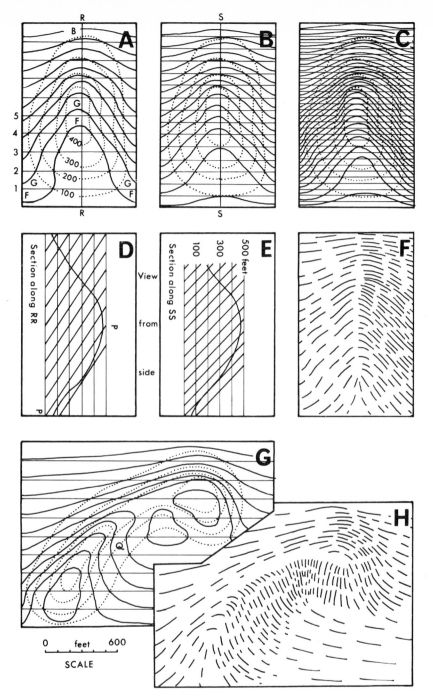

**Fig. 93:** Aspects of the inclined profiles associated with Professor Tanaka's orthographical relief method of relief representation. Notice that closer horizontal lines in **B** produce more profiles but 'flatter' ones (compare **A**). **C:** Even closer lines have been used here, but further flattening is prevented by *ignoring alternate horizontal lines* when drawing a profile. This method is not recommended, however, since confusion is hard to avoid in the construction process.

0.016″ apart for a 1″ map with 50′ VI or only 1 mm apart for a 1 : 50,000 map with 50 m VI. When drawn so closely the slight variation in shape which the relief introduced between one profile and the next caused 'bunching' or 'opening' of the lines giving the desired effect of variation in light and shade on the surface of the area.

How can the tedium of drawing so many lines be overcome? One could of course use only selected contours, widening the VI and hence the horizontal spacing of the lines too, but confusion easily arises and a crudely pragmatic approach may offer better prospects. Let us assume that $\frac{1}{10}$″ spacing is reasonably practicable for the parallel lines [17] and experiment from there to find a suitable VI-slope combination. For example, in areas mapped at 1″ to 1 mile, and having a moderate relief (say up to 1,000′ amplitude) and simple land forms, a profile inclination of as little as 100′ per $\frac{1}{10}$″ appears to give satisfactory results (i.e. draw the construction described above using $\frac{1}{10}$″ lines and 100′ contours, for example the original of Fig. 94). This represents a profile gradient of 1 in 5.28 ($\frac{1}{10}$″ = $\frac{1}{10}$ mile = 528′; VI = 100′), giving very reasonable results here but too low for hillier or more dissected areas where the profiles would emerge too much like contours. Robinson and Thrower (1957) used a gradient of 1 : 2.3 for a very successful rendering of part of Colorado, though this necessitated using a 500′ VI to give lines 0.188″ apart,[18] and such a VI would only be feasible in mountainous regions. There is no reason to believe, however, that experiment with gradients somewhere between these two values would not yield satisfactory and practicable compromises in difficult terrain.

Unfortunately profile slope is not the only likely source of trouble and disappointment with this modification of the method; the nature and direction of the terrain appear to be fairly critical. As Fig. 93A shows, the profiles are at their best when they run *across* relief features and are much less successful when running along them, or obliquely to them, and in the last case with low profile inclinations the lines may obviously 'slant up' the hillsides, weakening the three-dimensional effect, for example at Q in Fig. 93G.[19] The impression is weak too at the rear of features (for example B, Fig. 93A), where too gradual slopes are suggested, and frontal slopes often emerge bare because there are considerable areas not intersected by a profile at all (compare the foreground of Fig. 93A and the corresponding part of Fig. 93D). In extreme cases sections will cut clean through shoulders on some frontal slopes, giving 'ring profiles' as in Fig. 93G, and these must be added wherever a double contour-parallel intersection remains *after* the normal profiles are completed. Where several such intersections occur on a frontal slope they should be joined up into one ring as in Fig. 93G using the normal 'rise or turn' rule stated earlier, in their construction.

*Finishing the drawing.*     The defects just described will not prevent the resultant profiles for many areas giving a strong sense of three-dimensional relief (see Fig. 94), but this will

[17] A major attraction here is that the lines of $\frac{1}{10}$″ graph paper laid over the map can be used and this obviates the need to rule any parallels. 2 mm spacing using millimetre graph tracing paper would be even better but would be more confusing to use in practice.

[18] The resultant drawing is shown in Robinson and Thrower (1957).

[19] For all of these reasons attempts with varied profile inclinations in the Quellyn Lake area of Snowdonia proved relatively unsuccessful. Only valleys parallel with the line of view came out well and corries at the 'backs' of hills were poorly represented.

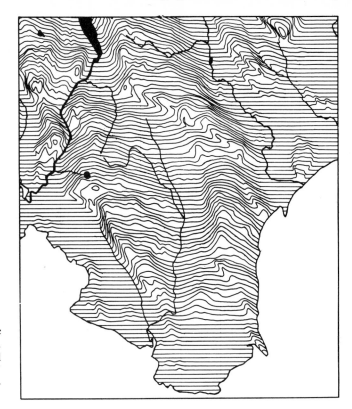

**Fig. 94:** Inclined profiles for the Cartmel peninsula, north Lancashire. The original drawing was constructed on 1/10″ graph paper and the 100′ contours of a 1″ map were used to obtain these profiles.

usually need augmenting. Fortunately this can be done quite simply. Place a sheet of paper over the inclined profiles and trace them in using the following conventions:

(a) Break the lines irregularly.
(b) On the *right-hand* side of the hills sketch in an additional profile between the existing ones.[20]
(c) On frontal slopes *ignore any profiles which might mislead*, especially the 'ring-profiles' and instead drawn in *hachure-type lines* running down the slope.

Figs. 93F and H were derived from Figs. 93B and G in this manner, and Fig. 95 represents a larger-scale application made from Fig. 94 by the same method. As can be seen it is a complete three-dimensional rendering of the terrain produced almost entirely mechanically.

If further detail (of drainage, or roads, for example) has to be added to a drawing, such as Fig. 95 the implications of this modified version become clear. Although Tanaka's inclined profiles suggest the shape of the relief *this was not his prime objective*. As we have seen, what he sought was a system of closely spaced lines whose varied spacing was produced by the relief and which would therefore produce variations of drawing intensity

[20] To give a 'left-hand-light' hill-shading effect. This is not necessarily a north-west light since the horizontal lines need not run east-west, but are best arranged to suit the run of the topography.

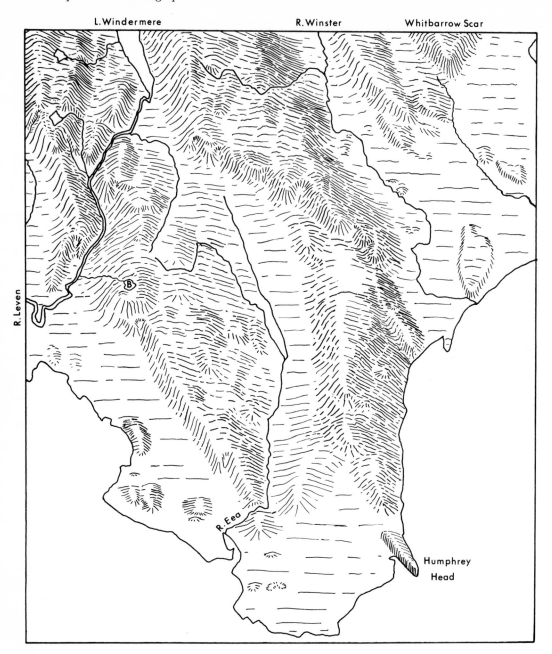

**Fig. 95:** A representation of the Cartmel peninsula in north Lancashire. This was obtained with the use of a modified version of Tanaka's inclined profile method of relief representation. The drawing was derived from Fig. 94 as described in the text; it also covers very nearly the same area as the block diagram in Fig. 89. This is by no means the most artistic result possible, but has again been obtained by keeping strictly to the rules described in the text.

which would simulate that relief. The lines did not represent the hills and valleys, they merely shaded or 'illuminated' them, hence the planimetrically correct nature of the original plot. In the modified construction just described, however, this basic idea has been abandoned. By opening up the profiles we have allowed their shape to become more apparent so that it *represents* the relief and the slopes of the profiles *become* those of the ground over much of the drawing. In allowing this impression, therefore, positions do appear distorted and detail traced from the map added to the drawing would not appear in its appropriate position, though displacement would be small. Even so, detail may *look* wrong: for example, the stream from Bigland Tarn (B on Fig. 95), when traced from the map seems to run *across*, not down, the slope because the profiles, which really run across the slope, i.e. inclined obliquely up it, are being used instead to simulate lines running *down* it. For the same reason we have introduced into the drawing vertical exaggeration equal to the *secant* of the inclination of the profiles,[21] but these points, though difficult to grasp in theory, are relatively minor quibbles in practice. For many circumstances and terrains here is a method of representation which, though needing meticulous work, is 95% construction and well within the artistic competence of most people. It offers a potential, and much simpler, alternative to the block diagram, particularly when computer-drawn examples are not available.

# Techniques for the further analysis of the terrain

In recent years techniques concerned with this second aim have increased quite rapidly, originating particularly with geomorphologists who have sought to obtain from the relatively complete record of the well-contoured map, indicative or confirmatory evidence of the existence of certain features in an area.

As is often the case in cartographic work the techniques which have developed for this purpose are not, in themselves, complex; but it must be stressed that their use is only likely to be successful when it is coupled with a full understanding of the characteristics of the features being investigated, and the effects and limitations these will have on the results. In short these are techniques for specialized geomorphologists working within their own field, and as such lie outside the more general scope of this book. This section of this chapter will therefore be confined to a description of two simple techniques which, though capable of more specialized adaptation, have widespread usefulness for anyone seeking a more detailed understanding of the general physical characteristics of an area.

*Slope and Slope Mapping*

The slope of the ground, with its frequent interrelationship with the physical evolution or human occupation of an area, is one of the most fundamental of the quantitative aspects of terrain that can be measured from a contoured map, though it must be stressed

---

[21] Because a given vertical distance is now represented by the inclined distance measured up the slope.

again here that measurement on the map will only yield the *average* slope between contours which may or may not be representative of ground conditions – see for example Fig. 43A, p. 90. In practice, slope may be defined in several ways, in degrees, as a gradient, as a percentage and as so many feet per mile for example, but all are easily derived from the relationship between the vertical interval between two contours (the VI) and the horizontal distance (the horizontal equivalent or HE) which separates them. These relationships are as follows:

*To obtain the slope:*

1 in degrees $\dfrac{\text{VI}}{\text{HE}}$ = the tangent of the angle of slope. Find the angle whose tangent has this value in a table of natural tangents.

2 as a gradient Let HE ÷ VI = x. The gradient is 1 in x.

3 as a percentage $\dfrac{\text{VI}}{\text{HE}} \times 100$ = the slope as a percentage.

4 as so many feet per mile $\dfrac{\text{VI}}{\text{HE}} \times 5280$ = the slope in feet per mile

Interconversion is also relatively simple:

5 with a slope in degrees the *cotangent* of the angle of slope is the same as the slope expressed as a gradient.

6 With a slope in degrees 100 × the tangent of the angle of slope gives the slope as a percentage.

7 With a slope as a gradient of 1 in x   x is the cotangent of the angle of slope in degrees

8 With a slope as a gradient of 1 in x   100 ÷ x is the slope as a percentage.

For more rough-and-ready purposes the fact that a slope of 1° is approximately equal to a gradient of 1 in 60 (actually 1 in 57.14) may be used to obtain the following *crude* conversion formulae:

1 slope in degrees = slope as a gradient (expressed as a fraction, i.e. $\dfrac{\text{VI}}{\text{HE}}$ or $\dfrac{1}{x}$) × 60

2 slope as a gradient (expressed as a fraction) = slope in degrees ÷ 60.

These will give tolerable results up to slopes of about 20° or 1 in 3, for example, if slope is 1 in 3, then slope in degrees is approx. $\frac{1}{3} \times 60 = 20°$ (actually 18° 26′); or if slope is 20°, then slope as a gradient is approx. $\frac{20}{60} = \frac{1}{3}$ or 1 in 3 (actually 1 : 2.75).

*Construction of a scale for slope measurement.*   Certain foreign map series, e.g. many official German and Swedish maps, contain in their margin a *scale of slopes*. This indicates the spacing of contours corresponding to particular slopes for a map of that VI and scale. Such scales are very useful if large numbers of slopes have to be measured and they are not difficult to construct if one is not provided. Fig. 96 illustrates such a scale which can be constructed, on durable transparent material, as follows:

1   Using the formula *HE = VI × cotangent of the angle of slope* calculate the HEs corresponding to various angles of slope chosen at suitable intervals (every degree from 1° to 10° and every 5° from 10° to 40° will often suffice).[22]

[22] For more accurate construction, and especially where intermediate values are to be read off, additional intervals will be needed, e.g. every $\frac{1}{2}$° below 5°. It will rarely be necessary to go beyond 40°.

2  Mark out these intervals along a suitable horizontal scale line, which need not be regular (see Fig. 96) and mark off at each point perpendiculars of length 10 × the HE for that value.

3  Subdivide these perpendiculars into 10 equal parts thus: let the perpendicular which has to be divided be MN; at some distance away construct another perpendicular PQ 10 units high; join PM and project this line to cut the base of the scale at R (see Fig. 96); join all 10 divisions on PQ to R when these lines will subdivide MN as required.

4  When all the perpendiculars have been divided join all corresponding subdivisions with curved or straight lines. Curved lines are essential if intermediate values are to be read off from the scale but straight lines are easier and will suit most purposes.

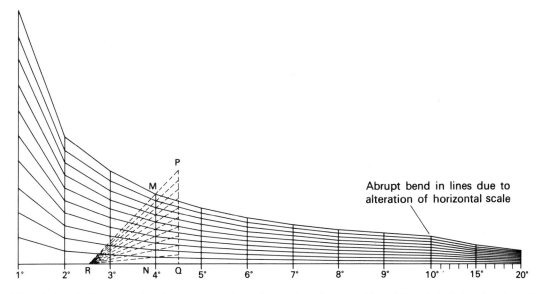

**Fig. 96:** A scale for measuring slope on maps from the spacing of contour lines. The original drawing showed the spacing of contours at 50′ VI on a map of 1″ to a mile. This reproduction is reduced to exactly half original size and therefore represents the spacing of contours at 50′ VI on a $\frac{1}{2}$″ map.

An alternative method of subdivision is to rule out, on a separate piece of tracing paper, a right-angled triangle PQR. PQ the perpendicular should be longer than any of the lines which has to be subdivided and should be itself divided into 10 equal parts, each division being joined to the opposite corner, R. To divide any line make the base of the triangle QR coincide with the base line of the scale and slide it along until the perpendicular height of the triangle exactly corresponds to the line to be divided. The situation will now appear exactly as in Fig. 96 when the radial lines effect the necessary subdivision of MN.

Whilst many people can judge variations in slope from contour patterns, few can relate contour-spacing on a map to a visual impression of the kind of slope they would encounter in practice, and it is always useful to take a contoured map into the field to compare contour-spacing with reality. Working towards a somewhat similar end of relating slope to everyday experience, McGregor (1957) describes the useful classification listed below.

| DESCRIPTION | SLOPE | GRADIENT | COMMENTS |
|---|---|---|---|
| very steep | $35°$–$45°$ | I in 2 *to* I in I | At $40°$ terracettes are usually well marked. Scree accumulations often show an angle of rest of about $30°$. |
| steep | $25°$ | I in 2 | |
| steep | $18°$ | I in 3 | About the maximum slope under cultivation and then generally under permanent grass. |
| fairly steep | $11°$ | I in 5 | Often critical. About the limit for ground that has to be ploughed and cut annually. Also about the maximum that could be used for conventional housing; would need stepped profile of roofs and gables. |
| moderate slope | $6°$ | I in 10 | Still clearly noticeable when walking. Well drained; easily cultivated and built on. |
| gently sloping | $3°$ | I in 20 | Drainage good. |
| flat | $1°$ or $\frac{1}{2}°$ | I in 60 *to* I in 100 | Difficult to distinguish, but water shows no tendency to meander on its own account until the slope is less than $\frac{1}{2}°$. |

*Construction of a slope map.*     It is often useful to map the slope of the ground within an area to study its possible correlations with other features, as in Fig. 97, and there are several ways of making such a map.[23] In this book the method described in Raisz and Henry (1937) has been selected because of its relative simplicity and obvious adaptation to correlative studies.

The principal aim of the Raisz and Henry method is the definition on the map of *areas of similar slope*, these being differentially shaded according to steepness. In practice this amounts to defining areas which fall within a given category or range of slope, since only some 6 or 7 shadings are feasible and these must embrace all slopes encountered in the terrain. It follows from this that an important preliminary step is the choice of limiting values for these slope categories, and this is best made from a variety of considerations. Certain critical values, for example the slope of land too steep for building or ploughing where this is relevant, may be suggested by the intended use of the map; but one should also sample, and be guided by, slopes over the whole area, particularly those associated with different types of terrain. In Fig. 97 the slope of the surface formed by the Rough Rock around Halifax averages about $5°$, so that a choice of $6°$ as limiting value for one category ensured that this surface would remain distinctly defined. Category limits should also be chosen so that prominent breaks of slope are marked by the boundaries between different types of shading, and not lost within larger areas.

Once limiting values for the slope categories have been selected the contour-spacings corresponding to these should all be marked on the edge of a piece of paper: this is moved over the map until slopes of the critical values are found, and the boundaries of the areas

[23] A brief description of some of the other methods is contained in Monkhouse and Wilkinson (1971), pp. 136–43.

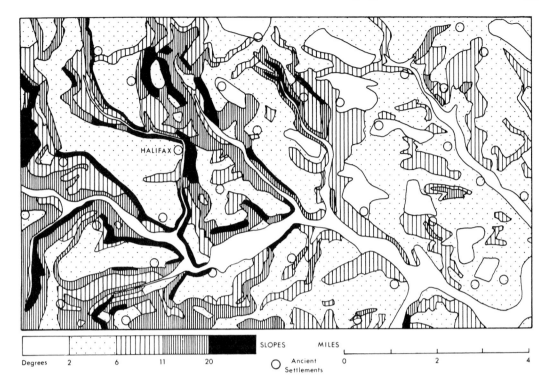

**Fig. 97:** A Raisz-and-Henry-type slope map of the area around Halifax, West Yorkshire. A map of this sort emphasizes quite strongly the relationship between the sites of ancient settlements and areas of more gently sloping land.

can then be drawn in. Alternatively a pair of dividers can be set to the corresponding spacing and moved along between a pair of contours until the critical spacing is reached, the so-called 'moving interval' method of Denness and Grainger (1976). In practice these processes are rather more difficult than one might suspect, and the following points may help.

1 Slopes must always be measured at right-angles to the contours.
2 Unless extremely precise or detailed correlation is envisaged, only the generalized slope across groups of *similarly spaced* contours can normally be considered. As slopes approach the limiting values there will often be found within a fairly homogeneous slope contours whose spacing exceeds the limit; the definition of such deviations will often confuse rather than clarify the result.
3 At crest lines and in valley bottoms two kinds of slope, longitudinal and transverse will meet; the steeper of the two should be selected, though in some cases it may be possible to define narrow gently sloping valley floor and crest-top facets, for example the main valley floors in Fig. 97. Crests, cols, spur ends and similar features do, however, provide some of the more difficult situations for this type of map, and in these cases much may depend on individual judgement. In some terrains endless judgements of this type have to be made, e.g. in very hummocky country, and it is doubtful whether this method is really feasible in such cases.

The reader may have realized that the computer-drawn hill-shading, described in Chapter 6, p. 111 is also, in effect, a computer-produced slope map derived from very accurate measurement and classification of slope over very small areas.

*The mapping of relative relief or 'local relief'.*[24]    In Britain, as in other islands and countries near the sea, there is often a distinct correlation between altitude and the incidence of mountainous or hilly terrain, but this is by no means always the case elsewhere. In the Canadian prairies for example, at altitudes of almost 2,000 feet, local terrain may be no more than 'rolling' and to obtain a satisfactory impression of what an area is like it may be important to study and map the amplitude of the relief as well as its altitude. Once again several methods are possible but only one, that of G. H. Smith (1935), which is widely known and illustrates many of the principles of this group of techniques, will be described.

*Construction of a map showing the amplitude of relief in an area.*

1   The area to be studied is divided up into areas of uniform size (Smith, working in Ohio, used rectangles 5′ longitude by 5′ latitude – 4.40 miles × 5.75 miles).
2   Within each of these the amplitude of relief (highest point–lowest point) is calculated and plotted as a spot value in the middle of the area.
3   Isolines are drawn in as required between these values[25] and the map hyposometrically shaded or coloured, as in Fig. 98B.

Within these elementary principles there is often scope for modification and experiment, particularly in response to the type of terrain and the essential purpose of the finished map. The size of the square or rectangle can be varied and will affect the result: too large a square gives generalizations little related to 'on the ground' impressions; too small a square allows local detail to blur regional patterns. The same amplitude within a square can, of course, be produced by quite different types of terrain, for example widespread dissection or gradual rise across the square; but careful choice of square size may help to minimize this effect. Further examples of potential variations in this method are illustrated in the construction of Fig. 98, which simply attempts to answer the question: 'What kind of terrain shall I find in Northern England?' The modifications made to Smith's method are listed below; the aim was to make a map which would reflect as closely as possible impressions obtained on the ground:

1   A national-grid square 5 km × 5 km (3.14 × 3.14 miles) was selected as the basic unit. This is convenient, slightly smaller than Smith's unit but not too small, and is not dissimilar to the extent of an observer's 'immediate surroundings' in the field.
2   To obtain more typical amplitude values within each square these were measured between the highest and lowest *contours* (not spot heights), using only contours which enclosed at least an area of 1 km² above them (highest) or below them (lowest) within the square.[26]

[24] The terms 'relative relief', 'local relief' and 'amplitude of relief' have all been used to describe this type of map.

[25] See Dickinson, G. C. (1973), p. 58.

[26] This works well except where prominent isolated hills rise above much lower surrounding areas, e.g. in the Lleyn Peninsula. In this case the first contour which has 1 km² above it, may be much lower than the summit and the map value does not reflect reality; fortunately such terrain is unusual in the north of England.

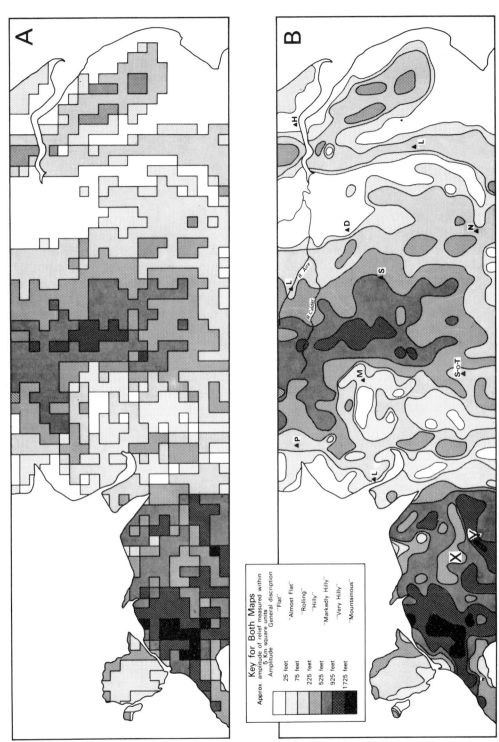

**Fig. 98:** Amplitude of relief in northern England. **A:** Amplitude within 5-km squares, determined as described in the text, and plotted for whole squares. **B:** The same, but with the amplitude treated as a 'spot value' at the centre of each square, and with isolines drawn between the 'spot values'.

3   Where squares were incomplete because cut by the coastline, this minimum 1 km² was modified proportionately, and the lowest contour was taken as 0 only where valleys penetrated to sea-level; otherwise the lowest contour on the cliff top was used.

4   The resultant values were plotted in two ways, direct as complete squares and using spot values and isolines. In the former case 25′ (half the VI) was added to all calculated values, so that more realistic figures were obtained at the lower end of the range where squares with no contour, or only one contour, would have emerged with a misleading amplitude of 0. In Fig. 98B however the isolines were deliberately chosen at values intermediate to the calculated amplitudes (i.e. 25s and 75s, not 50s and 100s), so that this modification was not necessary.

5   The seven amplitude divisions used were suggested by plotting a dispersal graph[27] of all amplitudes and selecting divisions compatible with this, and yet amenable also to simple description.

One rather surprising point about maps showing amplitude of relief is that they are a little difficult to interpret at first impression. The layman invariably tends to equate the higher amplitudes with the occurrence of hill masses, but this is far from being a simple correlation. Many hilly areas with flattened summits are marked by ring isolines of *lower* amplitude, and higher values may occur peripheral to such masses, or where they are penetrated by a major valley unit. This occurs on Fig. 98B where the hills of the Denbigh Moors at X are bounded, and partly penetrated, by the Dee Valley Y.

This chapter has described several methods which can be used to come to a clearer understanding of the 'solid form' of an area. Each offers its own emphasis, and though many are time-consuming to execute, none is difficult to understand in principle. Between them they allow some investigation to be made of all the main characteristics of the relief of an area, and whether this is a prelude to other detailed work or simply undertaken for more general purposes, there can be few areas where the application of one or more of these techniques would not result in greatly increased understanding of the three-dimensional nature of an area.

[27] See Dickinson, G. C. (1973) pp. 87–8.

# Chapter 13

## The Map as an Historical Record

Anyone who wishes to study past landscapes or the changes by which the present landscape evolved, must sooner or later consider the possibility of using historic maps as a source of information. This chapter discusses the advantages and, more significantly, the less obvious disadvantages inherent in this type of source material.

Chapter 3 described how in many advanced countries official surveys, comprehensive of landscape detail and of good accuracy, have a history extending back almost a century and sometimes much more. Should there also have been during this period several revisions or resurveys, then these maps may yield much historical information relevant to studies of many kinds, particularly those relating to the development of urban and rural landscapes. In Britain this is especially the case: the table in Chapter 7 (pp. 130–32) listing the revisions of the large scale Ordnance Survey maps gives some idea of the range and amount of material available up to about 1940, which Fig. 99 reaffirms with a practical example of a study made entirely on this basis.

Unfortunately the considerable success of this type of study is rather atypical, and can lead to unawareness of the dangers inherent in the method generally if it is more widely applied, particularly when maps are used which are not official surveys or are more than a century and a half old. Official surveys are important here because the State, as cartographer, was distinctive in two respects: its maps were unusually comprehensive, and it could afford far more than the private cartographer to pursue high standards of accuracy. If, for example, we were to try to fill gaps in the sequence in Fig. 99 by additional information from privately published maps, we should enter a cartographic field where both accuracy and reliability are poorer than in the official surveys, though this statement does not, of course, apply *uniformly* to non-official productions. The best of these can often match official surveys (not least because they are often derived from them), but this was far less true a century or so ago than it is today, and in particular revision was often less complete and reliable. It is not uncommon to find, e.g. railways which were only projected and stations which had closed 10 years before the map was published, marked on nineteenth-century maps of Britain. If, however, we go back beyond the nineteenth century then the limitations and inaccuracies inherent in privately published maps become so serious and widespread as to warrant systematic description.

In the first place, as Chapter 2 emphasized, early maps are grossly incomplete as to

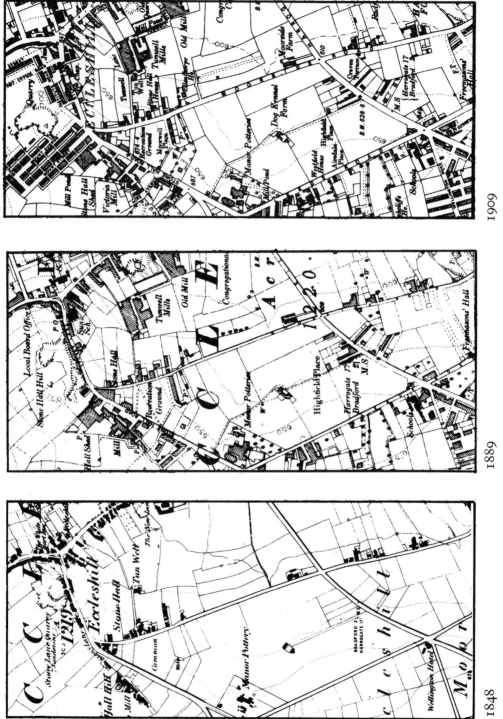

**Fig. 99:** The growth of Eccleshill, near Bradford, Yorkshire as illustrated by portions of the 6″ to a mile Ordnance Survey maps of 1848, 1889 and 1909. Detailed maps of this sort present a remarkably clear picture of the sequence of industrial and 'civic' developments during this period, the predominating residential growth being easily noted as well.

content. Generally speaking they show only fundamental landscape details such as towns, villages, mountains or main rivers; and there are many features, such as roads (for a time) or the boundaries of enclosed land, which are not recorded. Additionally the small scale of many early maps proves a severe limiting factor so far as detail and content are concerned.

Secondly much detail which is shown on old maps is inaccurately placed as regards both its absolute and, often, its relative position. This again is not surprising bearing in mind the limitations of early surveying techniques (see Chapter 2), and even where accurate techniques were known, lack of time and money often prevented their use. Triangulation, once it had become common practice, might improve the general overall accuracy of a map, and the *triangulated* points (usually villages, churches or hilltops) would thereafter be well defined; but other detail was often fixed by much less accurate means, perhaps even by sketching or copying from pre-existing maps (see below), so that quite serious errors could result. Early official surveys too are apt to show similar characteristics, for example Carr (1962) records, significantly, that the first edition of the one-inch Ordnance Survey map of Devon in 1809 shows a rocky cliff over quarter of a mile inland from its present position, and that even in 1906 a former Director-General of the Ordnance Survey pointed out that 'old charts and maps in the Ordnance Survey Department furnished no evidence of any real value as to changes on the coastline'. It was for such reasons, of course, that many countries later undertook complete resurvey of their official maps.

Undoubtedly certain types of feature are more prone to errors of shape and position than others. Features of little direct use, such as forest boundaries, river courses and coastlines are more likely to be erroneous than villages or roads, though understandably Admiralty Charts may portray marine features better than topographical maps. Nor do large scale and abundant detail necessarily entail accuracy, and some of Roque's large-scale, very detailed maps have been criticized on this count. Some idea of the Ordnance Survey's accuracy is given in *Survey Computations*,[1] but even in this work it was admitted that 'most topographical maps show traces of bad survey here and there', and it was not until the use of air photographs became widespread that completeness and accuracy in the recording of much intricate topographical detail became relatively easy to achieve.

Whilst lack of completeness and inaccuracy of position might be expected on old maps, errors arising out of inconsistent definition are less obvious. Land use and vegetation features are the most likely sources of error here: for example, Ordnance Survey one-inch maps of Britain have traditionally marked the boundaries of 'rough' land, such as moor, heath, rough pasture; but can we be sure that a consistent definition has been applied over a century and a half? 'Rough' cannot be equated with 'unenclosed', for there has been some reversion, and similar difficulties might arise on maps showing the margins of marshy areas or unenclosed woodland. Scandinavian maps are unusual in differentiating not only farms but different types of farm settlement, but as Sund and **Sømme** have pointed out there have been inconsistencies here, too.[2]

[1] Properly *Survey computations to be used in conjunction with the Text Book of Topographical and Geographical Surveying*, third edition, 1926, London HMSO, p. 4.

[2] Sund, T. and Sømme, A. (1947), pp. 12–13.

The final class of inaccuracy on old maps concerns date. It cannot be stressed too strongly that the recording of a particular date on a map does *not* necessarily imply that the map is a record of that area *at that date*, not least because the date most commonly recorded is that of *publication* and not (more relevantly) of *survey*. The point is well illustrated in the problem of dating sheets of the Old Series of the British 1″ Ordnance Survey, published between 1805 and 1840. The date shown on the maps is that of the original publication and the survey date, which may precede this by anything from ten to twenty years, is recorded only on the manuscript drawings now in the British Museum. Moreover this publication date remains *unaltered* on subsequent printings, even though these may incorporate partial revision, no details of which are given. Railways were often added in this way to later printings, and may help to date a sheet, but it cannot be assumed that the whole sheet was revised along with the railway details. Fortunately notes and guidelines to the complex printing history of these sheets are now to be found at the foot of the reproductions of them currently being published by David & Charles.[3]

If official nineteenth-century surveys present problems of this sort it might be expected that even more serious difficulties will arise with respect to earlier, private ventures. In many cases, for example, even where a map is dated it does not necessarily follow that it was preceded by systematic survey and it may have to be regarded as the best delineation of an area which the publisher could *compile* at that date. This element of compilation may be extremely important. Large portions of many old maps contain little more than detail taken unchanged, unchecked and unacknowledged from even earlier maps, so that inaccuracies were perpetuated for decades and whole 'families' of maps, obviously derived from one another, can be observed. The notes 'revised in . . .' or 'amended in . . .' carry no real guarantee, for revision may have been confined to important detail only, new roads, railways or urban extensions for example. It is not until the official maps arrive, based on complete surveys or full revision, that this weakness entirely disappears. It is this uncertainty as to the completeness of revision at the dates given which renders privately published maps less useful than official ones in a study of the type illustrated in Fig. 99.

Enough has been said here to indicate that historic maps rarely provide unequivocal answers to straightforward questions such as 'what was there?', 'when was it there?' or 'where was it?'. The answers may need qualifying because of the nature of the object, the type of locality where it occurs, or the reputation of the cartographer; and it is therefore worth noting that better results may sometimes be achieved by approaching the problem from the opposite direction. Where fragments of a historic landscape have survived to the present day old maps may help to establish a successful interpretation of their nature, whilst their remaining physical traces establish their position far more accurately than any ancient cartographer might have done.

In practice, of course, the difficulties which have been described systematically above appear on old maps integrated to a considerable degree. This chapter concludes, therefore, with three brief examples which will illustrate some of the general and specific difficulties involved in using old maps to answer historic problems and considers also the relationship of cartographic to other forms of historical evidence.

[3] Harley, J. B. (Ed.) (1969–71), *Reprint of the first edition of the one-inch Ordnance Survey of England & Wales*, David & Charles, Newton Abbot. (Note the sheet lines of this reprint are the same as those indicated in Fig. 54 (p. 122) but the numbering is different, running from north to south and not vice versa.)

*Example 1   Investigation of early routes in Britain using the fourteenth-century Gough Map*

As the earliest map of medieval Britain to show roads, the Gough Map has considerable significance for anyone tracing the evolution of our national highways. Let us compare part of today's 'Great North Road' with its counterpart marked on the Gough Map.

The general course of the Gough Map's Great North Road is easily traced and passes from London through Waltham, Ware, Royston and Caxton to Huntingdon (see Fig. 100) coinciding not with today's A1 but with the A10–A14 roads. This is no surprise for the use of this latter and essentially Roman route as the Great North Road persisted quite late and is well known; but between Hungtingdon and the Nene crossing at Wansford quite a different sort of deviation occurs. The Gough map distinctly marks one intermediate place on this section, namely Ogerston, which, though it takes some finding, survives today simply as 'Ogerston Manor, site of' (OS 1 : 25,000 map, sheet TL 19, Grid Ref. 121905), some 2 miles *west* of the present A14–A1 route but lying on the line of a remarkably direct system of country lanes which might well, reasoning along lines which will be described in Chapter 15, represent a 'fossil' Great North Road. Is there here, then, clear indication of a former deviation of the present route? On cartographic evidence alone the answer can only be 'no', for all that this might mean is that this was *a* route used by *some* travellers and was the one known to the compiler of the Gough Map. It does not in itself preclude the contemporary coexistence of today's A14–A1 route from Huntingdon to Wansford (it is significantly the Roman Ermine Street for much of the way), and only

**Fig. 100:** Part of the fourteenth-century Gough map showing the Great North Road from London to Stamford. (Ordnance Survey facsimile, reproduced by permission.) *Note*: the map has *east* at the top (see p. 31–2).

other types of historical information could settle the question. Certainly Ogerston was an establishment of the Knight's Templar, and there are records of its use as a halting place for important travellers,[4] but we should need far more evidence than this to conclude whether one or both routes were in use and, if the latter was the case, which was the dominant one.

*Example 2   Investigation of old roads in Kent using Symonson's map of 1596*

Symonson's map, like the Gough Map, is an unusually early example of a map showing a road system and it makes an interesting comparison with the previous section to attempt the same sort of study on the much more detailed background of the county map. One example will suffice – an investigation of Symonson's road from Dover to Sandwich.

Quite obviously (see Fig. 101) Symonson's road is not the modern A256, which lies further west and enters Sandwich via Eastry; but if this is not so, where was Symonson's road and does any trace of it survive today? The limited accuracy of maps of this period precludes placing much reliance on the actual shape and absolute position of the road as it is shown, and instead its position must be fixed relative to other detail. What we need then, to begin with, is a road passing as Symonson's does through Charlton,[5] just west of Guston and between 'Bewtfield' (an obvious mistake for Whitfield) and West Langdon. Here the old Roman road, first as a footpath, then as a lane, fits these requirements admirably (Fig. 101), but since it eventually joins A256 at Eastry this is not the whole story. Symonson's road passes just west of Little Mongeham (Mongeham pva) and between Betteshanger and Norborne and Norborne and Ham, so that a much more likely candidate now is the quite direct country road via East Studdal to West Street.[6] Beyond this point however it is impossible to conjecture. The marshes south of Sandwich today bear little resemblance to detail on Symonson's map, which shows the main stream *west* of Worth, and there are no hints on the modern map of the whereabouts of Symonson's road with its unlikely double crossing of this stream. Presumably drainage and/or enclosure have modified the pattern here, and much more detailed cartographic evidence might be needed to get further. In any event the whole alignment suggested from Dover would need confirming from other types of evidence. But Symonson's map has, at least, offered a strong pointer to a possible older road and a good indication of localities where it might be profitable to seek further information.

*Example 3   Cartographic evidence and the study of the evolution of variable coastal features, such as sand spits, shingle bars, etc.*

In the study of the evolution of these relatively rapidly changing physiographic features, cartographic evidence may indeed prove a two-edged weapon. While old maps

---

[4] Edward I stayed there, e.g. in 1299 and 1303. For further details see Stenton and Parsons (1958).

[5] A distinctive feature of Symonson's roads is the rarity with which they pass *through* villages. Perhaps the church symbols make it difficult to show this but the awkward relationship of the roads to these and other detail suggests, to the author at least, a possibility that the roads may have been added later.

[6] Rather oddly this road too finishes only a mile short of a Roman temple ¼-mile south of Worth; the hamlet name West *Street* is also intriguing and suggests a possible Roman by-way.

**Fig. 101:** Part of Kent between Dover and Sandwich as shown on Philip Symonson's map of Kent, 1596, and sheet 290 of the 3rd edition of 1″ Ordnance Survey map (1911). The latter map has been reduced to about two-thirds original size. (Symonson's map is reproduced here from an Ordnance Survey facsimile, by permission.)

could, of course, offer a unique record of changes in the form of such features over perhaps four centuries or so, one remains very conscious of the fact that, until the coming of the official surveys at least, they may be far from the reliable guide to the definition of shape and position that is needed in this context, particularly since these features would have relatively little interest for most cartographers and would contribute little to the commercial value of their products.

There is no easy solution to this particular dilemma, but there are two sensible lines of approach. The first is to assess the possible accuracy of each map through a wider knowledge of the general quality and character of a particular cartographer's work, rejecting the evidence of some maps as unreliable but accepting others: Diver (1933) studying the evolution of the South Haven Peninsula in Dorset, provides an admirable example of the sifting and weighing of cartographic evidence in this manner. The second is to question any cartographic evidence which cannot be reconciled with a reasonable estimate of the rates of physiographic processes or the dating of remains by any other method. Thus Steers (1969), tracing the southward growth of Orford Ness in Suffolk was able to establish, from cartographic evidence, a fairly consistent development at an average rate of about 15 yards per year, between Norden's detailed and fairly accurate survey of the area in 1601 and the spit's maximum extent attained in 1897. He rejected, however, the position of the tip as shown on a coastal chart of Henry VIII's time because it would have necessitated almost double this rate of growth before 1601, which seems unlikely. Similarly Carr (1962) in a further study of cartographic evidence on this subject points out that, even with nineteenth-century maps of more reliable accuracy, lack of precise information of the date of survey raises difficulties. For example, the Admiralty Chart of 1819 and the revised 1″ Ordnance map *published* in 1838 show the tip of Orford Ness in almost exactly the same position, whereas Bullock's survey of 1847 places it 3,000 feet further south. As Carr remarks 'both experimental and documentary evidence together suggest that the rate of growth necessary – well over 300 feet per year – could never have been achieved between 1838 and 1847, nor is it likely that the spit was static for the previous 20 years'. In this case the discrepancies might perhaps arise not so much from cartographic inaccuracy as from the fact that the middle map (the 1838 Ordnance map) is misleadingly dated, the survey on which it was based having occurred several years before the date of publication. On the other hand the differences between the maps which appear in Fig. 102 may derive from a much less rational explanation, and it would be difficult to know *without other evidence* how much of this difference had its roots in reality, how much in poor surveying; the same observation has equal relevance to yet further cartographic examples of the shape of Orford Ness since 1530 which appear in *Orford Ness* (W. Heffer & Sons Ltd., Cambridge, 1966).

These three examples should go some way towards illustrating the potential of historic cartographic evidence 'in the round' so to speak. Certainly old maps will contain inaccuracies and in consequence their indications will often need to be qualified or treated with suspicion but if their historical content is viewed realistically in the light of their cartographic background, they can make a unique and valuable contribution to research studies of all kinds.

**Fig. 102:** The representation of Orford Beach, Suffolk on four maps all published at 1″ to a mile between 1783 and 1838. **A:** Hodgkinson published 1783. **B:** O S first edition published 1805. **C:** C. and J. Greenwood published 1825. **D:** O S first edition revised, published 1838. (Reproduced from Carr, 1962 by permission of the Geographical Association and the Trustees of the British Museum.)

# Chapter 14

## Looking at Maps (1) Features of the Physical Landscape

To the man in the street the map is essentially a practical tool to answer simple questions – 'how does one get from A to B?', 'where is C?', 'how extensive is D?' – though it is obvious that, once maps attained modern standards of completeness and accuracy, much more searching questions could be asked of them than that. Geographers for example, concerned both to describe the components of a landscape and to explain their disposition, have traditionally seen in maps not only a concise summary of what they must explain but also a useful pointer to possible explanations of origins and differences. In their case the aim has often been to see *beyond the image* – beyond the obvious on a map into a whole realm of subtler implications; not simply 'here are two ranges of hills, a town, a road and a river' but 'why are these two ranges of hills different in their alignment/ form/drainage pattern?', 'why does this town have a grid pattern of streets when its neighbours do not?', 'why is this road so smoothly aligned when its neighbours are irregular and winding?', or 'what is such a small river doing in so large a valley?'. If one appreciates that a map can be used not only to pose questions such as these but sometimes also to suggest possible answers to them it becomes at once stimulating and intriguing as well as merely informative, and it is with this concern, *to use maps* (and air photographs) *as a source of further ideas about landscape, its components and origins* that the final section of this book is concerned.

As will become obvious, the key to using maps in this way lies basically in the recognition of patterns which are distinctive and characteristically associated with particular features, and in this respect the air photograph, with its even more detailed representation of the landscape, will have a similar potential to the map. Of course in the case of the air photograph there is the additional problem that one must first learn to recognize on it the appearance of even the most basic features, which are so explicitly and familiarly marked on maps, but it is not solely for this reason that maps and air photographs are separately treated here. Whilst it is true that the map patterns described in this chapter and the next can equally be sought and similarly interpreted on air photographs, in this business of describing and analysing the landscape the potential of the latter so far transcends that of the traditional topographic map that separate treatment becomes inevitable.

The most obvious, practical, manifestation of this superior potential is seen in the way the air photograph has virtually ousted the topographical map as a source of information

on aspects of landscape evaluation which have commercial application – geological exploration, vegetational or agricultural resource evaluation for example – but in other sectors the more traditional map may still retain pride of place. Maps are still a more familiar sight in the classroom than air photographs, not least because they are both cheaper and more easily obtained, and they are still therefore the most convenient place in which to begin recognizing and thinking about the peculiar patterns displayed in the landscape. That is what we shall do next; we can progress later to the subtler and more complex implications of patterns on air photographs.

# Map analysis

The idea of examining maps to obtain important information or conclusions of the kind just described is often termed map analysis – not perhaps the most fortunate terminology. The word 'analysis' almost inevitably implies analogies with processes such as quantitative or volumetric analysis in chemistry in which the application of a particular technique yields very positive and definite results, whereas it is obvious from the reasoning of the previous paragraphs that no such process would be possible using topographical maps alone. In fact no one has yet tried to draw up such a technique of investigation for topographical maps;[1] yet the term has stuck, perhaps because very often in existing literature map analysis has been *made* to yield positive and definite results by the introduction of quite a new approach – teaching by example. Suppose one chooses, for example, an area of glacial deposition, or of large-scale iron mining, reads the literature on that area and *then* examines the topographical maps of it, naturally one can point out the distinctive features found on those maps and offer definite explanations and conclusions about them: that that low, insignificant, vaguely curving ridge is a terminal moraine; that no mines occur around X because the ore-bearing strata are down-faulted, and so on. Properly done studies of this kind can be both rewarding and stimulating, especially from an illustrative point of view; but they seem to be fundamentally wrong as an approach to map *analysis*. Such studies know the answers first, and because of this may be of little help, or even positively harmful, to a person confronted by a map of an unknown area, an area moreover which is probably a good deal less 'textbook' than the one previously studied. With this sort of map training the student might easily draw erroneous analogies between features on this map and the one he has previously examined, particularly if no one pointed out any alternative possibilities; and, what is perhaps even worse, he may attempt to frame his conclusions in the same definite way as in the example presented to him where these conclusions were backed by much wider evidence.

To avoid pitfalls of this kind and to try to encourage students to approach topographical maps with an open mind, a rather different approach has been tried in this book. It is concerned essentially not to show people what is on a map but to encourage them to ask

[1] The nearest parallel is an interesting analytical approach by Dury (1972) but the scheme deals with features of the physical landscape only.

'what should I look for on a map?' and 'what *might* this signify?'. The importance of the italicized 'might' in the previous sentence cannot be overemphasized for it must be accepted, at the very outset, that *inconclusiveness is inherent in map analysis*. All one can get are *ideas* which could lead to other work; *likely* causes; *probable* origins. Map evidence cannot and should not be used alone as a basis for conclusions but should lead on to detailed field work, further survey, documentary or statistical investigation. It is essential too to appreciate that when maps of a region are examined with this type of approach, several possibilities, rather than one, will arise from many of the features studied. In some cases, of course, there will often be corroborative evidence from one feature to another favouring a particular conclusion, but the examination may well finish with a few very definite ideas, rather more less conclusive ones and several outright 'don't knows'. This is as it should be; the topographical map has played its part, yielded some ideas for consideration, and other forms of investigation and research must now take over – not an unsatisfactory standpoint from which to proceed to further study of an area.

*Limitations of Style, Content and Scale*

So far, whilst the general ideas and problems of 'looking at maps' were being considered, topographical maps were treated as a group, yet obviously the style, content and especially scale of a map are very relevant to its suitability for this purpose. With style and content unfortunately there is often little choice, one must either take the maps or leave them, but in many areas there is at least a choice of scale. What scale will be most suitable? Generally speaking and particularly if only one series can be purchased for the operation, good topographical maps at scales of between 1 : 40,000 and 1 : 126,720 ($\frac{1}{2}''$ to 1 mile) will give the best all-round results. Unless the sheets are very small a sufficient area is covered to allow regional patterns and variations to emerge, yet the content is usually sufficiently full and clear to allow many patterns to be examined in detail. Below about 1 : 100,000 or $\frac{1}{2}''$ to 1 mile, though the maps are useful to obtain overall impressions, detail is too generalized to be much use; while scales above 1 : 40,000, though admirable and often necessary for studying one feature in detail, usually cover too small an area to allow wider distributional patterns to be recognized. Ideally of course all three groups of scales should be employed – a quick 'lie of the land' from the smaller scale, the main weight of the examination from the medium scales and a following-up of any more interesting points of detail on the large-scale maps.

In the examples which follow, a wide variety of scales have been employed deliberately, partly to suit the convenience of the features or areas being shown but also to present the appearance of the same feature at different scales. It should be remembered however that many of these features may themselves exhibit enormous variation in 'scale'. A cuesta for example may be anything from a quarter of a mile to several miles across, and whilst greater size will not necessarily invalidate the explanations which are offered it will leave more opportunity for the presence of minor features which can modify the 'textbook' form.

Not all the illustrations used in this chapter are 'textbook' versions by any means, for it is extremely important to recognize features in both 'classic' and 'not-quite-so-classic' forms and of the two in fact the latter variety is probably the best 'teacher': one is likely to

discover far more possible incised meanders after looking at Fig. 109G than by being shown only such classic versions as the lower Wye in Britain or the Moselle in Germany.

There is little more that need now be said by way of introduction to the idea of 'looking at maps' save two general points of technique. The first of these is to approach the study and analysis of any pattern by *working from the whole to the part*, and *from the general to the particular*. Eye-catching detail may offer tempting diversions, but it will be better appreciated and understood if first set in a more general context. The second point concerns the actual technique of examination. It is not always easy to study individual patterns on topographical maps, where they may be confused by the other patterns present, and in these cases it is useful to be able to 'take them out' and consider them in isolation. With physical features 'water and contour' versions of sheets, available in some countries, help greatly, but where no ready-made answers can be had, it is best to lay a sheet of transparent material over the maps and trace onto it those portions of a particular pattern which seem important or interesting. Ideally the whole pattern should be traced but this is an incredibly tedious and time-consuming task, often unnecessary except in areas where other detail renders a pattern completely unappreciable. Once this has been done not only can one 'see the wood for the trees', but the transparent sheet can be used as something on which to 'think aloud' by drawing freely, adding notes or queries, sketching in other relevant detail not marked on the map, for example, watersheds, or anything else which will help towards a fuller understanding of what is there. Transparent plastic sheets popularly known as 'talc' sheets are ideal for this purpose; special crayons, e.g. 'Chinagraph' or 'Glassrite' pencils, are needed to draw on these, but the lines can easily be erased with a rag moistened with methylated spirits or 'Banda' fluid and the sheet used over and over again.

# Features of the physical landscape on maps
# I Relief

## 1 *Summit Levels*

There is no more general or useful way to begin a study of the relief of an area than by examining summit levels, preferably by marking their position and altitude (approximate if no better value is available) on a plastic sheet laid over the map. It is also useful at this stage to add the altitude of any prominent shoulders or benches which surround the main hill features even though these are not necessarily summits in the strict sense of the word. The results will not only present the quickest way of getting the 'lie of the land' in an area and of assisting a factual description of it but may also reveal the following significant features:

(a) *Areas with accordant summit levels.* It is by no means uncommon to find that over quite extensive areas summits are at approximately the same level or lie within a narrow height range. Where this occurs further work has often suggested that such hills are the remains of a former erosion surface or *peneplain*, i.e. a near-level or gently undulating surface formed during a previous erosion cycle. Only portions of this surface now remain

**Fig. 103: A:** Djebel Chemsi, Tunisia – an eroded anticlinal structure. **B:** Part of Cardiganshire, south of Aberystwyth. **C:** The northeastern corner of the Forest of Dean, Gloucestershire. **D:** The Upper Greensand plateau, north of Honiton, Devon.

forming the tops of hills or spurs, the remainder having been eroded away by the down-cutting of streams following a rise in the level of the land or fall in sea level.

(b) *Areas with summit levels very different from their surroundings.* Areas noticeably higher or lower than their surroundings will naturally attract attention. Where they occur on a regional scale an obvious possibility is that they may represent, in the most general way, areas of more resistant or less resistant rocks, for example in Britain the Malvern Hills and the Vale of Clwyd. Alternatively erosional influences like those mentioned in the previous section may be involved, and these generally higher or lower regions may represent areas which either were not attacked during former peneplanations, or where a further cycle of downcutting is well advanced. Fig. 103B illustrates something of both these ideas. Many of the hills between the coast and the Teifi valley, for example, have summits between 900' and 1,100', a rather crude measure of accordance but one which becomes increasingly significant when it is found that a similar situation occurs widely elsewhere in Wales; from this and other evidence Brown has deduced that these hills are remnants of the gently undulating Low Peneplain of Wales.[2]

Nearer the coast, in Fig. 103B, accordant summit levels again appear. Several isolated hills just top the 600' contour and immediately below this height the wide spacing of the 500' and 600' contour in places suggests the existence of a marked bench at several points. This is a rather more narrow degree of accordance than in the previous example and is thought to represent the remains of a former wave-cut coastal platform.[3]

## 2 Prominent, Isolated Hills

Unlike many other features listed in this section there is no single probable explanation for these distinctive features. The following possible causes should be considered:

(a) The hill is formed from an isolated outcrop of rock, different from and more resistant than its surroundings. The distinctive landmark of the Wrekin (Fig. 104B), formed by resistant Pre-Cambrian rocks emerging from beneath the younger rocks of the Shropshire plain is a well known example of such a hill. It is not uncommon for these resistant, isolated outcrops to be of *igneous* rocks, and within this group come the often striking and craggy examples formed from old *volcanic necks*, i.e. solidified lava filling the central opening of a former volcano and remaining after the surrounding cone has been eroded away (for example X in Fig. 104E). The Devil's Tower, Wyoming, USA is a striking example of such a feature; there are many others in the Central Scottish Lowlands, Castle Rock for instance and Arthur's Seat (rather a complex example) at Edinburgh, Bass Rock and Traprain Law, and in the Le Puy area of Central France.

(b) The whole hill is not formed from a more resistant rock but is merely capped, and hence protected, by a more resistant layer. The Brown Clee Hills, another Shropshire landmark, are protected in this way by a double capping of Carboniferous rocks and Dolerite (Fig. 104C); Billingen, in central Sweden, with a diabase capping is a further

[2] Brown, E. H., (1960).
[3] Brown, *op. cit.* Differences between remnants of marine platforms and those of subaerially formed peneplains are not confined to the generally narrower altitudinal range of the former. Differences of drainage patterns for example, would also be manifest, but these are too complex to be elaborated here.

**Fig. 104: A:** Mt Kartala, Comoro Islands. **B:** The Wrekin, Shropshire. **C:** Wenlock Edge and Brown Clee Hill, Shropshire. **D:** Upper Greensand and chalk escarpments near Mere, Wiltshire. **E:** Relationship of various topographical features and geological structures.

example. A special case of such 'capped' hills is formed by the many *outliers* of escarpments (see below).

(c) The feature may be a *residual* one, not associated with any marked lithological change. Erosion acting upon a resistant mass may ultimately reduce it to one or two isolated hills which may remain simply because they are 'last to go'. Occasionally these remnants may have been helped in their survival by being slightly more resistant to erosion than their surroundings, by possessing fewer joints for example, or by being better cemented; but they would not be fundamentally different from their surroundings, and would not be differentiated on a geological map. The rocky granite tors of Dartmoor are examples of residual features of this kind, as are the even more striking *inselbergs* or *bornhardts* characteristic of the plateau uplands of East Africa. It is impossible here to consider the conflicting views which have been expressed about the origin of these curious features but inselbergs in particular, rising abruptly out of plains composed of the *same* material, emphasize that lithological change need not necessarily be expected at the foot of prominent isolated hills.

(d) Volcanoes, both present and ancient, form a fourth, perhaps less obvious, cause of isolated hills. Despite enormous variety of shape and size, from hundreds to thousands of feet in height, hills of this sort usually show two distinctive characteristics. The first is a remarkable *concentricity* of contours (see Fig. 104A), the other the presence of a crater or *caldera*. Both are subject to some modification in practice. Gullying and erosion may destroy the contour pattern (but rarely the generally circular shape) while the crater may be small and unrecognizable or complex, as in the cone-in-crater or crater-in-crater type (Fig. 104A). It is worth remembering too that crater, crater rim and volcanic cone are sometimes incomplete, having been partly destroyed by later eruptions.

### 3 *Linear Hill Features*

(a) *Asymmetrical hills with one steep face and one gently sloping face.* Provided that both of these features, the steep scarp slope[4] and the gentle dip slope can be recognized, for example as at Whitbarrow in Fig. 105C, the feature can fairly confidently be described as a *cuesta* or *escarpment*,[4] caused by the outcrop of resistant, gently dipping rocks (see features marked A in Fig. 104E). Cuestas thus give indications of both the lithology of an area and its structure, the strike of the rocks running parallel with the cuesta and the dip at right angles to it.

(b) *More symmetrical hill-ridges with both sides steeply sloping.* Features of this type are known as *hog-backs* and are often formed by an outcrop of resistant steeply dipping or even near vertical rocks, (see B in Fig. 104E). They are therefore really an exaggerated form of cuesta; but in this case it is often difficult to tell on the map which is really the scarp and which the dip slope, and only the strike of the rocks can be seen clearly.

(c) *Multiple cuestas, all facing the same way* usually point to erosion acting upon alternating hard and soft rocks all dipping in the same direction.

---

[4] Sometimes called merely a 'scarp face'. The English usage of such terms is rather lax since 'scarp' is commonly employed to describe the whole feature as well. For this latter purpose the terms 'cuesta' or 'escarpment' are preferable.

**Fig. 105: A:** Part of the west coast of Jutland, Denmark. **B:** The Dollard embayment near Emden. **C:** Whitbarrow and the Kent estuary, Cumbria. **D:** The Quinson depression, Provence, France. **E:** Area around Napoleon, Ohio. **F:** 'Drumlin country', 20 miles west of Syracuse, New York State. **G:** The site of the former 'Lake Milfield', near Wooler, Northumberland. **H:** Kettle-hole country and outwash plain, southwest of Vejle, Denmark.

(d) *Twin cuestas facing inwards* indicate the possible presence of an eroded anticline (see D and E Fig. 104E).

(e) *Twin cuestas facing outwards* indicate the possible presence of a synclinal structure (for example C and D Fig. 104E). The twin cuestas need not be in close proximity, and indeed on a regional scale they may be many miles apart, as in the case of the North and South Downs in England which form a 'regional example' of inward-facing cuestas, and the North Downs and Chiltern Hills which form a 'regional example' of outward-facing ones.

(f) *Curved cuestas, 'concentric' cuestas*. These are merely further modifications of the themes listed in sections (a), (c), (d) and (e) above, and suggest eroded dome structures if the scarps face inwards, basin structures if they face outwards.

*Further comment on* (a)–(f) *above.*    The descriptions given in (a)–(f) above are of the simplest possible cases. Let us consider for a moment features which may complicate these 'textbook' patterns both in reality and on the map. A very common feature 'camouflaging' many an escarpment is its dissection by streams into a number of short sections. This is the case in Fig. 104C where the cuesta A–A–A–A formed by the Aymestry Limestone is far less obvious than neighbouring Wenlock Edge, yet even here the ⊓-shaped hills still have the cuesta form, with a steep northwest-facing side, and a more gentle southeast-facing side characterized by noticeably regular contour spacing. Many cuestas show this very regular contour spacing on their dip slopes; though this does not necessarily mean that the slope of the ground is the same as the dip of the rocks. Wenlock Edge in Fig. 104C is often regarded as a classic English escarpment, yet on the map its true cuesta form is disguised because it carries a second scarp, that of the Aymestry limestone 'on its back'. However, the form of the latter plus the straight, steep scarp face of Wenlock Edge itself give clear evidence of its true nature. Not all scarps are as straight and clear as Wenlock Edge and many that are not cut through completely by streams may be much 'fretted' by erosion. In Fig. 104D, for example, the western cuesta formed by the Upper Greensand (G–G–G–G), is fretted only in its northern portion (notice the even contours on the dip slope again); but the eastern cuesta, formed by the chalk (C–C–C–D), has been cut back into a very complicated form, so much so that in one place erosion has quite isolated a portion of the chalk, leaving it standing clear of the main escarpment and forming the prominent outliers of Long and Little Knolls. The relationship of an outlier to the main escarpment is further illustrated at F in Fig. 104E, which explains why it can also be regarded as a special example of a 'capped' hill (see 2 (b) above).

Alteration in both the thickness and angle of dip of the scarp-forming rock may also cause the form of a cuesta to vary a great deal. The rock may thicken, thin out, split into two to form a *stepped* or *compound scarp* (as at D and E in Fig. 104E), or disappear completely, for example at a fault. Faulting may also cause the line of the scarp to be set backwards or forwards, while minor anticlines running at right angles to the strike may produce curvature in plan or give zones of weakness where erosion may cut great embayments in the scarp. In Fig. 104D the Upper Greensand forms a prominent scarp, yet a few miles to the north it has thinned so much that it produces only a weak feature 150' high. In contrast, at D on Fig. 104D, the prominent scarp which has bounded the chalk hills for

many miles suddenly becomes much weaker because the chalk is 'faulted away', and
when a scarp does appear, much fretted, on the southern side of the hills at E–F–G–H, it
is formed by the Upper Greensand again faulted and folded round through 90° and
dipping north, northeast and then east around the east–west anticline of Wardour.

The same complications beset eroded anticlines, domes etc. The Djebel Chemsi area
(Tunisia) in Fig. 103A (p. 250) is clearly a 'textbook' eroded, elongated dome (though
even here several of the 'rims' are incomplete); but this should be contrasted with Fig.
103C. The sinuous scarp A–G does not look much like the Djebel Chemsi, yet the curved
scarp C–D–E is really a curved outward facing scarp bounding the elongated northern
extension of the Forest of Dean coal-basin, while the curved inward facing scarp D–E–F–
G bounds the southern end of an adjacent dome structure; notice also the dissected hog-
backs of the Brownstones at H–H–H and, less obviously at J–J–J.

### 4 *Flat-topped Hills Bounded by Steep Slopes*

Features such as this, sometimes termed *mesas*, are often caused by resistant rocks which
are nearly horizontal. They stand therefore at the opposite end of the 'cuesta variations'
from the hog-back (see G in Fig. 104E) and Fig. 103D shows an example, oddly enough
formed by the Upper Greensand again, in Devon. Although the hills in Fig. 103D have
often been used as an example of this phenomenon, the fact that the near-level surface
cuts across, rather than coincides with, the very gentle dip of the rocks has also led them
to be explained as a remnant of a former erosion surface, i.e. as an area of accordant
summit levels under 1(a) above. Here is an obvious case where contour evidence alone
cannot decide the issue.

### 5 *'Stepped' and 'Terraced' Hillsides, Hillsides with 'Benches'*

(a) If multiple layers of gently-dipping resistant rocks are present, many may not be
able to form cuestas or mesas themselves but will merely appear as 'steps' along the sides
of such features. Wherever two or three close contours suggest a steepening of the slope on
a valley or hillside, therefore, it is worth suspecting the presence of a layer of resistant
rock, which may well support a gentle slope or bench above it, as in the stepped scarps at
D and E Fig. 104E.

(b) Not all benches have a structural origin, however. They may be produced where an
erosion surface cuts into a hillside. Thus the step at the foot of Whitbarrow (A–A–A on
Fig. 105C) is truly structural, caused by resistant limestone; but that under Brown Clee
Hill (B–B–B–B on Fig. 104C) is probably erosional, the accordant spur top levels pro-
claiming a possible hillside remnant of the Low Peneplain of Wales mentioned earlier.

### 6 *Hill Masses and other Features with almost Straight, Steep Edges*

The characteristic feature here is not steepness, as in 2–5 above, but straightness. Where
features have steep straight or near straight boundaries this may be caused by a fault, the
steep slope then being either a true *fault-scarp*, i.e. literally caused by the movement of
rocks along the fault; or a *fault-line scarp* produced where differential erosion acts on hard

and soft rocks brought into juxtaposition by the fault. Notice that from the crest of a fault-line scarp ground level may rise or fall depending partly on the dip of the resistant beds (see Y Fig. 104E); if the latter is the case only the straightness of the scarp face may differentiate it from a normal cuesta. Two very clear and straight fault-line scarps can be seen bounding the Quinson depression in Southern France (Fig. 105D) where down-faulted sands and marls give rise to an abrupt hollow in the resistant limestones.

## 7 Very Flat Areas

While hill features are distinctive on a map by the closeness and number of their contours equally distinctive are the areas virtually without contours – the very flat areas. Areas of very low relief may already have been noticed above under 1(a) (possible former peneplains), and 1(b) (possible outcrops of less resistant rocks). This section is concerned with areas which show scarcely any relief at all and once again several possibilities must be considered.

(a) *Very flat areas with a coastal location.* These often represent land which has 'emerged' from the sea due to the deposition of material either by rivers or by the sea. Typical locations are in embayments or estuaries, for example around the Wash in Britain, and in parts of the coast sheltered by spits (for example at Tyborön in Jutland, Fig. 105A) or offshore islands (for example in the Wadden See between NW Germany and the Frisian Islands). Areas of this sort are often completely 'contourless' on maps because of their low altitude and usually show several other characteristic associated features as well. Extensive sandbanks offshore are common, so is a fringe of coastal marshes, where plants help the emergence by trapping sediment, while man has often hastened the natural process by land reclamation, and a succession of sea-banks and the rectilinear artificial drainage of the land mark his efforts. All of these characteristics can be recognized in the Dollard area, Fig. 105B; alternatively if reclamation has not taken place there may be widespread coastal marshes or swamps.

The part played by rivers in this sedimentation process is easily imagined, indeed river deltas would be included here in this category, but the part played by the sea should not be overlooked. This may account, among other things, for very flat areas produced by such sedimentation but related to a former sea level, for example, around Morecambe Bay where the prominent flat areas at about twenty feet above mean sea level were so formed (see Fig. 105C), while the extensive sand-banks and coastal marshes hint at the continuance of the process today, related to the present sea level.

(b) *Very flat areas in an inland location.* Rather more possibilities present themselves here. For example the areas may be either (i) *the flood plains of large rivers* (see below) – a very obvious form of flat area – or (ii) *formed from the floors of now vanished lakes*, sedimentation within the lake having created a level floor which became exposed when the lake was drained. Many such lakes, some tens of miles across, were formed when ice sheets blocked and impounded pre-existing drainage in the glacial period and Fig. 105E shows part of the now exposed floor of a very large lake of this sort, a glacial extension of the present Lake Erie. With smaller-scale examples the idea of an enclosed lake basin may be a little more obvious, as in the Northumberland example shown in Fig. 105G, which was formed when ice blocked the northward-flowing River Till. Once exposed of course, these

former level areas may become subject to downcutting and dissection by streams, as for example in Fig. 105E where the River Maumee is now incised into the old lake floor.

A third category of very flat area is formed by either natural or reclaimed areas of bog, fen and marsh. The former are easily recognizable, the latter usually show signs of reclamation similar to those described in 7(a) above.

### 8 *Areas which Slope Extremely Gradually in One Direction*

A very gradual, sometimes almost imperceptible, slope in one direction, indicated by widely and often fairly regularly spaced contours, may point to the existence of single or coalescing large-scale *alluvial fans*, or similar features comprised of depositional material (for an example of a small-scale fan see X in Fig. 109H). In certain circumstances these may be very large-scale features: Fig. 106 shows a portion of one some 15 miles or so across with a slope of only 1 in 80 to 1 in 170 and with the *bowed contours* often characteristic of these features; the coalescence of adjacent fans of this type may produce a *piedmont alluvial plain* in front of a mountain range.

Other depositional features which have similar characteristics are *glacial outwash fans and plains* (the edge of one occupies the lower portion of Fig. 105H), the aprons of debris which may surround hill masses in desert areas, (for example around the Djebel Chemsi in Fig. 103A), and the similarly situated *desert pediments*, though these are thought to be erosional rather than depositional in origin. As in the case of volcanoes the classic form of these features may be confused by gullying and renewed dissection, but the remnants are often still quite recognizable.

Between the distinctly hilly and the very flat area lies an enormous range of potential shape and form which quite obviously it would be impossible to categorize. Within this range however three features may be selected as both distinctive and usually associated with the presence of certain features.

### 9 *Very Hummocky Areas*

These will show a generally intricate and close contour pattern; two distinct types may be recognized.

(a) *Those with many closed 'ring' contours*, the rings usually being elongated and sometimes joined laterally also (see Fig. 105F). Contour patterns of this type almost certainly indicate an area of drumlins, i.e. elongated smooth hills formed largely of boulder clay, not unlike half an egg in shape and often of considerable size (up to 200 feet high perhaps). In the 'classic' areas, for example County Down, N. Ireland, they occur in very great numbers with the long axis aligned parallel to the direction of flow of the ice.

(b) *Those with contorted contours, often with small enclosed depressions and perhaps small lakes* (see Fig. 105H). Features of this kind are often found associated with extensive *glacial moraines* (for more restricted morainic features see 10 below). They reflect the uneven nature of the original deposition of the morainic material further confused by the subsequent melting of buried masses of ice, which leads to the formation of depressions or *kettles*, hence the terms *knob-and-kettle* or *knob-and-basin topography* often applied to such areas.

**Fig. 106:** Twin-lobed glacial moraine 'blocking the mouth' of the upper valley of the Dora Baltea valley in northern Italy. In front of the moraine is a fragment of the extensive piedmont alluvial plain, of fluvioglacial origin, which fronts the Alps in this area.

10 *Low, Arcuate Hills*

Low hills, crudely arcuate in plan and not associated with similar concentric features [5] may be indicative of the presence of a *terminal glacial moraine*. As such the arcuate form is the only consistent characteristic, for slopes may vary from quite gentle to steep on one or

[5] Curved cuestas might obviously also qualify for such a description. In the case of curved cuestas however there is often more than one, exhibiting crude concentricity as in Fig. 103A.

both sides (but often steep on the up-valley side), and heights from a few feet to well over a hundred. Likely situations, however, are running across a major lowland or large valley, as in Fig. 106 which shows a rather more unusual twin-lobed version almost blocking the 'mouth' of a valley, that of the upper Dora Baltea in Italy; the river has breached the barrier, of course, but there is confused drainage with small lakes behind it. Where such features formerly blocked smaller valleys, however, they are often so dissected today that their remains, on the map at any rate, show little resemblance to the classic form.

# II Rivers and streams

The patterns of rivers and streams in an area will often give indications of characteristics which underlie its nature or origins. Because it is often advisable to treat stream and valley as one unit, valleys are included in this section and, as before, a general inspection should be made before a more detailed examination is begun. Such an inspection may reveal the following features:

11 *Areas with no Drainage Pattern, Disappearing Streams or with Rivers only in the Main Valleys and Many Dry Tributary Valleys*

Aridity may, of course, cause a drainage system either to be absent in an area or to peter out; but where there is no reason to suspect such an explanation the presence of an outcrop of pervious rock will be the most likely explanation. Although occasionally porous sandstones may be responsible chalk or limestone outcrops are the most usual causes, and it is often possible from other evidence to guess which it is. As the right-hand portion of Fig. 104D shows, dry valleys in a chalk area typically show smooth rounded contours and a fairly regularly branching *dendritic pattern*; those in hard limestones on the other hand often have a more angular appearance with sharp bends in plan and crags or steep slopes on the valley sides.

Figs. 107 B and G show two different examples of such streamless areas, the one almost completely 'dry' the other with actual disappearing streams; but in both cases the correlation between streamless area and limestone outcrop is remarkably good. Disappearing streams with associated caves, pot-holes, etc., are characteristic of many limestone areas; but isolated disappearing streams should be treated with caution. Very often they are streams which do no more than pass into a roadside ditch (unmarked), or are piped temporarily under some obstacle, for example a built-up area. Notice too that the beginning of a stream on a map is often of no significance: it may be a cartographic averaging-out of a very variable feature, or it may mark an actual spring or source. The last-named features are not at all easy to detect on maps: for example in Fig. 103D many streams begin significantly just below the 750′ contour, but this is not in fact a spring line, even though the hills are capped with greensand overlying Keuper marls.

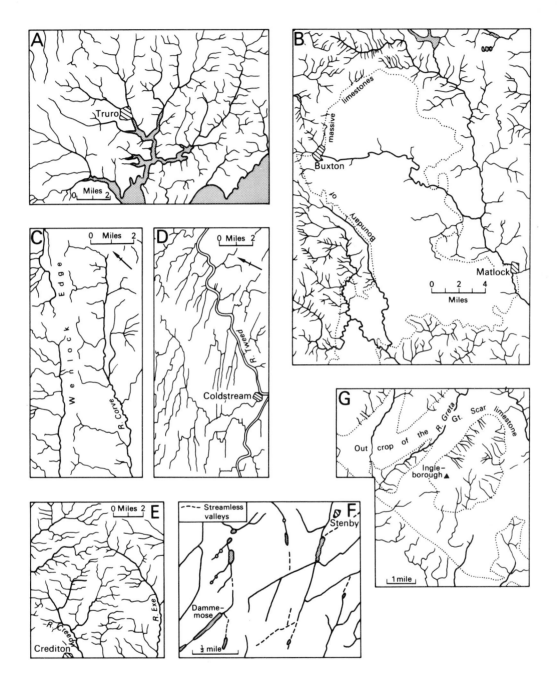

**Fig. 107:** Drainage patterns. **A:** Around Truro, Cornwall. **B:** Central Derbyshire. **C:** Wenlock Edge and Corve Dale, Shropshire. **D:** Tweed valley, near Coldstream, Berwickshire. **E:** Near Crediton, Devon. **F:** Southwest of Rö, Bornholm, Denmark. **G:** Around Ingleborough, Yorkshire.

12 *Drainage Patterns where the Main Elements cut across or through Prominent Relief Features*

In many areas the main rivers do not, as might be supposed, always follow the alignment of the principal lowland units, but sometimes flow across rather than along them, and subsequently cut across or through the main upland units. A slightly different version of the same idea can be seen in Fig. 109J where the River Argens, in southern France, instead of flowing along the main lowland to Le Muy, abruptly leaves it to cut through a corner of the hill mass to the south. Where features of this kind occur the drainage may have been superimposed on the relief or be antecedent to it, though on the map it is rarely possible to tell which. In superimposed drainage the alignment of the streams was initiated on a now vanished cover and maintained even when erosion revealed the underlying structures which form the present relief, this being the case in the area shown in Fig. 109J. Antecedent streams on the other hand have maintained their course across obstacles which have risen in their path. A further possible explanation is that the drainage may have been glacially impounded until it overflowed across the former watershed (see section 21, p. 268).

Having looked at drainage in general, more detailed aspects can now be considered. What, for example, is the general arrangement of streams within the network or parts of the network and what kind of patterns do they make?

13 *Dendritic Drainage Patterns*

A drainage system which branches evenly and continuously as one proceeds from its lower to its upper portions is said to be *dendritic* (i.e. like a tree). Since this is the kind of drainage pattern which evolves 'where the rocks have no conspicuous grain and offer nearly uniform resistance to erosion',[6] it hints at the presence of such conditions, either today or in the past, for superimposition may have occurred. Notice that 'nearly uniform resistance to erosion' is all that is implied, not uniformity of composition, and this may perhaps indicate why in Fig. 107A a fairly even dendritic pattern has evolved on the sandstones and slates of the Portscatho Series in Cornwall.

14 *Drainage Patterns showing Marked Alignments in One or more Directions*

Conditions uniform enough to lead to extensive dendritic drainage patterns are not particularly common, for more usually the rocks of an area contain certain lines of weakness along which drainage will develop more easily, giving predominant alignments or characteristics within the patterns. Common features causing weakness are outcrops of less resistant rocks, and structural features such as anticlines, shatter belts, faults and major joints in the rocks; where these have an extensive influence, certain characteristics in the pattern may give some indication of which factor is responsible. Conversely where only one or two examples occur they will be less easy to distinguish and differentiate.

(a) *Drainage patterns with remarkably straight stream courses aligned in one, two or more directions*, (for example Fig. 107F). These are more likely to have been influenced by faults or joints, though it is not easy in many cases to suggest which. In areas where examples are

[6] Holmes, A., (1965), p. 557.

widespread, or where there are several alignments running in different directions, joints are more likely to be the cause, and this is particularly so in extensive outcrops of igneous rocks, (though in Fig. 107F joints, in the granite of Bornholm, produce only the two very definite alignments). Conversely in Fig. 107E where a crudely dendritic main drainage pattern has marked east–west-aligned tributaries, the latter probably followed parallel lines of weakness resulting from the widespread and intense folding which characterizes the carboniferous rocks of this part of Devon. Drainage patterns which show two dominant alignments, (for example Fig. 107F) are sometimes referred to as 'trellissed', though this term is also applied to rectangular arrangements (see below).

(b) *Drainage patterns with rather irregular stream courses showing one predominant alignment* (for example Fig. 107D). Ground moraine moulded by the movement of ice does not always assume the characteristic drumlin form. In some areas less pronounced relief, formed by more elongated subdued mounds, or swells, roughly aligned to give a gently grooved or grained topography, may be found. Drainage patterns associated with this type of landscape often resemble that in Fig. 107D, long sections following the 'grain' of the country being linked by rather indirect portions as streams find their way from one 'groove' to the next.

(c) *Drainage patterns with irregular stream courses but one predominant alignment and another minor one at right angles to it* (for example Fig. 107C). This is a rectangular drainage pattern and is often associated with alternating outcrops of hard and soft rocks, the latter forming the zones of weakness along which the dominant alignment is found. In contrast the outcrops of more resistant rocks are often crossed by short tributaries at right angles to the first element and which bifurcate to give a characteristic T-form as soon as the next outcrop of soft rocks is reached. With this type of pattern the topography will naturally reflect these lithological characteristics as well, the hard rocks usually forming parallel cuestas or hogbacks, as in the area covered by Fig. 107C, which is the classic scarp and vale topography of the Wenlock Edge area, part of which is also shown in Fig. 104C (p. 252). The T-pattern of tributaries, which is much in evidence in Fig. 107C, is a useful indicator, and, even when the rectangular main pattern is not widespread, a T-shaped tributary will often indicate the presence of an outcrop of softer or weaker rock. A further variant of the rectangular drainage pattern is the 'concentric' pattern which may emerge for similar reasons around eroded anticlines and synclines. If the Djebel Chemsi area (Fig. 103A) (p. 250) were not too arid, it would obviously support a drainage pattern of this type.

## 15 *Abrupt Changes in the Direction or Alignment of a River*

Features of this sort are often distinctive enough to attract attention, though their explanation is not necessarily simple or possible from map evidence alone. A river may turn sharply, to follow a line of weakness of any of the kinds described in section 14 above, and sudden bends are intrinsic characteristics of rectangular or trellissed drainage patterns. See for instance Figs. 107C and F and also 107B where the pronounced double bend of the River Wye between Buxton and Matlock is caused by the river adjusting itself to underlying structures in the limestone. Alternatively the bend may be caused by *river capture* (being then known as an *elbow of capture*) or by *glacial diversion* of a section of the

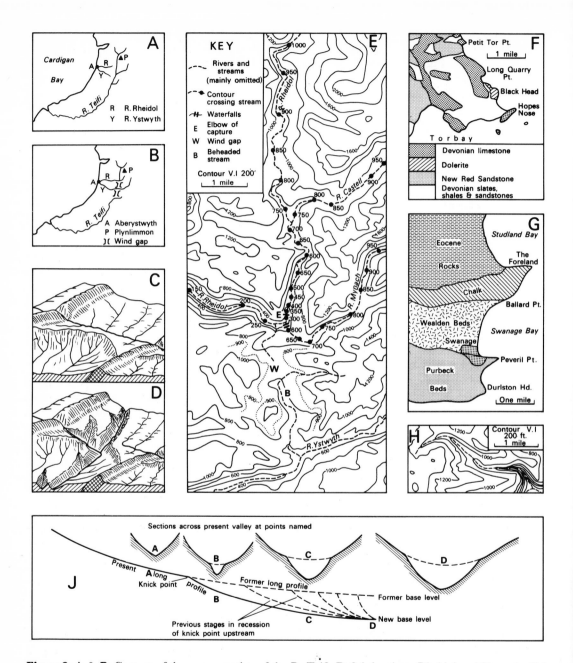

**Fig. 108: A** & **B:** Capture of the upper portion of the R. Teifi, Dyfed, by rivers Rheidol and Ystwyth. **C** & **D:** Development of river capture (after Davis). **E:** Rheidol valley near Devil's Bridge, Dyfed. **F:** Geological map of the part of the Torbay area, Devon. **G:** Geological map of the Swanage area, Dorset. **H:** Valley of the Colden Water, near Hebden Bridge, West Yorkshire. **J:** Effect of rejuvenation on valley form.

river's course. In both these cases there will usually be some trace of the former alignment of the stream – a wind-gap or through valley (but see also below under section 21) in the former case, perhaps a lowland unit in the latter. Very often of course the explanation may be a compound one, for lines of weakness – faults or softer rocks for example – may obviously assist in the development of river captures where the circumstances are favourable. Fig. 108E shows a clearly marked bend in the course of the main river, the Rheidol, and an obvious open wind-gap marking its former alignment before it was captured and diverted into its present lower course (see Figs. 108A–D).

# III Valleys

It is obviously quite impossible to formulate descriptive categories which will cover all the many forms of valleys which may be encountered on maps, and the policy adopted here therefore will be the same as in the description of hill features, i.e. to concentrate on a few distinctive and commonly recurrent types for which fairly probable explanations may be conjectured. What we are looking for, of course, is really abnormal examples of river, or valley development and it may be as well to attempt some sort of very general definition of normality in this respect even though such 'textbook' conditions are seldom if ever encountered. For example, as one follows a river from source to mouth one might expect to find, in the most general way, a progressive decrease in its longitudinal gradient, in the slope of the valley sides and often too in the amplitude of the relief bounding its valley, but a progressive increase in the width of the valley floor and openness of the plan of the valley consequent upon the formation of meanders and the creation of a flood plain by lateral erosion (compare Fig. 109A, showing the upper portion of the River Plym on Dartmoor and Fig. 109B the lower portion of the River Ribble in Lancashire). In extreme cases the meandering may ultimately create a flood plain several miles wide, not so much a valley as a very flat area worthy of inclusion under 7 above and easily recognized by the intricate patterns of existing and abandoned meanders (see Fig. 109C).

Once equipped even with so broad a generalization we are now in a position to recognize where something has 'gone wrong', where either stream form, or valley form, or both have unusual characteristics, pointing to the occurrence of some feature or event preventing the normal course of river development from taking place, or modifying it once it has occurred.

*16 Constriction of a Valley; Steepening of the Valley Sides; 'Big River-in-Small Valley' Types of Situation*

Any or all of these features point to a section of the valley where the forces such as slipping, rainwash and gullying normally responsible for valley widening are unable to do so as effectively as in the adjoining section. Several possible reasons may underlie this happening, though evidence outside the valley itself may often hint at which is most likely. The possibilities are:

(a) *Increasing rock hardness*. Where an outcrop of more resistant rock is crossed by a river

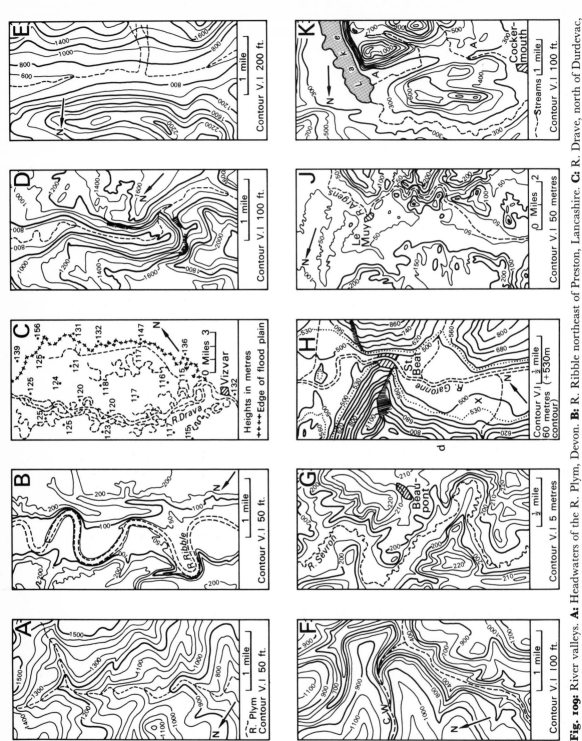

**Fig. 109:** River valleys. **A:** Headwaters of the R. Plym, Devon. **B:** R. Ribble northeast of Preston, Lancashire. **C:** R. Drave, north of Durdevac, Yugoslavia. **D:** Swindale, Cumbria. **E:** Glen Loy, near Fort William, Scotland. **F:** Upper Calder valley, West Yorkshire. **G:** R. Sevron, Bresse,

valley widening will naturally be retarded, but one would also expect some other indication of the presence of the resistant rock, for example as a cuesta or hog-back, perhaps with similar constrictions where other rivers crossed it also. In Fig. 109H the remarkable constriction of the valley of the Garonne at St-Béat is caused by an outcrop of resistant limestone sandwiched between schists upstream and gneiss downstream, though glacial erosion has here exaggerated initial differences; a second ridge, half a mile to the north provides a further, less obvious, example. The limestone outcrop in Fig. 109H is a restricted one: more extensive spreads of limestone often produce narrow, gorge-like valleys in rivers that cross them, the permeability of the rock sometimes accentuating its resistance to widening agents. The gorge-like valley of the River Verdon in Fig. 105D is not untypical of many valleys crossing limestone outcrops in semi-arid areas, while the contrast between the gorge and the open section across the softer rocks of the Quinson depression is very clear.

(b) *Increasing aridity.* As rivers pass into increasingly arid areas the lack of tributaries and rain-wash may result in the narrowing of the valley to a gorge-like form. Since the aridity will be widespread one would expect all the rivers in the area to be affected similarly.

(c) *Lack of time.* If one portion of a river valley is much more recent than the remainder there may have been insufficient time to widen it to similar dimensions. Glacially diverted sections of rivers not infrequently show this steep-sided characteristic, which in this case would be an isolated example, and would perhaps have a sudden bend at its beginning (see 15 above) and may also cross a major watershed (see 12 above and 21 below).

(d) The feature may be the *upper portion of a 'rejuvenation head'*. (See 22 (b) below.)

## 17 *'Small-River-in-Big-Valley' Types of Situation*

This situation, where a 'misfit' or 'underfit' stream occupies a valley much too large for it to have cut itself, is to some extent the opposite of that just described. It is often encountered where drainage has been diverted, either by capture or by glacial interference. In Fig. 107K the broad open valley A–A drained by two insignificant streams contrasts with the much more restricted valley which actually takes the drainage from Lake Bassenthwaite, offering at least a suggestion that the former may represent the original outlet from the lake, later blocked by drift or ice and replaced by the present course of the River Derwent.

## 18 *Valleys U-Shaped in Cross Section in Hilly or Mountainous Areas*

It is common knowledge that in mountainous areas, valleys which show an atypical U-shaped rather than V-shaped cross section have probably been modified by glacial erosion. Fig. 109D, illustrates an example of such a valley at Swindale in the English Lake District, and comparison with Fig. 109A will also help to emphasize the existence of other useful 'give-away' features associated with glaciated valleys. The U-shape here contributes the steep sides and obvious valley floor, but there can also be seen the relatively open plan of the valley and its abrupt 'amphitheatre' head into which the stream 'hangs'

abruptly. The blunted or *truncated* spurs often associated with such valleys are not shown here, nor are they always easy to recognize on maps.

### 19 *Valley-in-Valley Forms, with Widespread 'Shoulders' or 'Benches'*

In some valleys the sides do not slope regularly down to the floor but show a marked slackening of slope to produce a pronounced shoulder (either continuous or eroded into fragments), before steepening again as the river is approached. The result, in profile, gives the impression of a broad, open upper valley, into the floor of which a second inner valley has been cut, and this, in fact, is often how such valleys have been formed. For some reason – for example rise of the land, fall of sea level or removal of a glacial obstruction – the base level of the whole river, or part of it, has been lowered and the river has thus become rejuvenated enabling it to begin to cut down again into its former valley floor. Alternatively the bench may be structural, caused by an outcrop of more resistant rock on the valley side (see 5 above), though a characteristic of this type of feature will often be its relatively limited extent, while the indications of rejuvenation will usually be found widespread throughout a river system and often in neighbouring systems as well. Glacial overdeepening is yet another very common cause of valley-in-valley form, in which case the inner valley will often show the characteristics of U-shaped valleys listed above. Fig. 109F, which is a portion of the Calder Valley above Hebden Bridge in West Yorkshire, shows a very clear valley-in-valley form with a characteristic valley side bench through which the hanging tributaries have cut a steep notch down to the main valley floor.

### 20 *Intrenched Meanders and Ingrown Meanders*

Whenever meanders, particularly those with free, swinging curves, are found not on the flat flood plain of a river valley, as in Figs. 109B and C, but at the bottom of a sinuous valley and with pronounced spurs of higher land projecting into the actual meander core, they are worth considering as intrenched or ingrown meanders[7] produced by the effect of rejuvenation on a river which formerly meandered across a now-vanished nearly flat surface. Many classic examples of such features are known, for example those of the English River Wye and the River Moselle in Germany, but Fig. 109G shows a rather less obvious instance. Here it is not the tiny sinuosities of the River Sevron that matter but the larger curves of the general plan of the stream which, if it were simplified as it would be for example on a smaller scale map, would assume a form not unlike that of the Ribble in Fig. 109B yet quite without the open, flat flood plain expected in normal meander development.

### 21 *'Through Valleys', 'Back-to-Back Valleys' Breaching Major Watersheds*

Not all valleys terminate in marked divides. A valley from one system may meet one from another system 'back-to-back' so that together they form a *through valley* with scarcely

---

[7] Intrenched meanders have roughly symmetrical cross-sections due to rapid downcutting, ingrown ones, which formed more slowly show more asymmetrical profiles. The term *incised meanders* is applicable in both cases.

any feature separating the headwaters of the two systems as in Fig. 109E (Glen Loy, near Fort William). There are several possible explanations for this type of feature, among them:

(a) The valleys are merely aligned along a zone of weakness (see section 14 above) which has also facilitated the removal of an original divide.

(b) Ice or glacial overflow water moving across the original divide has eroded it away. The former probably explains the through valley in Fig. 109E; many such valleys occur in Western Scotland, and many exhibit other characteristics of glaciation, for example the U-shaped cross section and straight open plan clearly visible in Fig. 109E.

Where overflowing glacial meltwater is responsible, the resultant valleys may have more typical fluvial characteristics – for example, a sinuous course – but in addition they are often steep sided, almost gorge-like as well. After removal of the impounding barrier the overflow stream may continue to occupy the valley, as in the Severn Gorge in England, or a divide may emerge in the overflow valley giving a through valley with drainage flowing two ways from the summit, as in Newton Dale in North Yorkshire.

(c) Diversion of the headwaters of a river by river capture may also cause partial reversal of drainage along the main valley just beyond the capture so that the drainage now flows back to the capturing river, creating a divide where none formerly existed, for example at W in Fig. 108E (p. 264), and leaving a through valley or *wind gap* and beheaded stream (B) to mark the original alignment.

## 22 *Waterfalls, Rapids, Steeper Sections and Similar Irregularities in the Long Profiles of Rivers*

On the map a rough indication of the gradient of a river, and of change in that gradient, can be obtained by examining the distance between successive contour crossings. In theory a river whose long profile had developed under ideal conditions would show a progressively decreasing gradient from source to mouth; in practice (as on the River Castell in Fig. 108E) many minor irregularities occur, as well as possibly some major ones in the form of waterfalls, rapids or markedly more steeply graded sections, for example on the rivers Rheidol and Mynach in Fig. 108E. Map evidence alone is unlikely to yield much information about the many minor irregularities, but the more pronounced ones may be worth study. They can usually be attributed to the presence of one of two features namely:

(a) *An outcrop of more resistant rock crossing the river.* Here true waterfalls (usually marked as such on maps), rapids or simply more steeply graded sections may be found, depending on the nature and arrangement of the rock, while in many cases a gorge-like or steep-sided section below the fall marks its gradual retreat upstream. Where major falls are produced in this way the resistant rock may produce a prominent feature away from the river (Niagara Falls and the Niagara Escarpment for example), but often there is little indication away from the river itself.

(b) *A rejuvenation head.* If, for reasons such as rise of the land, fall in sea level, or glacial overdeepening of the main valley, a river begins to cut down into its valley floor, a rejuvenation head will form at the upper limits of this downcutting, working its way progressively upstream (see Fig. 108J). Conditions below this head may vary from consistently steeply graded to gently graded (see Fig. 108J); but in either case there will be a

marked knick-point at the head itself, and changes in the cross profile of the valley below this with valley-in-valley characteristics and steeper sides usually appearing. All of these features can be seen in Fig. 108H where the Colden Water (CW on Fig. 109F) rejuvenated by the overdeepening of the Calder Valley now 'hangs' markedly above that feature, and also in Fig. 108E where river capture of the former headwaters of the Teifi by the more steeply graded Rheidol has caused the rejuvenation. With the exception of rejuvenation by capture it will be obvious that most 'rejuvenating agents' will affect all or large portions of a drainage system, so that one might expect to find similar rejuvenation heads on other rivers as well.

(c) In certain glaciated valleys the presence of characteristic and pronounced steps in the long profile will give rise to irregularities along the long profile of the stream draining the valley as well.

## 23 *Lakes and Depressions*

Since lakes may be considered as depressions in the earth's surface filled to overflowing with water, the possible implications of the existence of both features may be considered together after noting that the existence of a depression without a lake normally indicates either porosity or aridity sufficient to allow evaporation permanently or temporarily to exceed inflow. In the former case the depression is formed in a pervious material (usually limestone or glacial sands and gravels) but is not deep enough to penetrate to the water table.

Furthermore since lakes are essentially flooded portions of the earth's surface, it is clear that the detailed shape of lakes will follow as much from the type of landscape flooded as from the 'flooding agent', a moraine-dammed lake in a glaciated valley being quite a different feature from one in, say, an area of drumlins. Nevertheless the general shape of a lake, or some particular feature about it, will often hint at its origin and since many of these 'pointers' relate to landscape features already discussed, the paragraph which follows merely lists the principal lake-forming agents together with any relevant comments.

Among factors forming natural depressions are:

(a) *Irregular warping* of the earth's crust. This often produces large 'regional' lakes shallow in proportion to their size, for example the Caspian Sea and the Sea of Aral.

(b) *Down-faulting* of a portion of the earth's crust. Lakes formed in this way will often be long, relatively narrow and perhaps deep as well, like Lake Baikal. In addition the depression and/or lake itself may show signs of 'fault' topography (see section 6 above).

(c) *Volcanic craters and calderas.* A relatively easily recognized type (see Fig. 104A). Lakes formed as a result of these agencies are likely to be isolated examples, not multiple forms.

(d) *Glacial scouring action.* Much depends here on where the scouring occurs. If in a glaciated valley the result will often reflect the shape of that valley, giving long, relatively narrow, deep and often straight sided finger lakes; in a corrie or cirque, tiny rounded *tarns* may result; and in more extensively glaciated lowland areas there may be a highly irregular chaos of lakes, though sometimes having a characteristic orientation corresponding to the direction of ice movement.

(e) *The irregular surface of sand dunes, glacial moraines and kettle-hole type country.* Here there are usually many small irregular depressions which may be dry or contain lakes according

to the level of the water table in any area. The general setting is distinctive enough to be easily recognized and a classic example of the second type of area is the Pays de Dombes in France.

(f) *Solution hollows in limestone areas.*[8] In areas where thick limestones occur, depressions formed by solution of this limestone may be widespread and of widely varying size. Though they are usually dry those which descend to water-table level will contain lakes. Other features of limestone areas, for example disappearing streams or angular dry valleys (see section 11 above), will usually be present also, but it should be noted that the limestone whose solution formed the hollows need not be at the surface and may be covered by superficial deposits, as in the Florida lakes region where pleistocene sands cover much of the limestone bedrock.

(g) *'Depressions' resulting from the damming of existing valleys or arms of the sea.* These are most usually produced either by glacial morainic dams, as at Lake Constance or Lake Garda or by the construction of sandspits and bay-bars. In the former case the morainic dam may or may not be recognizable depending on its size and many such lakes are really compound, the morainic dam adding depth to a glacially hollowed valley floor. The second type is easily recognizable (see Fig. 105A). Less frequently blockages are produced by landslides (as at Lake Waikaremoana in New Zealand), lava flows, or alluvial fans formed by tributaries.

Man-made lakes formed by similarly impounding existing valleys are of course another version of the same phenomena. Even where the name does not indicate their true nature, such features are characterized by the presence of an obvious straight or smoothly curved portion of the 'shore' where the dam blocks the valley outlet. Other and often considerable man-induced lakes may develop as a consequence of extractive operations, for example 'flashes' developed in subsidence hollows in coal and salt-fields, marl and gravel pits and peat diggings. Lakes formed as a result of the last-named activity are particularly numerous in the Netherlands.

# IV Coastlines

Since few features are more clearly defined on a map than the line of contact between land and sea, the shapes of coastlines inevitably attract attention. The list below considers some of the more commonly recurring features and their possible implications.

## 24 *Deeply Indented Coastlines with many Inlets and often Islands Offshore*

Coastlines with these characteristics usually owe their general form to submergence[9] of a former land area. As with lakes the detailed shape of the coastline may be much influenced by the type of topography which became submerged, for example submerged

---

[8] Similar hollows have also been formed by the solution of beds of gypsum as well as limestone and of course by the man-induced solution of underground salt-beds as well.

[9] Submerged here implies merely a rise in the level of the sea relative to that of the land: this could be produced either by a true rise in sea-level or by the subsidence of the land, or both simultaneously.

glacial troughs will produce *fjords*, submerged river valleys *rias* (as in Fig. 107A), and an area where structures are generally transverse to the coast (as in SW Ireland) will give quite different shapes from one where trends are generally parallel to it (as in Dalmatia). Though former submergence may have contributed dominant characteristics to a coastline it is important to note that contemporary developments may be quite different, stillstand for instance or even emergence. Unfortunately contemporary or recent developments on many shorelines are often represented by features such as raised beaches or very low, new cliffs, whose amplitude is far too small to show clearly on topographical maps,[10] though in some cases compound shorelines are clearly recognizable; the general features of the coastline around Morecambe Bay include many characteristics of submergence (for example the long estuaries of the Duddon, Leven and Kent and the islands of Walney, Roa and Piel), but in detail there are also suggestions of emergence, see Fig. Fig. 105C (p. 254) and section 7(a) above.

### 25 *Individual Irregularities in the Coastline, Prominent Headlands or Inlets, 'Cape and Bay' Coastlines*

Although differential warping of the earth's crust may ultimately impose a limit upon the extent of a submerged shoreline such a feature must, by its very mode of formation, be 'regional' rather than local in extent. More individual prominences and embayments (as well as many forming part of a submerged coastline, of course) may be caused by the variable resistance to erosion shown by the rocks forming the coast, resistant areas producing capes and headlands, weaker areas bays and inlets. Lithological variations, i.e. variations in the nature of the rocks themselves, are perhaps the commonest cause of this differential erosion but lines of weakness may also be introduced by the presence of a fault or major joint. Where the last two are responsible, the inlets which result are often narrow and continued inland by a fault or joint-guided 'straight' valley; but the commoner lithological differences produce much greater variety of forms. If structures are simple and resistance very variable, a rather obvious 'cape and bay' coastline may result (as in Fig. 108G), with the cape continued inland by prominent ridges, and the bays by areas of lower ground. More complex patterns of outcrops are, however, more usual (for example in Fig. 108F), and often the landward relief gives no clear indication of what is happening along the coastline, particularly since the relevant strength or weakness there need only be present at or around sea level.

### 26 *Gently Curving Stretches of Coastline*

Where stretches of coastline show the form of smooth, gentle curves they will usually be found to be either *eroded in or formed by uniformly weak material*. Within this general description several very varying types may be found, for example:

(a) *Coastlines continuously backed by low cliffs*. Unless there is evidence of the accumulation of material at their foot, cliffs, wherever they occur, indicate that erosion is active along a particular section of the coast. In this case then a smooth coast is being formed by the

[10] The same is true of course of river terraces, which provide a similar useful indicator of changes in a river system.

erosion of areas of relatively unresistant material such as soft sands, clays, or glacial drift, as Holderness in Humberside. Characteristic accompanying features are sandy beaches devoid of rock outcrops and low ground inland of the cliffs.

(b) *Coastlines where cliffs alternate with 'low' sections composed of either very flat areas, sandspits, bay-bars or tombolos.* Coastlines of this sort are usually found where the sea is smoothing out a formerly more indented coastline. As erosion cuts back the former headlands to form the cliffed sections it provides material which can be moved along the coast to form *sand-spits* and *bay-bars* projecting across, perhaps blocking, former embayments in the coastline, or *tombolos* linking former islands to the shore. In the earlier stages of its formation such a coastline is easily recognized by these characteristic features protruding either across embayments (as in Fig. 105A), or wherever a marked change occurs in the direction of the coastline; but in the later stages these features may apparently 'disappear' as sedimentation in their lee forms more extensive flat areas: this is beginning to happen at X in Fig. 105A (p. 254).

(c) *Coastlines with offshore bars.* Although offshore bars are among the most distinctive coastal features marked on maps the only other features with which they may reasonably certainly be associated are the presence of a very gentle beach gradient yielding shallow water some distance off-shore, and (usually) the absence of very marked tidal range. In the past they have often been taken as indicative of an *emergent coast*, since emergence seemed most likely to produce such shallow-water conditions. Similar situations could however arise with the submergence of a nearly flat coastal plain, an outwash plain for example, or where large scale deltaic deposition is occurring.

## 27 *Nearly Straight Stretches of Coastline*

It has been shown above (see section 6) that 'straight-line' aspects of landscape often indicate the presence of faults and a similar origin might be suggested for coastal stretches which show these characteristics. In this case there would usually be highland behind the coast and, as with fault-scarps, only the *general* alignment need be straight; in detail considerable 'fretting' of the coastline will often occur.

## *Specialized Map Series and Map Analysis*

Many of the features described above have been seen to be indicators of other possible attributes of the physical landscape, notably its geology (both lithology and structure) and, to a much lesser and more indirect extent, aspects such as soils. Increasingly, however, map series portraying geology and soils *directly* already exist, usually by overprinting relevant colours and symbols on a topographic map as base. Where this is so it is no more than common sense to carry out any map analysis in conjunction with them. There is no sense in playing 'Sherlock Holmes' with one's topographic map when the 'riddle' has already been solved on the geological one, particularly since the latter will allow far more positive statements to be made and subtler relationships to be evaluated. Even in these circumstances, however, the topographical map is not without its usefulness. Its easy availability may lead to the initial observations which first prompt one to obtain the

geological or soil map to confirm initial reactions, and there is no denying that confirmation of these from other sources encourages one to develop further this awareness of or 'feel for' landscape and its portrayal which can be most rewarding, not unlike the ability to appreciate painting or music. This apart, however, the examination of the topographical map *alongside* such specialized maps will open up yet wider fields of understanding, not simply of relationships between physical components and physical forms but between physical components and social and human forms of occupation. These, as we shall see, are considerations very relevant to material contained in the next chapter.

# Chapter 15

## Looking at Maps (2) Features of the Human, Social and Economic Landscape on Maps

So far as specialized studies dealing with the nature and evolution of the physical features of the landscape are concerned, topographical maps have proved a fruitful source of both inspiration and information; the same is not nearly so true for investigations concerned with features of the human occupation of an area, and the reasons are not far to seek. Essentially two broad qualifications, inherent in the nature of map evidence, underlie this difference. In the first place for studies of the physical landscape the map is often virtually the only form of documentary evidence to set beside observations derived from the landscape itself; whereas features of the human landscape are obviously counted, measured or recorded in many other ways as well. Secondly, within its general limits of accuracy and contour interval, the map normally shows a more complete record of the physical landscape than of the human one. The implications of this last-named defect are particularly serious. If a feature is incompletely or indistinctly shown on a map, as for example the distribution of industrial premises often is, a misleading impression of its distribution and relationships may be obtained, while even where a feature is properly recorded, for example the distribution of vineyards or orchards, this may be related as much to other features (such as technological change or land ownership) which are not marked on the map, as to features (such as slopes and aspect) which are.

These are important limitations to the part which map examination can play in any investigation concerning the nature and origins of the features of the human landscape; but even so the general advantages which derive from map examination, and which were stated at the beginning of the previous chapter will still hold good. *Provided that the distribution of a feature is reliably and clearly shown* (or that allowances are made for defects of this sort), the map's unique contribution is that it will reveal the extent and nature of this distribution and its relationship to at least *some* other features; in many instances it will also suggest theories of *possible* relationships or origins, but these can *and must* be checked against other available sources of evidence. In the author's experience it is, at times, almost impossible to prevent students using map evidence alone to draw the most unqualified, generalized and highly erroneous conclusions concerning the origins of features in the human landscape. To make matters worse these conclusions are rarely checked against other evidence, nor in many cases is there regard for the need or even the possibility of doing this. A major concern of this chapter will therefore be to emphasize

negative aspects of any examination, to show the kind of conclusions which cannot or should not be made, and to stress the very wide range of explanations which may exist for any particular map pattern formed by features of the human landscape.

# Settlement Patterns

Of the three broad categories of patterns discussed in this section, that of settlement is perhaps the most fundamental and in consequence attracts the most attention. It is therefore particularly necessary at the outset to stress two general characteristics which are very relevant to the representation of settlement on maps. The first of these is that, with very limited exceptions, maps are concerned to show the pattern of buildings, not settlement (i.e. inhabited buildings). The difference between the two patterns may well be considerable, not only in urban areas, where it is relatively easy to make mental allowances for the inclusion of industrial and commercial buildings in the mass of towns, but more relevantly in rural areas, particularly those where there are seasonal settlements or numerous isolated barns and storage buildings. The map in Fig. 110A for example gives no indication whether the clusters of buildings represent permanent villages or seasonal ones or whether the many isolated buildings are dwellings or not. Norwegian maps (as in Fig. 110B) are virtually alone in making this distinction clear, though the new Swedish 1 : 50,000 series makes an attempt to do so, albeit with symbols which are not particularly distinctive.[1] In the absence of any definite indication of this sort the best that can be attempted is the rather inconclusive line of reasoning that an isolated building to which no means of access is indicated is unlikely to be a dwelling (permanent *or* seasonal), though this assumes the map would be detailed enough to show such access, which might be by track or even by footpath. Many map series, for example the 1″ OS maps, distinguish isolated farms by name, but this is not wholly reliable and even so, isolated labourers' cottages or smallholdings are not clearly differentiated from other scattered buildings such as barns.

The second general point derives from the nature of settlement itself. Unlike the features of the physical landscape both the settlement pattern and the factors which may affect it (availability of water or communications, systems of land tenure, etc.) have often undergone very marked variation in relatively short periods of time, so that today's final pattern is likely to be a highly compound one and any correlation which the map suggests must be sensible with regard both to the possible age of the settlement (assuming that there is any indication of this on the map) and to the validity of this factor at that particular time. It would be ridiculous, for example, to suggest a correlation between the juxtaposition of an isolated compact village-type arrangement of buildings and the presence of a nearby railway station (rather the reverse), but quite reasonable to consider this if the settlement exhibited largely an open low-density type of street pattern more suggestive of modern development. Alternatively many settlement patterns tend to persist,

[1] See also, however, footnote 2, p. 239.

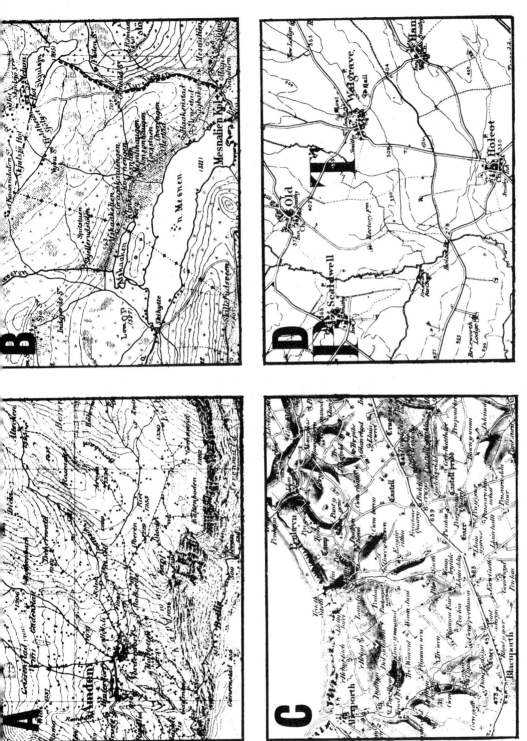

**Fig. 110:** Settlement patterns on maps. **A:** Near Amden, Switzerland. Sheet 250, old Swiss 1 : 50,000 series (*Siegfriedatlas*), 1883. (Reproduced by permission of the Topographical Survey of Switzerland.) **B:** Near Lillehammer, Norway. Sheet 25D, old Norwegian 1 : 100,000 series, 1936. Note the rare distinction between permanent (open rings) and seasonal (dots) farm buildings. (Reproduced by permission of the Geographical Survey of Norway.) **C:** Dyfed. Sheet 57 of the 1st edition (Old Series) 1″ Ordnance Survey map, 1834. **D:** Northamptonshire. Sheet 185 of the 3rd edition 1″ Ordnance Survey map.

with only minor modifications, long after the factors which originally conditioned them have disappeared.

With these qualifications in mind let us examine, in a guarded way, the possible significance of certain characteristic types of settlement patterns taking the more general patterns first and detailed features later.

### 1 *Rural Settlement Patterns which are Basically 'Nucleated'*

Reduced to its essentials the enormous variety of settlement pattern found on maps can be considered simply as an admixture, in varying proportions, of two basic forms – *nucleated* and *dispersed*. In a basically nucleated settlement pattern, such as that illustrated in Fig. 110D, the great majority of habitations (though very rarely all) will be contained within well-defined nuclei. These nuclei may vary considerably in size, but the essential feature is that scattered dwellings either singly or in tiny groups form a negligible part of the whole. With a basically dispersed pattern the reverse is the case; nuclei will not be absent entirely, and may even be substantial in size, but a very important part of the settlement form consists of scattered dwellings or tiny groups of dwellings, as in Fig. 110C. Examples where nucleation or dispersal are as strongly marked as in Figs. 110C and D are, however, somewhat unusual, and there are many areas where a mixed type of settlement pattern occurs – elements of both types being present but neither really dominating the picture. In Fig. 111A for example, clearly defined nuclei such as Bray are found, rather more loosely knit ones such as Holyport, but also many scattered buildings and straggly ill-defined settlements whose names, characteristically for England at least, are often Something-Common, -End, -Street or -Green.

A markedly nucleated settlement pattern, like that in Fig. 110D, poses one obvious question: 'What are or were the factors which might have been responsible for this nucleation?' There are several possible answers to this question but since most of these are prone to be overworked by ill-informed, if enthusiastic, map examiners the following account is concerned as much to stress their limitations as it is to point out their very existence.

(a) *'Wet-point' sites – i.e. places with an available water supply.* Of all the factors which may be invoked to explain nucleation in a settlement pattern none has probably been more overworked than this one. In areas where water is widely available, either at the surface or by the sinking of shallow wells, it is unlikely to be an important factor; alternatively in extreme cases, like desert oases, it will obviously be the dominant one, and will remain a relatively important *potential* factor in waterless areas such as wide expanses of chalk, limestone or pervious sands. Yet even in these cases it will not necessarily emerge as the decisive factor. A great deal will depend on the depth of the water-table (hence the possibility of wells), and the amount of rainfall, giving possibilities for storing water, whilst in extreme cases water may even be carried some considerable distance to settlements whose location has been determined by other factors. In parts of the Garonne valley, for example, 'people have preferred to live on low plateau tops and to fetch their water from a distance; in Languedoc there are villages located near a few hectares of good land in preference to a spring'; [2] and even in the case of the so-called 'spring-line' villages it is

[2] Naval Intelligence Division (1942), p. 61.

**Fig. 111: A:** A 'mixed settlement' pattern, Thames valley, Berkshire. Sheet 269, 2nd edition (New Series) 1″ Ordnance Survey map. **B:** A completely nucleated settlement pattern near Delfzijl, north-eastern Netherlands. Sheet 7F, Dutch 1:25,000 series. The villages are built on or (now) around man-made mounds (*terps*) erected as a defence against flooding by the sea. (Reproduced by permission of the Netherlands Topographic Service, Delft.) **C:** Pierrefeu-du-Var, Provence, France, a village defensively situated on a hilltop. Sheet Collobrières no. 5, French 1:20,000 series. (Reproduced by permission of the Institut Géographique National.) **D:** An almost completely dispersed settlement pattern near Napoleon, Ohio. Napoleon Quadrangle Sheet, US 1:62,500 series. In this area the establishment of dispersed farms on individual land holdings was not preceded, as it often was in Europe, by a nucleated phase with population grouped in villages. (Reproduced by permission of the US Department of the Interior, Geological Survey.)

open to question whether they owe their presence as much to the springs (they are, in any case, by no means always *at* the springs) as to the linear zone of good mixed soils which must also mark the line of the geological junction.

To sum up therefore, nucleation resulting from scarcity of water supply is likely to be highly exceptional, and even in areas where water supply may once have been an important nucleating factor technological improvements in recent times may well have reduced or even removed its effectiveness. Other things being equal availability of water supply may, however, have played a part as a locational factor affecting the *siting* of some settlements even where it was not necessarily responsible for nucleation. There would be little point in sinking wells or building cisterns if a site where surface water was available was equally suitable on other grounds; but it is important to remember that in many areas other things were not equal, and factors such as good soil may have triumphed over water supply in determining settlement location.

(b) *'Dry-point' sites – i.e. sites offering protection from flooding by rivers or the sea.* In the flood plains of major rivers, ill-drained inland areas or flat, and often reclaimed, coastal areas, flood danger may obviously play an important part in influencing the settlement pattern. As was the case with water supply, however, this is a factor prone to influence location of settlement generally rather than to force nucleation. Nucleation will result only if the dry point sites are very restricted, as they were in the area shown in Fig. 111B where they consist in fact of man-made mounds or *terps*; in other areas of similar physical conditions, however, settlement may be either markedly linear (see below), or even much dispersed due to later improvements, as in many parts of the English Fenland. A major difficulty in assessing the possible importance of this flood factor from map evidence is that the altitude difference required is usually much less than the contour interval, making such 'dry' sites difficult to recognize whilst, again as with water supply, later technical developments in flood prevention may permit the addition of a prominent scatter of isolated dwellings to a pattern which was once, of necessity, nucleated.

(c) *'Strong-point' sites – i.e. sites offering defensive advantages.* If the nuclei in a settlement pattern consistently occupy the tops of steep-sided hills or spurs,[3] it is obviously open to suggestion that defensive considerations may have played an important part in enforcing nucleation. Once again here is a factor which is likely to be of more use in explaining a particular location rather than widespread nucleation for, though isolated examples of nuclei with a situation like that shown in Fig. 111C are not difficult to find, areas where this forms a 'regional-type' are relatively uncommon. In Europe such villages are perhaps commonest around parts of the Mediterranean, for example in Languedoc, southern Italy and Sicily, and here liability to attack by pirates is usually cited as the explanation. Alternatively the abandonment of such villages in Nigeria serves as a reminder that where the need for a defensive location has been removed, as it usually has today, the hill-top situation has many disadvantages.[4]

(d) *Social factors prompting nucleation.* The factors so far considered may, as we have seen, prompt nucleation in certain rather unusual physical or social conditions, but do little to explain its widespread occurrence where conditions are less extreme. In such areas some

[3] The general siting of settlement on top of *low* hills cannot be considered decisive in this respect.
[4] Gleave, M. B. (1966), pp. 39–49.

more general explanation for nucleation is necessary, and it seems likely that it is often indicative of the former existence of a group of factors of a broadly social-cum-cultural type. For example in areas where land holdings were much fragmented and/or impermanent, whether through rotation or necessary abandonment, it might be impossible for a person to establish his dwelling on his own land, and he might therefore place it alongside those of his fellows in a grouped community adjacent to the cultivated land. Such conditions of fragmented land holdings were common wherever the 'open-field' system of cultivation was practised in Europe, and the late continuation of this type of land-tenure, in some areas even to the present day, has done much to maintain a markedly nucleated settlement pattern in parts of Europe. Alternatively in other areas the reorganization of this system giving consolidated holdings, as occurred for example with the Enclosure Movement in England, offered the possibility of establishing individual dwellings within these holdings, thus adding a dispersed element to the nucleated pattern or, in extreme cases, resulting its virtual replacement by a dispersed settlement pattern.

### 2 *Rural Settlement Patterns which are Basically Dispersed*

Something of the possible explanations underlying markedly dispersed settlement patterns may already have been deduced, negatively, from arguments already put forward above. Dispersion seems to presuppose, for instance, the absence of overwhelming need for nucleation to withstand water shortage, flood or attack and, in Europe at least, the absence or early abandonment of large-scale [5] communal cultivation systems of the open-field type. As with nucleated settlement, however, there are many other social factors, often of a 'national' or traditional type, which may be involved.

With any dispersed settlement pattern a very important aspect affecting its possible significance is the age of the dwellings, and here of course the map gives little guidance. In the relatively recent past the commonest factor underlying the establishment of isolated dwellings has probably been the formation of compact holdings, either as just described by reorganization of open-field systems or by reclamation from former areas of heath, moor, forest or marsh. In many parts of North America the establishment *ab initio* of compact holdings on which a farm could be situated has produced a pattern exhibiting almost complete dispersion (Fig. 111D).

In areas where dispersed settlement is old-established a more fundamental cause has often been the occurrence of good agricultural land in units too small to support more than one, or a few families, so that individual farms or tiny hamlets became the normal settlement pattern, for example in parts of the Welsh mountains or the dry limestone *Causses* in France.

### 3 '*Mixed' Settlement Patterns*

Any attempt to establish the particular significance of mixed settlement patterns, such as that shown in Fig. 111A, is obviously fraught with even more difficulties than were

---

[5] Where open-field land was restricted in extent, a scatter of farms round its periphery sometimes replaces the expected nucleated settlement.

encountered in examining the purer forms. While the possible general correlations underlying dispersion or nucleation can of course be brought forward as equally valid here, the essential characteristic of these patterns is their mixture of components and the variations which occur in the proportions of these, and explanations are likely to be far too complex for map evidence alone to throw much light upon them.

Once again it must be emphasized that the broad possible correlations which have been suggested above between various settlement patterns and other features or distributions are intended to do no more than create an awareness of some of the factors which may be at work underlying this particular group of map patterns. Even within these broad groups wide variations are possible, and in particular the ramification and variety of socio-cultural factors are enormous. Indeed all attempts to draw simple correlations between settlement patterns and other features have been continually confounded by exceptional cases; and modern work increasingly points to the great complexity of the factors which are involved. Even quite simple patterns may have complex origins, not least because in many areas several factors are working in the same direction. The hilltop towns of Sicily have a strong defensive element underlying their nucleation but in any case an 'upland', if not a hill-top, site would have been likely in preference to one in the originally forested and malarial valleys. Another well known simple pattern, produced by more than one factor, is formed by the remarkedly nucleated settlements of the southern Hungarian Basin (see Fig. 112A). Here in an area formerly extensively marshy, new eighteenth-century agricultural 'colonies' were established on 'dry point' sites, just as the older settlements had been; the need for defence against the Turks and particularly against wandering brigands also prompted nucleation, however, and the new and larger 'village-towns' grew as the inhabitants of the former villages fled to the greater safety which they offered.

# Details within the settlement pattern

*4 Towns and Major Nuclei*

In any examination of the settlement patterns found on a map attention will inevitably be drawn to the largest nuclei within it, stimulating questions concerning their particular pattern or precise details of location. Here, however, more than ever, is an area where it is dangerous to attempt to find explanations from the map itself. Since the factors underlying the growth and location of towns are often enormously complex and owe much to forces which could not possibly be detected on a map, it is pointless and sometimes misleading to speculate on the significance of a town's size, function or location, from map evidence alone. For example, neither the absolute nor even the relative size of a settlement, as depicted on a map, is an *accurate* guide to its status. Many a recent, low density ex-urban residential community may occupy a larger area than a small, compact market town but the latter, would almost certainly be of higher urban status. Similarly the size of

**Fig. 112: A:** The peculiar 'planned' village-towns of the Hungarian Plain. Sheet 51, German army copy of the 1:100,000 series of Yugoslavia. **B:** Contrasting main road networks around Crewe and Nantwich, Cheshire. Sheet N30SO1, German military 1:200,000 series of Great Britain and Ireland, which was redrawn from the ¼″ Ordnance Survey map. **C:** St Rémy-de-Provence, France. Sheet Châteaurénard, no. 6, French 1:20,000 series. (Reproduced by permission of the Institut Géographique National.) **D:** Como, Italy, a town which has retained elements of a Roman rectilinear street plan. Sheet 32 III N.E., Italian 1:25,000 series. (Reproduced by permission of the Istituto Geografico Militare, Firenze.)

many large mining villages, or those shown in Fig. 112A, belies their very lowly, or non-existent, urban functions.

This said, however, there are aspects of the pattern of larger settlements, not least its relationship to other patterns, which may be worthy of attention, and if the map is seen here as a *source of questions rather than a basis for answers* much of interest may usefully be found. The section which follows is designed with this in mind but since many of the factors considered are almost universal aspects of the location and/or function of urban settlements, it will often be the 'odd man out', where normality is left behind, that is particularly significant.

(a)  *Towns and rivers.* In many parts of the world towns are typically found on the coast, on the larger rivers or at sites closely related to these, e.g. a short distance away at the edge of a flood plain; this appears to be particularly true of the very largest cities, of old established centres and in hilly and mountainous areas.

The advantages of a coastal location are obvious. Possible *contributory* factors to urban development on *rivers* are listed below, though contrariwise they also direct attention to towns which developed *away* from rivers and the advantages associated with them. In this case the map may again offer further suggestions. Small non-riverine towns may be hinting at the price to be paid for less advantageous locations, whilst alternatively sizeable towns in such locations hint at relatively late development when more advanced technology could help to surmount former locational handicaps. Factors which might be considered at the riverine sites are:

1   The river provided a ready-made water supply. Conversely location away from rivers suggest the availability *originally* (modern supplies may be 'imported') of ground water from springs or wells, (conventional or artesian).

2   The river provided power or water for urban industries, though it is worth noting that quite small streams could be just as effective here.

3   The river provided water transport. Even as a speculation (it is easily checked) this should not be overworked. Really large rivers may have done so but few smaller ones have much record of consistent usage for navigation before the period of canalization and improvement, say after 1650, long after most towns were firmly established.

4   Position in a river valley facilitated early development of canal or railway transport, offering initial advantage over less fortunately placed rivals.

5   The river contributed an element of defence, particularly in low-lying 'moat-building' situations, or where the river is deeply incised with steep banks.

6   Location at a traditional crossing point offered incipient 'nodality' or 'centrality' in a region. Naturally the larger the river the more potentially important (and rare) the crossing, but this factor appears to have been effective on quite small rivers, where traditional crossing points would rarely be abandoned without good reason or incentive.[6] Conversely road or rail crossings of large rivers which are *not* related to an urban nucleus[7] may have been constructed rather late, when the urban system had become too inert to adapt to such developments.

[6] In the first edition of this book it was suggested that nodality could only seriously be considered at the crossing points of large barriers. Alas for rash statements! Further research into the development of urban systems and communications history suggests that inertia has been a prime factor maintaining traditional crossing points of even the most trivial rivers or large streams.

[7] The nucleus may of course be away from the actual crossing point to escape flood hazard.

Where towns lie away from the natural node of a river crossing it is interesting to speculate what other factor gave them the nodality which nourished their growth. Obvious possibilities are defensive sites which could function as 'operational headquarters', location between two contrasting regions, e.g. hill-foot/vale-margin positions, or the exploitation of a resource, such as minerals, a spa, or even a place of religious significance.

Despite the advantages listed above there are also areas where towns are either typically, or quite commonly, located away from rivers. In Portugal many quite important towns are so situated, occupying the sites of defensive Celtic *oppida* or Roman foundations and maintaining central functions there for some 2,000 years, however apparently inconvenient the location in modern terms. In western Texas, Oklahoma and Kansas, and notwithstanding the low rainfall, late-developed towns are not infrequently away from major rivers, having relied originally on railways (relatively 'unfettered' in a prairie environment) and underground water supplies to provide and sustain their nodality.

(b) *Towns and communications*. The map is not a good place to speculate about *past* relationships between towns and the communications pattern, for the simple reason that traditionally important routes are not marked as such on maps, and the focusing of *modern* main roads or railways on a town may have little or no historical significance. In most parts of the world the establishment of towns preceded the creation of railways and the *classified* road system,[8] and since towns are obvious generators of road and rail traffic these systems were naturally designed to converge upon them. Converging *modern* routes, therefore, may have reinforced a town's location but they cannot *explain* it. What might be more relevant to the argument would be that the convergence was of unusually important routes – 'main lines' so to speak – but, with the exception of motorways, the map offers no such differentiation,[9] and even where important routes are involved some actual transfer of traffic from one to another is usually needed as well, not simply a 'cross-roads'. In the English Midlands there has never been an important town at or even near to the crossing of the Roman Fosse Way and Watling Street; Tamworth at the crossing-point of two railway trunk routes has gained little advantage from this, apart from the exchange of mails in the middle of the night. Towns such as Crewe and March, which have grown largely because they were railway junctions, are conspicuous by their rarity. Alternatively towns where transfer from one transport medium to another was enforced are almost certain to have derived some advantage from this. 'Railheads', even of small branch lines, and towns at the head of seaborne navigation (often the lowest bridging point) are typical examples, though such factors may no longer be operative today.

As in the previous section there is much to be said for looking at the exceptions to this towns-are-usually-route-centres relationship. Towns which are not at obvious foci of the main-road network are likely to be of relatively recent development. Compare for example in Fig. 112B the *main-road* network of Nantwich, the traditional market focus of an area, with that of nearby Crewe, the railway-based 'upstart' with little more than a century's history as an urban centre.

[8] Which is what the map shows. In Britain it is little more than half a century old.

[9] Main roads are far too commonplace to serve here; so too used to be double-track railways, but with increased pruning of the network they are perhaps becoming of greater significance in this respect. Unfortunately no distinction is maintained between double and single-track lines on the sheets of the *second* series of the British 1 : 50,000 map.

A word might also be added here about the dangers of finding 'natural routeways' from map evidence alone. As Dury (1972) has pointed out, 'gaps' and 'gap towns' can often suggest an erroneous relationship. Today the conspicuous through-the-gap route is often a railway which, since it is later than the town, can have done nothing to foster its early development. Paradoxically too, ancient roads were quite as prone to take ridge-top routes as valley ones, and the route-town-gap relationship may here be that of a hill route descending to cross the obstacle of a river gap rather than a valley route using the gap to cross the hills. Even where early routes did follow gaps, e.g. in the Aire Gap and Tyne Gap in the Pennines of Northern England, there is more than a suggestion that the gap may have been used as a '*marker*', *not* to provide an easy route, since the old roads there run up on the hillside, even over the hilltops, and not along the valley floor. Similarly towns such as Salisbury, which today appear at the focus of several valley-based routes, were equally at the focus of ancient ridgeways running along the spurs separating these valleys.

(c) *Towns and other towns*. At any given level of urban status there are several factors tending to produce regularity of spacing in the pattern of urban nuclei. Economic reasons, formalized by Christaller and Lösch,[10] stem from the interplay of the need for a minimum trade area to sustain a given function, coupled with reluctance to travel more than a certain distance to have access to it. More pragmatic reasons, such as the limit of a day's travel, have been suggested with respect to medieval East Anglian market towns[11] and county seat spacings in Western Kansas.[12]

Regularity of urban spacing to conform with such rules should not be expected however, though it can always be looked for. Equally important factors, from major physical features to sheer human opportunism, would tend to deform the theoretical patterns produced by economic forces, even if these were not, in any event, liable to change with the passing of time. Even so their importance cannot be gainsaid. The existence of one town is a major factor inhibiting the *close* development of another, and closely spaced pairs of towns consequently should therefore attract attention, particularly outside the more densely urbanized industrial areas. Possible factors responsible are the presence of a barrier such as a major boundary inhibiting some urban functions and preventing one town 'doing the lot', e.g. at Detroit – Windsor; a major river which interrupted early rail communication producing termini on both banks, e.g. New York – Newark NJ; or the presence of a later 'upstart' created to exploit a resource, e.g. Poole (Dorset) (ancient borough and port) and Bournemouth (new seaside resort) only 5 miles away.[13]

(d) *The shape of towns*. Few towns are circular, or even approximately so, suggesting factors inhibiting growth in certain directions. When a river is involved, for example, growth is often much reduced 'across the bridge' compared to that on the bank containing the original nucleus (e.g. at Cologne, Fig. 114B) though the factors responsible may be very complex and simplistic 'difficulty-of-communication'-type explanations should be guarded against. Certain physical factors may, of course, encourage a town to develop in

[10] For a concise summary of these, together with other empirical examples of regularity see Berry (1967).
[11] Dickinson (1932) and (1934).
[12] Socolofsky and Self (1972), Section 41.
[13] Many seaside resorts were intruders into established urban patterns; another similar pair is Lancaster–Morecambe (4 miles).

particular directions – sea-side resorts, not surprisingly, are often relatively linear – but so too may hidden factors *not* obvious on the map, e.g. availability of land for development in some sectors but not others; the former asymmetry of Kettering, England, has been explained in these latter terms.[14]

5 *Formalized Street Patterns within Settlements*

In many parts of the world the typical pattern of streets and buildings found in the older settlements, whether towns or villages, is compact and irregular, not too difficult to distinguish from the still irregular but usually much more spacious pattern of the later development which often surrounds it (for example, in St Rémy-de-Provence – Fig. 112C). Both are distinct from areas where formal and recognizable patterns can be discerned in the street plan; this section examines some of the most commonly encountered patterns and their probable significance.

(a) *Chequer-board or rectangular grids of streets.* In either square or rectangular form this is easily the most commonly encountered formal street pattern, and since it has been in use from the earliest times in all manner of circumstances, only the broadest conclusions about its significance can be attempted. As a first line of approach it may be argued that, as with any formal street pattern, its very existence signifies either ownership of, or control over, land units large enough to allow the pattern to be laid down, in other words the existence of some form of direction over the evolution of that part of a settlement.

Where the core of a settlement exhibits such a plan this is often an indication that the settlement was at one time a newly founded one, either created at the bidding or for the purpose of some particular authority or land-owner. When new settlements have had to be founded a grid-iron plan has very often been adopted; the Roman *castrum* exhibited this form (a few towns which have developed from this origin have retained that pattern to the present day, for example Como, Fig. 112D) and it was employed for many 'new' medieval foundations, such as Salisbury (New Sarum, Fig. 53, p. 121), several of the well known 'bastide' towns and, as we have seen, for new eighteenth-century agricultural colonies on the Hungarian Plain. To many Europeans it is above all the pattern of the 'new' towns of North America, though here it has sometimes been imposed from above by public authority, as in the New York 'grid' laid down in 1811, and in other places represents nothing more than an obvious way of subdividing land which had already been parcelled out in square units (see Fig. 68, p. 170). Employed in a slightly more eccentric location the chequer-board may represent a new area of suburban development, perhaps added at a time when the town was growing rapidly. A clear example of an eccentric grid of this kind can be seen at Aix-en-Provence (Fig. 113A); but in smaller settlements the two types of grid – central and 'suburban-addition' – are not always easily differentiated for the new grid was often much larger than the pre-existing settlement which is therefore difficult to distinguish. Fig. 67 (p. 168) shows such an example at Lossiemouth where the new grid of Brandeburgh, added in the mid-nineteenth century, renders unrecognizable the existence of the former hamlets of Seatown and Old Lossie.

[14] It is no longer present, pressure ultimately having brought about development. See J. Steane (1974), pp. 274–5.

**Fig. 113: A:** Aix-en-Provence. Notice the grid-iron plan of the later addition to the south of the medieval town. Sheet Aix, no. 1, French 1 : 20,000 series. (Reproduced by permission of the Institut Géographique National.) **B:** Heavily formalized 'baroque' street patterns in the Vittoria quarter of Rome. *Citta de Roma:* a special sheet at 1 : 20,000 (Reproduced by permission of the Istituto Geografico Militare, Firenze.) **C:** Less grandiose formalized street patterns in the Villeparisis area of suburban Paris. Sheet XXIV, French 1 : 50,000 series. (Reproduced by permission of the Institut Géographique National.) **D:** Part of Liverpool: the street patterns in the Norris Green Area are very typical of those in large estates of between-the-wars or immediately post-war Local

(b) *Other formal patterns.* Although examples of whole settlements laid out in truly formal patterns are quite rare (Karlsruhe in Germany is one, Palma Nova in Italy is another), major portions of towns treated in this way are more frequent and show features such as streets focusing on an open square or *place*, broad avenues, circles and crescents: for instance, Edinburgh New Town (Fig. 41, p. 83), and the Vittoria quarter of Rome (Fig. 113B). As with the suburban chequer-boards, these usually represent major new planned additions to existing settlements, though occasionally, as with many of Haussmann's boulevards in Paris, they were imposed on top of an existing street pattern. When carried out in the grand manner with broad avenues, continuous built-up frontages and spacious squares or 'public' gardens (the two examples illustrated above for example) areas of this type are often good quality residential districts of the seventeenth to nineteenth centuries. In rather more cramped and less imposing styles they are more likely to be associated with pretentious private housing developments of the last hundred years, as for example Fig. 113C from suburban Paris, where the many individual houses indicate small plots and relatively lower status: in fact the street pattern, focusing on the railway stations, was often the only impressive feature of these decidedly poor quality 'build-it-yourself' 'lotis-sement' suburbs.[15] In Britain too such formalized patterns are often associated with post-1919 local-authority housing schemes. Particularly between the wars these British 'council estates' regularly exhibit a rather geometric plan, at first somewhat rectangular in style, later very curvilinear, and this, along with the scattering of small 'greens', the obvious incorporation of churches, schools and playing fields into the layout and the extensive use of the short cul-de-sac,[16] render them instantly recognizable on a 1″ or 1:50,000 map. The area around Norris Green, in Fig. 113D, shows several of these characteristics which contrast strikingly with, for instance, the simpler patterns of private development at West Derby to the south.

Less formal in street plan but distinctive enough in building layouts are housing developments, either private or public authority, incorporating tall blocks of flats (see Fig. 114A).

### 6 'Circular' Street Patterns

Although *truly* circular or elliptical street patterns within towns are often associated with formally planned areas as described above, crudely circular or semi-circular ones may have rather different origins, being often related either to topography or to former defensive elements and not infrequently to both. Not surprisingly settlements or parts of settlements built on a steep hillside often have crudely circular streets which run along the slopes or climb them obliquely; in many other towns crudely circular patterns may derive from streets which run either just inside or outside the line of walls or former walls, as at St Rémy-de-Provence, Fig. 112C; or alternatively have been established along the line of the walls when these were demolished as at Aix, Fig. 113A. At Cologne (Fig. 114B) two circular elements can be seen, the inner one a boulevard marking the line of the

---

[15] For a full account of the development of these fascinating areas see Bastié (1964).

[16] The *short* cul-de-sac was much more widely employed in local-authority housing layouts than in those of private developers.

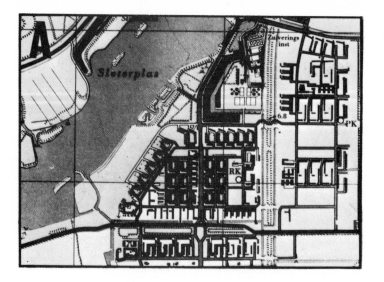

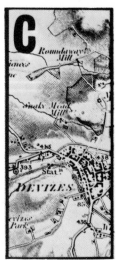

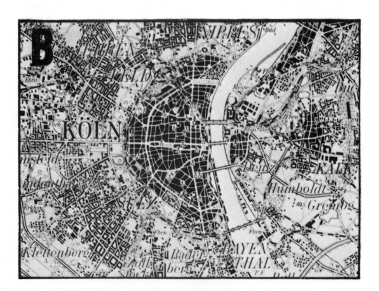

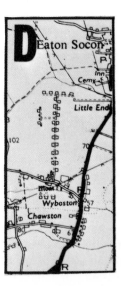

**Fig. 114: A:** Typical patterns of multiple blocks of flats in suburban Amsterdam. Sheet 25D, Dutch 1 : 25,000 series. (Reproduced by Permission of the Netherlands Topographic Service, Delft.) **B:** Circular road elements, Cologne. Sheet C5106, German 1 : 100,000 series. (Reproduced by permission of the West German Landesvermessungsamt.) **C:** Less obvious circular elements in the street pattern of Devizes, Wiltshire. Sheet 14, 1st edition 1″ Ordnance Survey map. **D:** A peculiar linear settlement formed of planned smallholdings along a road near St Neots, Cambridgeshire. Sheet 134, 1″ Ordnance Survey map, seventh series. (Reproduced with the sanction of the Controller of H M Stationery Office, Crown copyright reserved.)

outermost medieval wall of 1180, demolished in 1880, the outer one associated with the fortifications of 1880 and marking the position of a 500-yard wide zone in which building was prohibited. In many cases street patterns may be 'arcuate' rather than completely circular as for example at Devizes Fig. 113C.

A much later and generally fairly clearly recognizable circular or semi-circular element is the twentieth-century ring or by-pass road as in Fig. 117C.

## 7 *Linear Settlement*

Unlike the patterns just described, which are more commonly encountered in towns, the most obvious cases of linearity are usually associated with villages and rural settlements. Twentieth-century ribbon development around large towns and cities is, however, a common enough hybrid form and one which, more clearly than most, emphasizes the essential feature underlying linear settlement patterns, namely that they are usually derived from the exploitation of some feature or resource which is itself linear. In the case of ribbon development this is the ready-made road (which cheapens housing costs) and the services which it usually carried as well. Other commonly encountered linear features which underlie distinctive settlement patterns are:

(a) *Linear dry-point sites.* In areas liable to flood, man-made dykes or natural levees often provide the best dry-point sites available, whilst in addition land drainage and soil quality is also often better near to the dykes, further emphasizing their attraction for settlements. The linear form of the dykes tends to discourage nucleation and encourages the development of long, straggling villages, such as are common in the river-clay area of the Netherlands (Fig. 115C).

(b) *Linear access features – roads, canals and rivers.* In several parts of Europe the reclamation of forest or marsh for agricultural use has been achieved by driving a road, or more rarely a canal, into the area and allotting land for reclamation in long rectilinear holdings running back from a narrow frontage on the road or canal. Dwellings established on these holdings would usually be built at the road or canal end giving the appearance of long, straggling settlements reflecting the linear nature of the means of access. This is probably the kind of background underlying the remarkable long villages in Slavonia (Fig. 115A) and the equally fantastic ones (the village of Stadskanaal/Musselkanaal is almost ten miles long) in the NE Netherlands (Fig. 115B), though it should be noted that a good deal of the present-day continuity of such settlements probably results from later infillings along the frontage between the original habitations as population pressure increased. Even where physical conditions are not extreme, a linear settlement pattern is often associated with markedly rectilinear holdings, as in the long villages of the not-quite-so-flat country of interior Friesland and Groningen provinces in the Netherlands where rectilinear holdings were produced by a rearrangement of former 'open-field' type lands. Fig. 114D shows an unusual linear settlement near St Neots in England, and this too has resulted from the reapportionment of former farm lands, in this case into multiple smallholdings served by a principal access road.

(c) *Other linear features* whose exploitation sometimes tends to produce linear settlement and/or rectilinear holdings are strips of better soil, at a break of slope for example, or at a geological junction (which additionally may offer two environments to exploit), or where

**Fig. 115:** Some examples of linear settlements. **A:** Near Bjelovar, Yugoslavia. Sheet 31, British military series of Yugoslavia at 1 : 100,000 (Crown copyright reserved.) **B:** a fen-colony village in the northeastern Netherlands near Standskanaal. Sheet 12H, Dutch 1 : 25,000 series. (Reproduced by permission of the Netherlands Topographic Service, Delft.) **C:** In the poldered river-clay areas of the Netherlands near Schoonhoven. Sheet 38B, Dutch 1 : 25,000 series. (Reproduced by permission of the Netherlands Topographic Service, Delft.)

narrow valleys breaking a wild and inhospitable coastline give shelter and infrequent access to the sea. Examples of the first type are found in straggling settlements around the peripheries of larger *poljes* in the Yugoslavian Karst, a location which combines freedom from possible flooding associated with the *polje* floor and the use of the narrow zone of deeper soils which accumulate along the break of slope. Villages aligned along 'geological' junctions occur, for example in Vendsyssel in Denmark, where settlement appears often to have been rearranged into linear forms along the junction between raised beach and low-lying wet meadow lands, associated with arable and pasture areas respectively.

## 8 *Territorial Organization – Boundaries of Parishes and Similar Units*

In addition to settlement itself many maps also give some indication of the territorial organization of an area by marking administrative boundaries of various sorts. At scales of 1 : 100,000 and larger the boundaries marked are often those of the smallest unit to have an administrative significance – the civil parish in England and Wales for example, or the *commune* in France – and since these boundaries have in many cases been little changed for centuries, they may hint at possible relationships which existed at the time of their definition between a settlement and the lands surrounding it. Only ancient boundaries are likely to have much significance in this respect, and the antiquity of any interesting patterns which are discovered should immediately be verified against older maps. In this respect it is worth noting that the boundaries of urban units are unlikely to be very ancient, having often attained their present form only after many recent adjustments.[17] Although the units defined by these boundaries will often present a bewildering variety of shapes and sizes the following patterns or relationships may be worth further investigation.

(a) *Rectangular parishes.* Elongated, crudely rectangular parishes, of the type shown in Fig. 116B are usually associated with areas showing marked physical, geological or pedological diversity, the long dimension of the parishes running across the diversity; in this way portions of several different types of land, exploitable in different ways, were included in the village territory: for example Ditchling parish in Fig. 116B which straddles chalk scarp, gault and greensand sub-scarp, and Wealden clay vale. Parishes of this shape are particularly common in scarpland areas.

(b) *'Circular' or 'square' parishes.* In contrast to the rectangular shapes just described parishes of crudely 'circular' or 'square' shape (see Fig. 116A) suggest a relatively uniform background at the time of their evolution, so that a village gained little advantage by possessing territory in one direction in preference to another. Usually too the relief is too feeble to impress any definite pattern on the boundaries and in Britain the 'circular' parishes are often associated with extensive clay lands, such as the area covered by Fig. 116B which lies on the Essex–Suffolk border.

(c) *Relationship of parish boundaries and relief.* In addition to their shape the disposition of parish boundaries relative to relief units may also hint at former relationships. The areas covered by Figs. 116C and D are both largely composed of pervious rocks – chalk in Fig. 116C, massive limestone in the eastern two-thirds of Fig. 116D – so that surface water is

---

[17] For an example of these complex boundary modifications see Dickinson (1973), pp. 182–4.

**Fig. 116:** Shapes formed by parish boundaries. **A:** 'Circular' parishes, northeast of Halstead, Essex. **B:** 'Rectangular' parishes, east Sussex. **C:** Valley-focusing parishes, northeast of Salisbury, Wiltshire. **D:** Plateau-focusing parishes, north Staffordshire.

Key (Figs. C&D)

Scale
0    miles    4

⬭ Villages     ▬Streams which are also boundaries
∼ Parish B'dies     ▬ ▬Streams which are not boundaries

limited in both cases; the deep, narrow valleys of the Dove and Manifold, however, could never play the same type of focal role in their area as the broad open Bourne valley in the area of Fig. 116C, and in the former case settlement sought instead the gentler slopes of the plateau and interfluves. The contrasting 'hill-centred' and 'valley-centred' parishes neatly underline the difference.

## 9 *Place Names*

Place names form yet another aspect of settlement which can be studied from maps, and an analysis will often throw interesting light on the history of settlement in an area or on former topographical features. In Britain for example there are elements of place names associated with the presence of particular 'national' groups in an area – Roman, Welsh, Saxon, Danish or Norwegian; it must be stressed, however, that the detection of these elements and interpretation of the names generally needs expert guidance, and hence the map can do little more than yield the names for checking against an established source, such as Ekwall's *Concise Oxford Dictionary of English Place Names*,[18] or the very much fuller volumes produced by the English Place-Name Society.[19] Once again it is the his-

[18] Ekwall, E. (1960), *The Concise Oxford Dictionary of English Place Names*, (4th Edn.), Oxford, OUP.

[19] Volumes exist for most English counties, entitled *The Place Names of (County)*. Publishers are the Cambridge University Press, Cambridge.

toric form of the name which is significant, modern forms being often much altered and sometimes very misleading. The many English Normantons, for example, are the 'tuns' (or villages) of the Norsemen (i.e. Norwegians), not the later Normans as the layman might believe; but perhaps the neatest example of all is provided by the Leicestershire village of Willoughby Waterless; the second element is in fact derived from 'water leys', the *riverside* meadows which distinguish it from the other Leicestershire Willoughby 'on-the-Wolds'.

# Communication Patterns

The pattern of the modern communications network, like that of modern settlement, is one of great complexity underlain by centuries of change. In many areas as settlement patterns have changed communication patterns have changed with them, necessitating adaptation of, addition to and discard from the pre-existing network. For the student of the history of communications there is an intriguing challenge in the idea of revealing this pre-existing network by successively stripping off each round of additions and modifications, but unfortunately this has rarely proved feasible outside the narrow time limits of the past two centuries. A major deterrent here is undoubtedly the diffuse and often incidental nature of much of the documentary evidence relating to communications; masses of material may have to be searched to produce only a handful of references pointing to the existence or functions of a particular road, and any technique which would reduce the magnitude of such a search would be of considerable assistance. It is here that map examination, using significant patterns to detect likely candidates for further investigation, can possibly be of real help, and this brief review of road communication patterns and their possible significance has therefore been designed with this idea particularly in mind. It begins by considering patterns which are often associated with relatively late additions to the network, and concludes with a description of those patterns which seem most likely to be of significance once these later elements have been discarded.

# Roads *– Patterns Frequently Associated with Modern or Late Additions to the Road Network*

10 *Motorways, Ring Roads and By-passes*

Few communications features on maps are more readily recognized than the patterns formed by these latest additions to the road network. Motorways are in any case clearly differentiated from other roads but the smooth curves and characteristic position of earlier ring roads and by-passes is almost equally distinctive, for example, the very obvious Chichester by-pass in Fig. 117C.

**Fig. 117:** Road patterns. **A:** Road diverted to pass around a park at Harewood, near Leeds. Sheet 70, 3rd edition 1″ Ordnance Survey map (Crown copyright reserved). **B:** The straight roads produced by major enclosure movements at Fewston, near Harrogate, North Yorkshire. Sheet 61, 3rd edition 1″ Ordnance Survey map (Crown copyright reserved). **C:** An obvious by-pass round Chichester, Sussex. Sheet 181, 1″ Ordnance Survey map, seventh series (Crown copyright reserved). **D:** A typical Devon ridgeway between the Tamar and the Tavy rivers. Sheets 337 and 348, 3rd edition 1″ Ordnance Survey map (Crown copyright reserved). *All* are reduced to about two-thirds original size.

## 11 *Roads which are Consistently Intersected by Other Roads*

Motorways, by-passes (and railways) have one feature in common on maps; because all were laid down on top of an existing communications pattern, they will cut across that pattern rather than join it. This characteristic is not restricted to motorways and by-passes; many other lengths of main road may be seen to cut across the minor road network in similar fashion and it seems reasonable to speculate whether these roads too may not have originated, as motorways and modern by-passes do, as new roads laid across an existing pattern in response to the requirements of some particular time. During the past two centuries the need to adapt roads to cope with increasing amounts of wheeled traffic rather than pack-horses was a powerful stimulus to the construction of many brand new main roads, and it is at least worth considering that lengths of modern main road with this 'cross-roads' characteristic may have originated in this way, as relatively late new and better main roads from A to B – the 'motorways' of a century or two ago – or as early 'by-passes', smaller-scale improvements designed to avoid particularly difficult sections.

In Britain main roads of this kind abound in industrial counties such as Lancashire and Yorkshire, and Fig. 118A illustrates one or two fairly clear examples from West Yorkshire. The road AB, for example, is part of a completely new main road from Leeds to Halifax constructed as recently as 1832, long after most of the local road network was established. Not surprisingly it exhibits between A and B only two T-junctions but eight cross-roads; in contrast the very ancient Wakefield–Halifax road, marked CEA in Fig. 118A, which has acted as 'parent' to the local road system, shows only three crossroads but nine T-junctions in a similar length CA. A further interesting speculation, once 'new' main roads of this sort are suspected, is the location of the former main road which they

**Fig. 118:** Road patterns. **A:** South of Bradford, West Yorkshire. **B:** Near Worcester.

replaced. In the case of the Leeds–Halifax road the ancient route lies outside the area of Fig. 118A but another example will illustrate the point. The direct road DE with ten cross-roads and one T-junction aptly reflects its origin as a new and late Bradford–Huddersfield road; the directness of the closely parallel DFGE just as aptly suggests the presence of the former route.

## 12 *Straight Roads, Smoothly Curved Roads*

The moral here is a fairly obvious one. Ruler-straight or very smoothly-curved roads do not happen; they are conceived first on a drawing board and later executed as part of some predetermined scheme. The same might also be claimed for roads which exhibit smoothly curved and neatly engineered alignments, and both forms suggest a relatively late origin, after the application of surveying to such problems as road construction had become widespread. Several possibilities may have to be considered however.

(a) *A formerly winding or irregular road has been improved and straightened.* In this case the modern lines would in fact disguise the more ancient forerunner but fortunately traces of the older course are often visible in the form of 'cut-offs' to suggest where this has occurred.

(b) *The road was a late-surveyed new main road* of the type described in 11 above. In this case the relation with the minor road pattern should hint at such an origin and often there will be a similar relationship with the field pattern as well, if this is marked on the map.

(c) The road, or more often in this case network of roads, *was laid down as part of a scheme to open up or newly exploit an area* in some way, in connection with the enclosure of former open fields, draining of marshes or clearing of forest, for example. Schemes of this sort which were formally surveyed (hence the ruler-straight roads) are probably relatively late, so that the straight roads will be of no great age generally, though they may occasionally be straightened versions of former routes through the area. The straight alignments of some typical 'enclosure roads' in the Forest of Knaresborough can be seen in Fig. 117B where they contrast very noticeably with the older winding lanes around the villages of Fewston and Kettlesing. The fact that one of these straight roads is also a Roman road, Watling Street, raises an interesting point, for here is a much *older* type of straight road. Generally speaking, however, quite apart from the fact that the extent of Roman roads is becoming increasingly known and marked on maps, there is usually a marked difference in the types of straightness. Roman roads which have survived are normally associated with general straightness but minute irregularities and deviations, at least where they are marked only by minor roads, footpaths or parish boundaries. Where their course is now followed by a main road, however, as in the section in Fig. 117B, they may have been 'remade' back into something like their original straightness. Even so long stretches of Roman Road would be quite distinctive by their straightness – Ermine Street for instance in Fig. 119 – though shorter sections, as in Fig. 117B, would remain undetected without additional evidence.

## 13 *'Elbows of Diversion'*

An 'elbow of diversion' may be defined as *a point at which a modern main road makes a marked change of direction whilst the original alignment is continued by a less important road.* The

**Fig. 119:** Road patterns in the area between Grantham and Stamford, Lincolnshire. Sheet 143, 3rd edition, 1″ Ordnance Survey map reduced to about two-thirds full size (Crown copyright reserved).

explanation usually associated with such features is that the straight road is the older road, and that the modern main road has been made by utilizing part of the older system until this became 'inconvenient' and then adding a new section on a different alignment. A very obvious situation where this will happen is at the two ends of a newly added by-pass around a town – the turn, for example, which the trunk route A27 makes at each end of the Chichester by-pass (Fig. 117C), while the older route continues straight on – but the feature occurs in many other situations as well. There is another 'elbow' just east of Croxton Kerrial (Fig. 119 top left); the present Melton–Grantham main road bends sharply here, but the straight alignment is continued by what is known to be a much older road, Roman or even pre-Roman, which may also at a later date have served as a 'high-level' approach to Grantham.

### 14 *Roads which Follow the Edges of Large Parks and Country Estates*

In a situation such as this it is quite possible that the road network may have determined the shape of the park; but the reverse may also be true, the road having been diverted to allow the creation of the park, particularly where at the park edge there is an 'elbow' as above with a footpath continuing the original alignment. In Fig. 117A diversion of the east–west main road which formerly ran directly between Harewood and Weardley is known to have occurred, and perhaps, at an earlier date, diversion of the awkwardly aligned north–south Leeds–Harrogate road as well.

### *Patterns often Associated with Important Ancient Elements in the Road Network*

### 15 *Roads Following Long, Direct Alignments*

Two distinct elements normally contribute to the overall road pattern in an area; a mass of irregular, short lengths of road and a few more smoothly aligned ones maintaining a continuous direct path for several miles. Usually the roads in the latter category are the modern main roads and their alignment does not seem surprising; if they are to function efficiently a reasonably direct course is essential and we might expect the 'pressure' of continued use exerted over centuries to modify main roads until they exhibited this form, unless there were good reason to the contrary. Occasionally however the map will reveal a similar continuous route, smoothly aligned but of no modern importance, and marked only by minor roads, lanes and foothpaths. The directness of such a route inevitably suggests an analogy with modern main roads. The road has an air of 'going somewhere' and prompts one to ask whether this may not be an ancient route, formerly fulfilling some important function which has since disappeared or been transferred elsewhere. Consider, for example, the remarkable road which skirts Sewstern in Fig. 119. Its continued directness distinguishes it from most other *local* roads and additionally for several miles it forms the county boundary between Leicestershire and Lincolnshire. In this particular case the inference above would be correct, for Sewstern Lane is a pre-Roman trackway, as also very probably, is the 'direct' road branching from it and passing between Sewstern and Coston. Yet another obvious 'direct' branch made up of minor roads and footpaths goes via Skillington to Grantham; it is known as an ancient way from Grantham to Stamford

and, in later years at least, was probably used as a drove road for cattle passing south to London. These continued alignments are among the most intriguing elements in the road patterns found on maps. Two more, for example, run parallel and north–south on either side of the Witham Valley in Fig. 119. One we know is Roman, but what of the other? Equally intriguing is the way the Great North Road slips from one alignment to the other, through Colsterworth, with a clear 'elbow' at each end of that section. It is at this point that the Roman and 'medieval' 'Great North Roads' part company as the latter begins the great cut-off avoiding Lincoln; was the first stage in this deviation simply to slide across the Witham Valley and use a convenient length of another old route?

The fact that parts of these old direct routes may today be only 'footpaths' may make them less easy to see, and in this respect the marking of footpaths and bridle-ways (the latter almost certainly the more important historically) prominently in green on the OS 1 : 25,000 map *Second* series makes that map particularly useful in any search. Not all these direct alignments are significant of course. Wherever there were no important features, which had to be avoided – extensive areas of cultivated land or marsh for example – even local roads would tend to take a direct line; and so in areas which were formerly heath, moor, or downland such roads are particularly common; it is when these alignments continue for several miles, beyond the immediate local scale, that such roads become interesting.

## 16 *Roads Followed by Boundaries*

Here again a common example suggests a wider analogy. In Britain Roman roads frequently are followed by parish boundaries, the road presumably acting as a useful 'marker' for this purpose when the parishes had to be defined. This coincidence is not confined to Roman roads, however, and the possible inference is obvious: might not some of these other roads be old roads useful as markers when boundaries were delineated, particularly where the roads show other interesting features such as directness. In Fig. 119 the coincidence of the county boundary and Sewstern Lane has already been mentioned; another example, in this case connected with a minor Roman road, is found east of Croxton Kerrial. At this point the coincidence is scarcely maintained for long enough to be very significant, but becomes much more so in conjunction with a further six miles of aligned road–boundary coincidence beyond Fig. 119 east of the Witham Valley, correctly hinting at the antiquity of the roads.

A word of caution is necessary about roads and boundaries, however. In many instances the road and boundary relationship is the reverse of the above, the road having arisen to mark the boundary and so being of purely local interest. Such 'mere-ways' are quite common. On Fig. 119 the well marked coincidence of roads and boundaries for four miles east–west through South Stoke probably arose in this way, and there are many other shorter sections to be seen which probably have no significance. As with alignments it is the long-continued examples which are intriguing.

## 17 *Ridge-Ways*

In many parts of Britain prominent ridges such as structural scarps or interfluves are found to carry a road continuously aligned along them, often on or near the crest, hence

the term 'ridge-way'. Roads such as these may have originated a very long time ago when movement along ridges was easier than in the forested valleys and lowlands. Certainly many authenticated instances of such ancient routes are known, for instance the Berkshire Ridgeway along the chalk scarp, or the many examples in Devon (see Fig. 117D, p. 296), and whilst not every ridge-way need be ancient, minor examples may be worth further investigation.

### 18 *Roads which Ignore the Settlement Pattern*

Roads which ignore the village settlement pattern in an area, i.e. pass between rather than through the villages, are often significant for two possible reasons. They may be roughly contemporaneous with, or later than these villages, in which case the fact that they ignore them seems to indicate functions more pressing than mere local needs, i.e. they were 'main roads' or regional routes; or they were established before the settlement pattern, which then ignored them. It follows from this reasoning that minor roads with these characteristics may be worth investigating, and a good example of such a 'promising' road is shown in Fig. 118B (p. 297). The direct alignment of the road is striking, but so is the fact that the road serves neither to link the villages with lands of their parish nor with their county town, Worcester, which it ignores. On the other hand the fact that the route heads directly for Droitwich, a salt-producing centre of considerable antiquity, suggests that it may have been one of the network of 'salt-ways' radiating from that place and by means of which salt was carried throughout much of the South Midlands. Similar routes for the distribution of coal, lime or salt are not uncommon – the 'Collier's Gates', 'Limer's Gates' and Salter's Gates of Northern England for example – as too are drove roads along which Welsh or Scotch cattle were formerly driven to London or other English Markets; the names Welsh Way or Welsh Road, applied to such routes, are still found marked on maps of parts of the English Midlands.

# Railways

The pattern of railway communications, like that of roads, is complete on most maps at reasonable scales, but as railway networks themselves have shrunk in recent years (e.g. in many parts of Europe and North America) the former patterns, which had much to reveal, are no longer there to see, despite the frequent marking of more prominent remains as 'track of old railway'. Anyone who would study railway patterns of the kind described here, therefore, should sensibly choose a map ten or twenty years old rather than a contemporary one, but since the greater availability of other documentary evidence about railways ensures that their history is better known, map patterns are of less significance than with roads and the subject will be dealt with far more briefly.

### 19 *Railways and Physical Features*

The important control exerted by physical features on the alignment of railways is well known and need not be referred to in detail here. It should be remembered, though, that

there were often powerful pressures for making the railways overcome physical difficulties by unusual means (long tunnels or viaducts for example), and the supposed effectiveness of any physical barrier to railway development must always be judged in the light of the potential traffic flow across it. An estuary which might be an effective deterrent to a local line need not necessarily be so to a trunk route.

### 20 *Single and Multiple Railway Networks*

If the railway networks of different areas are examined two basic types of pattern may be found. In the first, though the mesh of lines may be quite close, only a single network or system is present: there is no duplication of facilities, even important towns have only one station, and only rarely can the journey between two local centres be made by alternative routes. In the opposite case, where there are multiple networks, there may be two or more systems independent of each other giving considerable duplication of facilities – railways running closely parallel, two or more stations in towns and alternative routes between centres. Figs. 120A and B illustrate the two types and many of these points. In only one instance, Malmo–Tralleborg, is there duplication of route in Fig. 120A and only at Lund are there two (adjacent) stations; the whole network contrasts clearly with the disconnected systems, and multiple stations of Fig. 120B where alternative routes are (or rather were) also seen between Leicester and Rugby, Loughborough, and Melton Mowbray.

The latter type of pattern, very common in Britain and the United States, is usually found in areas where the railway network was developed by several competitive companies, implying an official attitude favourable to such a situation, and also the belief (often unjustified by results) that the area offered sufficient traffic to make this duplication worth while. In particularly competitive areas, or areas of marked physical restriction there are often lines very closely paralleling one another, as in Fig. 120C, a type of network explicable only in terms of this competitive background.

The single-network systems do not necessarily suggest simply development by one company, but rather imply merely lack of competitiveness, often caused by the state itself constructing the trunk lines and leaving only construction of local and feeder lines to private enterprise. Circumstances such as this encourage simple, locally focusing networks, though where light local traffic prompted narrow-gauge local lines, dual termini and occasionally parallel routes may be found.

### 21 *Stub Terminals, 'Circle' or 'Belt' Lines*

In the early period of railway construction, when lines were often only local in scale, they usually attempted to establish at each end termini as close to the town centre as resources, property values, physical features, etc., would allow. If at a later date the line had to be extended beyond the town, or to a more convenient terminus this was usually done by going back a little way and beginning a deviation, leaving the original alignment as a *stub terminal*, often relegated to goods traffic, (see Fig. 120D). A railway pattern of this type should always be suspected of having such a history, particularly where, once again, there is a clear 'elbow of diversion'.

**Fig. 120:** Railway patterns at the time of their maximum development. **A:** Southern Sweden. **B:** English Midlands. **C:** Near Mansfield, Nottinghamshire. **D:** Lancaster, Lancashire.

In larger cities, where many separate termini were established at first, the need to transfer traffic between them often prompted the construction of complete or partial 'circle' or 'belt' lines around the city – as in Cologne Fig. 114B (p. 290) – leaving in consequence multiple stub termini in many cases. Such lines are easily recognized by their form.

# Patterns Shown by Other Features on Maps

It is no accident that the patterns of settlement (or rather buildings) and communications are the two great features of the human landscape which occupy pride of place on maps. This is, after all, only commercialism written large, for it is on these two items that the interests of the great majority of map users are centred. Chapter 5 indicated however that many other features of the human landscape were also marked on maps – specialized buildings such as factories or specialized land uses, for example orchards; can we also make with respect to these items, an approach similar to that used above for settlement and communication?

On balance, even speaking generally, the answer is probably 'no', and certainly it must be within the limited scope of this book, for the difficulties, both cartographic and non-cartographic, besetting such an approach would be enormous. On the cartographic side alone it is often very difficult to determine how complete such distributions are; specialized land uses are in many cases fairly reliably recorded, but features such as factories – often simply vaguely marked 'factory', 'works', 'mine' – are equally likely to be confined to prominent or isolated examples. Then again, whilst it might be expected that full revision would correct the distribution of these features along with the rest of the content of the map, 'partial revision', so often resorted to under pressure of work, will usually mean 'settlement and communication only' on the human side, leaving obsolete patterns elsewhere.

The cartographic limitations are, however, not the most serious obstacle to the classification of such patterns. In many cases the circumstances underlying the distributions which can be seen on the maps are so complex, often so *local* that it would be pointless to speculate on them from map evidence. Consider Fig. 121, for example, which shows the patterns produced by land under vineyards in three areas. Fig. 121A shows an area in Languedoc where vines form so dominant a land use that it is the areas not devoted to this crop which are distinctive. In Fig. 121B, in the Rhineland a more restricted distribution can be seen, based on strong linear emphasis as vineyards are confined to steeply sloping land, and in Fig. 121C vines form only a sporadic element in a mixed pattern. Here then we have three basically different types of pattern, massed, linear and sporadic, all associated with the cultivation of the vine; but quite obviously it would be foolish to draw any inferences from these patterns save in the broadest possible terms.

One might suspect, reasonably enough, that viticulture held a dominant, specialized but important, and rather unimportant position respectively in the economy of these three rural areas, but it would be impossible to speculate from map evidence why this should be so, particularly with so specialized a tree crop as the vine. Even in Fig. 121B where the pattern of the vineyards has a distinct association with one element – slope – there are still very many factors, such as shelter, insolation, drainage, soil differences, lack of an alternative use, which might be related to this besides factors quite unconnected with the physical form of the ground but perhaps determining the total scale of the cultivation, for example local land holdings, their arrangement and size, labour supply, government policy, limitation or otherwise of the local market, and so on. Quite obviously

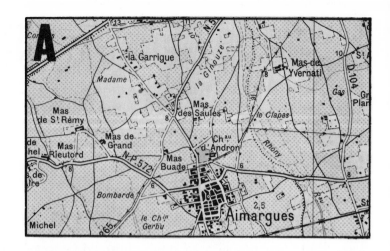

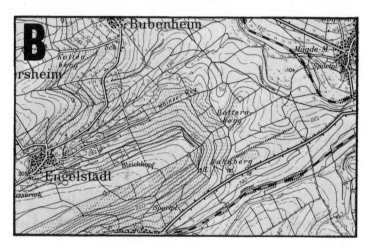

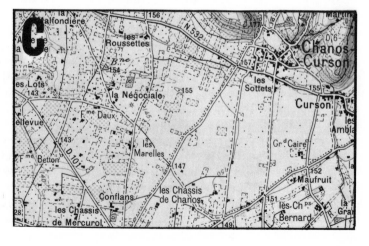

**Fig. 121:** Three different patterns produced on maps by the distribution of vineyards. **A:** Languedoc, France, near Lunel. Sheet XXVIII-43, French 1:50,000 series. (Reproduced by permission of the Institut Géographique National.) **B:** The Rhineland near Mainz. Sheet L6114, German 1:50,000 series. (Reproduced by permission of the German Landesvermessungsamt.) **C:** In the Rhône valley, France, near Tournon. Sheet XXX-35, French 1:50,000 series (Reproduced as for **A**.) The vineyards are indicated by the coarse grey dots in **A** and **C** (the finer blacker dots in **C** are orchards), and by the hatched areas in **B**.

in a field as complex as this the map is not the place to begin the search for the answers. What we can use the map for, if the cartographic limitations described above do not apply and a reasonably complete and up-to-date representation of any feature seems feasible, is to define the distribution which has to be explained; alternatively we can use the map distribution as an 'acid-test' against which to judge the validity and completeness of any explanations which are offered elsewhere. If we want to go much further into the subject than that it will be surprising if, as has happened so frequently in these last two chapters, we do not conclude that the map is as likely to pose questions about the landscapes it portrays as it is to answer them.

# Chapter 16

## Looking at Air Photographs – The Landscape as seen from the air

Because the air camera records everything that it sees, the inventory of the features of the earth's surface found on an air photograph is far more complete than that presented by even the largest-scale map. There are, however, important obstacles to be overcome before one can 'read' the message of an air photograph as easily and unequivocally as one reads that of a map. Maps are, above all, *selective* and *explicit*. Because the cartographer has chosen what to show, and labelled this clearly with name or symbol, map-reading is a skill relatively easily acquired, even at an early age. 'Reading' an air photograph is a good deal less simple. Not only is nothing 'labelled' but most things are presented from a totally unfamiliar viewpoint and the totality of detail may confuse as much as it helps, at least until some basic skills are acquired.

The main purpose of this chapter therefore is to help the reader become accustomed to this 'new view' of the landscape presented by vertical air photographs,[1] describing the appearance on air photographs of familiar features and indicating an approach towards the interpretation of less familiar ones. In doing so something of the enormous potential of air-photo interpretation should become apparent. As was indicated in Chapter 14 there are important commercial applications here, in fields as varied as mineral prospecting, archaeological exploration, forestry, soil, land-use and property-condition surveys, and livestock, pedestrian and traffic counts. Even though these need skilled interpretative techniques beyond the compass of this book it should not be difficult to see, from the simple examples illustrated here, where the potential originates. There are, however, developments far beyond these. As the last section of the chapter very briefly shows, the simple air photograph has acquired some rather more sophisticated relatives, so that it now forms no more than a part of the wider and rapidly developing field of *remote sensing*, which includes all techniques recording an image of the earth from afar or above, and involves methods much more complex than conventional photography.

Even without developments such as the American space programme this richer range of techniques would have produced a greater amount of material to interpret. But when one considers that to these must now be added continuously recorded imagery of the earth

[1] As mentioned in Chapter 4 obliques present far fewer interpretational problems and this chapter is therefore concerned only with vertical photographs.

derived from orbiting satellites the whole process of interpretation can be seen to have been pushed into a new dimension. *Quantity* quite as much as content is now a major problem [2] and it will come as no surprise, after the experience of earlier chapters in this book, to find that major new developments have sought to transfer a good deal of the routine processes of interpretation from the human observer to a machine.

All of this is, however, anticipation of a glimpse into a highly technological world which is likely to remain the prerogative of a limited number of specialist workers. Most people's experience of remote sensing is likely to be confined to 'look-see' interpretational techniques applied to conventional air photographs. There is no need to despise this. As we shall see, this is quite capable of yielding a surprising amount of information about the earth's surface and its components. Let us examine these quite rewarding fields before passing on to look, however briefly, at more elaborate developments.

# Air Photo Interpretation – General Aspects; Factors Underlying the Appearance of Objects on Air Photographs

In everyday vision we recognize an object by a combination of the three processes of observing (a) its size and shape (b) its colour and (c) the features with which it is associated. The same processes will help to identify objects seen on air photographs, though with different emphasis. Association, for example, may be called upon far more consciously than usual, colour (with black and white photos) far less, while size and shape are still crucial but demand a whole new set of identifiers to replace those normally used.

## Size and Shape on Air Photographs

Because the shape of an object on an air photograph is usually its *plan* form the familiar, distinctive and often 'labelled' elevations of many features, such as buildings, are replaced by the quite unfamiliar combination of roof patterns and layout. There are obvious difficulties here. Many objects vastly different in elevation may have a similar plan form, for example a row of houses and a row of shops, and though it is possible to use aspects such as size, setting, number and general arrangement to sort out such crude plan similarities as (say) a dog kennel, a haystack and a house, they will not help so much with the row of houses/row of shops problem. A few categories of building do, in fact, have distinctive roof patterns e.g. a maltings, the ridged roof of a factory with 'north lights' or the row of ventilators on the roofs of many heavy industrial buildings; others have distinctive building arrangements, e.g. the quadrangle arrangement sometimes used in schools, but it is obvious that in most cases other much more individual indications are going to be

---

[2] e.g. with imagery from ERTS 1 (Earth Resources Technology Satellite 1, now known as LANDSAT 1) complete coverage of most of the earth's surface is provided every 18 days – about 800 new 'views' each day.

needed as well. Fortunately air photographs provide plenty of these, particularly if 'size and shape' is applied to *land-use units* rather than just buildings. Thus the 'shape' of a modern school usually includes large areas of associated playing fields, a far more distinctive feature than building arrangement. With an older school these may be absent and one may simply have a largish building standing in a hard-surfaced playground, but the latter shows up quite distinctively on an air photo (see M, Fig. 125, p. 316) and older school buildings are often symmetrical or formal in layout. If therefore 'size and shape' are taken to imply a combination of roof pattern, building layout, general size, character and size of associated open areas and evidence of provision for vehicular access and use, the varied combinations of these offer many new definitions of 'size and shape' with which to identify objects. There are, however, one or two 'bonuses' as well.

*Elevational Aspects.*      These may not be entirely absent. As Fig. 29 shows the elevation of tall objects *may* be recognizable, due to height displacement, particularly when they lie towards the edge of the photo or when a wide-angle lens was used, increasing the obliquity of view. This same effect may of course produce areas of 'uninterpretable' 'dead ground' behind these tall features.

A more widespread indication of the elevation of an object is given by its *shadow*, typically present on air photographs since these are usually taken on sunny days. Where objects have insubstantial plan forms, e.g. chimneys, pylons, deciduous trees in winter, their more prominent shadows may often be the best indication that anything is there at all, but more typically shadows help to distinguish between buildings and vegetation of different heights and shape (Fig. 122A) and may sometimes positively identify an object where the shadow, despite elongation, illustrates its distinctive shape e.g. with cooling towers, church spires, blast furnaces and farm silos.

In the same way shadows often help to mark the presence of relief features, particularly sharply defined ones such as crags or glacial overflow channels. In this connection note that an air photograph should always be interpreted with the shadows falling *towards the observer*; if this rule is not followed a *pseudoscopic effect* of inverted relief may be produced. It will, however, be obvious that the most positive impression of relief features, as indeed of *all* objects on an air photo, is obtained when they are viewed stereoscopically, and this approach should always be used, whenever possible.

*Temporal Aspects of Size and Shape.*      Unlike maps, which usually stick to permanent features, air photographs may record 'shapes' which are very temporary, so that the appearance of a feature will change from month to month, or even hour to hour. Since many of these temporal aspects are unusually distinctive they can also be a useful asset in interpretation. The most obvious application here is in identifying agricultural crops which have distinctive patterns of harvesting, e.g. stooked corn, piled hay, potato 'pies', or are simply harvested at distinctive times (air photographs are usually dated). A corollary of this, though, is that around harvest time the same crop may appear in several aspects. In Fig. 122C it is possible that fields a to e contain the same crop – probably alfalfa. In a the crop is still standing but the field is covered with a last flush of irrigation water; at b this has dried out and mowing is in progress as shown by the border of partially mown crop; c is the completely mown crop lying flat, whilst at d this has been partially raked

**Fig. 122:** Vegetation and crops on air photographs. **A:** Shadows revealing differing heights and species of trees and hedges in winter, Clwyd, N. Wales. Scale *c.* 1 : 10,000 **B:** Trees of many different sizes and species in summer, Beeca Park, near Aberford, West Yorkshire. Scale *c.* 1 : 40,000. (**A** & **B** respectively sortie nos. V(Pt.2)3G/TUD/UK 34 (16/1/46) and 541/30 (17/5/48) and print nos. 5520 and 4007, reproduced by permission of the Ministry of Defence, Crown copyright reserved.) **C:** One crop (alfalfa) appearing in five different forms on one air photograph, Colorado, USA. Scale *c.* 1 : 40,000. **D:** Different types of agriculture and landholdings visible on an air photograph in Central Europe. For explanation see p. 317. Scale *c.* 1 : 40,000.

into rows to dry and fully so at e. f may be a field where this drying has finished and the crop has been completely removed. These temporal bonuses are not confined to crops. The chance presence of unusually large amounts of stored raw material or finished products at a factory may help positively to identify its nature; a bus-depot, deserted at rush hour, may have large numbers of distinctive parked vehicles at other times, and equally distinctive features such as shop awnings come and go with weather and time of day. So too do shadows, which may be noticeable even from very low objects at times of low sun, a property put to good use by archaeologists (see below).

*The Effect of Scale on 'Size and Shape'*

Because quite tiny detailed features may play a key role in interpretation, with air

photos (as with maps) one gets far more information from the large-scale product. In theory differences of scale should be less critical with air photographs than with maps, for there is no conscious elimination or simplification at small scales, and enlargement can effect a simple transformation. In practice however all photos have a limit of resolution beyond which further enlargement produces only fuzziness without increase in readable detail. Even so, most air photographs will be better interpreted under magnification, using a hand lens or pocket magnifier which commonly provide this up to about ×6; without these the information yielded by an air photo may be a little disappointing. A 1:50,000 photograph, for example, provides only a very general impression of an area, though one which is still arguably more detailed than a 1:50,000 map. In urban areas even at 1:10,000 scale (Fig. 125) the unenlarged image may still be relatively unrevealing and full interpretation may really need scales of around 1:3,000 to allow finer points of detail to be noted.

Where an estimate of the actual size of an object/feature will help identification this can often be obtained crudely by comparison with familiar features e.g. houses, cars, sports pitches, or more accurately by measurement and scale calculation as described in Chapter 8 (p. 150). Size is best measured against a transparent scale with light coloured markings (black markings are not particularly legible), graduated either in millimetres or thousandths of a foot. Some pocket magnifiers, e.g. the Polaron, incorporate such a transparent scale which rests on the photo and can therefore be seen at the same time as the magnified image.

*Colour on Air Photographs.* Although the use of colour film in air photography is increasing the vast majority of air photographs are still in black and white, since for many purposes the additional advantages of colour do not outweigh the extra cost. On most air photographs, therefore, the colour of an object is replaced by its *value* or *tone*, which will be white, black or an intermediate shade of grey. In addition to this the panchromatic film normally used does not differentiate between coloured objects in a manner consistent with the impression of our eyes, but this effect is usually quite eclipsed by other more important factors which contribute to tone. For example the four identically coloured sides of a hipped roof may each appear in a different tone on an air photograph.

The most important contributory factor here is the *amount of reflected light* which the camera receives from an object or its constituent parts. Since large amounts of reflected light produce light tones, and vice versa, smooth surfaces, such as roofs or roads which act as reasonably good reflectors, produce fairly light tones; the effect is even further enhanced if the light is reflected directly towards the camera. Thus in Fig. 112A pure accident of camera position would cause the same smooth surface to be much lighter on a photo taken from position A than from position B. Alternatively a rougher surface will scatter the light more, leaving less to reach the camera (Fig. 112B). Because of this effect the *texture* of a surface, which drastically affects its ability to trap or reflect light, makes a major contribution to its tone and appearance on an air photograph. Flattened grass will therefore reflect more light than undisturbed grass (Fig. 112C) and the track of a person across a field of long grass is usually clearly visible on an air photograph. In the same way the same crop, e.g. immature wheat, could appear different in tone at different stages of growth (Fig. 123D), though its true colour remained unchanged.

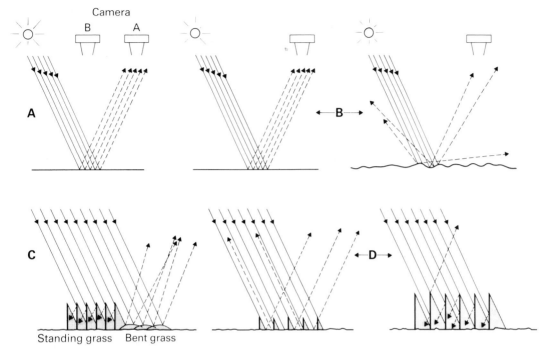

**Fig. 123:** Surface reflection and tone (after Branch).

Quite apart from its contribution to tone the effect of surface texture is important, in its own right, in interpretation and different textural appearances, such as 'smooth', 'mottled', 'bobbly' may help to distinguish between crops or different forms of vegetation.

Still further features affecting the tone of an object are weather conditions and photographic processing. Even with the same landscape a greater range of tone will be obtained on a sunny day than on a dull one and bad photographic processing may produce prints which are generally too light or too dark, often with loss of important minor tone differences.

### Associated Features

If, in normal vision, we reason that the none too clearly seen person who waved to us from a passing red car was Smith, because he is one of the few people we know who has a red car, we are using the setting of an object and features associated with it help to identify that object. The same kind of reasoning can be useful in air-photo interpretation. For example modern schools are not the only large buildings to have sports fields attached; so too do some modern factories, but the latter will have more extensive car parks, and more evidence of vehicular use than the former, and their settings are often different. Factories are often associated with other factories and with main road locations, schools more typically have residential surroundings.

The setting of a feature – within settlements or removed from them, alongside main lines of communication, occurring mainly in valley bottoms, on steep land, or on hill tops, and so on – may offer an important clue to its nature. So too will *number* – is it unique or commonplace – and *associated features*. Certain of the most obvious associated features may already have been considered under size and shape but others straddle the boundary between intrinsic part and associated setting, e.g. the service road, parking bays and paved forecourt often associated with a row of shops.

Recognition of the most useful things to look for here tends to come only with experience, but there is no better way to acquire this than to walk over familiar ground accompanied by a good quality large scale air photograph. The process is two way. The explanation of puzzling detailed features on the photograph can often be found on the ground (unless time has erased them) and one can check to see whether differences in land or building use encountered on the ground are apparent on the photograph, either at first glance or after prompting and further search. It is a good thing to do this in both an urban and a rural area, though since the latter landscape is far more ephemeral it is sensible to go at the same time of year as the photographs and to make allowances for features such as crop rotation. The result should impress quite firmly just how much information the air-photograph, properly interpreted, has to offer and how it compares in this respect with the comparable topographic map.

*Appearance of Specific Features on Air Photographs and the Potential of Air Photographs in Studies of these Features* [3]

### 1 *Relief*

Relief is probably the most weakly represented category of major features on single air photographs and its essential outlines may often have to be inferred from the presence of viaducts, cuttings, embankments, hairpin bends, terracettes and similar features. Conversely with a stereoscope and photography of good scale (about 1 : 10,000 preferably) quite small relief features such as overflow channels or river terraces are easily detectable, far more so usually than on a contoured map.

### 2 *Rocks and Soil*

Particularly where they show bare rock (Fig. 124B) or areas only lightly masked by vegetation, air photographs will often reveal to a skilled interpreter intricate patterns of joints, bedding planes, structures, faults, mineral veins, etc., and from this potential a whole new science of photo-geology has emerged. In bare or nearly bare soil, too, intricate patterns produced by variations in the composition, colour or moisture content of the soil can be seen and in all these cases the air photograph offers the easiest, sometimes the only, satisfactory method of recording the distribution of these features. Both bare rock and soil are apt to appear lighter on photographs than would be expected

---

[3] The subsequent list makes no pretensions to being more than the merest introduction to this subject. For a fuller treatment of these topics and themes see, St Joseph (1977) or Chevallier (1965).

**Fig. 124:** Beaches, shallow water features and rock on air photographs. **A:** Beach with off-shore bar, Island of Spiekeroog, W. Germany. For explanation of letters see below (Reproduced from Gutkind, *Our World from the Air*, by permission of Chatto & Windus Ltd and the Hansa Luftbild GmbH.) **B:** Bare rock surface, with small lakes, Mackenzie, N W Territories, Canada. (Reproduced from Gutkind, *op. cit.* by permission of Chatto & Windus Ltd and the National Air Photographs Library, Surveys and Mapping Branch, Department of Energy, Mines and Resources, Ottawa.)

from their normal appearance, and though freshly turned soil may be medium to dark grey in tone, this can change to nearly white as the soil dries out.[4] 'Disturbed earth', for example a ploughed field, soil placed along a newly dug ditch or the trampled earth of a building site, is often among the lightest features on a photograph (for example field f in Fig. 122B). Tiny patches of disturbed or 'scuffed' earth often show as distinctive light *'flare marks'* and may indicate areas of intensive movement e.g. through gateways in fields, around goal-mouths etc. Not surprisingly, beaches and sand dunes also show characteristic whiteness (Fig. 124A).

### 3 *Water*

The appearance of water varies enormously on air photographs, even within the same water body. Very still, deep water, for example, often appears almost black, indicating (rather unexpectedly) an absence of reflected light. This arises partly because still, deep water is able to *absorb* light and partly because its smooth surface is too perfect a reflector and only rarely scatters any light in the direction of the camera. Occasionally, however, when conditions are exactly right, as in Fig. 123A, the surface will 'mirror' the sunlight into the camera and therefore appear very bright, as at J in Fig. 125. Since ripple or wave marks destroy this too-perfect reflecting property they tend, conversely to normal practice, to roughen it and *lighten* the tone, as well as adding a texture. Muddy water, because of reflection from suspended particles, may give a rather light tone (for example the River Ouse in Fig. 125) but shallow, clear water, on the other hand, is often inconspicuous, being penetrated by the light and allowing bottom details, such as channels and sandbanks, to show through, a property of considerable use to river and harbour authorities. In Fig. 124A only the double bar GG and beach H are above the water line, the ribbed area J and ripple-marked lagoon floor K are both seen through shallow water; notice the shadow of the bar LL masking detail and also indicating variations in the bar's height.

[4] A similar change to a lighter colour can, of course, be observed in a newly dug garden.

**Fig. 125:** Urban detail on an air photograph. Vertical air photograph of Selby, North Yorkshire. Scale *c.* 1 : 10,000. Selby contains most of the buildings and features typical of a country market town – schools, shops, churches, hotels, etc. – yet few of these are clearly identifiable on a photograph at this scale. For explanation of letters see p. 318. (Sortie no. West Riding Area 3 (14/6/67) print no. 60 67 095, reproduced by permission of the County Planning Officer, West Riding of Yorkshire County Council.)

## 4 *Vegetation – Woods*

The 'rough' and chlorophyll-rich surface presented by woods causes them normally to appear dark on air photographs. Coniferous trees will usually appear darker than deciduous ones, and very obviously so in winter when young deciduous trees may be too insubstantial to record well; at such times deciduous woods are often more clearly revealed by the striped pattern formed by the shadows of the main trunks than by the trees themselves. Fig. 122B gives an idea of the remarkable amount of detail concerning woodland revealed by an air photograph. Size, tone and texture differences are related to variations in age and species of tree, and these properties have been widely used to produce forestry surveys and inventories from air photographs. The nature of individual trees, as well as variations in woodland height may often be deduced from shadows (see Fig. 122A).

*Grassland.*    A good rule to adopt here is that the better the quality of the grass the darker and more even in tone it will appear. Whereas a good lawn may show an even, medium grey tone, poorer pasture, for example almost all the fields on Fig. 32, appears both lighter in tone and more mottled in texture due to the presence of grasses and plants of mixed species and lower chlorophyll content. With very rough pasture and moorland the intricate patterns of bracken, heather, cotton grass, etc., can usually be distinguished on air photographs.

*Crops.*    Enormous variety exists here and the most useful asset for specific identification is a detailed knowledge of agricultural techniques coupled with a good deal of luck relating to the seasonal nature of the photography. As indicated earlier, photography taken around harvest time often offers the most posititive indications. By way of contrast air photographs of rural areas in winter will often reveal intricate patterns of farming operations – for example, ploughing, harrowing, manuring – but these will tell little about subsequent land use. Where individual crops cannot be recognized it may still be possible to distinguish between different types of land use or agricultural technologies. Fig. 122D reveals a clear four-fold division into valley floor meadows m, vineyards v, unconsolidated strip holdings s and rarer large estates or consolidated holdings e. In Fig. 32A (p. 65) the dark rectangles of poultry houses Q are obvious evidence of an agricultural activity very characteristic of these steep Pennine valleys, while features such as glass-house areas, extensive orchards or plantations of tree crops are easily recognized.

## 5 *Communications – Roads*

The important point to remember here is that a conspicuous light tone exhibited by a road indicates only the nature of its surface, *not* its importance. Very often prominent, white roads may have only bare soil or loose gravel surfaces, whereas because of metalling, oil drip, tyre marks, etc., main roads may appear much darker, as at R in Fig. 125. Even on the same road, tone may vary abruptly due to surfacing, as in Fig. 32A, and the class of a road will usually have to be inferred from other evidence, such as cut-off corners, cut-and-fill, traffic densities, well-defined kerbs and so on. At the other end of the communications range footpaths and tracks are normally recorded by the air photograph in

amazing detail, largely because the flattened earth or vegetation produced by the passing of even only one vehicle or person usually forms a distinct and rather better reflecting surface than its undisturbed surroundings.

*Railways.*    Although railways are much less conspicuous on air photographs than on maps and the number of tracks may be impossible to distinguish (see Fig. 125), their distinctive form and associated features (cuttings, tunnels, under- and over-bridges, smooth curves, stations, etc.) render them quite unmistakable.

### 6 *Towns and Built-up Areas*

Fig. 125, which shows a reasonable cross section of urban features, indicates some of the difficulties of air-photograph interpretation in this field. While buildings of different ages and types can often be differentiated, as the old 'yard' property A, nineteenth-century terraces B and more modern units C, it is not easy, at least at this scale, to distinguish the possible uses of these buildings, the distinction, for instance, between housing, shopping and business areas. In the same way sizeable industrial buildings are usually distinctive as a class but do not easily allow specific identification. Only the shipyard D, with two vessels building, offers a clear indication of its identity though, under different conditions of sun, the flour mill E might have cast a distinctive shadow, suggesting the tall buildings characteristic of that industry, and the combination of large size, wasteponds, rail access, etc., at F might perhaps be recognizable as a beet-sugar factory by an expert. On the other hand there is little to identify G as a large vegetable oil and cattle-cake works (despite obvious evidence of water-borne raw materials and/or finished products), H as a paper mill (the pond is quite misleading here: it antedates the industry), and certainly not J as a works where citric acid is manufactured.

Apart from industry, housing and commercial uses other characteristic urban features possess varying degrees of distinctiveness. The abbey church K is clear, so are the allotments L; cemeteries too (none shown) are often recognizable from their combination of minuscule texture (graves), formal layout and typical border of trees. Modern schools may be distinguished by their size and adjacent playing field, and older schools by their hard-surfaced playgrounds, as M on Fig. 125 (there is a small playing field too). Even so, in most urban areas there remains much that is obscure and unrecognizable and this is one branch of study where the good, large scale map (say 6″ or 25″ in this case) may more readily offer positive information, unless the photo interpretation is done by a very experienced observer.

### 7 *Archaeological and Historic Sites*

The results produced by the air photograph in the field of archaeology have been both striking and of enormous importance. Where visible remains of former sites exist, for example banks, ditches, mounds, the shadows cast under a *low* sun by these often insignificant features may reveal patterns far more complete than those recognizable by ground inspection only. Even more spectacular, however, are results obtained at sites where all visible trace appears to have vanished. The presence of archaeological remains is prone to

affect the nature and/or quality of the soil, for instance former walls may leave thinner, stonier soils, and silted-up ditches and post-holes deeper soils, and the patterns formed by these variations are often visible from the air either directly or more usually through their differential effect on vegetation at critical stages of growth or under critical climatic conditions. An air photograph specially taken at times such as these can reveal the outlines of these former features with startling clarity, as in Fig. 126 which shows the clear plan of a Roman fort at Glenlochar, Dumfries & Galloway, revealed by its effect on vegetation at a time of drought; in this photograph the positions of ramparts and streets are clearly visible, though a second photograph taken on another occasion revealed absolutely no trace of their presence.

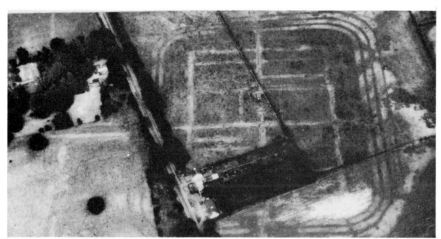

**Fig. 126:** The remarkable potential of the air photograph in assisting archaeological discovery is well illustrated by this example. The positions of the ramparts and streets of a former Roman camp are clearly revealed by their effect on growing vegetation at a time of drought. Glenlochar, Dumfries & Galloway. (Reproduced from J. K. St Joseph, *The Uses of Air Photography*, John Baker Publishers Ltd, by permission of the author.)

*Further Procedures for the Interpretation of Objects or Features on Air Photographs*

Knowledge of the exact location of an air photograph is probably the most useful 'outside' aid to interpretation. Even if only the approximate location is known books and articles on the area can yield background information and it may be possible, without too much difficulty, to identify the exact location on a map. To do so, crudely orient the photograph if possible (see below) and select on it a pattern or shape which will also be boldly marked on the map, for example, particularly distinctive railways, lakes, coastlines, or isolated patches of woodland. Search the map for such a feature and once this appears to have been located check the solution carefully against several other points of detail. The crude orientation required above is best obtained from shadows. Since many air photographs are taken in the middle hours of the day (to obtain the best lighting conditions) it will often be correct to assume that, in northern, temperate latitudes for example, shadows point somewhere between northwest and northeast;[5] failing this the

[5] This rule should be taken as a likely but not infallible guide. Where photographs indicate the *time* as well as date of photography more precise orientation is possible, of course.

characteristic roughly east–west orientation of older Christian churches offers a less reliable guide.

Once location is known, and thus any further map evidence utilized, remaining puzzling features are best interpreted by working systematically from the whole to the part, as indicated earlier; general characteristics such as setting, number and characteristic associations should be considered first before any specific interpretation derived from tone, size and shape is attempted.

# Extending the Possibilities of Interpretation – Further Developments in Air Photographs and Remote Sensing

Despite the enormous potential of the conventional air photograph in providing a detailed inventory of the earth's surface, its resources, and their use, there are ultimate limits to this process and difficulties in practical use. Some of these, such as the very fragmented format of air photographs, are not really serious; others, as with the limitations of the human eye in differentiating photographic detail, are quite fundamental. Not surprisingly there have been attempts to overcome these limitations and some of the more important developments will be described in the final section of this chapter.

### *'Conventional' Photographs in Different Format*

#### 1 *Strip and Stereostrip photography*

In studies of linear features, e.g. roads, power lines, a photographic image in the form of a *continuous strip* may have advantages and can be produced by a *strip camera*. The film in such cameras is exposed not by the intermittent action of a shutter (which gives separate pictures) but by passing it continuously across a narrow slit at a rate just equal to the speed of passage of the ground image. Despite continuous photography stereoscopic vision of an area can still be obtained but this is achieved by producing two films (with overlapping ground coverage) from two lenses, adjacent to each other but with their axes slightly inclined to one another. This inclination produces the slight difference in appearance necessary to allow fusion into a stereoscopic image (Chapter 5, p. 92).

#### 2 *Panoramic Cameras*

In certain situations the back-and-forth flight path of vertical photography may become either a financial or operational luxury (e.g. in military situations). To achieve much wider coverage from a single flight path a *panoramic camera* can be used, with each photograph covering a strip of terrain at right angles to the flight path but stretching almost from horizon to horizon if desired. This is achieved by mounting the camera lens

on a rotating arm so that it can sweep out this transverse path [6] (Fig. 127). The width of the strip so covered (i.e. its dimension *along* the flight path) is relatively narrow but sweeping is sufficiently rapid for the area of each subsequent sweep to overlap that of the previous one, providing continuous cover. The resultant photographs, one for each sweep, are rather unusual, being 'tall and thin' and passing gradually from a true vertical view at the centre to increasingly oblique views at top and bottom. Not surprisingly the complicated distortions of such photographs present difficulties for mapping but their main use is in interpretation work, especially intelligence and reconnaissance. Because the internal optics of this camera use only the most central portions of the lens the photographs produced have much better resolution (ability to show fine detail) than ordinary frame photos arranged to cover wide areas, e.g. the trimetrogon (vertical plus two flanking obliques) arrangement mentioned in Chapter 4 (p. 57, Fig. 26). Once again stereoscopic viewing (of localized areas) is still possible using a double-camera-with-inclined-axes arrangement similar to that described under strip photographs.

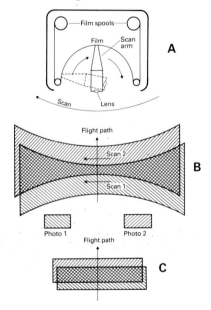

**Fig. 127:** Panoramic photography, (after Branch and Wolf). **A:** Panoramic Camera (diagrammatic). **B:** Ground coverage of two successive scans. **C:** Photo shape and arrangement of two successive photos.

*'Non-Conventional' Photographs – Remote Sensing*

1 *Introduction*

Because the sensitivity of 'conventional' (i.e. panchromatic) photographic film extends relatively little beyond the visible light to which our own eyes respond it produces images which are not startlingly unusual, even allowing for translation of colour into grey on black-and-white film. The 'visible light' which we use in our own perception is, however,

---

[6] In other types of camera, sweeping is provided by rotating a prism in front of a fixed lens. Coverage from horizon to horizon is then possible.

only a small part of the *electromagnetic spectrum*, a term which embraces all forms of radiant energy that move with the constant velocity of light in harmonic wave patterns, including such familiar energy forms as X-rays, ultraviolet and infrared radiation (associated with tanning and sunburn), microwaves (radar) and radio waves (Fig. 128). All materials whose temperature is above absolute zero ($-273°C$) continuously emit or reflect electromagnetic energy, most of which is derived directly or indirectly from solar radiation, though earth-generated sources also play a part. When solar energy is received at the earth's surface it reacts with the materials it impinges upon and is either reflected, transmitted, absorbed, emitted or scattered, depending upon the physico-chemical composition of the material. Different materials produce very different reactions, a result with which we are very familiar so far as visible wavelengths are concerned since it is the basis of visual differentiation. A red surface, for example, appears red because reflectance of incident light from it is greatest in the red portion of the spectrum, but similarly distinctive reactions can also occur with incident *non-visible* energy. Detectors which are sensitive to *non-visible* energy may therefore be able to produce images which include features or differences which are not visible to our eyes or on 'conventional' film, and operations which attempt to do this are often referred to as *remote sensing*.

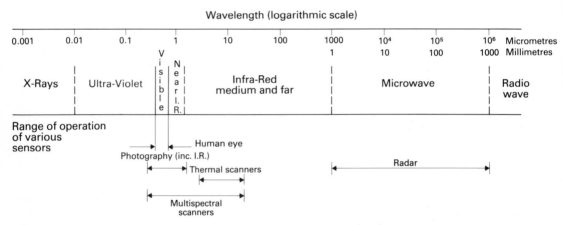

**Fig. 128:** The electromagnetic spectrum and the range of operation of various sensors.

In its most literal interpretation the term remote sensing can be applied to any process which attempts to study the physical character of objects from a distance. In this sense conventional air photography, human vision, and even smell, are forms of remote sensing, but the term has recently come to be used particularly to refer to methods which attempt to do this using detectors sensitive to those parts of the electromagnetic spectrum which lie outside the visible wavelengths.

### 2 Infrared and False-Colour Photography

One of the earliest developments in this field, and one which illustrates its potential advantages quite well, was the development of *black-and-white infrared film* sensitive not

only to most visible wavelengths but also to infrared wavelengths just outside that range – the so-called near- or reflectance-infrared [7] (Fig. 128). Although the presence of the visible wavelengths ensures that the image produced has much in common with a normal photograph there are important differences produced by the impact of infrared energy on the film.

To the layman the most obvious of these is often clarity of view. Because infrared radiation reflected from objects is scattered far less by dust and haze particles than visible wavelengths infrared photography 'sees through' such obstacles far more clearly, producing, for example, long distance obliques of great clarity or clearer verticals of towns and cities which, to the naked eye, seem to be obscured by haze.

More important interpretation-wise, however, are changed tonal values. Since ability to reflect infrared radiation is linked to surface temperature water and wet areas (which are relatively cool) appear darker than usual whereas land areas (warmer) are light in tone, giving sharper land-water contrasts. Vegetation also appears differently. Deciduous vegetation is a far better reflector of infrared radiation than is coniferous, and so the latter appears distinctively darker in tone, far more positively so than on panchromatic film. Within the same species of vegetation far higher reflectivity is possessed by healthy areas than by diseased or dying areas, a property which has important applications in disease detection in crops, making possible earlier detection than could be achieved using the eye, or on panchromatic film (Fig. 129).

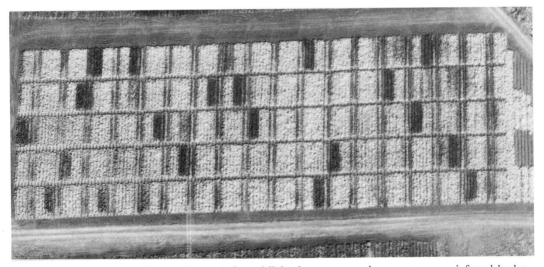

**Fig. 129:** Black and white film sensitive to infra-red light detects areas where potatoes are infected by late-blight disease in test plots at a farm in Maine. The areas affected showed as dark patches on the film, even before the plants developed discernible visual evidence of disease, but they were not visible on comparable photographs taken using normal panchromatic black-and-white film. False colour infra-red film proved even more effective in detecting the disease. (Photograph by courtesy of F. E. Manzer and G. R. Cooper.)

---

[7] So called because it consists of infrared wavelengths present in solar radiation and reflected from the surface of objects, as compared with *thermal* infrared wavelengths which are also emitted by materials themselves.

This last property has been further enhanced in *colour-infrared* or *false-colour* film in which, after processing, the healthy vegetation appears bright red, less healthy areas are in progressively darker tone, and man-made surfaces often bluish grey, hence the term *false colour*. An early application of this type of film was in camouflage detection since 'dead' vegetation, cut and used as camouflage, appeared darker than the living vegetation with which it was intended to merge.

### 3 *Multiband Photography*

A further development of the idea of extending normal perception of an area is provided by *multiband photography* which employs a composite camera consisting of a number (often 4, but sometimes more) of separate small cameras, each equipped with distinctive film/filter combinations so that it records only a particular band of electromagnetic energy. All cameras expose simultaneously but because of their differing sensitivities each produces an image of the same area but with differing tonal values, e.g. certain contrasts may be heightened on one film, damped down on another. Comparison of these varying images of the same area may make interpretation of certain features either easier or more complete than would be possible on a single photograph, and the idea has been applied in fields as varied as forest-species identification, water-resource management and landform identification. Because photographic film is being used the wavelengths recorded are still confined to the visible and near infrared and for general reconnaissance work the bands received by each camera may be relatively broad, e.g. a four-band camera may utilize one band each for the blue, green, red, and near infrared wavelengths. The idea, can, however, be applied in more refined form. If features under study are known to be particularly reflective of certain wavebands incorporation of lens/filter combinations which would exploit this might make such features more easily detectable on the resultant films.

### 4 *Optical Mechanical Scanners*

The potential of photographic film in recording the non-visible portion of the electromagnetic spectrum is, unfortunately, rather limited. As Fig. 128 shows sensitivity does not extend very much beyond the visible wave lengths, and film must therefore normally be used in daylight and under favourable weather conditions. To exploit other areas of the spectrum beyond this it is necessary to employ different sensing devices which, though they may ultimately produce visual output, do so indirectly and at lower levels of resolution and geometrical accuracy than are obtained with camera and film.

One such group of devices is formed by *optical mechanical scanners* which have, at least in the collection of their data, some analogy with panoramic cameras described above. In scanners however the collecting device is a rotating mirror which repeatedly sweeps a band of territory by making contiguous scan lines transverse to the direction of flight (Fig. 130). The mirror views only a small portion of the surface at a time and, as it does so, receives or 'reads' the electromagnetic energy being emitted by that portion of the surface. The wavelengths received include not only the visible and near infrared but extend into the ultraviolet and the thermal infrared (Fig. 128). Unlike the camera, where the energy

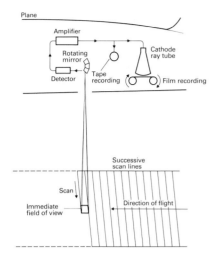

**Fig. 130:** Operation and principal components of a single-channel optical mechanical scanner (after Branch and Wolf). Diagrammatic representation only: not to scale.

received is used directly to activate a film, the scanner uses the mirror to focus incoming radiation on a detecting element where it generates an electrical impulse proportional to the amount of energy received. This electrical impulse is then amplified and used to modulate a beam of electrons such as the moving luminous spot on a cathode ray tube, making the spot brighter or darker according to the intensity of the signal. The received energy has therefore once again been given visual form and though this is continually changing as the mirror scans back and forth these variations can be photographed using a strip camera to produce a permanent visual *image*.[8] In addition the impulse is also simultaneously recorded on magnetic tape to permit future analysis by computer (Fig. 130 and below). Where this is envisaged it is not necessary to recreate a visual image, as described above, unless this were required for illustrative or publicity purposes.

One important branch of scanner output consists of images produced by the *thermal infrared* portion of the spectrum, which consists of energy actually emitted by an object in quantities related to its temperature. Such images therefore reflect quite clearly surface temperature differences within the area being observed and have obvious application where these are important, having been used to study such things as flow of warm effluent discharged into larger water bodies, variations in soil moisture (which affects soil temperature) and the effect of shelter belts on wind flow and surface temperatures (Fig. 131B). On all such imagery warmer areas appear distinctively light and vice versa. Since thermal infrared energy continues to be emitted by objects at night as well as by day images can continue to be received at night with many objects still clearly distinguishable, a property with obvious application to military reconnaissance (Fig. 131A).

The multiple selective-sensitivity approach of the multiband camera can also be applied to scanners, producing the *multispectral scanner*. The goal – spectral fragmentation of the energy received – is the same as with the multiband camera but since this energy is

[8] In the technical parlance of remote sensing an *image* is produced by emitted or reflected energy which has been *converted* by a detector into a picture-like format; a *photograph* is produced when reflected energy impinges *directly* on a photographic emulsion.

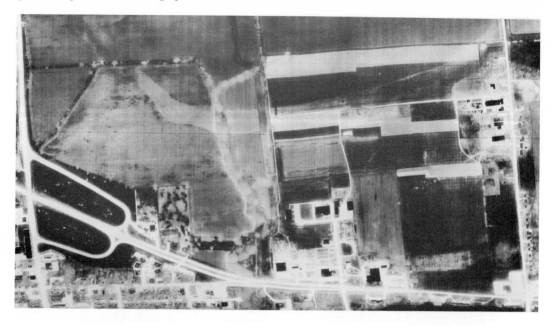

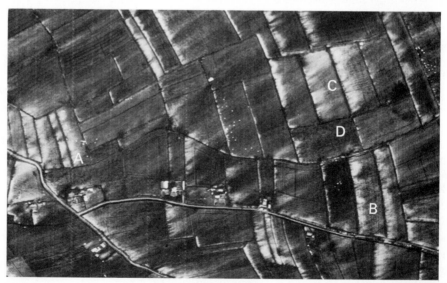

**Fig. 131:** Temperature differences in the landscape revealed by thermal infra-red line-scan imagery. Fig. 131**A** taken at night near Madison, Wisconsin differentiates between bare soil (lighter) and vegetated fields (darker); warm sandy soils (the lighter thin horizontal 'sausage') and cooler surrounding ones, commercial buildings (large and dark) and dwellings. **B:** Daytime imagery of Somerset reveals warmer areas produced in the lee of hedges, particularly where multiple barriers are present as at A, B and C. 'Warm blooded' cattle also stand out clearly as bright dots in the darker pasture. (Photograph courtesy of the Institute for Environmental Studies of the University of Wisconsin, NASA and NCAR; and of the Royal Radar Establishment, Malvern.)

translated into the form of an electrical impulse it is much more easily measured and analysed than is photographic response [9] and a larger number of bands may be employed.

The result has important implications for 'computerized interpretation'. Objects differ markedly in their capacity to reflect or emit energy in different parts of the electromagnetic spectrum. If therefore multispectral imagery is flown over an area whose surface composition is known, e.g. from ground survey, selected features can be examined, one at a time, and the amounts of energy produced by them in each of, say, 12 bands can be noted. Hopefully different objects will each produce a different 'package of energy' or *spectral signature*, recognizable by the amount of energy contained in each band. An array of such spectral signatures belonging to typically occurring features can then be prepared and stored in computer-readable form. Areas of unknown composition, photographed at the same time as the known areas, can now be examined a small portion at a time and their spectral signatures measured. If these are then presented to the computer they can be compared with those in the known array to determine which of these they most resemble. The area concerned is then regarded as most probably corresponding to that known land use or surface feature. If the whole of the scanned energy input is systematically analysed in this way by computer a complete picture of the most probable surface features of the area would be produced. Needless to say in this, as in many other procedures described in simplified form in this chapter, there are still important technological problems to be overcome but enough has been said to indicate the potential of the idea, particularly in studying imagery produced from satellites, where traditional 'look-see' interpretation would be quite unable to cope with the enormous and continuing output.

## 5 *Side-looking Radar*

Yet another portion of the electromagnetic spectrum is exploited by radar-produced imagery of which the most commonly encountered form is *side-looking air-borne radar* (SLAR). Unlike the *passive* systems so far considered, i.e. systems which generate no energy of their own but rely on sensing natural radiation, SLAR is an *active* system with its own energy source emitting a radio beam which is reflected back and sensed by a receiver. In this respect it can be likened to hypothetical 'continual flash-bulb photography' (flash bulbs also generate their own energy), but with the difference that, as in scanners, the reflected energy has to be sensed and processed before a visual image can be produced.

As the name implies, SLAR observes a band of territory to one side of the plane and its imagery has therefore a good deal of resemblance to low oblique photography. A major advantage is that because the radar beam is able to penetrate clouds, smog, and precipitation SLAR imagery is particularly useful in areas which are subject to persistent cloud or haze. As with most other forms of remote sensing resolution is less than with air photography but stereoscopic viewing is still possible if cover of a region is flown from opposite directions or by combining a thermal infrared image with a radar one. However the geometry of SLAR imagery is quite different from that of air photographs and tall

---

[9] Photographic response in the various films of a multiband camera can be measured and compared by means of a *densitometer*.

features may appear to lean *towards* the 'camera',[10] a property which can cause difficulties when the area observed has slopes greater than 30° or more than 3,000 feet of relief.

### 6 *Imagery from satellites*

Imagery produced by the *Landsat* satellites (launched 1972, Landsat 1, and 1975 Landsat 2) is perhaps the example of remote sensing most likely to be encountered by the layman. Equipped with Return Beam Vidicon (RBV) cameras (essentially small TV cameras with very high resolution) and Multispectral Scanners (MSS) each of the twin satellites orbits the earth at a height of 920 km once every 103 minutes, producing a record of the whole earth's surface, except the areas poleward of 82°, once every eighteen days. Moreover the orbits are sun-synchronous so that all parts of the earth are viewed  at the same local time on each pass.

The most successful imagery to date has been that provided by the multispectral scanners which contain four sensors, each recording in a different part of the electromagnetic spectrum – one each in the green and red bands and two in the near infrared. The imagery is transmitted to earth-receiving stations electronically and is then converted into both computer-compatible tapes (permitting computer-controlled analysis – see above) and photographic form, the latter being either black and white photos of individual band recordings or colour composites of all bands, giving a photo which has an appearance similar to that of a false-colour infrared (p. 324). Because of its scanning origins each picture covers a slightly parallelogrammatic area 185 km × 185 km and is available reproduced at $1:3\frac{1}{2}$ million (approx.); 1:1,000,000; 1:500,000 or 1:250,000 scale, an example of the 1:1,000,000 scale output being reproduced in Fig. 132.[11]

Because extensive geometrical corrections have been applied to all Landsat products the imagery is virtually planimetrically correct (it has been accepted by the Cartographic Section of the International Geographical Union as meeting map standard accuracy for mapping at 1:250,000 scale) and, though resolution varies according to the degree of contrast of an area with its surroundings in ideal conditions distinct areas as small as about 80 metres square may be detected under magnification. At the other end of the interpretation scale the enormous field of view of satellite images enables us, often for the first time, to perceive in unfragmented view really large features of the earth's surface, such as water movements or meteorological phenomena.

With satellite imagery we have come a long way indeed from the tentative fumblings towards earth-knowledge with which we began in Chapter 1. The most poignant contrast, however, is not with the cruder techniques of that chapter, (or of Chapters 2 and 3), but with the earth-recording technology of no more than twenty years ago. Of course many of the latest technological developments, whether in map-making or remote sensing, are still at a very experimental stage and have hardly even approached mass application. We may at last find ourselves buying large-scale maps drawn by computer, or even 'rolled up' as

---

[10] It is not difficult to see why. Radar imagery is dependent upon time and therefore length of path of the reflected beam is critical. Since the tops of features are nearer to the transmitter than their bases they appear so on the resultant imagery.

[11] Information on Landsat Data and copies of Landsat output can be obtained from EROS Data Centre, US Geological Survey, Sioux Falls, South Dakota 57198, USA.

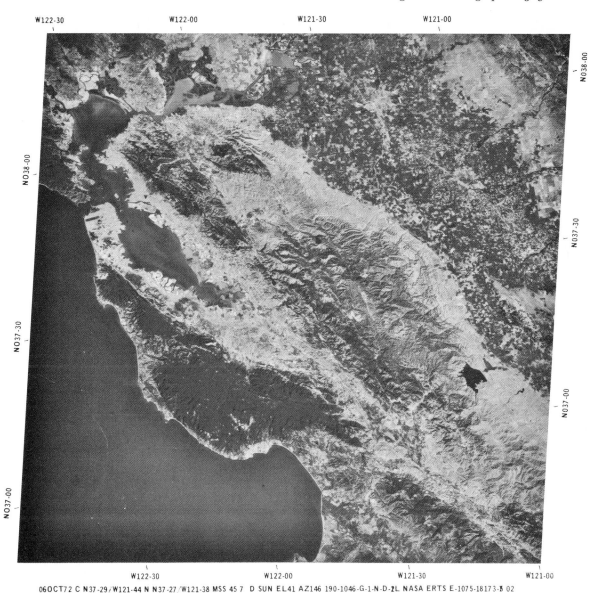

06OCT72 C N37-29/W121-44 N N37-27/W121-38 MSS 45 7  D SUN EL41 AZ146 190-1046-G-1-N-D-2L NASA ERTS E-1075-18173-5 02

**Fig. 132:** Imagery of the San Francisco–Stockton area of of California (1972) produced by the satellite Landsat 1 ERTS 1) (Photo-identification no. ERTS E-1075-18173). Taken from a height of about 570 miles and at a scale of about 1 : 1,500,000 (original scale 1 : 1,000,000 here reduced) the image shows, in succession from the coast, the Santa Cruz Mountains (heavily forested); the San Francisco Bay – San Jose – San Benito valley; the Coastal Range; the agricultural land of the Central Valley and the foothills of the Sierra Nevada. Neither San Francisco nor the East Bay cities show clearly on this reproduction but urban areas such as Stockton can be distinguished among the agricultural land of the Central Valley. (Photo courtesy of NASA (original image) and US Geological Survey, EROS Data Center (reproduction).)

magnetic tape, but the realization of the idea of 'dial-a-map', by computer selection from a data bank, is much further off. So too would be many of the developments in remote sensing had they not been associated with the very atypical financial climate of a space-research programme.

The last-made point is indeed a telling one. It is, alas, so often mundane financial considerations which keep our acquaintance with 'earth imagery' so small in amount and so far behind the advances of the technological frontier. For most people an 'earth image' is still a map simply because it is usually cheaper to buy and far easier to obtain. Nor do things change so quickly. Even after widespread use began, during and after World War I, it still took the air photograph (and certainly the vertical air photograph) nearly half a century to secure a firm foothold in school textbooks and examination structures, and many people still have no acquaintance with topographical maps beyond those of their own country. This is to be regretted. Quite apart from startling new developments just described, even the standard topographic map and 'conventional' air photograph have a great deal to offer – a valuable measured, detailed, and often complex, inventory of an area to set against the necessarily more simplified generalizations of textual description.

A prime concern of this book has been to show just how much, in this respect, 'earth imagery' has to offer, whether it be from map, air photograph or remote-sensing image. In what can be, at best, no more than a general introduction to the field it has attempted to convey an understanding of what may be found there; it would be pleasant to believe that it may also provide a stimulus for further exploration in a rewarding and fascinating field of study.

# Suggestions for further reading

The list that follows is not a full bibliography; it is intended only to indicate works which will expand the introduction to various topics offered in this book or provide greater detail on technical processes referred to. It also includes any works referred to in the text.

## Chapters 1, 2 and 3

*The History of Cartography – general*

Bricker, C. and Tooley, R. V. (1969) *A history of cartography – 2,500 years of maps and map making*, London, Thames and Hudson – a lavishly illustrated text with a continent-by-continent approach. Also printed as *Land marks of map making – an illustrated survey of maps and map makers*, Oxford, Phaidon (1977).

Crone, G. R. (1966) *Maps and their makers*, London, Hutchinson (3rd Edition), a useful paperback covering developments from classical to modern times.

Brown, L. A. (1949) *The story of maps*, Boston, Little Brown – thirty years old but still one of the best systematic accounts.

Crone, G. R. (1965) 'New light on the Hereford map', (see Fig. 2B), *Geogr. Journal* 131, 447–62.

Tooley, R. V. (1949) *Maps and Map Makers*, London, Batsford.

*The History of Cartography – Great Britain*

Harley, J. B. (1972) *Maps for the local historian – a guide to the British Sources*, London, National Council of Social Service. An invaluable (and cheap) introduction and guide to all aspects of British mapping with a particularly useful bibliography.

Crone, G. R., Campbell, E. M., and Skelton, R. A. (1962) 'Landmarks in British Cartography', *Geogr. Journal* 128, 406–30.

Mitchell, J. B., and Pelham, R. A. (1933) 'Early maps of Britain', *Geogr. Journal* 81, 27–9.

Stenton, Sir, F., and Parsons, E. J. S. (1958) *The map of Great Britain c. A.D. 1360 known as the Gough map*, Oxford, OUP. This volume was prepared and sold as an introduction to the facsimile of the map published by the Royal Geographical Society.

Lynam, E. (1953) *The map makers art – essays on the history of maps*, London, Batchworth Press.

Harley, J. B. (1965) 'The re-mapping of England 1750–1800', *Imago Mundi* XIX, 56–67.

Rogers, E. M. (1972) *The large-scale maps of the British Isles 1696–1850*, Oxford, Bodleian Library, 2nd Edition. A hand list of British county maps.

*Twentieth Century Cartography*

Lock, M. (1976) *Geography and cartography – a reference handbook*, London, Bingley (3rd Revised Edition). Probably the most comprehensive single volume text on maps and map series in the countries of the world. Earlier versions appeared as *Modern maps and atlases*.

Brandenburger, A. J. (1970) 'World-wide mapping survey', *Photogrammetric Engineering* XXXVI, 355–9. An unusual comparison of the state of mapping and photogrammetry in the USA, USSR, China and India.

McGrath, G. (1976) 'From hills to Hotine', *Cartographic Journal* 13, 7–21. The story of the quest for a central Survey and Mapping Organization for the British Colonial territories in Africa.

Bond, B. A. (1973) 'Cartographic source material and its evaluation', *Cartographic Journal* 10, 54–8. An interesting study of compilation.

*Map Projections*

Steers, J. A. (1971) *An introduction to the study of map projections*, London, Univ. of London (15th Edition).

Kellaway, G. P. (1949 reprinted 1970) *Map projections*, London, Methuen. A useful introduction in paperback form.

Maling, D. H. (1973) *Coordinate systems and map projections*, London, Phillip. A fuller and more advanced treatment than the two previous references.

The Cartographic Sub-committee of the British National Committee for Geography (1966) *Glossary of technical terms in cartography*, London, The Royal Society. A most useful glossary and guide to dozens of projections.

*Surveying*

Hinks, A. R. (1947) *Maps and survey*, Cambridge, Univ. Press, (5th Edition). An old book but one of the few that treat the subject simply and essentially from the viewpoint of topographic mapping. Has also useful notes on many older official map series.

Ministry of Defence (1965) *Textbook of topographical surveying*, London, HMSO (4th Edition). A fuller treatment with sections on map reproduction and design which have relevance to Chapter 6 also.

# Chapter 4

Dalgleish, A. G. (1977) Chapter 2 of St Joseph, J. K. S. (ed.) *The uses of air photography*, London, Baker (2nd Edition), 35–47. A useful introductory account.

Kilford, W. K. (1973) *Elementary air survey*, London, Pitman (Third Edition). A 'short course' is indicated within the book for those requiring only a general understanding.

Wolf, P. R. (1974) *Elements of photogrammetry*, New York, McGraw Hill.

Van Zuylen, L. (1969) 'Production of photomaps', *Cartographic Journal* 6, 92–102.

Petrie, G. (1977) 'Orthophotomaps', *Trans. Institute of British Geographers*, New Series, 2, 49–70.

Thrower, N. J. W., and Jensen, J. R. (1976) 'The orthophoto and orthophotomap; characteristics, development and application', *American Cartographer* 3, 39–86.

Blachut, T. J. (1968) 'Further extensions of the orthophoto technique', *Canadian Surveyor* XXII, 206–20. Places useful emphasis on the differences between conventional maps and orthophotomaps rather than the technique of orthophotography.

# Chapter 5

Baldock, E. D. (1971) 'Cartographic relief portrayal', *International Yearbook of Cartography* XI, 75–8. Describes hill-shading using manual techniques; an illuminating comparison with Yoeli (1967) below.

Pannekoek, A. J. (1967) 'Generalisation of Coastlines and contours', *International Yearbook of Cartography* II, 55–75.

Keates, J. S. (1972) 'Symbols and meaning in topographic maps', *International Yearbook of Cartography* XII, 168–81.

Couzinet, M. (1947 & 1948) *Etudes comparatives des signes conventionnels*, see text p. 99.

Gertsen, W. M. (1970) 'Danish topographical mapping', *Cartographic Journal* 7, 113–22. An illustrated description and catalogue of the content of maps at different scale; includes Greenland.

Knowles, R., and Stowe, P. W. E. (1969, 1971 & 1976) *Europe in Maps (Books 1 & 2)*, *North America in Maps*, London, Longman. Provide an excellent introduction to, and illustration of, the topographic maps of several European countries, USA and Canada. There are also air photographs and text which have relevance to Chapters 14, 15 and 16.

Harley, J. B. (1975) *Ordnance Survey Maps, a Descriptive Manual*, London, HMSO.

Harley, J. B. and Phillips, C. W. (1964) *The Historian's Guide to Ordnance Survey Maps*, London, National Council of Social Service.

Winterbotham, H. St J. L. (1934) *The National Plans*, London, HMSO.

# Chapter 6

*Map Printing*

Keates, J. S. (1973) *Cartographic design and production*, London, Longman. Parts II and III, the technical basis of cartography and map production, are relevant here but Part I, the graphical basis of cartography, has relevance to Chapter 5.

Keates, J. S. (1977) 'Developments in non-automated techniques', *Trans. Institute of British Geographers*, New Series, 2, 37–48.

Woodward, D. (ed.) (1975) *Five centuries of map printing*, Chicago, Univ. of Chicago Press.

*Automation in Cartography*

Rhind, D. (1977) 'Computer-Aided Cartography', and

Robinson, A. H., Morrison, J. L., and Muehrcke, P. C. (1977) 'Cartography 1950–2000',

both in *Trans. Institute of British Geographers*, New Series, 2, pp. 71–94 and 3–18 respectively.

British Cartographic Society (1974) *Automated Cartography – Papers presented at the Annual Symposium of the British Cartographical Society, Southampton, 1973*, London, British Cartog. Socy.

Cobb, M. H. (1971) 'Changing map scales by automation', *Geographical Mag.* 43, 786–9.

Rhind, D. (1974) 'High speed maps by laser beam', *Geogr. Mag.* 46, 393–4.

Yoeli, P. (1967) 'The mechanisation of analytical hill shading', *Cartog. Journal* 4, 82–8.

Brassel, K., Little, J., and Peuker, T. K. (1974) 'Automated relief representation', *Annuals of Associatn. of American Geographers* 64, 610–1. Including Map Supplement No. 17 – shows the same area represented in 6 different ways.

# Chapter 7

*International Cartography*

United Nations (1955) 'The International map of the world on the millionth scale and the international cooperation in the field of cartography', *World Cartography* 13, 1–12.

Gardiner, R. A. (1961) 'A reappraisal of the international map of the world (IMW) on the millionth scale', *International Yearbook of Cartography* I, 31–49.

Robinson, A. H. (1965) 'The future of the international map', *Cartogr. Journal* 2, 23–6.

Sallat, R. (1975) 'Un exemple de coopération internationale en Europe de l'Ouest; la carte au 1:500,000 type World et ses variations', *International Yearbook of Cartography* XV, 19–26.

Bennet, H. A., Hogg, L. A., and Lockyer, A. A. H. (1967) 'The land map and air chart at 1:250,000', (Joint Operations Graphic), *Cartographic Journal* 4, 89–95.

*The British Ordnance Survey and its Maps*

Harley, J. B. (1975) *Ordnance Survey Maps, a Descriptive Manual*, London, HMSO.

Harley, J. B. and Phillips, C. W. (1964) *The Historian's Guide to Ordnance Survey Maps*, London, National Council of Social Service.

Winterbotham, H. St. J. L. (1934) *The National Plans*, London, HMSO.

Close, Sir, C. (1926, reprinted 1969) *The early years of the Ordnance Survey*, Newton Abbot, David and Charles.

—— (1938) *Final report of the Departmental Committee on the Ordnance Survey*, (The Davidson Committee's recommendations), London, HMSO.

Gardiner-Hill, R. C. (1972) 'The development of digital mapping', *Ordnance Survey, Professional Papers, New Series*, 23.

Price, J. G. (1975) 'A Review of Design and production factors for the Ordnance Survey 1:50,000 map series', *Cartographic Journal* 12, 22–9.

Rugg, D. S. (1965) 'Post war progress in cartography in the Federal Republic of Germany', *Cartogr. Journal* 2, 75–83. Provides an interesting example of a National mapping programme evolving under quite dissimilar circumstances to those in Britain.

# Chapters 8, 9, 10 and 11

Debenham, F. (1937) *Exercises in Cartography.*
Ministry of Defence (1955) *Manual of map reading, air photo reading and field sketching* – Part I map reading, (Part II – Air Photo Reading (1958) has relevance to Chapter 16), London, HMSO.
—— (1974) *Manual of map reading, 1973*, London, HMSO. (A replacement for the above.) Both offer simple, straightforward guidance on many aspects of map usage.

*Defining and Determining Position*

Ordnance Survey (1955 and reprinted 1962) *The projection for Ordnance Survey maps and plans and the national reference system*, London, HMSO.
Clayton, K. M. (1971) 'Geographical reference systems', *Geographical Journal* 137, 1–13.

*Measurement of Area*

Stobbs, A. R. (1968) 'Some problems of measuring land use in underdeveloped countries: the land use survey of Malawi', *Cartographic Journal* 5. Page 110 has an interesting table comparing the efficiencies of various techniques.
McKay, C. J. (1966) 'Automation applied to area measurement', *Cartographic Journal* 3, 22–5 describes automatic reading planimeters.
Maling, D. H. (1968) *A comparison of the simpler methods of measuring area by planimeter and counting*, Paper presented at the Annual Symposium of the British Cartographic Society, University of Sussex.
Debenham, F. (1937) *Exercises in Cartography*, London, Blackie.
Frolov, Y. S. and Maling, D. H. (1969) The Accuracy of Area Measurement by Point-counting Techniques, *Cartographic Journal* (6, 1) British Cartographic Society, London.
Hodgkiss, A. G. (1966) 'Methods of Changing Scale in the Drawing Office', *Bulletin of the Society of University Cartographers*, (June), Liverpool, (mimeographed).
Monkhouse, F. J. and Wilkinson, H. R. (1971) *Maps and Diagrams*, (3rd edition), London, Methuen.

# Chapter 12

*Block Diagrams*

Schou, A. (1964) *The construction of block diagrams*, London, Nelson.
Debenham, F. (1937) *Exercises in Cartography*, London, Blackie.
Monkhouse, F. J. and Wilkinson, H. R. (1971) *Maps and Diagrams*, London, Methuen.
Goodrich, J. (1971) *SYMVU Manual*, Cambridge, Mass. – Harvard University Laboratory for Computer Graphics and Spatial Analysis.
Sprunt, B. F. (1972) 'Contours in Perspective'. Paper presented at the Institute of Bristol Geographers Annual Conference, Aberdeen, 18 pp.

*Tanaka's Method*

Tanaka, K. (1932) 'The orthographical method of representing hill features on a topographical map', *Geogr. Journal* 79, 213–9.

Oberlander, T. M. (1968) 'A critical appraisal of the inclined contour technique of surface representation', *Annals of the Association of American Geographers* 58, 802–13.

Peucker, Tichenor and Rase (1975) 'The Computer Version of Three Relief Representations', in Davis, J. C. and McCullogh, M. J. (Eds.) (1975) *Display and Analysis of Spatial Data*, London, Wiley.

Robinson, A. H. and Thrower, N. J. (1957) 'A New Method of Terrain Representation', *Geographical Review*, New York, pp. 507–520.

*Slope Maps*

McGregor, D. R. (1957) 'Some observations on the Geographical Significance of Slopes', *Geography* (42), Geographical Association, Sheffield, pp. 167–73.

Denness, B. E. and Grainger, P. (1976) 'The preparation of slope maps by the moving interval method', *Area* 8, 3, Institute of British Geographers, London, pp. 213–218.

Raisz, E. and Henry, J. (1937) 'An Average Slope Map of Southern New England', *Geographical Review* (27), New York, pp. 467–72.

*Relative Relief Maps*

Smith, G. H. (1935) 'The Relative Relief of Ohio', *Geographical Review* (25), New York, pp. 272–84.

Dickinson, G. C. (1973) *Statistical Mapping and the Presentation of Statistics*, (2nd Edition), London, Edward Arnold.

# Chapter 13

Harley, J. B. (1968) 'The evaluation of early maps: towards a methodology', *Imago Mundi* 22, 62–74.

Laxton, P. (1976) 'The geodetic and topographical evaluation of English County Maps 1740–1840', *Cartographic Journal* 13, 37–54. An invaluable review covering many aspects of map content.

Mumford, I., and Clark, P. K. (1968) 'Engraved Ordnance Survey one-inch maps – the methodology of dating', *Cart. Journal* 5, 111–14.

—— (1966) *Orford Ness – a selection of maps mainly by John Norden*, Cambridge, Heffer.

Carr, A. P. (1962) 'Cartographic Record and Historical Accuracy', *Geography* (47), Geographical Association, Sheffield.

Diver, G. (1950) 'The Physiography of the South Haven Peninsula, Studland Heath, Dorset', *Geographical Journal* 81, London, pp. 404–427.

Steers, J. A. (1969) *The Coastline of England and Wales*, Cambridge, Cambridge U.P.

Stenton, Sir F. and Parson, E. J. S. (1958) *The Map of Great Britain c. AD 1360 known as the Gough Map*, Oxford U.P.

Sund, T. and Sømme, A. (1947) *Norway in Maps, Text Volume*, Bergen, Griegs.

# Chapters 14 and 15

Dury, G. H. (1972) *Map interpretation*, Pitman, London.

Curran, A. H., *et al.* (1974) *Atlas of landforms*, London and New York, Wiley (2nd Edition).

Cholley, A. (ed.) (1956) *Atlas des formes du relief*, Paris, Institut Geographique National. Both the above are essentially map and air photo illustrations with little text.

Schou, A. (1949) *Atlas of Denmark, Vol. 1, the landscape*, (two parts – text and maps), Copenhagen, Royal Danish Geographical Society is a superb blend of maps, evolutionary diagrams and text (English version available). It deals only with physical landscapes, mainly of glacial deposition.

Sebrader, P. H. (1957) *Die landschaften Niedersachsens – Bau, Bild und Deuting der landschaft*, Hannover, Niedersächsisches Landvermessungsamt. Excellent series of map pages of 'human', and 'physical' landscapes with opposed pages of text (in German).

All the above take the traditional approach to map analysis, illustration by exemplification.

Lobeck, A. K. (1958) *Things maps don't tell us – an adventure into map interpretation*, New York, Macmillan. Has a more questioning approach rather like that of this book.

Worthington, B. D. R., and Gant, R. (1975) *Techniques in map analysis*, London, Macmillan. Takes a more mathematical/analytical view.

Brown, D. H. (1960) *The Relief and Drainage of Wales*, Cardiff, Univ. of Wales Press.

Holmes, A. (1965) *Principles of Physical Geology*, London, Nelson.

Bastié, J. (1964) *La Croissance de la Banlieue Parisienne*, Paris, Presses Universitaires de France.

Berry, B. J. L. (1967) *Geography of Market Centres and Retail Distribution*, Englewood Cliffs, Prentice-Hall.

Dickinson, G. C. (1973) *Statistical Mapping and the Presentation of Statistics*, London, Edward Arnold.

Dickinson, R. E. (1932) 'The Distribution and Function of the Small Urban Settlements of East Anglia', *Geography* (XVII), Geographical Association, Manchester, pp. 19–31.

Dickinson, R. E. (1934) 'The Markets and Market Areas of East Anglia', *Economic Geography* X, Clark University, Worcester, Mass., pp. 172–87.

Gleeve, M. B. (1966) 'Hill Settlements and Their Abandonment in Tropical Africa', *Transactions* (40), Institute of British Geographers, London, pp. 39–49.

Naval Intelligence Division (1962) *Geographical Handbook Series, France*, Vol. III.

Socolofsky, E. and Self, H. (1972) *A Historical Atlas of Kansas*, Norman. Univ. of Oklahoma Press.

Steane, J. (1974) *The Northamptonshire Landscape*, London, Hodder and Stoughton.

# Chapter 16

*Air Photo Interpretation*

Avery, T. E. (1977) *Interpretation of aerial photographs*, Minneapolis, Burgess (3rd Edition).

St Joseph, J. K. S. (ed.) (1977) *The uses of air photography*, London, Baker (2nd Edition). Illustrates the applications of air photography to Cartography, Geology, Geography, Soil Science, Plant Ecology, Plant disease, Zoology, Game management, Archaeology, History and Town Planning.

Branch, M. C. (1971) *City Planning and aerial information*, Cambridge, Mass., Harvard University Press. Good for examples of urban detail but is also a useful introduction to air photographs generally.

Wolf, P. R. (1974) *Elements of Photogrammetry*, New York, McGraw-Hill.

Collins, W. G., and El-Beik, A. H. A. (1971) 'The acquisition of land use information from aerial photographs of the city of Leeds', *Photogrammetria* 27, 71–92.

Manzer, F. E., and Cooper, G. R. (1967) *Aerial photographic methods of potato-disease detection*, Oronto, Maine, University of Maine Agricultural Experiment Station, Bulletin 646.

Chevallier, R. (1965) *Photographie Aérienne*, Paris, Gauthier-Villars.

*Remote Sensing*

Lillesand, T. M., and Stevens, A. R. (1974) in Wolf, P. R. (1974) above.

Estes, J. E., and Senger, L. W. (1974) *Remote sensing – techniques for environmental analysis*, Santa Barbara, Hamilton Pub. Co.

Barrett, E. C. and Curtis, L. F. (1974) *Environmental remote sensing: applications and achievements*, London, Arnold.

The World Bank (1976) *Landsat Index Atlas of the Developing Countries of the World*, Baltimore, Johns Hopkins. Index diagram of all the Landsat coverage, indicating time of year, quality, etc., together with an introduction describing the Landsat recording systems and the characteristics of their imagery.

Colvocoresses, A. P. (1975) 'Evaluation of the Cartographic Application of ERTS–1 Imagery', *The American Cartographer* 2, 5–18.

# Index

All references to mapping agencies and to official map series are listed by country, with the exception of the Ordnance Survey which is to be found under its own name; topographical features appear under their proper names; map projections are all listed alphabetically under the general heading 'map projections'; references in bold type refer to figure numbers, those marked *n* to footnotes.